THE HUNCHBACK OF EAST HOLLYWOOD

A biography of Charles Bukowski

by Aubrey Malone

Critical Vision
An imprint of Headpress

A CRITICAL VISION BOOK
Published in 2003
by Headpress

Headpress/Critical Vision
PO Box 26
Manchester
M26 1PQ
Great Britain

Tel +44 (0)161 796 1935
Fax +44 (0)161 796 9703
Email info.headpress@zen.co.uk
Web www.headpress.com

Drawings of Bukowski © Rik Rawling
Photos of Bukowski (taken during an
interview for *Poetry Now* circa mid
seventies) © William Childress, courtesy
Al Berlinski
Photo of Jane Cooney Baker © Roswell
High School, Mexico

Printed in Great Britain
by The Bath Press, Bath

**THE HUNCHBACK OF
EAST HOLLYWOOD**
A Biography of Charles Bukowski
Text copyright © Aubrey Malone
This volume copyright © 2003 Headpress
Layout & design: Walt Meaties
World Rights Reserved

**British Library Cataloguing in
Publication Data**
A catalogue record for this book is available
from the British Library

ISBN 1-900486-28-8

Acknowledgements
Quotations from *Women*, *Factotum* and
Post Office by Charles Bukowski © Virgin
Publishing Ltd.
Sincere thanks for help and advice from
Don Skirving, Al Berlinski, Sarah
Fordham, Kevin Ring, Joanna Burgess
and Katherine Norman-Butler.

**Send an SAE/IRC for our book cata-
logue, or visit www.headpress.com**

Contents

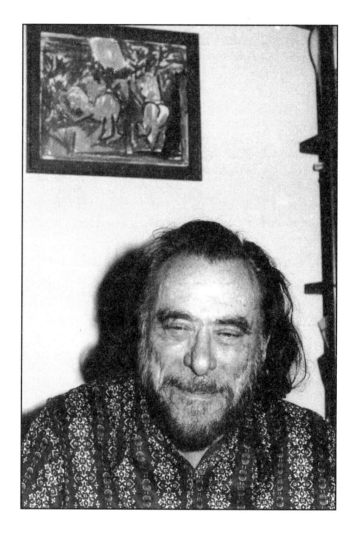

He might have been just another inhibited boy. He might have been just another misunderstood son of a disgruntled milkman and his subservient wife. He might have grown up like any other people in his class on the block, toeing the line, pocketing his weekly pay-check, raising his 2.2 kids and going to the ballgame at the weekend.

But he always knew that could never happen. He knew he was different. He knew it was better to be an idiot or a bank robber than live his life as others did.

Whatever his future was, it wouldn't be predictable. He decided he would be brilliant or a disaster. Or both...

Introduction

THE STORY OF CHARLES BUKOWSKI IS THE STORY OF A man who went from suffering unspeakable neglect as a child to becoming a worldwide celebrity courtesy of a gift many still decry. The story of a man almost given up for dead who went on to the live the biblical span. The story of a man who never knew what he wanted to say but kept on saying it anyway. The story of a man who lived fast, died old, and made a not-too-pretty-looking corpse.

There have been few unlikelier candidates for literary success than he, and few unlikelier candidates for longevity. And yet he achieved both in no mean degree. If he had a secret he didn't know it. He never sought the blinding flash of inspiration or the Road-to-Damascus experience. He simply decided to keep on keeping on, and one day the dam opened. When it did, he knew it didn't make him a better writer. His quality was roughly the same when he was a hobo as when he became an icon.

What it was all about was timing, pacing yourself for when the chink would appear. When it did, it meant dredging up material he had cast into the wilderness for all those decades — letters he never xeroxed, poems he submitted to boondocks journals without an sae because he was either too lazy or he depended, usually unwisely, upon the integrity of editors to return them if they proved unsuitable, which was the case most of the time.

Both in his life and his art he wore his heart on his sleeve, disgusting many and impressing some, but always always always himself, the hobo poet *manqué* screaming against a wall for succour, or depending on the kindness of strangers to let him in. He wanted to rock the temple of poetry to its foundations and create a new one from the rubble, one that wasn't built on shifting sand.

When he was young he didn't have the preciousness of most fledgling scribes who think they're going to change the world. When something came back to him in the post he threw it away. It was only later he started to spar with editors and question their judgement, imagining the rejection was their problem rather than his, or that they had a hidden agenda.

Bukowski once sent a long short story about a doomed alcoholic to a magazine. They sent it back saying it had literary merit but they were rejecting it because the central character seemed to have no meaning. Bukowski fumed at their attitude, not so much because that character was himself as for their high-handed attitude. What was

meaning anyway? Was there significance in the fall of a sparrow? All God's chillum had wings, or so we were led to believe. Did every story necessarily have to have a message tagged onto it like a letter to a pigeon's foot? Surely the message was in the telling. But that wasn't the way editors looked at it.

Nobody had the answers, he knew, neither those who lived in ivory towers nor on skid row. In fact you were better off in the latter place because at least there was honesty there, even if it was of the grubby variety. He wouldn't seek sermons under the stones, like Wordsworth, but integrity.

He had little to call his own, and was occasionally evicted from apartments for failing to pay the rent. He grew accustomed to park benches, and ladies of the night.

He lived in a world of hockshops and hookers: two sets of people who said yes to him when everyone else said no, and to that extent they were to be welcomed.

He was fascinated by the diseased imagination, the masochistic zeal of the romantics.

Poetry, he knew, ought to reprise the sickly mess of our lives rather than attempt to order or subdue it into tightly-woven verbal constructs.

His parents told him that the public didn't want to read the kind of material he wrote, which focused on the seamy side of life. He agreed, but then he didn't write for the public at large. He wrote for a niche following, for people like him who weren't afraid to walk down the dark side of the street and take the consequences.

In the fifties there were only piecemeal publications, so many droppings from the rich men's plates. At this time in his life he was being chewed up by the world, wondering if the break would ever come. Such a strain continued throughout the next decade on and off. He never expected to become big, and one wonders if he even felt he deserved to. If he had attained just a modest success he would probably have settled for that. Anything that kept him off the park benches was to be aspired to. After that, everything else was a bonus.

His brief had always been to endure rather than conquer, to hit back at the eight count.

In time his every negligible missive became treasured by those who stole his books from libraries, or drank where he drank, ate where he ate.

He did a reading in Germany in 1978 which, according to his German translator Carl Weissner, drew a bigger crowd than Hitler.

'Now the professors come by with their little six-packs of beer,' he told Neeli Cherkovski, 'and they want to know the secret. There isn't any fucking secret. It's just work, day by day, banging on the typer.' He would always demystify the process in this way.

Anything was fair game for him. He even called a poem '462-0614', which was his phone number at that time. The fact that he wasn't ex-directory probably put him in a minority of one among popular poets. The point the poem makes — a familiar one for him — is that he doesn't see himself as having any answers to life merely because he's famous. If people call him, he wants them to help him as much as vice versa. The Bukowski household was never going to be a Samaritan helpline.

He never really suffered from writer's block, which isn't the same thing as saying he was always satisfied with his work. But if good poems wouldn't come he still put *something* down on paper, however feeble. Maybe it could be modified later, or maybe there was a line or two he could rework into something approaching an epiphany.

He refused to accept the well-turned word for its own sake. There had to be something more to it, some juice, some demon, some bare-knuckle challenge that made it different.

He hated the well-heeled bigots with their air-conditioning and their colour-coordinated clothes, their fast cars and their slow women, their tidy minds and their tidy lawns, their affluence and life-denying bombast.

He would prefer, he said once, if somebody handed him a lead pipe instead of a poem. At least a lead pipe was itself, and it didn't make any designs on you. Most poems, on the contrary, had an agenda. They tried to coerce you, however subliminally, into a point of view, which was a form of aesthetic totalitarianism. His own work, he promised, wouldn't creak with these grandiose designs.

Poetry, he said, had its head stuck up its own crotch. And poets were as obnoxious off the page as they were on it.

He was always in the eye of the storm, whether with his father, with women, with landlords, with barmen, with publishers, with the police, with himself. His life was a war zone and that was the way he liked it — tranquillity made him uncomfortable. He liked, needed, to rock the boat. Just as they say that a shark will die if it stops moving, he sought out recalcitrance like a holy grail, testing himself against its stern limits time and again, rolling his boulder up the hill like Camus' Sisyphus, or even his Meursault from *The Outsider*. He understood Meursault because he too found it difficult to cry at his mother's funeral, and he too felt traumatised by a society that expected certain responses from a man, responses that turned him into a robot. He always preferred to be greeted with howls of execration than bouquets of flowers. He dealt in the jagged edge of life, the rusty tin cans, the diseased seed.

Somebody said that Stephen King took horror away from Transylvania and brought it to the trailer park up the road. Hank went one further: with him the horror was in his own head. He captured the dank odour of brothels, the death of hope for those born on the wrong side of the tracks, the muggy dawns in bad roominghouses as he lay between broken sleep and imminent hangover, between abusing or abused whore and a job he would leave on payday because he couldn't face its humiliations any more.

He's a man one imagines falling out of bed each morning, staggering towards his wardrobe for his cleanest dirty shirt and having a hair of the dog that bit him the night before. And then inching his way through half-empty bottles on smoke-stained tables to his writing desk. The sun would sting his eyes and he would pull the shades down. A woman might call out to him from the bedroom and he would holler something back. He would take a quick shot of whiskey and then maybe cough up some blood.

When other poets were doing college courses or preparing lecture notes to earn a crust, Bukowski was fighting the fight on his own terms, going down into the belly of the beast to commune with his dark side. Except he wouldn't call it that. Hell, no. He would just call it getting the word down as it came to him. No strings, no pretensions, no agenda and no tricks. Just the word, sent out from one struggling soul to another to find what readers it might. And if it didn't, he would try again tomorrow. If he was still around.

His vision is narrow in that the lion's share of his work is in the first person, but his mind was such a volcano that one rarely feels a sense of claustrophobia. The narrowness, in a way, is its strength. From these hermetically-sealed slices of dementia we get his essence, and the essence of that crude milieu from which he alchemised the sickness of loss and deprivation into the flat diction that was the way poetry had to go if it was to survive. It was unwriterly, of course, but for Bukowski poetry had rammed itself into a brick wall from decades of pansies searching for what Hemingway would call 'the true declarative sentence', and he had no time for that.

He didn't want to hone language, but tear it apart. Like a one-take actor he railed against the preciousness that came with editing or revision. Reworking something, for him, seemed to bring an untruth to it, an overlay of contrivance. Better a bad book that came out naturally, he seemed to say, than a good one touched up with the benefit of second-guessing hindsight.

He was a hippie before hippies became fashionable. When he himself became fashionable, he shied away from the attention after basking in its glory for a brief time. Fame bought financial comfort and a few other accoutrements, but he didn't sell his soul to it, even if he described himself as the oldest whore on the beat when it came to making deals.

You often wait for something to happen in his poems but he usually disappoints on this score, preferring to end them on an anticlimactic dying fall. Many of them are written like diary entries, begging the question: what *is* a poem? It wasn't that he pushed back the frontiers as simply ignored them.

We remember him primarily today for his wild shenanigans, his brushes with the law and his manifold dalliances with women, but he had a devotion to his craft that's all too often ignored, or trivialised.

It was to the page he returned every night when the bars had all shut down. In fact he often used the image of a bar closing to denote that he was turning off his typer for the night. Drinking and writing bled into one another almost osmotically for him. The only difference was that in the former capacity he was the receptacle, and in the latter the creator.

Booze and writing, he frequently assured us, saved his ass. Sometimes women helped, but they came with a price. At least you knew where you stood with alcohol, even when you over-indulged. Women were different. They were like horses he backed at the track: a gamble. They promised him they would be different from the last one, but they all ended up exactly the same.

And yet he repeatedly went back to them, like a murderer returning to the scene of the crime, waiting for them to turn the screw one more time.

What surprised most people was the fact that he had any kind of survival instinct. They didn't realise that he never really had a self-destructive impulse. It was simply that his life was so miserable. True depressives are depressed even when their lives are going well. Bukowski could never be like that. His bleak moods were usually circumstantial.

Sometimes he wrote himself out of them — the typer was his altar when all else failed. As far back as 1966 he claimed he would be writing 'on my drooling bib in my senile crib.' He was almost as good as his word on this. Language was the only form of marketable currency he had when he was poor, his only manner of screaming out his dementia at a world that pierced his soul.

Making money for the activity was almost a side issue, which was why he grabbed at the lifeline John Martin threw him in the sixties. It was a deal not likely to make him rich, but it enabled him to continue doing what he was doing with some semblance of a buffer. And of course it took him away from the slow suicide of being a desk clerk. The irony was that the novel documenting that slow suicide would put him on the literary map for keeps.

He refused to write for the sake of it, for the sake of filling a space on a shelf. If it came down to that he'd prefer to go back to his barstool in Planet Nowhere.

He once sold his blood to the Red Cross to make ends meet... and then to poetry magazines. Maybe the latter activity drained him more, because this kind of blood

didn't regenerate itself. A west coast writer with an east coast sensibility, he spent over a half-century drinking to excess: a ridiculously long time to practise self-abuse in the manner he did.

He never wrote a book that could be singled out as his masterpiece. *Ham on Rye* came close to that status as a novel, and *The Last Night of the Earth Poems* as poetry, but there's no *Farewell to Arms* or *Catcher in the Rye* we can conveniently point at and say, 'This is the one to read; this is the definitive Buk book, the one that won't go bad, that will continue to be read when his detractors are pushing up daisies.' No, it's easier to connect with him on the overall body of his work. To use a movie analogy, he was a much more likely contender for the Lifetime Achievement Award than an Oscar. The genius was in the persistence, not the white heat of inspiration. Whether stumbling or not, he continued to tap it out, making the reader, like himself, wallow through the sludge before he came upon the blinding flash. Or didn't...

He knew his direct style alienated many, as did his stout refusal to be obscure, or to insert any symbolic content into his work. This in itself gave it little appeal for those of an academic bent. They wanted obfuscation for its own sweet sake to justify their hermeneutical perversity.

The negative reception his work received didn't depress him. On the contrary, the more often people rubbished him, the more he felt he must have been doing something right. It was only the bad writers who failed to provoke anger. These were the ones who had nothing to say and spent all day saying it, the ones who wrote for people who didn't walk on the grass, who left out their garbage on time, who bore a hole in the knees of their trousers at church every Sunday.

The people he wrote for, and who he represented, were those who didn't read books. This posed an obvious barrier to his chances of making it to the top. The self-styled Poet Laureate of the disenfranchised, he tried to empower them with his work, to use it to tell them they could crawl out of the sewer too. He had no message to impart, no healing balm. His work was a mirror, not a lamp — and a cracked mirror at that. He hated to be seen as a bargain basement Moses leading people to the promised land of poesy. He would insist he was as lost as they were. Far from being a shaman, he was more like a black sheep. In his later years maybe he'd concede to being a black *shepherd*. But that was as far as it went.

Many of his poems weren't poems at all, but rather prose that simply didn't reach the end of the page. He would have been the first to admit that himself. But he liked the poetic *form*. It was akin to a comfort blanket he pulled round himself: thoughts and sensations were crammed up against other thoughts and sensations and sometimes, just sometimes, they approximated to a unity. But if they didn't, that was all right too. Even then they served a healing function for him, like a confessional diary.

He never had any time for writing that had to be studied or interpreted. You either got it first time or you didn't get it at all. He didn't want to approach literature by the scenic route, didn't want to talk it out of existence. It appealed to him on a sensual, instantaneous level.

He didn't trust the mind, he said, unless it was run by the bellybutton.

He considered writer's block a self-imposed ailment. It was an author's mind trying to tell him there was something wrong with his life. Otherwise, how could the sentences be impeded? This was obviously the attitude of a man who didn't like to over-elaborate his scenarios, who would prefer to use the wrong word than no word at all if the search meant he would be slowed down.

He wasn't a Beat, but his career probably wouldn't have been possible without the Beats. They widened the boundaries of taste and thus opened the floodgates for his anti-literary literature, for his impressionistic prose-poems, for his subversive posturing and his whimsically misanthropic asides. He would have no truck with quasi-political sloganeering as they did, nor would he envelop himself in the cosy myth of the appeal of life on the road — his own brief experiences in this regard had made him terminally bored — but he shared their general *zeitgeist* if not their particular proclivities.

His writing is often flat and toneless, but that was the way he liked it. Any affectation, he felt, was artificial, a tugging of the reader towards a preconceived orientation.

He was our last mad writer, the end of a species the literary world can ill afford to do without.

Fear and Loathing in Los Angles

Los Angeles is the capital of all the termites in America, a place where the greedy, noisy little monsters are endlessly consuming the rotting timber of jerry-built homes.
Carey McWilliams

It began as a mistake.

Army sergeant Henry Bukowski proposed marriage to his German girlfriend Katharina Fett in the medieval town of Andernach in 1920. She was pregnant at that time with what would be their only child. Three years later they left Germany because of the poor state of the economy, moving first to Baltimore and then Los Angeles. Their child was christened Heinrich but this was later changed to Charles. His classmates called him Heinie to annoy him, and later Hank, which seemed to complete his Americanisation.

He was born in a building that would subsequently become a brothel, or so the legend would have it. An unwanted child from a country he would soon learn to disparage, born to parents he would also learn to detest, it was hardly the formula for the all-American childhood.

Graham Greene once said that an unhappy youth is a wonderful inspiration for a writer. If this is true, Hank Bukowski should have been one of the best, minting poetry out of this pain.

'The first thing I remember,' he wrote in *Ham on Rye*, 'is being under something.' He liked the anonymity. Maybe even this early we can see the root of his misanthropy. (He lost his zest for life, he once claimed, around the age of two!)

Literary childhoods are awash with experiences of one brutal or unfeeling parent, but rarely two of them. What made Charles Bukowski's unique was its unremitting grimness on the part of both his father *and* his mother. We might be entitled to imagine that a woman with an only child would confer some kind of maternal instinct on him, but Katharina Fett didn't, either due to the fact that he was an unwanted arrival or because of her natural sang-froid. The result of this was that his emotions lay buried for much of his early life. When they resurfaced it was against his will. People had failed him in his formative years, which gave rise to a recurring distrust on his part of anyone offering him anything afterwards. He felt that there always had to be a catch.

11

His parents were the dead hand that stifled his first steps in life. He grew up without affection from either of them, without those gentle acts of kindness any child is entitled to expect. He was dutifully clothed and fed by a couple who seemed to regard these as activities that would be repaid in kind when their child grew up to be a God-fearing pillar of the community.

In *Ham on Rye* he describes his parents as little more than fringe figures, presences. There's nothing of an umbilical connection here at all. There's no sense of him being drawn to either of them. They're just people. They might as well be the neighbours, or somebody who lived down the street.

They dressed him formally, which increased his desire to cut loose from them in the great tradition of American writers all the way from Mark Twain through to Ernest Hemingway. The Teutonic efficiency of his mother also meant that the house was run like a boot camp, with designated times for meals, chores and bed.

Some people, as the saying goes, wouldn't commit suicide for fear of what the neighbours would say. Hank's parents were like this in the sense that public image meant everything to them. For him they were the parents from hell.

Don't walk on the grass. Toe the party line. Work from nine to five. Pay your parking fines. Obey Big Brother. Fight for your country. Take the dog for a walk. Put out the garbage. Have the relations around for Thanksgiving.

Even when they took him for Sunday drives, or to the beach, there was an air of dutifulness about it, as if this was the sort of thing parents were expected to do with their progeny. There was no sense of spontaneity, no spirit of adventure. It was almost like 'We have ways of making you enjoy yourself.' They were the epitome of provincial sterility transported from an anonymous town in Germany to an equally anonymous la suburb. There was no light and shade in their lives, there were no moments of magic: just the dull, plodding routine of making do in a manner that would inspire social respect. For the young Heinie they were just paper people with paper lives — emotion-by-numbers folk who tried to infect him with their own frustrated dreams.

He believed that they hated anything life-enhancing. In the poem 'the man with the beautiful eyes', which he wrote late in his life, he even went so far as to say that he was warned away from visiting a neighbour's house because the man who lived there was a gentle person.

They worshipped at the altar of ordinariness, fearing the truth that would set them free, or the imagination that could bring them to an enlightenment about their grey, tawdry lives. They wanted to protect Heinie from the underclass but as far as he was concerned he was already *in* it. Longwood Avenue was the bad end of town because it was the good end of town. Respectability was the only thing you could say for sure was *dis*respectable. Heinie would have preferred to be Jack the Ripper than Lucille Ball.

His heroes were people like John Dillinger and Pretty Boy Floyd. He thought he might rob banks like they did when he grew up. It certainly beat delivering milk for a living, as his father did.

But of course he couldn't tell his parents all this, even if he could have articulated it.

Their unequivocal embrace of social conformity is doubly ironic considering they kept themselves apart from others. One wonders why reputation was so important for a couple that seemed to go their own way so much. (Who would have *cared* if there was a scandal in the family?)

The Bukowskis were also possessive of their son, not allowing him to play with other children on the street. Maybe they were afraid he would discover happiness away from

them, which they didn't want. They wanted his world to be their world and vice versa. It was tantamount to keeping him locked up in his room.

One year he got an Indian suit from his father when all the other kids had cowboy outfits. Once again he had drawn the short straw. At playtime he was surrounded by his classmates with their cowboy suits, forever the outsider. But he stood up to them, pulling an arrow from his scabbard and waiting for them to make their play. He knew what it was like to be the underdog. He was getting good at playing the role.

His father was the quintessence of the semi-detached suburban Mr Jones, a man who had ransomed his life to his mortgage account — and then crowed about the fact. He believed in the system even though it had stamped him into the ground and effectively denied him a life. He hadn't the vision to see beyond it, or beyond himself. He didn't know the difference between living and *earning* a living. His world was 'Yes sir, no sir, three bags full, sir', a world where you served your time and then gave grief to those below you on the ladder, such as your son, just as you once took it from those above you. And so the circle turned, with each era throwing up new demagogues and new victims. The big fish ate the little fish and thus all the institutions were preserved.

This was a man who gorged on his food, which had the effect of making Hank into a person who didn't care whether he ate or not. A man who worshipped the rich, which gave Hank even more of a loathing for that breed than he might otherwise have had. A man who had dreams of turning his life around... whereas his son preferred simply to lurch from one day to the next.

His pathological need for some form of social cachet probably resulted in Hank's desire to shock, either as an overreaction or because he saw how ultimately pathetic this goal was. His father existed on the fringes of Hank's life as a barking nuisance, cheating on his mother, killing beauty wherever he found it, flinging live mice into an incinerator at one point and generally mouthing about trivialities as if his life depended on them. Hank would meet similar men many times throughout his life in different guises and react even more aggressively to them than he normally might have done because of who they reminded him of: the loathsome nonentity who had almost single-handedly destroyed his youth — or rather robbed him of it. To people like this he became the lean, mean Hank, the dead man walking, the tramp with attitude.

His father approximated to the dumb banality of the stereotypical jokes against the Poles — his ethnic extraction. A pauper with the soul of a capitalist, this unlikely conformist wanted his son to be everything he himself wasn't in life, but as the young Henry grew, he didn't look to be shaping up that way. His attitude to school was lacklustre and he didn't evince talents at any particular activity. His father detected resentment in him, the kind of resentment he perhaps recognised in himself, and decided to beat it out of him. In a world in which he felt disempowered, his son was an easy target.

One day there was a letter home from school saying Hank had been misbehaving. His mother freaked when she read it. 'Wait till your father comes home!' she screamed. When he saw it he told Hank to go into the bathroom — the room that he would subsequently dub the Torture Chamber. He ordered him to take down his trousers and shorts and belted him with a razor strop until he was raw. That was the first of many beatings that would occur like clockwork over the next few years, on any trivial pretext he could think of.

Hank tried not to scream as the lashes rained down on him. He tried to be the Frozen Man. But it wasn't always possible. The bathroom was like a microcosm of his

world. So was the razor strop. Even the sun that shone on his house seemed to belong to his father. It was all like a giant conspiracy.

Of all the houses he could have grown up in, he felt he was in the worst one. But this didn't depress him. On the contrary, it fuelled his ambition to escape. He was determined not to be swallowed up in the vortex of apathy epitomised by an embittered father and a mother who didn't seem to have a mind of her own.

All in all it wasn't a pretty scenario. He was humiliated at school and then he had to come home and face more of the same. Sometimes he was beaten so badly by his father he had to sleep on his stomach. No matter where he went it was always the foot in the face, the heel against the head.

He rarely smiled — as we can see from any childhood photographs taken of him — and this annoyed his parents more. But what was there to smile about? Life was like a shit sandwich: wherever he looked he was snared. He looked bad, he felt bad, he hurt bad. So he brooded, brooded about the fact that his father was using him as a whipping boy out of frustration that his own life had amounted to so little, and that his mother was too much under her husband's thumb to do anything about the abuses being perpetrated.

His quietness made his father imagine that Hank was as intellectually challenged as he was himself. Little did he realise that this so-called freak of nature had a mind like a volcano, that every minuscule detail of his life was being stored up inside it like so much film footage for future use. Almost every comment that was made at the table, every nuance of disgruntlement between his parents, was noted internally by this sullen, insolent child. He was weighing up the hatred, the emptiness, the unrelenting gloom. It would all resurface in the poetry, in *Ham on Rye*, in almost everything he would write in the years ahead. And his father thought he was looking at a zombie. It took one to know one.

Hank lived in a generation gap house before the term was even invented. This was before Spock and the 'know your child' age. The child-centred curriculum hadn't infiltrated the schools, nor had minority rules slogans found their way into the homes. In the Bukowski household father knew best, and compliant mother rowed in behind him. Hank was expected to be seen and not heard, to speak only when spoken to. He might have been able to hack this if his father was a reputable role model, but this was no benign dictatorship. It was more like *Stalag 17*.

His father also swore by the consumerist ethos. He wanted to hitch on to the socio-economic totem pole, to collect those magic dollars like a squirrel storing away acorns for the winter. He bought into the American Dream with interest, swallowing all the apple pie notions Hank would make a career out of reviling.

Hank meanwhile acquired the reputation of being a tough guy at school — a reputation, it must be said, that he encouraged. He ran with the 'bad' crowd, feeling that if he was going to be beaten anyway he might as well do something to deserve it.

He was like the Marlon Brando character in *The Wild One* who, after being asked 'What are you rebelling against?' replied, 'Whaddya got?'

All high school meant to him, he once said, was realising there were people in the world as despicable as his parents: a very mixed benison.

He didn't make the baseball team, didn't carry pretty girls' books to the locker-room, didn't dream about the white picket fence in leafy suburbia.

Neither was he ever voted 'Most Likely to Succeed' by the school dons. In height he was five feet eleven and three-quarters: a Nearly Man even down to this detail.

He was neither a jock nor an academic, didn't he have a discernible talent in any field and never looked like a graduate of charm school. He sat smouldering on his bench, nursing his anger. For classmate and teacher alike he was the quintessential pariah who acted as he looked: mean and moody. White trash like his old man.

His colleagues called him 'Kraut' as well as Heinie, which confirmed him in his aspiration to rid himself of anything German. By the age of five he had cut all German words out of his vocabulary. (In later life, ironically, he would dally with Nazism.)

Teachers, he said, sent him to the principal's office just for what they saw in his eyes. He didn't have to mouth up his grievances. They were all there in his attitude, unvoiced. It was like a silent revolution.

He cycled his bike to school, eyeballing the richer and more handsome boys in their cars. They looked as if they had all the answers to life, but Hank intuited even then that these well-groomed people were as lost as he was, even more so, because they had to pretend they were something they weren't. His parents had fallen for the charade but he didn't. He identified with disadvantaged children like himself, always seeking out-siders he could empathise with, and later forming a friendship with a boy with only one arm.

He malingered somewhere between confusion and misery, wincing under his fa-ther's perpetual rages as the days yawned before him, promising nothing but more of the same. It was only a shell of a life, a small carbon copy of his parents' self-enforced lassitude. Nothing happening, nowhere to go, nothing to do: how often did those mantras resound from a tormented young man trapped in a loveless household in a futureless suburb?

And then there was the grass-cutting phase...

The first time he was told to mow the lawn he was playing a football game with some friends — which was unusual considering both his unsportsmanlike nature and his parents' galloping possessiveness. Maybe it was his father's very jealousy in this regard that made him draw Hank away to confront this home truth.

When he was given his weekly assignment of mowing the grass, directions were screamed out at him as if he were out on a military reconnaissance. 'Get your goddam ass out here!' his father would roar. He was warned against leaving any gaps with threats of a beating, and when his father inspected the finished work he invariably found these gaps and soundly thrashed his son. Even one blade of grass higher that its neighbour qualified for a beating. It was as if this was his father's only way of asserting himself in a world that ground him down, these weekly visits to the bathroom where he would humiliate and pummel the child he had brought into the world. Hank continued to be terrorised by these beatings all through his youth.

One day his father threw a two-by-four at him in frustration over his failure to do a job properly. He writhed in agony as a blood vessel burst. It stayed in a jutted-out position for the rest of his life.

His father represented for him all the negative characteristics one could possibly conjure up in one's mind: cruelty, domination, life-denying toil, bad ass-ness, self-righteousness. He also lived by the clock, espousing an 'early to bed, early to rise' philosophy perhaps understandable for a man who did a milk run. Hank would also overreact to this, becoming a nocturnal animal for most of his life.

His mother supported her husband no matter what cruelties he perpetrated: not because she thought he was always right but because she feared crossing him. Such fear over-rode whatever natural affection she had for her son.

America had conquered Germany on the battlefield and now it was doing it again on the domestic front. Even in civvies Henry played the enlisted man, barking out instructions to his army of two. Like all bullies, he picked as his targets those not strong enough to resist him.

Hank never understood why his mother didn't step in until years later when he said, 'She was German. That's all that mattered. In Germany the husband's word is law.' It was like the referee in a football game: right or wrong, you couldn't argue. But how could a child of ten be expected to see this? She let him down at a time when he needed her and he could never forget this, whatever her reasons. She was like a Stepford wife.

His mother's silent complicity was almost as culpable as his father's cruelty. For evil to prosper, all that's needed is for good people to stay silent. Or to remain apathetic. His mother wasn't cowardly, but she believed in what her husband was doing so much that she let it continue. She wasn't part of the solution so she was part of the problem.

Hank never forgave her. From now until the day she died she was a nothing to him. In a sense, she was the source from which all his misogyny sprang. He expected every woman he met afterwards to behave like her and he was often proved right. If they didn't, it was almost like a surprise to him. She was the yardstick by which he measured others of her gender, evaluating them on the basis of her shabby example. No less than Hitler's henchmen who stood by and watched Jews being gassed in the Holocaust, and this *hausfrau* stood by as Henry Bukowski thrashed his son to within an inch of his life. Once again he had drawn the short straw.

His mother admired strength and beauty, so she had little time for her plain, inhibited son. No more than the Hitler she so much revered, she would have preferred him to be a blonde, blue-eyed Aryan. But Hank was far from this. He had never been a pretty child. He had a face perhaps only a mother could love... but this one didn't.

As he grew up, an even more terrible curse visited itself upon him in the form of acne. With it came so many boils that he was almost classified by the medical establishment as being deformed.

He was embarrassed not only by his acne but his general appearance. Even his hands, which were delicate, bothered him. He thought they were like women's hands. Only his legs he liked. 'The rest of me is crap,' he would say in later years — usually when he had a bag on, which was most of the time — 'but I've got great legs.'

His grandmother felt he was possessed by the devil and made makeshift cross marks on his back as if to exorcise him. Hank knew she was the unhinged one, not he, but he didn't retaliate.

The doctors at the hospital told him he had the worst case of *acne vulgaris* they had ever seen. The news wasn't presented to him in a roundabout manner, but with his father's bluntness. They seemed almost amused by it, as if he was a freak sideshow at some circus. After the diagnosis came the treatment, which was painful in a different way. As with his father's beatings, he tried not to scream. There was no razor strop here, only needles, machines, ultraviolet rays. The boils were lanced and the pus gushed out, but each time one disappeared another seemed to flare up. They also seemed to come from every orifice in his body. Once again the Man Above, if He existed, was dealing Hank cards from the bottom of the deck. What had he done to deserve this? Was it his 'badness' that caused it? No, it was all the frustration coming out, the buried tension of a decade of pain and humiliation. His body was revolting against his life.

Because he felt so self-conscious about his boils, he enrolled in a training corps called

the ROTC to save having to go to gym. His uniform freed him of the embarrassment of stripping down to his underclothes, which always drew jeers and gasps.

One day he won a medal for his performance but threw it away on the way home. The award meant as little to him as the drill itself. He was there merely to avoid being somewhere else — the story of his life thus far.

An unlikely advantage of his acne was that it resulted in his being kept at home for stretches at a time. Home was hardly heaven, but school was hell, and at least he wasn't needled by his parents about the way he looked, however depressed they were about that fact in private.

Another advantage of it was that it made him look older than his years, so he was often able to procure beer from the local bars. The jeering about his boils toughened him just like this father's constant bickering did. After a time he even stopped hearing it.

When Hank started drinking, he discovered a new side to himself, a side that at last made the world seem a tranquil place. It was escapism, but a beautiful escapism. For him it was the happy drug — and would always be. Every time he had a problem now and in later life, he would try and drink his way through it to make it go away. Sometimes it worked and sometimes the drinking brought bigger problems than the original one he was trying to cure, but in either case it blotted out the momentary pain.

Drink also gave Hank courage, and one day as he watched his father beating his mother — the delightful man made this a practice too — he said to him, 'If you ever hit her again, I'll kill you.' What was even more remarkable was that his father stopped. Not long afterwards, he would also stop hitting Hank.

The fact that Hank knew his father had problems of his own reduced the effect of the beatings. He seemed to realise their function was more sadistic than punitive, which diluted their impact for him. In time they almost became boring in their predictability. And then one day they stopped, as if his father too realised this and became bored by them. Hank defeated his old man by soaking up whatever he had thrown at him ever since he drew his first breath in life. He defeated him by enduring his wrath. What didn't kill him made him stronger.

His father lost his milk run job in 1936 and his mother went back to work so they could keep up their mortgage repayments. But he pretended to go to work, driving out of the house each morning like clockwork and staying away until evening to preserve his image. There was little need for this, however, as the Depression had made his plight fairly ubiquitous in the area. His pretence was as much a function of arrogant bravado as anything else. His wife, meanwhile, spent her time pining that they had left the Fatherland as Hitler appeared to be ironing out the economic difficulties that had necessitated their journey across the Atlantic. Perhaps here we see the seeds of Hank's later flirtation with neo-Nazism, however frivolous that may have been.

Considering he had such little respect for his mother, it's surprising her respect for Hitler didn't cause an inverse reaction to Der Führer from himself. (In bed some nights he made trenches of his blankets to simulate battle scenes which the Germans always won. His memoir, *Shakespeare Never Did This*, also contains many flattering portraits of the German people. As somebody who had suffered much himself he admired their phoenix-like resilience.)

The next crisis in Hank's life occurred when his father enrolled him in Los Angeles High School, an upmarket establishment that only served to intensify his feelings of

inferiority with his classmates, who mostly came from the well-heeled families. 'He had sent me to that rich high school,' he would write years later, 'hoping that the ruler's attitude might rub off on me.'

Here his acne grew even worse, with boils the size of little apples growing on his chest, his back and even his face — as if all the tension of the preceding years were exploding out of this body in palpable form. He developed pustules on his shoulders which necessitated frequent trips to hospital for painful drainage procedures. Sometimes electric needles were used to drill them. Hank screwed his courage to the sticking-place once again and suffered it, suffered the humiliation and cruelty of doctors as well, which almost hurt more. Their sarcasm about his ungainly appearance made him wonder if he would ever make it in life. Or if he did, what woman could ever be interested in him physically.

After a time he became immune to the pain. One day a doctor said to him, 'I never saw anyone go under the needle that cool.' It wasn't courage, he insisted, more a question of blocking out the consciousness of where he was. God knows, he had had a lot of practice at this.

He had nobody to confide in: no brothers or sisters, no parents, no classmates, no teacher, no mentor. There were sporadic friendships but he lived most of the time inside his head, waiting for the moment something would happen to make him feel he was special, or could be.

He despised his environment with every fibre of his being. As soon as he got his wings he was going to fly — to where he knew not, but anything had to be better than where he was. This particular apple would fall very far from the tree it had grown on. One day he felt he would break free with a vengeance. And when he did, there would be no returning.

Hank now started to drink more and when he was drunk he found he was more at home with the world. It was like a journey back to his real self. At these times he didn't seem to mind that he came from a loveless home. He didn't seem to mind that the world wasn't his oyster, that the teachers gave him a rough time, that he couldn't get a girlfriend. The bottle could substitute itself for all these things. It brought him into a comfort zone, a harmony with himself and his immediate surroundings.

The drink was like a surge of electricity coursing through him. It was like kissing God. Once the magic juice kicked in he was like another person, relieved temporarily of all inhibitions, ready suddenly to take the world on.

The bar was an escape from the straitjacket of home and school, but this was another type of trap because it too was a cocoon, a jail of the mind, somewhere you went to escape the unbearableness of your situation. At the end of the day, was there really that much difference between gazing bovinely at an optic or a jerk at a blackboard? For Hank the answer to that question was yes, because this was at least his decision. Freedom, even the freedom to destroy oneself, was an ideal he espoused. Not to have his father nagging him to make good or cut the grass was almost enough for him even *without* the booze. Almost, but not quite.

The first time he got drunk in public, thereby disgracing his parents, he said he did so because they treated him 'like a murderer.' They replied that his behaviour was *worse* than murder — which perhaps tells us all we need to know about his childhood environment.

Both his maternal and paternal grandfathers had been big drinkers, making Hank wonder if he should really have been born to them. The wildness had missed a genera-

tion.

At the age of seventeen, Hank was terminally bored with suburbia. He longed for the nightlife of LA, the seedy underbelly that would define his future work. The dirty old man had to begin *somewhere*.

He became involved with a group that robbed gas stations, sneaking out of his room almost every night to be with them. He became the nominated 'leader of the pack' even though the others were older than him.

He sat in derelict houses with these people, engaging in drinking contests, idle boasts and plans of how they were going to change the world. Some of them carried guns, but not Hank. They felt his disgust with everything was a lack of fear, that his non-complaining, as he put it, was a 'soulful bravado'. They also admired his capacity for ingesting vast amounts of alcohol without showing the effects. But then one night his father refused to let him into the house when he came home drunk, telling him he was a disgrace to the family.

'You're not my son!' he roared through the door. Hank then lunged at it. It flew open and he went hurtling across the floor. Once inside, his father's 'hideous card-board face' made him throw up on the hallway rug. 'You're a dog!' his father bellowed, 'and when a dog shits on the carpet he gets its nose rubbed in it to stop him doing it again!'

'Don't do it,' he said to his father, but Henry grabbed him by the neck and pressed him down towards the floor. This was the moment where he decided enough was enough and he hit him with an uppercut. His father reeled back, spouting blood. His mother screamed, and dug at Hank's cheeks with her fingernails. 'I'll see you in the morning,' his father said when he caught his breath. 'Why wait till morning?' Hank said, squaring up to him. 'What's wrong with now?' His father must have realised at that moment that Hank had grown up, that the beatings would be no more. There was a long silence and then he walked away.

After this, the pressure at home eased somewhat. The hostility was still there but it was more muted now. The battle lines had been drawn and there was a point beyond which his father wouldn't go. He was now wary of the boy he had raised.

Hank stayed in his room reading for much of the time. The more he read, the more he wanted to write. But who would read it? Who would care about the thoughts of an unwanted child?

His writing career had begun the day he wrote an essay about a visit of President Hoover to a nearby town. He hadn't see Hoover, but that very fact gave Hank's imagination free rein. He wrote about the visit in a manner that so impressed his teacher she read his essay out to the whole class and they were dumbfounded. So Henry Bukowski had a mind. It was as if a rock had suddenly found a voice. Years later he wrote about the incident in *Ham on Rye*, a book that comes closer than any other to being his autobiography.

The circumstances of the essay were ironic not only because it was built of an event Hank hadn't attended, but also because he never had any great love for figures for authority — least of all American presidents. In retrospect we should probably view his composition as the first in a lifetime of piss-takes.

He had received his first literary buzz, he would always recall, from a lie. This led him to conclude that lies were the foundation stone upon which the world was built. Just as President Hoover had filled the populace with lies about how the economy was doing, Hank decided this would be the way forward for him. Lies would take him out of his

rut. His parents' lives were lies; America was a lie; the whole of life one fallacious funk.

He started to read widely in the local library at this point of his life, burying himself in beefy Russian novels and, more crucially, John Fante's *Ask the Dust*. Words became events to him, so many untravelled countries he could visit from the privacy of his room.

His father ordered him to put out the light at eight every night so he read with a lamp under the blankets, retreating into his make-believe world to block out the so-called real one.

His first short story concerned a one-armed pilot in World War One fighting off the enemy with an iron hand. It was significant that he would choose a cripple for his first hero. Perhaps he was thinking of his friend with one hand as he wrote it, or even himself.

When he told his father he wanted to be a writer he was advised to come down to planet Earth. 'Writers don't make money,' said Henry. Besides, where was his talent going to come from? The elder man saw it as just another pipedream to avoid having to search for gainful employment.

Hank wanted to describe the world as he saw it, not as his parents wanted it to be. He had to get away from the Great Lie that his father's life had been, to erode the cancer lodged at the core of his belief system.

In the next few months he put everything on hold, sleepwalking through his days like somebody only half-alive. It was as if he was in a cage, as if the world was only a chimera. He slunk back to being the anonymous pupil, the man without possibilities, filling in the time until something better offered itself. All around him was atrophy, so anything had to be an improvement.

Hank had one last crisis to undergo before he sloughed off his links with high school values. It occurred on the night of the Prom, a seminal night in any young boy's life. This is the night when one nails one's colours to the mast, when one comes out of the closet with one's partner or one's lack of a partner. It's the official seal on a phase, and the springboard for another.

Hank had no partner.

Like a Holden Caulfied before his time, he stuck his nose against the fog of a window-pane and peered in, the poor boy at the feast.

As he stood watching the dancing couples he felt a mixture of envy and disdain. He wanted to be a part of them and yet didn't. Deep down he knew that they meant nothing to him, these smug, self-satisfied people, but like any adolescent he wanted it to be his choice whether he was allowed to join them or not. For many, his cynicism about them smacked of jealousy, the disgruntlement of the also-ran.

It was taking place in the gym, the place he hated most of all in the school because it was where he had to expose his body with all its warts. But he still didn't feel inferior to these people. He knew one day his own time would come, and one day these people who looked like they hadn't a care in the world would experience the kind of suffering that defined his own life. One day he too would hold a woman in his arms who would tell him she loved him, even in a lie. It wouldn't be in a gym or at a Prom, and probably not soon, but some day.

Not long afterwards he left college for good. The outside world may not have held much promise, but it had to be better than here in this pussyfoot environment crammed with dead teachers and dead books. College didn't prepare you for life at all; what it did was spoil your chances of ever making it in life. It took away your mind instead of

giving you one. It tried to mould you into the cement of its own paralysis.

He would have preferred to dig ditches than go to college: you met a better class of people there.

When Hank spoke like this to his father he was scoffed at. It was deemed to be a rationalisation of laziness from a man who had failed in his own life and feared his son would too, even if his perspective was different. One man was on the bottom rung of the social ladder and the other one said he didn't want to get onto it at all, that it stank to high heaven. Hank said he would prefer to catch butterflies for a living than to lick ass. His father thought this was a convenient excuse.

Henry reminded him of the money he had invested in him, the money he had spent on his clothes, his food, even his medical treatment. All these things added up, he said. They also had to be paid back. Hank needed to develop a sense of responsibility. He needed to kick ass, to work his way up the corporate ladder until one day he owned a house like his father did. Then he would have two houses to call his own. In the next generation his own son would have three, and so on.

This was the great spirit of rugged individualism, delivered by a white trash milkman on Longwood Avenue to his jerk-off son. Hank listened to it with a kind of fascinated disgust. Was it possible that such a loser could believe so much in this lily-livered pap?

He went to his room and brooded, deciding this way wasn't for him, that there was another kind of world out there... maybe. He tried to conjure up this world in his writing, carving sharp syllables out of the stone of his heart.

This wasn't picnic-in-the-park lyricism: it was parables of the gutter, the bittersweet music of bruised love. If you tried to euphemise grief you sanitised it. So he tackled topics like masturbation, drunkenness, walks on the wild side.

His first job was with Sears Roebuck. He arrived five minutes late on his first day, giving as his excuse the fact that he had seen a starving dog on the way to work and stopped to give it food. It was true but greeted with incredulity by a boss who must have reminded him of his father with the manner in which he was married to the clock. Hank had his first black mark registered against him in the white collar cosmos... and he wasn't even registered yet. It would be the shape of things to come.

He lasted a week in this job. Shortly afterwards his father enrolled him in the Los Angeles City College journalism course. His writing here was predictably outrageous. Everytime he wrote something he saw as worthwhile he had to hide it from his parents, not brandish it about the place as other children might, knowing they would be commended. And then one day his father discovered his writings in his bedroom and evinced the predictable reaction: revulsion. Hank wasn't too surprised because he knew he would see it all as so much filth and depravity. It was like John Lennon's dictum, 'We are the people our mothers warned us against.'

His father was so shocked at what he found he threw it out the window along with the typewriter — the one he had bought Hank for his journalism, not this pornography. When Hank came back to the house he squared up to his father and the old man backed down. Hank collected his belongings and left home. That day was the beginning of the rest of his life.

On the Road

> Poverty is a giant. It uses your
> face like a mop to clear away the
> world's garbage.
> *Louis-Ferdinand Céline*

'Your parents are your world in the early years,' Hank said many times in his life, 'and when they're bad, your world is bad too.' That's why he was always surprised when anybody showed kindness to him afterwards, and why he remained sceptical about people's motives until he knew them really well. It was like an aberration, a fluke.

Some authors ran away from home for adventurous purposes or to meet beautiful women, but Hank left because he *had* to. He wanted to get away *from* it all, not *to* it all. Longwood Avenue was a nightmare to him: he would pitch his tent on another mountain. He had no overall motive in mind, no overall plan. He wasn't Huck Finn or Jack London or Hemingway. It wasn't the tradition of the wide-open plains he fell into. He was going away from sheer desperation and panic.

Another reason for setting out was to store up some experiences he might be able to write about. He knew he had the juice, but he needed a platform, or some external circumstances to amplify his disgruntlement. There had to be a lot of other Henry Bukowski Seniors out there, a lot of other Katharina Fetts.

Dorothy Parker once defined LA as seventy-two suburbs in search of a city. Raymond Chandler said it had all the personality of a paper cup. Hank would have known what they meant. For him it was a

soulless place, an extension of his own inertia. Down these mean streets a man had to go. Maybe somewhere better lay over the horizon, maybe not. Either way, all he was leaving behind him was a cultural bone-yard, a slum of the soul.

He left home to seek the kind of life that could never be possible within the boundaries his parents had erected. It was like breaking out of a cage for him, but he still had no sense of what he wanted to do with his freedom. The world was a big place, but there were too many devils inside his head to enable him to enjoy it properly. He had been a failure at school, a failure with women and a failure as far as his parents were concerned.

Neither were editors jumping up and down asking him to contribute more stories to their periodicals. All he enjoyed doing was drinking. Under the ease of the bottle he could conjure up lustful fantasies about women, or imagine himself a front-rank author like his hero John Fante, or maybe Knut Hamsun or Sherwood Anderson. But it didn't look like happening in the foreseeable future.

There wasn't anywhere in particular he wanted to go. Often he just closed his eyes and put his finger on a map. Wherever it landed, he made for there on a bus. He didn't think any place was basically different from anywhere else. Flophouses were flophouses and taverns were taverns. It would be difficult to escape the screaming mass of what was loosely called humanity. But at least it would be a relief from home. All he wanted was a small room and a job that paid him enough to drink at night and listen to classical music as he did so. (He always felt an empathy with composers, particularly indigent ones. The fact that Borodin's wife lined cat boxes with his compositions struck a particular chord with Bukowski).

He went to New Orleans first, and from there to Atlanta, Texas, San Francisco and St Louis, soaking up experiences like the wide-eyed picaro he was. The stories he wrote at this time were almost uniformly rejected. He had one accepted in *Story* magazine, called, fittingly, 'Aftermath of a Lengthy Rejection Slip', but it was relegated to the back pages, which dulled his satisfaction somewhat. (The man he sent it to, Whit Burnett, was actually its subject, so the irony of its composition was rich.)

Hank believed the life of a hobo meant mixing in a world of idealistic souls like himself who had dropped out, but when he got to 'the row' he discovered that many of the people there were uncomfortably similar to his father in the way they thought. It wasn't that they objected to the entrepreneurial ethos: they just failed to achieve it. Their social protest was based on selfish concerns rather than anything else. It was like the idea of a communist being an unsuccessful capitalist. The denizens of skid row, he realised, were no more romantic than those of Longwood Avenue. No income group or locale held the franchise on desirable human beings.

He took on some soul-destroying jobs that were only marginally preferable to life at home. Not for him the zany excitement of a Jack Kerouac or a Neal Cassady. All he was really doing was substituting one form of routine for another. He lived rough, met women almost as outrageous as he was, and wrote. He wandered into libraries some days to sleep when he had nowhere else to go to nurse a hangover. Sometimes he was accepted in these places and sometimes not. In lodging houses he told landladies he was a writer, which went down well until they found wine bottles under his bed.

Being a struggling writer might have been acceptable to them, but not a struggling

alcoholic one, so he was often evicted. He usually went quietly, but if he was drinking he might create a scene. There were occasional nights in jail and then the emission the next morning into a harsh dawn. He had nothing to call his own, no future plans nor memories to treasure.

At times like this, books came to his rescue again. He didn't have enough money to buy any, so he went into the libraries to read them. Here he could also use the toilet facilities and sleep without having to worry about being moved on by a policeman.

He regarded libraries as supermarkets of literature, reaching up to this shelf and then that one, plucking books down at random. He had no preconceptions of what he might find, which increased the sense of anticipation and adventure. These were build-ings that also offered him sanctuary from his past, being filled with people he could relate to through their words much more intimately than the so-called flesh-and-blood characters in his own house.

One book he read at this time was by a philosopher who 'proved' that the moon didn't exist. Hank adored it! It was like 'Give me more of that guy!' There was a point at which balderdash became endearing to him — even the kind of balderdash peddled by mellifluous literary critics who debunked genius from their parasitical perches. He got a perverse delight from savouring the pathetic character assassinations of these worthies.

He read Dostoevsky's *Notes from the Underground*, Camus' *The Outsider*, Artaud, Saroyan, Jeffers, Hemingway. In all of their voices he savoured the sense of liberation they espoused. It was as if he had finally discovered others who thought as he did, even if he didn't yet have the voice to express such thoughts. The country or the time didn't matter. What mattered was the empathetic nature of his response to their collec-tive sense of alienation. Particularly in the case of the doomed narrator of *The Outsider*.

Hank could understand the beautiful absurdity of Meursault, could understand a man who would kill for no apparent reason and then be brutalised by the state because he had the gall to confess to not having shed a tear at his mother's funeral. (How Charles Bukowski would empathise with *this*.)

He also read Knut Hamsun's 'Hunger' and was hugely impressed by it. Hamsun's subjective, fragmentary style influenced him, as did the peripatetic, poverty-stricken life he led. He could also empathise with the Norwegian's neglect by the critical fraternity. Like Hank, Hamsun also had a pro-Nazi bias, amazing considering Norway was occu-pied by the Germans during World War Two. Hamsun was subsequently examined by a psychiatrist — another circumstance that would be paralleled in Hank's life.

Bukowski read all these authors alphabetically, moving along the shelves from A to Z, which meant he would have come to Hamsun before Hemingway, Artaud before Camus, Jeffers before Saroyan.

And he found John Fante's *Ask the Dust*...

Just as some authors feel a book they write has existed before them and just waits for them to discover it (rather than create it), so Hank felt *Ask the Dust* was waiting for him to find it. It was 'the' book just like drink was 'the' thing or, in years to come, Linda Lee Beighle 'the' woman. He always saw life in these broad, even teleological, strokes. For such a nihilist (which was, in many ways, a pose) it's surprising he would speak of it like this. But such it was: the end of his search, the book that would be a touchstone for all others, even (especially) his own, the *terminus a quem*. So who was this Fante guy, and why hadn't he heard of him? Probably because Fante was too good to be famous, because he hadn't played the *game*. But he was still on a shelf. Was this an

omen for Hank? Maybe once in a generation a loser cut through the crapola ...

Apart from being a writer who inspired him greatly, he could identify with almost every aspect of Fante's life: his unhappy childhood, his cruel father, his rigorous manual jobs, his out-of-control drinking, his brushes with death (he was almost killed in an earthquake in Long Beach in 1933, and six years later was involved in a car crash that could have been a suicide attempt), his struggle to become a famous writer, and, most of all, his volatile relationships with women, particularly his wife Joyce, who tolerated all his raging tempers with saint-like patience, allowing genius its lapses. Many of these themes were present in the book itself, which Hank read and reread with increasing ardour.

Fante's alter ego in *Ask the Dust*, Arturo Bandini, was in many ways a forerunner of Henry Chinaski. Leching after women and obsessive about being a famous writer, his alternating between farce and profundity is Bukowski territory to a T. Hank loved the immediacy of the writing, the manner in which Fante could convey a multiplicity of sensations in a paragraph, his mind flowing wild and free. It's scorchingly satirical as well as being a heartbreaking book, and often the distinctions are blurred. At last Hank had found a friend who shared his experiences of lostness and longing, and who wasn't afraid to let it rip with his pen, right down to the dramatisation of himself as an ace writer sometime in the future. Every time Bandini gets even a minor fillip in the literary sphere, it's like he's just won the Pulitzer. He's particularly hilarious as he gives himself pep talks about his sexual shortcomings.

The book reverberates with visceral energy and quirky humour as Bandini, the little man with big dreams, oscillates between writing and sexual infatuation, the two themes wryly unified in the finale as he casts his precious book into the desert at the woman who has disappeared from his life. A man who's angry at the world and his own impotent place in it, he invites both pain and laughter as he engages in his irreverent dialogues with himself, mythologizing his status as a writer on the cusp of glory, but also tortured by the racist taunts of 'wop', 'dago' and 'greaser'. (How Hank, AKA Heinie the Hun, must have empathised with this). Hank often passed by the hotel in the bad end of LA where Fante lived as he wrote it — the Alta Vista in South Bunker Hill — and wondered if this was really the building where it all began for him. Perhaps it was Fante's Mariposa Avenue, his roominghouse madrigal, and Camilla Lopez his Jane Cooney Baker. But this is to get ahead of our story...

A much more delicious delineation of deprivation than Hamsun's *Hunger* (which left itself open to the charge of whingeing), in the end it's the self-mockery of this quirky little book that makes it so distinctive. It's not that Fante can't make up his mind if he's writing tragedy or comedy; rather that he simply doesn't care. It was the very blurring of such genre distinctions that made it take off — and which, I imagine, turned Hank on.

Fante knew he had written something important, but he was sufficiently versed in the harshness of the writing business not to expect anything to come from it — and it didn't. The reviews were kind, but it was always going to be a minor work, especially when it had to compete with the likes of Steinbeck's *Grapes of Wrath* and Raymond Chandler's *The Big Sleep*, both of which were published in the same year. Fante wasn't depressed by the lack of attention his book garnered because this was the way it had always been for him, but for Hank he was the man who stitched up lowlife LA in a manner he himself would spend the rest of his life emulating. Hank didn't only admire Fante/Bandini: he *was* him. (Bandini differs manifestly from Chinaski in both his religious fervour and sexual passion but even these *leitmotifs* are trivialised as the book

goes on.)

Another book that influenced him hugely, of course, was Louis-Ferdinand Céline's *Journey to the End of the Night*. This heady chronicle of wartime blues, factory oppression, hedonistic sex and medical scandal touched every possible chord it could for the impressionable Hank. He was even seduced by its appropriation of Nazism — which would eventually destroy Céline himself after the end of World War Two when he was imprisoned for his perceived fascism. The book was eventually hailed as a masterpiece, but Céline himself (perhaps justifiably) felt it augured his personal downfall and was less than enthused when it was reprinted in 1952, two decades after its original publication.

Hank relished its acerbic bite, its summary denunciation of the status quo. At last he had found a writer who agreed that the world was run by jackals and jackasses, while those they presided over finally became contemptuous of their victimisation.

This would have been Hank's desert island book. He read it over and over again throughout his life, savouring its free-flowing narrative thrust, its devil-may-care irreverence. The guy could tell a story, and tell it with both barrels blazing. He had contempt for authority, for the old order, and he liked to play it loose, like Hank. He also liked to make his feelings manifest, whether it was railing against stuffed shirts or conventionality or anything else Hank held in contempt.

He said he read it at a sitting, enthralled by its energised iconoclasm, its high humour, the manner in which it debunked so many sacred cows so summarily while still managing to have such a merry old time for itself in so many alien environments. After reading it, Céline became one of Hank's especial role models, a man who, like himself, liked to let it all hang out even when all occasions informed against him.

A picaresque yarn of quasi-epic proportions, it quickly entered Hank's blithely alienated heart, becoming the text he would never turn against even when he rubbished the giants of literature. To his way of thinking Céline was a one-off, an unsung hero, a talent who never fell from grace in his eyes no matter how many sea changes he went through.

The book became his comfort blanket in time, a reference book he always went back to when life threw him a curve. It reassured him in his belief that he had made the right decision to leave the home he had been thrown into with two automatons whose notions of excellence rarely threatened to advance beyond the tin god of social status. They were welcome to it as far as Hank was concerned. He wanted sex, he wanted fun, he wanted to spit in the face of those who would deny him such pleasures.

The only problem with the book, in his eyes, was that its composition emptied Céline. The author put so much into it he had little left for other works. It was his finest hour but also his creative tombstone.

Hank was always trying to get away from writers like Shakespeare, who occupied the high ground. He preferred the small men, the strugglers, those who hadn't as yet been pigeon-holed by the system. Fante was largely a forgotten writer until Hank brought him to prominence by his espousal of him. So was Céline and, to an extent, Jeffers. Hank said he liked Li Po because he burned his poems after he wrote them!

Reading these writers gave Hank the freedom that had been denied him by his unfeeling parents and his unfeeling bosses. At home he had felt owned, but now he was his own person. He could eat when he liked and he didn't have to worry about what he looked like. Untidiness was his method of revolt against the billiard-table lawns of his childhood, the short-back-and-sides ethos of his father, the ground-down sameness of his formative years. (In the story 'Too Sensitive' from *Tales of Ordinary Madness*

he tells us that those who keep tidy kitchens are usually dead inside.)

Roominghouse landlords took him in grudgingly, bewildered by this crusty but quiet man who carried a cardboard case and listened to classical music. Nothing hung together about him — not his manner, nor his dress, nor his occupation. Was he saint or sinner, sage or fool? And what was he writing? The people upstairs from him pounded the floor if he typed late at night, and the people below him tapped the ceiling. They preferred the beautiful noise of their television sets to his clacking so a curfew was arranged.

He agreed to type until a certain hour every night and then continue in longhand, using capital letters so that he could read it the next day. Drunk men rarely write legibly and Hank was no exception. If a job fell through he might have to leave, but this didn't bother him. He travelled light — in body and also in mind. He had nothing to prove to anybody: he wasn't in the world to live up to anybody's expectations. Often he drank the rent money but he could handle this situation too.

At loading docks he ate food that had fallen off trucks, keeping whatever few cents he had in his pockets for the next beer.

The jobs meant nothing to him other than getting the dollar. He could never understand the concept of a career: the idea that somebody would actually look forward to going to work, that it could be in any way fulfilling even at a theoretical level. (Until, of course, he made writing his career. But even then he would have baulked at the term.) Too many people were nailed to empty processes, empty rituals. They didn't admit this to anyone — maybe not even to themselves.

Some of the jobs he left, and some left him. After a while it got so that he expected to be sacked. It was like, 'Hey, I'm here three weeks and nothing has happened — what's goin' on?'

His bosses roared at him to make their presence felt, or maybe to justify their existence. Sometimes they manufactured things he did wrong as an extreme example of the same intention. In a way it was like his father all over again: they were using him as a punchbag for their own frustrations. He felt the best men got the worst jobs, and vice versa.

America had become involved in World War Two by this time, but Hank was blithely indifferent to the fact. He had vaguely tried to rouse some enthusiasm for the aftermath of the Pearl Harbour bombing, but it just wasn't there. Maybe he even had a sneaking fascination for the Austrian megalomaniac with the razor-brush moustache. The 'evil Hun' was too easy a target for righteous outrage vented by breast-beating jocks.

The war was very far away from this hard-drinking conscientious objector getting grief from his girlfriends, his landlords, his editors, the dark innards of his own psyche. He didn't feel like taking up arms to fight an unknown enemy when there were so many known ones about. The war was already taking place on his own doorstep: he didn't need to enlist to find it. To quote his mentor John Fante, 'The only war I care to fight is the one I start myself.'

He didn't object to killing a man, he wrote in his short story 'Life in a Texas Whorehouse', but he wasn't overly enthused about the idea of sleeping in a barracks with a bunch of smelly soldiers who snored.

Killing people in a war situation didn't take guts, he claimed, because it was legal. He had more respect for those who killed outside that privileged ambit.

Being anti-war in the 1940s, as Hank pointed out, was somewhat different to Jane Fonda wiggling her ass against a tank in Vietnam a couple of decades later. 'They looked on me as a cockroach,' he said, 'I was before my time.'

Playing the devil's advocate, of course, was one of his especial hobbies. A favourite target for his spleen was Elizabeth Taylor, whom he referred to as an ugly woman at a time when, along with the likes of Marilyn Monroe, she was regarded as most men's fantasy.

Every now and then he returned home from his travels, only to be met with more abuse. On one trip home he was dismayed to hear that his father told the neighbours his son had been conscripted and then killed in action: yet another of the many lies he invented to look good. Hank was more amused than shocked but obviously he couldn't stay in the house so he moved again, this time to Philadelphia. It was here he was arrested for alleged draft dodging in 1942, having failed to advise the Draft Board of where he was living. He had left a forwarding address at the local post office, but this wasn't enough for the FBI, who pounced on him one night for his tardiness.

He had been listening to Brahms when the doorbell rang. When they told him they were taking him 'downtown' his imagination went into overdrive as he tried to imagine what he had done to land himself in this pickle. Had he murdered somebody while drunk and then forgot about it? Anything was possible. As he was being led out the door, one of the other tenants shouted out, 'That horrible man — they've got him at last!' Maybe she thought he was a serial killer.

The arresting officers were amazed at his coolness, the same coolness the doctor had noticed when he went under the needle all those years ago. What surprised them most of all as they took him to the precinct was that he didn't once ask them what his offence was, or the possible punishment. What they didn't realise was that being jailed was hardly a threat for a man to whom liberty meant so little. Dammit, he was almost flattered that somebody cared about him this much to call. Interrogation could improve your social life!

He was locked up for a time, in the process meeting a man who told him the quickest way to electrocute oneself if one felt the need, for which he thanked him. Hank was no stranger to jail, and was more amused by the experience than anything else. Such amusement would find its way into many of his poems in years to come. And now the question of whether he was fit to fight in the war presented itself.

He passed his physical, but when it came to the psychological assessment there were obviously going to be problems. The army hardly wanted a hard-drinking malcontent like this in its ranks, and one imagines the psychiatrist had already made up his mind to reject him even before the interview, having read his work and being briefed about his life. After preliminary interrogation he told Hank he was having a party at his house, at which there would be artists, writers, scientists and lawyers. Would Hank be interested in going? 'No,' he replied flatly.

The psychiatrist had already asked Hank if he would be willing to fight in the war and he said he would, thus avoiding the 'conscientious objector' angle, but obviously he would have been going with bad grace. If one could be relieved of military duty on such a flimsy pretext as the unwillingness to attend a party, three-quarters of the American population would probably have been deemed unfit to wear battle fatigues, so it's more likely the psychiatrist was merely toying with him here, having already decided Hank was mentally unstable. (In his book *Bukowski in Pictures*, Howard Sounes says that it was simply Hank's physical condition that made him unsuitable for service).

A more obvious approach would have been to dig up references to his espousal of Nazism, but the authorities didn't even seem interested in going down that road. Hank later admitted, apropos that phase, that he didn't know the difference between Hitler

and Hercules. His motivation had merely been to put a fly in the jingoistic ointment. If he had been in Germany he would probably have sung the praises of the Stars and Stripes. When too many people were saying the same thing, Hank almost axiomatically saw a lie.

He said afterwards that if he had been sent to the front lines, he would have killed if necessary. Not from any high-sounding principles but simply because that was what he would have been asked to do. This is an amazing admission from a man who had such sensitivity to the suffering of his fellow man, and yet from another point of view it's not too surprising at all. It reminds us of the same Hank who kept his head down at all those boring jobs he had, or who was content to sit on a barstool from one end of the day to the other. On the surface it appears he's being victimised in these roles, but this isn't really the case. He hasn't given up so much as blanked out. He didn't work *for* his bosses: he simply worked on their behalf. And likewise as a soldier he would have donned the uniform and did what had to be done, but without even a vestige of commitment. He had no interest in being either a patriot or a conscientious objector.

If Uncle Sam had said go, he would have gone. Equally, he was content to walk away from a military barracks as bullets hailed about his head. He would play the game by their rules, or not do so, as circumstances dictated: he had no preference either way. To rebel, in a sense, would be to give in to them. He preferred to do nothing. Ignoring the very *fact* of the war effort was his ultimate insult to everything it represented. It couldn't hurt him because he refused to even think about it.

Released from custody and free to continue his rambunctious lifestyle, Hank embraced drinking with a new-found passion. He didn't see himself as an alcoholic because he didn't drop out of the workforce, and he was also able to write in a drunken condition, but he lowered some serious mixes in this period of his life. As far as some people were concerned, he seemed to be doing his best to end it. It was almost like an occupation for him, like a vocation. Sometimes he got into fights and woke up the next morning in an alleyway with his wallet robbed. Many of the fights he engaged in were merely to provide entertainment to those watching — people who needed any excuse at all to keep from going home. Others were simply to secure free drinks.

It was never a case of *winning* these fights as far as he was concerned, just participating in them out of some quasi-macho duty that seemed to go along with the fact that bars were all-male milieus. Besides, what did drunks do for kicks after closing time except beat each other's brains out? If you didn't ally yourself to this *Zeitgeist* you mightn't get served the following night. Only the walking wounded earned the right to that there bar stool. Such was the ethos of losers locked in their lonely hearts clubs where pugilism acted as a surrogate form of sex.

In one bar in Philadelphia he would start imbibing shortly after dawn and was usually still there at closing time that night. On his first night in the bar a fight broke out and bottles sailed over his head. In front of him two men started sparring and he had to go in between them to get to the toilet. As he did so he thought to himself: This is my kind of place. When he got back they were still at it. This was heaven, he thought: he would go back again the following night. When he did, though, there was nothing happening. And for the next two and a half years nothing happened. He knew this was so because he drank there every night of that time. He was trapped by his anticipation, he said, it was as if it had all been orchestrated for him, like an elaborate set-up to get his custom.

The bartender let him in at 5AM, two hours before the official opening time, and

gave him free drinks for those two hours. When he opened the doors, however, Hank became a paying customer like the rest. But the two-hour gap gave him a headstart on the other drinkers, which was the way he liked it.

Such a bar, smelling of 'piss and death', was so run down, he joked, that one night when a whore came in to do business the customers actually felt honoured! At about eleven o'clock he would be sent outside to sleep off the beer. He lay in alleys where children would come by and poke him with sticks, or else roll him.

One day he decided to check out a rougher bar in the area. When he got inside he started chatting up a woman at the counter. They got talking about music and she told him her favourite song was 'Her Tears Flowed Like Wine'. He said he liked it too and was going to play it for her, so he put a nickel in the jukebox and it came on. As they sat there singing it a man came up to him and told him he was a hood. 'That's my boss's girlfriend,' he said, 'Do you know what that means? Get your ass out of here.' Hank ignored him and continued singing 'Her Tears Flowed Like Wine'. A few minutes later he had to go to the toilet.

When he was down there the hood came up behind him and struck him across the head until he spouted blood. He went down but came up again. He then went up the stairs and back to the girl who was singing the song as the hood looked on, dumb-struck. He wasn't even interested in her: he just wanted to prove to them that he wasn't afraid of them. She left the bar soon afterwards and he continued singing 'Her Tears flowed Like Wine' as if he was some kind of nut.

After a while the hood came over to him with his friend and said, 'We love you. You're a madman. You're beautiful.' He told him he belonged to the biggest gang in Philly and he wanted Hank in it. 'You're just what we need,' he said. Hank looked at him hard and said, 'I don't fuck with that kind of shit'. Then he went off to hospital to have his head stitched. Once again the Frozen Man had reared his head... thanks to his father. Truly, that razor strop had left a huge legacy.

The excessive drinking of this time was accompanied by some fairly horrendous poverty. There were times he was so hungry he would have eaten the leg off a table for sustenance, when he was so cold he tried to break into churches at midnight for somewhere to lay his head. Libraries performed a similar function for him by day if he didn't look too down at heel. Finances were so bad he sometimes went without food in order to be able to afford the stamps he used to send his poems and stories to magazines.

He read magazines like *Harpers* and *Atlantic Monthly* and was aghast at what passed for quality fiction. To him it had all the staleness of those who had never sucked on the pap of life, who became established figures by refusing to take chances. He was soon to learn that writing was like everything else: a con game where people eventually stopped even knowing what was good anymore because they were so terrified of saying any-thing different to everybody else.

Editors told him to tone down his style but he found if he did that the lifeblood went out of it. (He also found out that this was precisely what the editors wanted!) He decided he would continue to do what felt right, regardless of whether it found favour with those to whom he submitted his work. If you wrote the way people told you to, it was time to call it a day.

In a tar-paper shack in Atlanta that had neither water, light nor heat he lived on sliced bread, writing begging letters to editors for as little as ten bucks to tide him by, but they invariably drew blank responses. He also wrote to his father advising him of

his impecunious state, but his father wrote back only to say Hank actually owed *him* money. He went on to declare that it was time Hank stopped being a bum and got a decent job rather than frittering his life away in the sewer.

The hectoring that had been part and parcel of his life was continuing even at this geographical remove, the old man's mouth merely replaced by pen and ink. The sad fact was that Hank couldn't even afford paper to write his poems on at this point, so he composed them on the edges of newspapers with pencil stubs. Another lecture. Here he was in Knut Hamsun territory... and expected to listen to the same old tune. He tore the letter up. You couldn't eat paper.

For a while it looked as if the cure was worse than the disease. At home he at least had food to put in his mouth — even if his father infuriated him by telling him how much every morsel cost — but here he was half starving to death. The cruelty of his parents was also replicated by the indifference of editors to his work. Maybe there were no answers anywhere. Maybe we were all on a treadmill to disaster.

Days passed by blankly, confirming his notion that nothing lay over the horizon but more of the same. He would never break through. Talent wasn't enough. Rejection slips would be as inevitable as the next sunrise, the next sunset. Readers didn't want truth: they wanted reassurances. Preferably from the already established. Literature, like any other walk of life, was geared towards its own self-perpetuation. Hank truly believed he would die as he had lived, in the silence of another sick hangover after another hellacious tryst with a beaten-up whore. It had always looked like this and now it looked like it more than ever.

He had to try the road, even if only to realise it meant nothing to him. He had to get it out of his system, to see it for the sham it was. Were Kerouac and Cassady trying to run from their minds? That was the only construction he could put on it. People who were at ease with themselves didn't need to go anywhere, especially writers. They could sit at a desk and travel anywhere they goddam wished. It didn't matter if you were in Harlem or Honolulu as long as your brain cells hadn't reached meltdown, as long as you didn't believe the lie that work — or love — would fulfil you.

People's freedom, he said once, stopped when they reached the age of four. That was when you were slotted into your first system, a system that gutted you in subversive fashion. School threw down the gauntlet and then jobs followed. Each stage progressively made you weaker until eventually there was nothing left to fight for, or with. You could break the stranglehold by walking away, but there was no Garden of Eden out there. Most likely you went from one form of hell to another.

He came home soon afterwards, but not to do what his father said. He expected nothing from his trip and nothing was what awaited him. There was a kind of comfort in the freedom from hoping something would turn up.

At this point of his life he was writing for the small magazines, but going nowhere fast. He developed something of a cult appeal, but cult appeal didn't pay the rent. And a lot of poems came back — or went missing.

All he had was his talent, rough-hewn as it was, and a pocketful of dreams. He didn't consider fame as a possibility, all he asked for was survival. To be allowed to drink and write — in that order — was enough. Anything else could come later, if at all. There had been so much pain up until this, anything had to be an improvement.

Rejection, he said, made him feel like a lamp-post with a dog pissing on it, but he continued to crank our his material. Mostly stories, but some poetry as well, a lot of it composed when he was drunk, which was most of the time, and maybe looking like it

too. Much of it was written in the first person because his own life was all he knew.

The rejection slips would have broken other writers' spirits but they fired this man with an anger he poured into further compositions. They were like knives in the heart that filled him with a kind of negative energy. Call it resentment if you like, or even the desire for revenge. He had to fight, fight, fight to be heard. He couldn't let the dross take him over. He had to clear the decks. One day maybe somebody out there would recognise the difference between chicken shit and chicken salad.

Whether he was in a dingy roominghouse guzzling bad wine as he waited for landlords to chuck him out for non-payment of rent or living in a more upmarket pad, there was still the word to be got down — and that could come from nowhere except the brutal coordinates of existence, the rough edges he refused to hone.

Maybe he couldn't beat the competition, but he could certainly try to outlast it. Greater gods were watching.

Every new poem he wrote was a kick in the teeth for those who said he was a no-hoper and this goaded him on almost as much as the inspiration itself.

With a beer in one hand and a cigarette in the other — hot ash burning into his trouser leg as he flicked the tip — he tried to tease words out of recalcitrant typewriters, tried to write poems that would improve upon a life that was dead, or maybe replicate that deadness.

Even if he didn't feel inspired he still wrote, keeping his hand in during the fallow patches like an athlete in training. Sometimes he felt the bad poems even created the good ones, as if they were the grunge he had to get out of his system to make way for the better work. It wasn't always like finding a genie in a magic bottle. Sometimes you had to wrestle with the muse, to graft out a lyric until it began to sing. Unlike many other writers who hung up their boots when things weren't happening, he continued to dig into the paper until something emerged, however paltry. It was a bit like jiggling a key around in a lock until it clicked. It could be frustrating but it could also be an enjoyable challenge. He was willing to tease out an idea for even one good line; if it came, it was like a diamond in the rough. A true 'eureka' experience, all the sweeter for its initial unlikeliness.

No matter how much stuff kept coming back he knew he had something, knew he was better than the fakers and parasites who were well connected, who were published because they belonged to a coterie, or because they themselves published others, rubbing backs that in turn rubbed theirs, keeping the whole incestuous dance going like a kind of literary mafia.

In 1946 he had a story published in a magazine featuring Jean-Paul Sartre, which so impressed his father he passed it off among his workmates as his own. (It carried the byline Henry Bukowski, which was, of course, his own name as well). Hank was so disgusted by this latest piece of fraud — to be placed opposite the 'invisible' job he had manufactured a few years before — that he left home again.

By now he was sufficiently devastated by his spectacularly unsuccessful literary career that he decided to put it on hold. And thus began what he would come to call his 'ten year drunk'.

He moved to the red light district of Alvarado Street, and it was here one night that he ran into the woman who would form an endemic part of his life for the next decade: Jane Cooney Baker. Of all the gin joints in all the world, he'd walked into hers...

One of the first questions he asked her as she sat at the counter was what she did for a living. 'I drink,' she replied, unfazed. She was obviously going to be Hank's sort of

person. 'You have beautiful eyes,' she said to him then. He felt it was a corny comment but he still bought it. Compliments had been thin on the ground for him in times past. Maybe his luck was about to turn. Pretty soon afterwards they started living together.

He heard rumours that Jane was a hooker, but doubted it — mainly because she was always broke. But he was under no illusions that she had sex with many other men after drink — or even *for* it.

She was lit up by a kind of decadent radiance for him. On the surface of things she was a fallen woman, but much more precious to him than the so-called unfallen ones — like his mother, for instance.

Together they rolled from apartment to apartment posing as husband and wife, her beer belly usually being mistaken for that of a pregnant woman, which made the charade easier to negotiate. They never looked to the morrow, just the next drink.

They paid a week's rent at a time, but they rarely lasted a week in most places they went. Within a few days a fight would break out between them and glasses and mirrors would go flying. Hank would say, 'You know we're out of here tomorrow morning, don't you?' and she would nod her head. 'I thought you were decent people,' the landlady would say as she evicted them. Sometimes their fights landed them in jail, each baling the other out on different occasions. They drank from dawn to dusk as if engaged in a twin suicide pact, each of them beacons of the other's despair.

She dared him to do outrageous things like break windows with beer bottles and he acceded to humour her. One time she even made him stay seated at the races when the American national anthem was being played.

She was also wild in bed, which completed the concept of an ideal woman for Hank. Even more importantly, she was the first girl who ever looked at him without apparently being aware of his complexion. Together they promised one another to challenge the world and its strictures, and they did. She influenced him at a deep emotional level and also became the template for many of his literary creations. She would become Betty in *Post Office*, Laura in *Factotum* and Wanda in *Barfly*.

Jane drifted into a part of him that he had once been too inhibited to disclose to anyone. He laid bare his insecurities to her, his neuroses and his fears. Because she put up no defences he didn't put up any either. There was no game playing in the relationship, no striking of poses, no Thanksgiving promises. They were just two people looking for a shoulder to cry on, for any port in the storm their lives had been up to this. It was like two negatives making a positive. They had nothing, so they had nothing to lose. Loving Jane was easier than anything Hank had ever done before: he slotted into her life like a hand into a glove and she reciprocated. All she asked of him was that he allowed her drink — an irony considering his own past. He imagined he would leave her at the starting gates in this department but it ended up being more the other way round. He had finally met his match when it came to bending his elbow. And it was a woman! Where was his machismo now?

In time Jane became the mother he never had: a woman who cared for him, who loved him. Even more importantly: *who drank with him*. She was a drug that made the other drug, alcohol, even more palatable.

Drink afforded him what he called a 'necessary release'. It also released his muse. The writers he knew didn't understand that when they nagged him, when they told him booze would kill him at a young age. He felt this wasn't true, that the absence of it would kill him quicker. Without it he would have died from apathy. It was the beer that wrote the books. Hank was merely the funnel through which it operated.

Jane Cooney Baker.

As well as writing a fair degree of creative material when he was drunk, he also composed hugely revelatory letters in this condition. We tend to get more passion and anger here than in the fiction, or even the poetry. These are his postcards from the edge, so many testaments to the savage indignation that lacerated his breast when there was nothing to confide in but a bottle, nothing to talk to but a grubby sheet of paper.

From 1946 to 1955 he drank with more dedication than somebody pursuing a career ambition. It wasn't so much falling off the wagon as a concerted policy. The sheer consistency of his intake would have killed lesser men before they reached thirty.

He drank to maintain his sanity in the face of jobs he abhorred. Booze also helped him cope with the depression that hit him when he saw writers he didn't respect becoming successful as he waited to be discovered. The majority of poets around him, he claimed, were 'sucking their own tits and crying for mama'. Their neuroses came from the fact that their mothers fed them on the right breast instead of the left one.

He hated their gentle agony. You couldn't put a rope round pain as they did. That made it synthetic. He had to conclude that much of the suffering was fabricated. He could never write that way himself. (How could *anyone* after coming out of a slaughter-house?) If this was the sort of thing that was being marketed, he had only two chances of making it: slim and none.

He knew poets, he said, who started off magazines publishing their friends but disappeared after the magazines folded because they couldn't do favours anymore and were thus snuffed out, not even having the savvy to realise why they had been praised in the first place. No favours could be received anymore because none were being *given*. (Even worse were those sad souls who deemed themselves so superior to the

literary magazines that they didn't even bother sending their poems to them, keeping them under the bed instead to be wheeled out for fellow fantasists.)

Such glad-handing went on wholesale in writing. Dammit, even the great Hemingway succumbed to it. Did he not use the likes of Sherwood Anderson and Gertrude Stein — both of whom he later abjured — in his climb to the top? Not to mention Scott Fitzgerald, the man who got him into Scribners with Maxwell Perkins... and who would later quip, 'Ernest was always willing to lend a helping hand to the man above him on the ladder'.

The main problem with writers, he believed, was that whether they sold well, badly or not at all, they held fast to their insane belief in their own worth. Further, such self-belief was usually in inverse proportion to objective merit. They sucked on flattery like oxygen, which is why they needed the 'brotherhood' of literary gatherings. But for Hank, 'None of it had anything to do with writing: none of it helped at the type-writer'. Maybe it even thwarted inspiration, increasing the smugness a hundredfold. 'The worst thing for a writer,' he declared once, 'is to know another writer. And worse than that, to know a *number* of other writers. They're like flies on the same turd.'

Poets who pursued academic careers endured his particular contumely. They became anal in his view: emasculated, feminised, stiffed. They took the safe road, and pretty soon started writing poetry that could have been produced by a computer. Even on the odd occasion that they got graphic they had to use a big word for it: existential. They were Eliot's Hollow Men: they had measured out their lives in coffee spoons. This was the final murder of the soul.

Hank preferred alcohol to coffee. Drink was an escape from literary rejection, from the notion that you had to earn your living, even from thought. To be allowed to sit on a stool and look at the ceiling was happiness for him. He asked for nothing else except to be left alone. Here he could sit and dream like the waiter from Hemingway's 'A Clean, Well-Lighted Place', without having to worry about dingy roominghouses or mad women... or his father grabbing him by the scruff of the neck and telling him to mow the grass.

He didn't drink so much because he wanted to as because he *needed* to. It was like a bulletproof vest of the soul he wore to inure him to life's casual cruelties.

You worked fourteen hours a day for three bucks an hour and then you entered this haven. That was enough for him. He asked for nothing more. He didn't want warmth or encouragement or even a beautiful woman. Just fill up that glass. And then fill it again. That killed his pain.

In his dark times he thought about ending it all, but hope and humour kept him going. In one of his early stories he wrote about an attempt to gas himself to death failing because he woke up with a headache! 'The automatic pilot on the stove wasn't working,' he wrote, 'or that little flame would have blasted me right out of my precious little season in hell.'

He was constantly wrestling with demons. He told Carl Weissner, his German translator, that one day he was so tempted to stab himself to death with a butcher knife he had to grab on to the mattress of his bed with both hands to stop himself. Each day of his life involved a similar kind of struggle.

Even when such feelings abated, he never relaxed, keeping the butcher knife sharpened in case of a more unbearable attack.

On another occasion he also confessed to feeling suicidal, suffering from depression over being poor and hung-over. He was out walking one day when he saw a headline

proclaiming 'Milton Berle's Cousin Hit On Head By Falling Rock' and he thought: how could he kill himself after seeing a headline like that? Its farcical nature, for some reason, highly amused him and he recovered his good spirits. He stole the paper and brought it back to Jane to show her. The pair of them then got drunk reading it. Hank would forever afterwards be grateful to Berle's cousin for saving his life.

He survived his depression by bottoming out, taking to bed for days on end, coming out only to eat and go to the bathroom. The therapeutic benefit of this, he said, was phenomenal. To lie there and just look at the ceiling was a much underrated pleasure. Not many people realised this. They didn't realise the necessity of taking time-outs, of seeking pauses between highs — or lows. After such breaks he appreciated everything round him that much more: the heat-soaked streets, the rain, even the traffic. His elation only disappeared when somebody crossed his path. That was when this misanthrope realised he was back in the real world, when he went, 'People — ugh. They still exist'.

I'm sure modern psychologists would view these times where he pulled the shades down and took the phone off the hook as high good sense. They were his own personal Betty Ford Clinic. A giving in to himself, if you like. An awareness that all wasn't well, that if he didn't cut himself off from the madding crowd he might hang himself from the bedpost. This was always his saving grace: his ability to *give in*. To ride out the bad times by doing nothing. All things came to the man who waited.

He could never understand the 'Friday night mentality' where people of limited intelligence deluded themselves into thinking that their inane guffaws over platitudes could blot out the fact that their lives, their minds, were cavernous holes.

The life Hank lived with Jane was somewhat removed from this. In one sense it was a destructive life but as he reminisced on it years later he always insisted that it was his happiest time of all. If we wish to be cynical we can call it a relationship of mutual convenience rather than love, and there was also infidelity on both sides, but it was still an Eden time for both of them, notwithstanding the violence, the stints in jail and the hangovers that felt like World War Three. She was often gone when he came home from work — he was now a mail carrier — but when she was there they had a communion he would find it difficult to replicate with any other woman, at least until Linda Lee.

Maybe it was inevitable he would one day meet a Jane Cooney Baker. Maybe there's a Jane Cooney Baker in every town in the US. If there was, Hank Bukowski was destined to find such a woman. The pair of them were like two rabbits caught momentarily in the headlights of life, loping their way towards dubious nirvanas... or maybe just marking time until the next hit.

What he particularly liked about her, he said, was the fact that she realised most human beings weren't worth a shit — a viewpoint that persuaded him somehow that she herself *was*.

In the *Barfly* screenplay Hank wrote that he drank because there was nothing else to do, whereas Wanda (i.e. Jane) drank because it was the *only* thing to do. In this one sentence we have perhaps the reason he survived and she didn't.

So they drank. And drank. And drank. Alcohol may have been killing his body, but he always insisted it saved his soul. 'When you work for a dollar and seventy-five cents an hour,' he said, 'you need to do something at night to keep yourself sane. You need a fist fight, you need a bitch, you need whiskey. Otherwise you couldn't face it all again the next day. I'm all for alcohol. It's the thing.' He always maintained that if he hadn't been a drunk he would probably have committed suicide.

Another time he was sitting by his window when a body fell in front of him. He said to Jane, 'Guess what — somebody from the building just committed suicide'. 'Get out of here!' she replied.

What made it all surreal for Hank was that the man was so neatly dressed: he even had a necktie on. He also seemed to fall in slow motion, as if he was almost suspended in the air for a moment as he passed the window.

'No shit,' Hank told her. 'Come and see for yourself.' She was puking in the bathroom at the time. When she came out, she looked down and saw the body. 'Oh my God!' she screamed. 'See,' said Hank, 'I told you so'. Then she went back into the bathroom and puked some more. It was that kind of time.

He woke and felt the fell of dark, not day. Life meant nothing to him. Jobs stole your soul but you could get some of it back on your own time. You could sleep through the day, pull the duvet over your head and knock the phone off the hook. You could do nothing as a rebellion against all the times people told you to do something. And nobody enjoyed doing nothing as much as Hank Bukowski. He did nothing when he sat on bar-stools and did nothing when he slept for days on end getting himself right to face that dirty world again.

One night a man put a gun to Hank's head after a dispute and told him he was going to kill him. 'Go ahead,' Hank told him, 'you'd be doing me a favour.' He explained to him that he was a depressive who had craved suicide more than once. The man relaxed his grip on the gun when he heard this. 'You would be solving my problem,' Hank said to him, 'and creating one for yourself. You'd either do life in jail or get the chair.' The man dropped the gun and left, but was later put in a madhouse after another violent incident. 'I was a nut too,' Hank said reminiscing about the night, 'that was what made it interesting. He bit off more than he could chew when he put that gun to my temple because I was ready to go. If I had said "Don't do it" he might have pulled the trigger.'

This kind of routine had to come to an end sometime and it did, fate taking a hand in 1955 when Hank came within a whisker of bleeding to death from a perforated ulcer. He could only burn the candle at both ends for so long.

Hardly the type to sign himself into a drying-out clinic for detox, it took something like this to stop him in his tracks. He lay in the balance between life and death, not really caring which way the pendulum swung.

It had taken ten years for his lifestyle to catch up with him. Now that it had, he didn't want to go back to it. His bleeding ulcer was nature's way of telling him to slow down.

He had been playing with death for years, as he wrote in his short story 'Life and Death in the Charity Ward', but this was a little too close for comfort. He had been getting sporadic pains for some time now but had generally dealt with them by using whiskey as an anaesthetic. The chickens were now coming home to roost, however, and he started to vomit blood. Blood that came from deep inside isn't the bright red colour that spurts from a cut on the finger, he explained in that story, but is so purple as to be almost black, and it gave off a foul odour to boot. So much so, in fact, that when the ambulance came to take him to hospital he swallowed it out of embarrassment instead of spitting it out when it rose up to his mouth.

At the hospital there was a lot of red tape to be negotiated, and Hank utilised his gallows humour to carry him through a scenario where people asked him what age and religion he was as he lay on a table possibly minutes away from death. At one point a nurse even slapped him across the face when he wasn't behaving in a manner she

regarded as appropriate, causing him to emit the immortal line, 'Florence Nightingale, I love you'. He was given multiple transfusions of blood but eventually his credit was used up. A priest was then sent for, but Hank gave him his marching papers. When he told him he had lost his faith, the priest said, 'Once a Catholic, always a Catholic'.

Hank fulminated heatedly at the myopic non-sequitur. In the end his father became his unlikely lifesaver with another transfusion, but Henry undid the good of this act by getting Jane roaring drunk and bringing her in to see him. It was his way of humiliating his son once again, confronting him with an abusive woman as a manner of telling him she was his own mirror image. She was so drunk she fell against the bed as she tried to sit down.

His father started to nag him and Hank exploded. 'One more word out of you,' he seethed, 'and I'll yank this needle out of my arm, climb out of my deathbed and whip your ass.' For once his father remained silent.

Lying in the hospital he reflected on the wild frenzy his life had been up to this. Writing had gotten him nowhere, and drinking had all but landed him in the grave. Was there a message in this? Some miracle — or freak — had saved him. His father wouldn't give him the time of day and yet he had provided the life-saving blood. The irony was choice. But perhaps he would have been better off to die. Who would have missed him? He could almost see the obituary: Charles Bukowski, three-time loser, had breathed his last in the charity ward of an LA Hospital. That meant one less drunk on the planet. OK, so Jane would be distraught, but maybe not for too long. Sooner or later she'd pick up another slacker who would provide a shoulder to cry on, or another excuse to get wasted. As if she needed one...

What did his future amount to — more rejection by editors, more crippling jobs, more problems with his liver? So meagre was his motivation to live, he wouldn't have regarded it as a tragedy if his ulcer had tipped him over the precipice. He was only taking up space.

Life was all about traps. You were trapped by being born. Your parents were another trap. Then school, jobs, women. Routine was a trap. Your mind was another one. You had to fight it, to fight all the dead things it put before you. You had to burn with a raw fury or learn how to be a number, to take orders like the rest until one day they put you in a nursing home with a bedpan and you sat there looking at the walls, zombified.

He left the hospital feeling '900 years older' in his mind. The doctors told him he would die if he took even one more drink — advice he promptly ignored as he partook himself to the nearest tavern to tank up on the (to him) energising juices. At that time it didn't really matter too much if they were right or not, so the gesture may not have had quite as much bravado in it as we've been led to believe. (A few decades later when cancer struck he was a better-behaved patient because now his life was *happening* and he had something to lose.)

He wasn't a man who believed in providence, but the fact that his life was spared galvanised him into writing. He resigned his job at the post office and threw himself into the composition of poetry with a vengeance. It flowed out of him effortlessly, confirming him in his belief that this was where his future lay.

So he continued to hammer out the words, dreaming of 'supine women and everlasting fame' — but hardly expecting either.

He bought himself a typewriter and started writing poetry. Up until now the lion's share of his work had been in prose form. In fact it wasn't too much of a transition

because his poems had the plain unadorned style of prose, and also a strong narrative element. He would preserve such qualities right into his seventies. Likewise, the stories — and even the letters — would have poetic elements. Hank never liked to demarcate between different forms. It came out how it came out, that was all that was important. If you knew what you were doing you probably wouldn't be able to do it. That was what was wrong with Hemingway: he tried too hard — and it showed. You knew the simplicity, or what passed for it, had been worked at. His art didn't conceal art.

Even though the writing was going well, however, he knew he had to cut down radically on his drinking, which meant finding other ways to fill the time he spent sucking on beer cans. One of the things we tend to forget about serious drinkers is that, quite apart from their physical and psychological dependency on alcohol, there's also the issue of how much it cuts into their daily timetable. For Hank this was even more pronounced than for most alcoholics. He worked and drank, worked and drank, worked and drank — and in between found some time to make love and write, not necessarily in that order.

Jane suggested the racetrack as a way of filling the gap, and for the next thirty-odd years it would do precisely that, in greater or lesser degrees. It became his home from home, his shrink's couch, his zoo, his temple, his well of inspiration. It was to Hank what the finca was to Hemingway. But whereas Hemingway thought about death there, Hank considered *life*.

It is, of course, somewhat simplistic to say Hemingway *only* went to bullfights to study death. To him, death was merely an adjunct of the ritual. What made it magical for him was the style of the matador, his balletic grace, his courage as he went in over the horns. He saw it as a primitive tussle between man and beast. And if the man wasn't skilled enough, the beast would win. (The fact that bulls who fatally gored matadors were afterwards slaughtered was, to him, beside the point.)

On Hank's first day at the track he picked no less than three winners. He was immediately hooked, as one might have expected. He would continue going to one track or another almost to his dying day.

He wasn't always happy here, and he dreaded the half-hour wait between races — a half-hour in which he was in danger of being approached by fans, or indeed anyone who knew him — but in time he worked out a sophisticated manner of beating the system, or at least staying financially alive in it. He didn't bet large amounts, which was unusual for a man who gambled wildly in almost every other aspect of his life, and enjoyed a handsome return on his investments pretty often. He had an elaborate system of betting worked out, which required a degree in mathematics to understand, but somehow it seemed to bear dividends.

When he wasn't watching the races he spent his time looking at the punters and writing poems about them. The track was like a metaphor for life for him and he saw in it the joy and cruelty he also saw everywhere else. He saw the con, the 'fixed game' as he called it, the prohibitive tax, the pathetic sights of poor people ripping up their slips of paper in disgust, the whole mad frenzy and crushing of hope.

Even the winners of the day were just postponing their eventual nemesis, maybe even making it more painful by having such evanescent illusions waved before their faces.

There were days he would have preferred to do anything but spend his time here, but still he went, knowing that it was as good a way as any to kill the day, to soak up the empty hours when his brain was recovering from last night's binge, or composition, and gee himself up for tonight's one. In this sense it was like a job to him, albeit one

in which nobody was ordering him about.

It was a place where he both wound down and wound up, a sanctuary, a stopgap, a balm. Here he watched the human animal at work and play and cried and laughed. He entered the fray and got on winning streaks and losing streaks and treated those two imposters just the same. He knew that there was no way anybody could beat the system at the end of the day, but it was still fun trying, pitting his wits against a stacked deck. The dreamer in him relished the prospect of the Big Win, while the cynic screamed against the sick injustice of it all. Somewhere between these two extremes he became just another regular guy shelling out his twenty dollars on the latest hot tip.

He drove to the races, he told Fernando Pivano in an interview once, in a car that cost him thirty-five dollars. It was falling apart, and one night as he and Jane left the track the lights refused to go on. He knew the only way to activate them was to hit a bump on the road so he did that. It didn't work the first time so he looked for a second bump, hitting this one harder. And the lights came on. The anecdote is fairly typical of their life together: a catalogue of adventure and whimsy but also aching misery as they gravitated between apartments where the cockroaches sometimes seemed to be the size of fieldmice.

The people he met at the track were similar to those he saw in the bars: lost, poor, abused, victimised. The thrill they got if their horse won was like the hit a barfly would get with a whiskey. In a sense the track was a beerless pub for Hank. It was somewhere to escape to. As he drove to it he was like a latter-day cowboy sashaying along the frontiers in search of a different kind of dream.

It replenished him like water replenished a flower. It was, he said, his god, his monster, his rat, his snail. He relished it for its excitement and also its banality. All human life was here, all of the glory and all of the pain.

The track also seemed to fill him with inspiration for his evening work, it was the nothing time of the day that recharged his batteries for later. To write with the intensity he did, he needed time away from the page, and this was as good a place as any to spend it. So he watched and waited, getting inspiration from the trivial events he saw around him. What was important was to stamp such events with your own personality.

Better to fail with an individual voice, he knew, than to succeed with an acquired one. Many of the writers who succeeded, however, disappointed him.

At the age of thirty-five, he claimed, nothing he read interested him. He needed to create a new way of seeing things, to strip tradition of its veneer of verbiage, to take it out of the hands of those who had never lived, the people with 'carbon copy souls'. The new geniuses, he said, were 'the dull whispers of nowhere'.

He admitted he wasn't a great writer, but said the literary heavyweights left him cold. He didn't even want to be significant, just a man who related to Joe Schmoe, the kind of writer he would have read himself when in the gutter: a writer who caused the same ripples as a Hamsun or an Artaud, albeit operating in a different stream. What he wanted more than anything else was to divest writing of its reputation.

He still sent his work to prestigious magazines like *Harpers*. Such magazines published stories beginning with sentences like 'Amanda carefully adjusted her Easter bonnet before heading down the tree-lined avenue towards the promenade'. What chance had he got with his down-and-dirty realism when that was the norm? On the other hand, how could such no-talent 'literature' threaten him? If he was to break through, he needed Lady Luck to smile, and/or an editor with street smarts to take the helm of an influential monthly.

Hemingway said there were many great writers of the past, which made his task of emulating them more challenging, but for Hank there was nobody and nothing to live up to. He wanted to start a new church. People like Fante and Jeffers had nudged him in the right direction but he could never be awed by anyone. He didn't really have the capacity for wonder, having had it cauterised out of him by his torrid past. He could only try to recover shards of it by setting his imagination on fire.

The concept of personal freedom was huge to him because of what he'd been through with his father and all the dead wood of the past. Such a past was the main instrument behind his cult of individualism — the individualism that told him that the masses were asses, that a herd mentality was an ignorant mentality, that if you saw two lines and one had fifty people in it and the other five, you should go for the latter because that was almost by definition more trustworthy. Reverse the spiral of received wisdom, he held, and you would get the heaven you were looking for.

This was his philosophy of life as much as it was his philosophy of the track — or anything else. Wherever you saw large groups of people, he exhorted, you should run the other way or you would regret it. Popular opinion was wrong and always *would* be wrong. The further away from the human race you could get, the better off you would be. 'I hate people's hairdos,' he said, 'I hate their dogs, I hate their flowers, I hate their cars. I hate the way they walk, I hate the way they talk.' If they said black, he said white — almost for that reason. It was like Nietzsche's transvaluation of values.

Even when someone brushed up against his elbow in a crowd, that was sufficient to unnerve him. It was almost as if the very fact of being a member of the human race meant you had inherited some contagious disease. People prattled, they rubbed off one another's prejudices, they saw nothing but the empirical. Genius had always turned its back on such beings, had always gone its own way. Maybe you got burned that way too, but at least you had a measure of choice in the matter.

That was what life was all about: getting burned. You got burned every day you woke up, every time you went to the corner store, every time you opened a can of mustard. There was no escaping it. All you could do was write about it, which helped. But even this was escapism.

He never felt he *chose* writing as a career. Maybe it chose *him*. He always professed to hate even the sight of his typewriter until he got going, it turned him off until he became so immersed in what he was doing that he didn't see it anymore. It became like an invisible tool.

He always said he would have preferred 'pimp' on his passport than writer. 'Writer' was a dirty word in his book. Most of them cheated. Many got the 'fat head'. And then there were the ones who suffered from an excess of fake sensitivity.

Too many writers wimped out by looking for grants, he felt, instead of spending their time nailing the word down. If they got them, which they usually seemed to do, their writing suffered from the resulting smugness. Hank himself would apply for a writing grant from the Humanities Foundation in 1967 but would be refused. He knew he was producing better material than some other recipients of grants but he also knew decisions were often made for the wrong reasons. In fact there was probably as much politics in the literary world as there was in, well, politics. Nepotism too. The providers of such grants tended to mete out their funds to 'safe' writers, to the clean fingernail boys. By right, he thought, there should have been a caveat on the application form: No Antichrists Need Apply.

Poetry, he said, was 'dying on the vine like a whore on the end stool on a Monday

night'. How ironic that he would come up with this very Bukowskiesque image that was in itself poetic to describe poetry's malaise.

He liked Hemingway's statement, 'Just because I don't use the ten dollar words doesn't mean I don't know them.' He always wore his learning lightly, if at all. Otherwise he felt he would alienate the people who put him where he was, the 'ordinary people'. Those who went to the races, to the bars, to the seedy boudoirs, to the girlie magazines. He wanted to bring poetry to those who had never read it before, to depoeticise it. He preferred 'pomes' to 'poems', as he showed when be called one of his books *longshot pomes for broken players*. (James Joyce had done the same thing with *Pomes Penyeach* in 1927).

Poems were literary things that had overtones of erudition and sterility. Pomes, on the contrary, were explorations drawn from real life — from the gutter, the dockyard, the slaughterhouse, the boxcar, the deli at the end of the block where the hookers hung out, and maybe their pimps as well. He wanted to democratise literature, to bring this cast of characters into the literary magazines, this rogue's gallery. Because these were the people he felt most at home with. They were his friends. They were the people he baited, and who baited him. They were he.

He never wore the raiment of the writer, preferring people to see him as an obese man who sat at a window, daft as a brush. It was like, 'Hey — there's Hank! They should have locked him up years ago. And this guy is supposed to be the chronicler of our *age*?'

Writers who went on to teach others the correct way to write became his pet hates because he felt the essence of it all was uncertainty. Once you started to advise people about it, you lost the openness to experimentation that could lead you into new areas. You became the enemy, a part of the machine. And most likely you painted yourself into a corner marked Writer's Block. Or if you didn't you deserved to. It was like turning your back on the muse to become a commentator *on* that muse — to become, as it were, an anti-self. Hank couldn't understand why people did this except for the easy money or because they were written out. (If they weren't, he believed, they soon would be after this move.) But even then it was a betrayal. When you analysed the creative process you killed it right there. It was like analysing breathing, or sex. Did you need a manual for those activities? You either hit the keys or you didn't. Everything else was irrelevant.

The jobs he took were hell, but they helped him hit those keys better. He worked in a biscuit factory, a brothel, a woman's underwear firm. These were hardly happy experiences but all the time he was storing up memories he would later put into his books. As he put it in 'the burning of the dream':

early on
I decided to be a writer.
I thought it might be the easy
way
out.

Sometimes he was sacked not for failure to do his work but for evincing an attitude problem. Either way he wasn't too put out. The only chance you had to save your soul was to get out of a job quickly, any which way.

Janitor, dockhand, nightwatchman, truck driver, shipping clerk, coconut man in a

cake factory: he would be all these things and more in the years ahead. Anything to keep him in beers, or at his desk. He could write ten stories a week, or up to a hundred poems, but getting them published was like trying to crack concrete with a feather duster.

There was no money in poetry but then there was no poetry in money either. He could be comfortable and dead like his father, or living and indigent. Hamsun and Fante had cut it: so could he. He was like a mad painter splashing blood-red paint on a canvas as the words spewed out of him.

He railed against the Disneyfication of life, the McDonaldisation of it. Writing had to grab him by the scruff of the neck. If it did, he didn't concern himself unduly about technical glitches. Maybe he even welcomed them. He didn't like to sense an author behind his lines, officiating over them, as it were. The poem had to write the writer rather than vice versa. Rigidity in poetry upset him almost as much as the sycophants who perpetrated it. He tried to write without sheet music, cutting to the chase.

e e cummings once said he preferred the company of ice cream salesmen to that of poets. Hank concurred with the sentiment. He preferred plumbers and fishermen and corner newsboys to poets.

He despised their cosy self-indulgence, their overweening solipsism. He would always keep a safe distance from the namby-pambies who offered little more than tea and sympathy.

Academics, as mentioned earlier, were the most contemptible of all. He saw them as so many eunuchs who licked their lips at the periphery of life, so many parasites of the cerebral who wrung texts out to dry to satisfy moribund preconceptions. (The only academic honour Hank himself ever received was a certificate for completing a drink driving course after a motoring offence. He remained quite proud of this to the end of his life!)

His typewriter was like a meat grinder to him, churning out poem after poem, story after story. The inspiration wasn't always rich, but the writing was usually crisp and heartfelt, and there were nuggets of magic. He became a writing machine in the same way as a shark is a killing machine.

He would splay pages across the floor and walk over them to his bed. The next morning he would try to edit his frantic ramblings into something approaching a unified construct.

He never wrote in the daytime. That would have been too much like running through a shopping mall in the nude. Writing had to be done in private, and preferably at night. That was when the magic happened for him.

Other writers corrected drunk writing when they were sober, but Hank often did it the other way round. Sobriety, sometimes, was the enemy; it was the conscious mind trying to hijack inspiration.

In *Women* he put it beautifully: 'I'm just an alcoholic who became a writer so I could stay in bed until noon'. Was he a writer who drank or a drinker who wrote? It hardly mattered because the two activities were nearly always synonymous for him. They were also the two main necessities of his life.

He continued to agonise over his future as the relationship with Jane waxed and waned. For a time she got a job in a furniture store and they lived a semi-normal life, but then the drinking would get out of control, or he would find her with another man, or she him with another woman, and the sparks would fly again. They never looked like going the distance, but neither was there ever an air of finality to their partings.

At least until Barbara came into his life.

A Texan
Interlude

I had no god. I liked to fuck.
Nature didn't interest me. I never
voted. I liked wars. Outer space
bored me. Baseball bored me.
History bored me.
'Women'

Barbara Frye was the editor of a Texan maga-
zine called *Harlequin* and Hank had sent her
some of his work in the mid fifties. He had
submitted it more in hope than expectation,
but her reaction to it was ecstatic and she
started publishing it. The pair of them then
became pen pals of sorts. As the volume of Barbara's letters increased, Hank seemed to
twig that she was reaching out to him not only as an editor, but a woman.

In one of her letters she said 'No man will marry me. I can't turn my neck from
shoulder to shoulder.' It turned out she was born with two vertebrae missing from her
neck, making her look as if she was permanently hunching her shoulders.

Barbara regarded herself as a freak on account of her cruel physiological condition.
Hank might almost have said 'Snap'. Hey, somebody else knew what it was like not to
look like Clark Gable or Liz Taylor! Factor in empathy, pronto. This could be the begin-
ning of a beautiful relationship.

His response to this letter was, let us say, impulsive. He wrote back. 'For Christ's
sake, *I'll* marry you!' He didn't really mean it. It was just Bukowski being Bukowski, but
she took him at his word. He was momentarily shocked when he realised this, but he
didn't renege on his offer. He liked her from what he knew of her, and never having
met her increased the adventurousness of the situation.

Barbara was eleven years younger than Hank, but had never dated a man in her life
and didn't regard herself as a likely prospect for marriage on account of her disability.
Hank, however, was just about eccentric enough not to mind. He had, after all, spent
his life in the company of desperadoes of one kind or another. He had always attracted
lame ducks perhaps because he looked like one himself.

He didn't meet Barbara until the very day before they were married. When he did
he was surprised to discover that she was as highly-sexed as Jane, if not more so.

For the honeymoon he brought her back to her home town of Wheeler, looking a

very unlikely dude among the cowpokes. She was a wealthy woman, the daughter of a man who owned a series of oil wells. Predictably, in view of the brevity of his daughter's 'engagement', he suspected Hank's motive in bringing her to the altar. Neither did Hank go out of his way to disabuse him of the notion that he was on the make.

The first time he met Hank he asked him what he did for a living. 'Nothing,' Hank replied, with his consummate directness. Her family looked him over and the verdict wasn't good. They thought her radar must have been on the blink for her to choose him. Was she this hard up for a mate?

Being married to the editor of a literary magazine gave Hank the opportunity to settle old scores with poet-editors who had formerly rejected his work. He now turned the tables on them as he vetted the MSS they submitted to *Harlequin*, advising Barbara of their unsuitability. His motive wasn't purely vengeful as he didn't like the work he saw *anyway*, but it was definitely a factor in the equation. Barbara didn't argue with him — their arguments would come later on in the relationship when it went sour — and sometimes even overruled her own original decisions to publish material at his behest. (One such overruling resulted in the threat of legal action from an unhappy subscriber.)

Barbara put him all over *Harlequin*, which was sweet music to the much-rejected maverick poet. He had arrived, albeit by the scenic route. If it were another writer being published by his wife in such a fashion, one can only imagine the fun Hank would have had lambasting him for nepotism!

Afterwards she insisted he get a job, which he found difficult to understand considering there was all that money lying around. (He didn't inherit his father's work ethic — unless it came to writing.) He thought it was a much better idea to spend his days at the racetrack and then come home and make love to her. Wasn't that more fun?

It was as if all his father's dreams about becoming wealthy had come true, but it meant nothing to him. Barbara, for Hank, was proof of the old adage that only the poor could be truly happy, because they at least believed money could solve their problems. The rich, on the contrary, knew it couldn't.

He eventually took a job as a shipping clerk while Barbara spent her time at art classes. It wasn't long, however, before his excessive drinking started to bother her. Neither did his erratic moods help. It wasn't like with Jane where both were content to roll with the punches and tolerate one another's shortcomings. Barbara wanted Hank to clean up his act and his life but he was willing to do neither. He wasn't the man she expected from the letters and neither was she what he expected.

Before long, friction turned to open aggression. When she miscarried his child she accused him of having 'bad sperm' — a charge Linda King would also level at him years later. Hank took all this in his stride as the relationship went down the toilet.

In *Barfly* he describes marriage as a kind of 'slow quicksand' and this it certainly was with Barbara, a woman who came to see him as a bastard pure and simple as time went on… while she, for him, changed from Cinderella to Lady Macbeth, deserting poetry to inch herself up the career ladder. Far from what he'd originally envisaged, he found her to be a small-minded social climber whose interest in the arts was merely cosmetic.

The *folie à deux* stumbled on for two years, after which she served him with divorce papers. Hank felt these were rather superfluous as he was never the kind of man to keep a woman against her will. His philosophy of life, like his philosophy of love, was easy come easy go — even when that love could have made him a millionaire.

He was actually with her when a man came to the door to give him the papers. To 'celebrate', he took her to bed and they made love. Maybe this said it all about how little their liaison meant. But does one have the right to expect happiness with a woman one has only met a day before the wedding?

Barbara's family told her he was a beast and she believed them. He agreed he had certain beastly qualities, but other women managed to tame that beast. Barbara, on the contrary, inflamed it. She left him for a Turk who wore a purple stickpin in his tie. What did this say to him? Yes, maybe he was better off without her.

The year after she walked out on him he wrote a poem entitled 'The Day I Kicked Away a Bankroll', a two-fingered salute to the life of easy affluence she offered briefly before withdrawing.

The main reason she left him, he felt, was because he always ran himself down, because he was always fighting an inner war with himself. What she didn't realise was that such a war kept him alive. It stopped him descending into the air-conditioned hell Henry Miller wrote about. But then Barbara always lived below a certain level of consciousness, right to the end. (She died in mysterious circumstances in India in the 1980s after a child she had by another man became involved with drug barons, but Hank shed few tears at the news. In fact he chuckled when he heard her family didn't even have her body flown home).

In the absence of Barbara, Jane tried to get back with him. She had grown in depth by now but her drinking had cost her her beauty as well as her health. It was as if somebody had turned off a light switch. He now saw her as the rest of the world did: objectively, in the cold light of day. Their twin leap into the bowels of wondrous disaster was missing its prime arbiter. Drink was the glue that blotted out that cold light but now it was blinding. It was like, 'You Jane, me no Tarzan'. He was both embarrassed and remorseful. He wondered if he should apologise to her or smack her one in the mouth. Would she too need a bleeding ulcer to bring her to her senses?

The life was gone out of her eyes. She was still in the place where he had been but he had moved on. Had she found another Hank? Maybe, maybe not. Either way, she looked bent on self-destruction. He knew this because he had once been there too — and not too long ago either. He dated her a few times for old time's sake but there was nothing there, they were dancing to a tune that had finished long ago. Their circumstances were the scotch tape that held them together before, and now that these were changed, their being together was irrelevant, hollow. Jane wanted to hang onto him like a drowning person to a reed, but he knew if he gave in to her she would bring him back to the bad places that he had been, that he had barely gotten out of.

The fact that they were still civil with each other nearly made it worse. A passionate split would have been more bearable to him than this bland vacuum of gentility.

He found himself becoming more affectionate to her than he'd ever been before, but in a strange way that killed what they had. How could you like somebody with whom you'd always been in a love-hate bind? It didn't gel. It had to be all or nothing, the dark colours rather than the sunny ones. The ultimate insult would be to treat Jane as a girlfriend. She could never be that. She was, after all, his whore.

He knew he couldn't go back to her. The time with Barbara had changed him,

made him less destructive, more whimsical about himself. Besides, he had something of a literary career going now. All of this meant nothing to Jane, who just wanted a drinking partner. Where had the old Hank gone, she wondered. Had he lost his nerve?

Anytime they met, an unasked question hung in the air: 'Can we get together again?' It remained unasked because she knew what the answer would be. She was part of his buried past, his pre-1955 death-scare past. He had jumped off the Titanic onto a tiny raft, but there wasn't room for the two of them on it. If she climbed on, both of them would drown. So what would he do?

In the absence of any other reasonable alternative, he decided to go back to the post office — the old faithful. Ironically, it was Jane who had first suggested that this might suit him.

In the next two years he wouldn't only lose Jane, but both of his parents as well. In this short space of time, three people who had once been the three main prongs of his life would be removed from it.

His mother contracted cancer in 1956 and he took the news philosophically. He visited her a few times in hospital, usually when he had drink taken. They had little to speak about when she was well and that didn't change now. On one of the visits, however, she made a comment that would have made all the difference if it had been said to him twenty years earlier. 'You are right, Henry,' she confessed, 'Your father is a terrible man'. So she had finally admitted it. But was it too little too late?

The last time he saw her was on Christmas Eve, 1956. He arrived at the hospital with rosary beads for her — an unusual gesture in itself from this supremely irreligious man — but the door of her room was locked. There was also a wreath on it. A nurse came over to him and said, 'She just died'. He tried to feel something but couldn't. There had been too much damage done in former years. She was a woman who meant little to him in life and, equally, could mean little to him in death. She hadn't been there when it counted, and for him that was all the difference he needed.

His father failed to grieve as well, but less than two years later he himself would be in his grave. It was hard for Hank to come to terms with the fact that the man who had 'bastardised' him upon this 'sad earth', as he once put it, was gone. He had suffered a massive coronary while reaching for a glass of water, a fact Hank would allude to in various poems in the years to come. In a sense, his death had been as absurd as everything else about him. For Hank, nothing became him so much in life as the leaving of it. He had collapsed before he even had time to turn the tap off, and was discovered by his new fiancée (his wife was hardly cold in the grave before he started 'dating' again) in a pool of water. In one way he had got out of life easily. He had been spared the fear and pain of his wife's lingering death from cancer.

On the day of the funeral the neighbours called and when they asked if they might have objects belonging to his father Hank gave them away without a thought. It was a kind of expiation for him, as if ridding the house of his possessions also ridded it of his memory. This, at least, was the theory. In reality he would find it virtually impossible to shake off the influence his father exerted over him.

Hank searched inside himself for an emotion but could find none except relief. This was a man who had done nothing for him but try to break his spirit. He had hit him while he was down, again and again. He was mean-minded and parochial: the anti-self of his son. Maybe the miracle was that he hadn't murdered him. Or that they hadn't murdered each other. All he could feel was a vague emptiness. There was nothing he needed to have said to him if he had met him one last time, no pact of forgiveness he

wanted to make. All his death meant was that there was one less malcontent on the planet, one less enemy for him to worry about.

Henry had made a god of social status even as that unlikely chimera disappeared from before his eyes, but it was forever manifest in his every thought and action. He was a glutton, a loser, a sociopath, a petty-minded liar. His death couldn't blot out any of this, or even soften it. How could you mourn a man who had nary a redeeming virtue?

His passing meant that Hank could get on with his life more, could take giant leaps rather than baby steps now that his resentful spirit wasn't chasing him anymore. Another ghost had been laid and he could move forward with a lighter heart. Or so he thought...

It wasn't his father's death that bothered him; rather that the man had never lived, his mind eaten up by resentment over his own disempowerment, the same disempowerment Hank himself would experience in his round of crucifying blue-collar jobs. The difference was that Hank knew such jobs represented a bullshit credo whereas his father bought into the conceit that they could lead to 'better things'. Because of this tunnel vision he stood no chance. He could have won the rat race — but he would still have been a rat.

Even after he died Hank felt his father's influence. He knew he had inherited a lot from Henry. He had a certain coldness in him that reminded him of his old man, and a certain crustiness of manner. But whereas his father had little emotion to begin with, Hank's feelings were merely buried, not non-existent. He was more like him than he liked to admit, however, and such emotions had to be dredged forth in the years to come. He also inherited a cruelty from him that became particularly apparent when he was drunk. (He also bore a striking *physical* resemblance to him, a fact he resented deeply.)

The line he particularly loved from Dostoevsky was: 'Who doesn't want to kill the father?' from *The Brothers Karamazov*.

He lost his anger against his father, he informed people in later life, but never the disgust. He looked on this as healthier for him. It was also easier to bear. You could even learn to laugh at it in time.

His father left him $15,000, part of which he drank and part invested, keeping at least one eye firmly fastened on the main chance. His father had destroyed Hank's youth but now, by dying, he had given him a financial lifeline. (He had also saved his life by dint of that blood transfusion in 1955, which Hank seemed to conveniently forget.) The money was particularly welcome to him because he was only earning a subsistence wage at the post office and many of the magazines he wrote for paid only in contributor copies. Having a few dollars in his pocket, however, only seemed to intensify his depression about not having made his mark on the world.

On the day after his fortieth birthday he felt he was already past it. To celebrate — or rather mourn — the occasion he went to a strip show. This bored him so he went on another wild binge. He ended up cracking his toe in one of the many drunken accidents that dogged his life. A few days later he told Jory Sherman, a poet friend, he thought he was written out, that he had nothing left to say. From here on in, he mused, it would be just whoring and booze and horses. He was nothing more than a dirty old man waiting to die.

And then Jane died in 1962, which compounded his depression.

He didn't know she was sick until he called to her apartment one day and found

blood on her pillow. When he enquired where she was he was told 'The County General' — the same hospital he had been in himself in 1955. When he got there she was in a coma, but she opened her eyes when he sat beside her bed.

'I wiped away her guts as they ran out of her mouth,' he said, later. She opened her eyes once and said six words to him that he would never forget: 'I knew it would be you'. Then she closed them again.

She had visited him in hospital in 1955 when *he* lay between life and death and now the roles were reversed. But there would be no reprieve for this lady. She had supped once too much on Whiskey Hill, her insides eaten up. She went back into the coma again and died two days later. For Hank it meant that a curtain had been pulled over a decade. His broken-winged raven had made her last flight, and a part of him died with her.

He went back to her room in the same way as a murderer might return to the scene of the crime and was shocked by its grottiness, a grottiness he had once been part of before some switch clicked inside him and he released himself from her addiction. As he went through the rooms he found an array of whiskey bottles.

The funeral was done on the cheap by her son who was half way back to Texas in his Mercedes Benz before she was cold in her grave.

There would be no more bunking down in tacky hotels, no more nights of wild sex and drinking, no more falling in and out of one another's arms as they laughed at the lousy hand life dealt them. It may not have been love in the conventional sense, but it beat the Hollywood treacle that so often passed for love. His precious gemstone was gone from him, and what made it worse was that she would have been there for him if he wanted her. They had gone from the status of lovers to friends, which made it almost more tragic again. But had he accelerated her demise by leaving her? The thought bled into his grief, mixing it round with a new remorse.

Nothing else in his life would have such a devastating effect on him as her passing. After the first death, there is no other. She was, he said, the only real woman and real friend he could ever have.

Seeing her in her coffin gave him a shock no doctor could. This was what happened to drinkers, the ones who didn't get warnings in the form of bleeding ulcers.

She died in the way *he* should have. It was a death everything pointed to, the inevitable spin-off of the years of excess. He wasn't surprised, but he was still shocked.

For twelve years they had been united in a bittersweet journey that was going nowhere. Such a journey was now over for one of them. How long would the other last?

He went through the motions of his days, watched people busying themselves with their lives as if nothing had happened. He would never again hear her laughter, never again be privy to that treasurable irreverence.

It was his first real experience of loss and he didn't know how to deal with it. He felt as if he were sleepwalking, as if speaking to people through a fishbowl. His last flicker of hope in the world was snuffed out.

Maybe the main difference between them was that Jane drank because there was nothing else in her life, whereas Hank did so to enable him to unwind from his labours in order that he could devote himself more fully to his writing. For one of them it was an end in itself, for the other a means to an end.

Like Hemingway's Hadley, she had been many years older than him, and like Hadley he dropped her when other pastures looked more promising. But Hadley survived,

going onto phase two of her life with another man. Jane had no such recuperative powers and pretty much drank herself to death in the absence of Hank.

Her age was just forty-nine, but it was an old forty-nine. Life had scarred her with its cruelties maybe twice as much as other women her age. She had, in any case, little to live for now. There was no future in rolling in and out of bars without a partner. She had hacked it better before she met Hank but after he deserted her the loneliness was an extra factor in the equation, the one that made the hours of isolation harder for her to bear. Maybe if he'd stayed longer with her, he thought, things could have got better again. But deep down he knew it had to end the way it did. Their relationship had been based on little more than being together until something happened to make either or both of their paths fork off.

Why was he spared in 1955 and not her now? There was no logic in it. It was a lottery. But once again, death sharpened his mind about his future — or lack of it.

The lure of suicide again posited itself before him, the sweet angel of death that would end his life and reunite him with Jane. To fellow poet Ann Bauman he wrote: 'I cannot hope for many more days'. This wasn't Hank being melodramatic or fishing for sympathy. It was simply the way he saw his life. He was always walking that knife-edge, that gangplank. Not falling off was the surprise more often than not. But the worse his health became in the next few decades, the more his optimism grew that he could kick any ailment. At least this is the impression that comes through the letters. Maybe he was practising self-hypnosis here, trying to convince himself that since he had lasted this long, he could continue to cheat fate.

All of his relationships thus far had been doomed to failure for one reason or another, but they had never been cut off with this finality. He had more pity than love for Jane in her last years, but he still liked to think she was there for him even if he didn't want her. The fact that she was now gone forever ate into him like a raw wound.

She wasn't supposed to die. This wasn't in the script. She was always supposed to be there for him, to be somewhere he could drop anchor maybe. For the good times.

He wrote to Bauman the following year telling her he awaited death 'like a plumed falcon with beak and song and talon for my caged blood'. This is the kind of pained intensity one expects more from a Van Gogh than a Bukowski. The difference, maybe, was that unlike the painter he could pull himself out of these moods almost willy-nilly. Which didn't mean the sentiments he expressed weren't heartfelt, but his mind was too mercurial for him to brood on them. How was he to know then that he would last another three decades? That he had nearly half of his life left to live — and that as a famous writer rather than a reprobate?

He evinced a similar martyr complex to his friends Jon and Louise Webb when he wrote to them with all the graphic details of his melancholia. The only thing that stopped him ending it all, he confessed, was cowardice. He told them he often went to bed for a week to sleep off his depression.

This married couple ran Loujon Press — the moniker combining both of their Christian names — on a shoestring. Hank was deeply indebted to both of them not only for giving him a forum when he found it difficult to get published, but also for the generosity of their spirit. He had many drunken nights with them in New Orleans as they discussed life, love and the whole damn thing, roaches crawling up the walls around them and Hank's pages fluttering in a bathtub nearby, waiting to be set into their plates. Loujon Press was run from their home and they also published *The Outsider* magazine, which was dear to Hank's heart during the lean years.

Knowing how difficult it was for *writers* to keep their heads above water, he realised how many more risks publishers took when they brought a book out, particularly publishers of small presses. That was why he appreciated the Webbs so much. They had much more to lose than the price of a subscriber's stamp or a few sheets of paper. Rejection hurt for a writer but publishers were gambling for the shirts on their back.

Webb had been involved in an armed robbery in his younger days and had served time in prison as a result, editing the prison magazine while in there. This impressed Hank no end. (William Wantling, another contributor to *The Outsider*, had also done time.)

Hank's life at this time consisted of work, drinking, writing and women: in roughly that order. He never believed fame would come his way, but he still had to write. He didn't hype up his intensity like, say, a Kerouac or a Ginsberg, but it was there nonetheless, maybe more so for that reason. He was poor, so words on a page were pretty much the only currency he had. He banged typewriter keys and annoyed landlords, and then he fell off bar stools and annoyed barmen. The future seemed to be mapped out for him in this continuum.

Everybody he knew, he said, had received a grant of some description, the 'Gugg' — his abbreviation for Guggenheim patronage — being given to the already fat. Meanwhile this sad specimen continued to malinger in the bunker, bringing home the bacon if not quite cooking it, putting in the hours by day and at night being visited by aspirants who wrote dreadful poetry but felt somehow superior to him because they didn't have white-collar jobs.

He trained himself to live in the moment because that, friend, was all you had. The past was a bitch and the future didn't exist. You could drive yourself nuts fantasising about chimeras or beating yourself up about stuff you didn't do. Guilt was a luxury he couldn't afford. So was hope. Emotions were like clogged drains. He didn't need them. The poetry came from somewhere else, some mad part of his head. He wouldn't question the source too much. Just let it gush out, soft and easy. Piss it out of yourself onto the page like a revenge, a spit at life. From the godforsaken misery that was the post office to the contrapuntal agony and ecstasy of a life in writing he negotiated a tenuous path: never expecting much but with his foot on the pedal, even a drunk foot on a broken pedal. He would mint music out of the dead bones of his bitterness. He would take his skeletons out of the cupboard and make them dance.

From the late fifties onwards he became 'king of the littles', his work appearing in practically every literary journal you would care to mention (and perhaps a few you wouldn't), the technological developments in the printing trade making the cost of publishing such pamphlets cheaper than it had ever been before. Many of these were mimeo magazines, i.e. stapled publications printed on hand-cranked machines and distributed in very limited numbers for a nominal price, or maybe even free.

The self-styled Muhammad Ali of the printed word, he bellowed out 'I'm the greatest!' at regular intervals when in the company of fellow poets. There were a lot of contenders for the throne but he felt head and shoulders above them, even if he didn't rant on about that fact when he was sober. He waited for the day society would agree with his self-estimation. Until then he was content to keep gunning it out. Even if it didn't happen there was no tragedy: he had the love of composition as an end in itself. Writing kept him sane. It enabled him to suffer the insults of nonentities, the indifference of the blind.

His day began when other people's ended. With a beer in his hand and the lines

flowing out of him he owned the world: he had the moxie. Sober he was more subdued, but his sober life was his non-life. Moving round his apartment in his shorts — because he felt the bottom half of his body was his best asset, he liked to show it off — he slammed the words out like vinegar, loving the sound the machine made, his finger digging hard into the keys like an act of violence itself. (In later years his computer made a lighter sound, but by then he was making lighter sounds himself so it didn't really matter: the aggression had been cauterised out of him by life conferring on him that long overdue U-turn.)

Hank's first book of poetry, slight and all as it was, came out in 1960, publication having been so long delayed for various reasons that he wrote publisher E V Griffith a snorter of a letter, at one point expressing his fear that he had been taken for a ride in trusting him. Such a letter makes us realise just how anxious Hank was to get on the shelf.

Hitting forty was a milestone. Maybe he felt time running out on him even this early. A week later, however, he had the book in his hands, which gave rise to an almost grovelling letter of apology. Unlike so many others, Griffith had come through, reviving Hank's faith in humanity, at least for the foreseeable future. The book was called *Flower, Fist and Bestial Wail*. Even though it was only thirty pages long and only 200 copies were printed, it would always hold a special place in his heart — probably because of the intensity of the images it contained.

Otherwise, however, things were as bad as they ever were. He continued to submit material to editors and continued to be rebuffed, with minor exceptions: those sparse droppings from the rich men's plates that kept the spark of hope alive in him. Many writers stopped writing because they weren't being published, due either to frustration or erosion of their self-confidence, but rejection seemed to spark Hank on to greater and greater productivity. He refused to let the system grind him down. His whore might have left him or his head might have felt like Mount Vesuvius but he continued to make love to the ribbon, forcing it to release itself to him like a woman's charms — or a drink's subtle magic.

The main thing that gave him confidence in his ability was the fact that he didn't regard any of his contemporaries as a threat. Mailer was a poser who strove too much after effect and was in love with publicity. Stevens was pretentious and Miller was up and down. Ginsberg needed an audience, and Faulkner was a fraud. Hemingway had his moments but he fudged his own dictates in the last reel, raising questions about his overall commitment to the macho cause. Was it all bulls and balls, as Vladimir Nabokov had once alleged?

Hemingway also lacked humour as far as Hank was concerned. When he says this, as he often does, one wonders if he read *The Torrents of Spring*, or the wry passages in books such as *Green Hills of Africa* and *Death in the Afternoon*. Many of the stories are also funny, but not laugh-out-loud funny like Hank's work. Maybe that was the difference: in Hemingway you have to search for the jokes. Some of them are even between the lines, which wasn't Hank's idea of comedy. Still, Hemingway has more humour than many of his contemporaries, certainly more than Sherwood Anderson, one of Hank's especial heroes. He would have been better picking somebody like D H Lawrence or T S Eliot for his criticism in this regard. Of course the absence of humour in a writer doesn't mean they're any less commendable. One could argue that Hank's *oeuvre* suffers from a surfeit of overblown humour and a dearth of solemnity. No writer can be all things to all men. All anyone owes himself is to be the best *he* can be.

Hank, in fact, spent so much time denouncing Hemingway in his life, one had to suspect a certain degree of envy on this score, fuelled no doubt by the number of critics who accused him of copying Hemingway's style and subject matter. Asked what he thought of Mailer, Papa's literary godson, he shot back, 'I don't think of Mailer'. But he did. It was only when he became relaxed about his own unassailable position in the literary pantheon that he stopped making cheap shots at these figures. He didn't do an about-turn on them, but the viewpoints he espouses in his later works — such as, say, *The Captain Is Out To Lunch and the Sailors Have Taken Over the Ship* — are much more balanced than heretofore, and neither is his praise for icons as grudging as before.

Sometimes one gets the feeling that any literary figure who became big automatically fell from grace in his eyes on that account. If Hemingway had remained as obscure a figure as Fante, Hank might have continued to ring his praises throughout his life. Likewise for Mailer and Miller — two writers who, on the surface, were saying exactly the kinds of things Hank was saying, and in very similar ways as well. Once Hank became outstripped by these people a resentment seemed to set in, but of course he wouldn't express it as such, professing a profound disregard for their fame as he attacked them on other fronts. The point to be borne in mind is that fame doesn't *always* mean writers are going to lower their standards, any more than the unestablished are *always* mute Homers.

Three small books by Bukowski came out in 1962: *Poems and Drawings* from Epos Press, *Longshot Pomes for Broke Players* from Seven Poets Press and *Run with the Hunted* from Midwest Press. The latter was published by R R Cuscaden, who wrote the first serious essay on Hank's work: 'Poet in a Ruined Landscape'.

The third issue of *The Outsider* in 1962 was devoted entirely to Hank, the Webbs dubbing him 'Outsider of the Year', an award that delighted him — not least because it was the first he won in his life. (To his death he never received a literary award in his own country). The honour, however, was somewhat tongue-in-cheek on Webb's part. Neither was it continued. There would never be any other 'Outsider of the Year' besides Hank.

Meanwhile, back at the post office, his problems worsened. At the end of the year he took a month's unpaid leave of absence to keep his sanity, but the idle hours gave rise to other pressures. He had less money to drink, but more time to do so, which led to one more catch-22.

Towards the end of the year he was arrested for being drunk and disorderly and feared a prison sentence, which would have meant the end of his post office job. In the event he got off with a fine, probably because the jails were full with Christmas revellers, he averred, but he was always sailing this close to the wind.

It Catches My Heart in Its Hands, his first major poetry collection, was published by Webb in 1963. He told Hank affectionately, 'You're a bastard but I'm going to publish you anyhow.' The book gives us an infinitely more subdued and imagistic Bukowski than we will see in later collections. There are tributes to legends such as Marilyn Monroe (who had died the preceding year) and the composer Borodin and various examples of rather standard lyrical verses without much biographical content, except for 'my father'. 'Don't ever get the idea I am a poet', he says in 'a 340 dollar horse and a hundred dollar whore', but he sounds very like one, which wouldn't always be the way in future work.

Some of the images are semi-surreal, like out-takes from a Richard Brautigan novel: coarse in texture but radiating an inner truth. The book contains his best work from the

mid fifties to the early sixties, and at last made him seriously imagine he could make a career from writing.

It Catches was hand-printed in the Webb's sweatshop behind a mansion in the French Quarter of New Orleans which fronted onto an exotic courtyard. They laboured over its production with such care and devotion that Hank was genuinely touched. It was the first book to be produced by Loujon Press and they were determined to make it special, using expensive paper that absorbed the ink beautifully without any offsetting.

It was printed in Dickensian fashion in a room where rats and rain played havoc with the printing press, but in a way this increased the romantic nature of the whole endeavour. Webb used a machete to guillotine the paper.

Hank was so euphoric about the book coming out, one finds his reaction hard to square with the man who's usually so downbeat about everything.

It was a great testament to his resilience that he could take whatever life threw at him and come back with a book like this. The elation he felt at its publication gave him the ballast to shore against the ruins of all his rejections up until now. He even offered Webb money to help promote it.

Everytime he hit the deck he bounced back: with a new poem or a new woman or both. He never thought all those dust-ups at bar counters would become the fodder for art, but it was happening. Everything that had ever taken place in his life was fair game for a book: the DT's, the suicidal feelings, the stinking poverty, the cold sun that hit him as he crept from a park bench at the dawn of day to seek out some hole to crawl into until the night brought his next thirst, his next mucky inspiration.

The stupid ones were the survivors, he would claim in his blacker moods, when ceasing upon the midnight with no pain became an option, but he always stopped one step short of that fatal move, either by accident or design. No matter how bleak life became, he couldn't get rid of the curiosity to see another sunrise. Drunk or sober, he would create a kind of black mass out of the diseased mosaic of his days.

Notes From the Underground

Christ wasn't the only bastard who
was nailed to the cross.
Charles Bukowski

Hank met Frances Smith, the woman who would become the mother of his only child, in the same way as he met Barbara Frye: through his work. She had been impressed by a poem of his which ended with the line: 'and I would have screamed, but they have places for people who scream'. In a way it's a line that seemed to sum up his youth, that time of his life when his emotional responses were stunted by forces outside him. Frances got into his work after this and they started communicating with one another. He learned that she wrote poetry herself, and that she was a divorced woman with four daughters. When they finally met he opened up to her about his childhood and Jane and all the other experiences that had formed him.

She concluded that the riotous critical image of him was a sorely misleading one, that he was a tenderfoot at heart. As time went on she saw his darker side, particularly when he was drunk, but she continued seeing him and moved in with him eventually.

After meeting Frances, Hank left his dilapidated apartment at 1623 North Mariposa Avenue where he'd lived from 1958 to 1964. Together they moved into an only slightly less seedy one at De Longpre Avenue. The two addresses in time would become indelibly enmeshed inside the Bukowski lore of wild drunken nights and mornings afterwards where he vainly sought 'the cure'.

Frances was the first gentle woman Hank got in deep with and he wasn't too sure he could take it. After living with miscreant molls, and being one with them, both her sense of philanthropy and her sunny disposition angered him. He felt her placidity was too easily won. She couldn't have suffered enough to be this way, to always to see the good side of people and not the snakes in the grass. She hadn't been blooded yet.

There would be nights when her do-goodery became unbearable to him, when he would incite arguments merely for the sake of them, as if he were trying to uproot her from her stability. And then there would be the times when he realised he had gone too far, and her reactions exceeded even his own.

He was also irked by her intellectualisation of literature, and her rent-a-cause personality. He himself, he said, was a rebel with no cause at all — except perhaps himself.

Pushed to it, he allowed a modicum of concern for the fate of his fellow man, but he said he found it more difficult to shed a tear for thousands killed in action miles from home than, say, a dog knocked down in the street in front of him. That was the trouble about ideals. By definition they were abstract. When he espoused Nazism for fun at high school it was to knock the self-righteous off their collective pedestals. The point was, it was too easy to castigate Hitler. It was too obvious as well. He sought out more obscure objects for his bile.

He admired anyone who could see the opposite of what was before them. These were usually classified as evil or insane by those who equated the moral with the normal.

Pressed on the question of his attitude to the distribution of wealth in the world, he joked that he thought capitalist when he won at the track, but spouted on about Karl Marx when he lost. If he became rich, he said, he wouldn't worry about the lettuce pickers of Salinas. No Steinbeck he. The only movement he was concerned with was a bowel movement.

He didn't see himself as left wing or right wing: he was apolitical to the core. There were elements of both extremes he despised, and those in the middle left him cold. The solution was to stay outside the whole machinery altogether. Only that way could you keep a clear mind. He might have said with W C Fields, 'I'm not prejudiced: I hate everyone equally'.

He told Italian author Fernando Pivano once that he was a conventional animal. 'I don't want to blow up a bridge,' he claimed, unlike Hemingway's Robert Jordan in *For Whom the Bell Tolls*, 'or change the government.' Neither did he stay awake worrying about nuclear war or saving the whale. 'I'm indifferent to the destruction of the human race,' he said, 'If they wiped out all humanity, nothing would be lost at all.' Of infinitely more importance to him was who would win the second race on Tuesday.

He hated being defined as a slum-king or a counter-cultural guru, as the academics of the time were dubbing him, looking for a convenient pigeonhole to slot him into. These were all labels designed to stifle him. He never saw himself as pro or anti anything. Striking poses and adopting roles limited you and eventually led to preconceptions about how you would 'go' on a particular issue. He fought hard against this in favour of keeping his options open. Asked about war or women's rights or black rights he always gave the answer: 'I don't know'. Revolution, he often said, was merely the substitution of one form of evil for another. When you were outside the system it was easy to be idealistic, but power had a strange way of making people corrupt — from both sides of the ideological divide. When the smoke cleared, new corruptions merely replaced the old ones.

He never wanted to hoist a flag for anything, refusing to load his writing with any cause present or past, with any message that might be construed as historical or hysterical. He didn't align himself with the peaceniks or those who liked the smell of napalm in the morning. All that mattered was the arabesque of lived experience.

He enlisted readers' trust because they never felt they were being set up for the big line or the big message. His message was life itself — or rather *his* life.

The anti-nuke brigade bored him, as did those hippies who chanted 'Hey, hey, LBJ, how many kids did you kill today?' In a few years, he knew, a lot of these same bleeding hearts would be hollowed-out civil servants like himself, or making large donations to the war effort from their stock market jobs.

The fact that he boasted about never having begged for help when he was 'on the

bum', and seemed to resent those who did, fed into his idea that success was a function of effort, a notion the nanny state couldn't countenance. You couldn't call him a capitalist, obviously, because if you put him beside a hobo and a rich man the chances are that he would prefer a beer with the former, but he seemed to believe in the foundations of the capitalist system, or at least the concept that people were entitled to reap the rewards of their efforts if and when success came their way. If it didn't, you had to accept your lot with dignity, be it on a park bench or at the back door of a bar, waiting for opening time to slake your thirst.

He didn't want to be anyone's hero. Like Bob Dylan he might have said, 'It Ain't Me, Babe'. Everybody had to look for their own answers. There were no shamans. You couldn't find them in religion or art or politics or anywhere. Witness his reaction to the death of John F Kennedy.

The assassination meant little to Hank. He believed we were all in the hole, creating illusions. Maybe Oswald did everybody a favour by removing one of them. Now you had to look inside yourself for answers. People said a martyr was mown down in his prime, but all Hank could see was the death of a man who had lived off the fat of the land, filling his myopic fans with idiotic pipedreams about social reform. If they were looking for martyrs, he could provide them with one closer to home.

His relationship to his father came from the same mindset.

Hank had been bothered by that man's capitalist philosophy all his life. Henry believed in the American Dream with a passion; the fact that he couldn't attain it was due to his own failure of purpose. As a result, he took out his frustrations on his wife and son. Hank always claimed he became a bum because of this man. His father filled him with a revulsion of the idea of owning property or becoming rich because he associated these things with a man he could never respect in even the slightest degree.

Hank's renunciation of such values didn't have a social or political edge and when he became rich himself he accepted it with equanimity as his due. In this he resembled his father. He differed from him on issues like social respectability or the war, but most other altruistic ideals he saw as little more than sententious mouthwashes that, far from *saving* the downtrodden, instead ensured their continuance — because they were now filled with airy-fairy hopes of salvation.

The pose of uncertainty he adopted on practically every social issue seems to have been a reaction — conscious or otherwise — to his father's vulgar dogmatism. Hank would never be as sure about anything as Henry Senior was about everything. War, socialism, human rights — nobody could ever pin him down on any of these. They talked to him of Black Liberation and women's liberation and he countered, 'What about White Male Liberation?' When were protestors going to march down Pennsylvania Avenue campaigning for petrified post office clerks or starving poets?

Even when he finally left the post office it wasn't as if he wanted to take anybody with him away from the latter-day torture chamber. His attitude seemed to be: let the slaves remain in their cages.

His colleagues weren't worth saving, he seemed to think, because they didn't *want* to be saved. What they craved was the comfort of the familiar: the same parking space each morning, the same roster that started and finished as planned, the same mindless twaddle to engage their minuscule minds.

All the time he worked with them he exhibited a quality we might refer to as passive aggressiveness rather than outright rebellion against the system. He kept his head down and did his work even though he abhorred it, feeling there was no other way

out. He seemed to abide by the 'render to Caesar the things that are Caesar's' diktat. You had to grin and bear it until your day of salvation came — if it ever did.

The secret of survival, he felt, was to play the system. This wasn't compromise in his eyes: it was giving an inch to take 400 miles. You had to straddle that middle course to stop yourself going under. The people at the top held the aces, but you could bring your own deck to the party.

While Frances went to her workshops and protest marches, Hank hung back and cracked open a beer. As he says to Fay, the character based on her in *Post Office*, 'I know you want to save the world. But can't you start in the kitchen?' Workshops for him were places where insecure people teamed up to massage each other's fragile egos.

He knew she was a good woman but her sense of triumphalism got up his nose. Sometimes when she pontificated he pretended to be asleep so as not to have to answer her or listen to her. So she attended the writers' workshops. Okay, but where was her writing? If you talked the talk you had to walk the walk. Equally irksome was her belief that the world was a fine place. Jane had known better: Jane knew it was a sewer. It wasn't just a case of seeing the glass half full or half empty. It was a dirty glass!

After Frances became pregnant Hank asked her if she wanted to marry him but she felt he was asking more out of duty than love. She said she had been stung by that institution once, which was once too often. He could identify with that.

Those who knew Hank by reputation rather than personally might have imagined him to do a runner when Frances became pregnant, but that wasn't his style. He would see this one through. When she gave birth to their daughter Marina at last he had something tangible to hold on to. This was what life was about, not her mother's prissy fantasies.

Whitman's wild child was, after all the tantrums and the violence, tamed by a baby. She made him love her. She wasn't a planned child: she just arrived. But when she did, a new Hank was also created. One is reminded of Boris Karloff showing his tender side to the little girl by the river in *Frankenstein*. What dumb beast, its hour come round at last, slouched towards Bethlehem to be born?

She forced him into submission with her basic desires much more easily than twenty hoodlums in a back alley waving switchblades. He was like putty in her hands. He would never be Happy Harry, would never buy into the Spock psychobabble, but he had a togetherness with her, a togetherness born of mutual need. He needed to be needed by this squalling apparition at his feet. She didn't talk dirty or over-indulge in alcohol or offer him sexual favours like most of the females in his life thus far. She was just there: a body in front of him to be catered for. His own flesh and blood. The sister he never had. A beacon for the future. His stabiliser. Could the diseased gene pool be reversed after all?

Marina Bukowski — even the sound of it was sweet to his ears. He would allow her to mould him to her wishes, allow her to make him young again, bring out the inner child all writers seemed to have buried somewhere inside them.

Hank was retreating, making way for his under-self, the persona gutted by early horrors but waiting to make a mark. Marina was his ticket back to a past that never was. She was his sanity, his reality check, a bonus he didn't deserve. Why was it that his relationships with adult females couldn't be this giving? Why did daughters have to grow up to be people?

He couldn't fight with a child. With Marina he could undo the sins of the past. He wouldn't make her mow the lawn on Saturday, wouldn't be gluttonous in front of her,

wouldn't try to make her mix with the rich set so other benefits might accrue. No, it would just be a bonding thing. No love beads, no promises, no moral landscape, just togetherness. The little details of her day and the little details of his, merging for moments as poems hinted, or potential glimpses at a future with or without a woman who would share resemblances to her mother. Dammit, he was getting to be like everyone else.

He had often stated that there was no glory in either marriage or fatherhood: they were states you got into because you had to. Seeing Marina in front of him, however, made him re-think his view.

Hank bonded with her as if she were a buddy rather than a daughter. He decided he wouldn't make the same mistakes with her as his father had with him. He gave her quality time, let her see his best side. He protected her with the same passion he unleashed on his enemies in the form of vitriol.

As he sat at his desk spitting out his demons she crawled onto his lap and smiled her beatific smile at him, gloriously oblivious to his problems — which succeeded in diminishing them for him.

Ernest Hemingway once said that when you become a father, the first absolute rule is that you don't look at your child for the first three years. Hank's take on fatherhood was somewhat different. Marina's antics were never much of a distraction to him because he didn't seem to need the kind of concentration Hemingway did, preferring an instinctive style of writing rather than a reflective one. If anything, she helped the creative process along.

In *Post Office* he wrote that he once held a knife against his throat, intent on ending it all, but then thought Marina might want him to take her to the zoo so desisted. This is reminiscent of Richard Brautigan, another alcoholic cult writer affiliated to the Beats in the sixties, who said to his daughter Ianthe one morning when she was fourteen, 'I would have killed myself last night but I didn't want you to find the body'. Ianthe was only nine when her father first told her he wanted to commit suicide; sixteen years later he carried through his threat by shooting himself. (It was weeks before his body was discovered as he set timers in his house which caused lights to go on and off at various times and thus give the illusion somebody was moving round the house. He also left his answering machine on to field calls.) We could even make a comparison between Hank and Brendan Behan, the Irish alcoholic author who had a daughter called Blanaid in the early sixties but didn't live to see her grow. Marina arrived in time to have a redemptive influence on Hank, but Behan already had one foot in the grave (due to liver disease) by the time his daughter arrived.

He showed Marina the reserves of tenderness that had attracted Frances to him originally, sometimes even surprising himself. He had been too hurt in youth to allow his feelings to show, but he had laid that ghost to rest now so there was no need to play the Hard Man anymore. He got fed up spitting blood out of the side or his mouth, he said, to show how tough he was.

He would have told the post office to shove their job many times before this were it not for Marina. His devotion to her made him tolerate the crap the postal system threw at him on a daily basis.

The relationship with Frances continued to deteriorate as that with Marina grew. He abused her both with and without drink and she responded in kind. It was like a carbon copy of the way the relationship with Barbara went. Hank Bukowski was a fine and lovely fellow from the safety of a sheet of paper, but the 3D specimen was some-

thing else. Who wanted to live with Heathcliffe? Relations between them by now could be summed up in a phrase: bed and bored.

He could never have stuck the pace with Frances any more than he could with Barbara, neither woman being able to tolerate his drinking or his mood swings. With Frances you also had to factor Marina into the equation. When he came home from the post office each day he was grumpy with both of them. Cramped for space, it was hardly an ideal writing environment with a child's cries and a woman's silent misery. Some evenings they would both be asleep when he got home and he would lay awake half the night listening to them snoring, wondering if one day the brutalising regime would end. Desk work, of course, was easier on his body than some of the labouring jobs he had taken up in the past, but it was killing his mind.

He went AWOL often, both on the job and by going sick, and sometimes took unpaid leave as well, but the situation couldn't go on indefinitely. Mindless white-collar work was an assault on everything he believed in: an automatic-pilot lifestyle could only last so long. The job paid for his lodgings and, more importantly, his booze, as well as killing off the boring parts of the day, but sooner or later something had to give.

His literary career hadn't taken off and he was dying from 'doing the other man's thing'. He was also suffering from insomnia. He drank to cure his problems but alcohol only made them worse. Jesus carried a cross but Hank had a sack of mail instead, each of them dying a daily death. The agony increased with every leaden second. His nerves shot to pieces, he was like an accident waiting to happen, his misery underscored by the mind-numbing banality of the work as his head exploded with a million writing ideas.

If the boss stayed off his back and he somehow managed to save enough of his salary to pay the rent, that was a good week for him. His life was this basic, this simple. Writing was like playing truant from reality: it was the place he ran to each evening so he could be a robot again the next day and not feel the pain too much. It was to him what spinach was to Popeye. Indeed, he sometimes compared himself to that character, especially the 'I am what I am' tag-line which suited him so well.

Frances also brought visitors to the house, which this recluse couldn't abide. Everything pointed towards the inevitability of her moving out, particularly after his obstreperous behaviour with drink became more prevalent. As with Barbara, he had no problem with her wanting out, never detaining a woman against her wishes. He wasn't very good at modifying his behaviour to accommodate the wishes of his partners, but he never demanded submission. You either took him as he was or bailed out: there was no in-between. (At least until Linda Lee.)

He sorted mail by day, mixing with dead people, and then came home to a dead house at night. Was this a life? Writers were supposed to have exciting adventures. They weren't supposed to have to apologise for their writing while holding down the kind of job their milkman father had, or come home to a flag-waving woman while a child cried in the background, amplifying the tension.

So you argue with the flag waver and grow annoyed at the child. Anger creeps into one of the drunken poems you half write, and then abandon, as you sink into a painful sleep. You toss and turn, listen to the cacophony outside, and before you know it it's morning. The sun blinds you. You look out at early morning people with early morning concerns and wonder where it all went wrong for you. Frances is kind and true, but not for you. And where's that beer? Where did you leave it last night? Did you finish

it? And the others? Bottles are strewn round the floor like relics of your beautiful decadence framed against this crude early morning sun. But at least you don't have to mow the lawn...

You can't take the heat and yet you don't want to get out of the kitchen. You want to stay because you're tired, beaten, clapped out. Creeping noiselessly towards the grave. Trying to conform. To be a father, to live the white collar life even if every fibre of your being cries out against it. But your lady friend knows better. She knows it isn't you. And because of that, she wants to move.

'I can't take you anymore,' she says, and you find it hard to blame her... because you can't take yourself anymore either. Who's to blame? Nobody — just the situation. But she tells you you're unbalanced. This is probably closer to the truth. Okay, but who wants to be balanced? Your old man, your old lady, they were balanced, and where did it get them? Chips on both shoulders. Buk would be different. He would scream against the fates, this sewer Shakespeare. To pee or not to pee, that was the question.

And if she goes? OK, you can take that too. That won't be a problem. You've been there with Barbara, with Jane. Shit happens. It's the nature of things. Who ever said relationships were meant to last? They ran their course. Either you changed or your partner did. Frances wanted different things, a different kind of guy. Maybe she would have been happy with a truck driver, a man who didn't stir the pot. She believed in twee revolutions, ones fine tuned in safe havens. Buk wasn't like that. He wanted to be out in the firing line. But he was still trapped in the concrete jungle of his psyche, the dark after teatime of the soul. Neither he nor Frances were going to change anything. It was important to realise that. That was the beginning of wisdom.

He would let her go, let her seek fresh pastures. Women always left. This was why he couldn't give himself over to them emotionally. They used him and then ran, unable to appreciate his purity — either on the page or off it. A part of him was actually relieved when this happened. It meant he was back to basics. The word. The piano. The gamble. The nothingness.

Frances took Marina to Washington to visit her other children and when she came back she told Hank she was moving out for good: news that hardly surprised him. ('I never leave women,' he would proclaim often in later years, 'they always leave me. And yet I have this image of being a chauvinist and a woman-hater!')

In one sense he was almost relieved that things had come to a head like this, but then the crippling emptiness set in and he searched for alternatives to fill the void. In a part of him there was a pining for her but he disavowed it, seeking instead the company of women who didn't know what it was to love, only to *make* love. His manuscripts lay scattered around the floor like so many aborted children, like parts of himself he had flushed out without thought or care. In bed at night he tossed between the sheets wondering what lay in store for him, what moronic infernos of the spirit lay ahead. When Marina came to visit he watched her playing and wondered what she would make of him when she grew up, this strange grizzled man who couldn't hold onto his women, who crawled into a job he despised every day and then came home and tapped out a mountain of pages that nobody wanted to see. When she reached adulthood would she tell him he was a lunatic? Or would he even live that long?

In a way there wasn't much difference between the bar stool and the post office seat. One destroyed his body, maybe, and the other his mind, but he was equally imprisoned by both. He was like an actor who waited on tables in the afternoon so that he could tread the boards at night, his day really beginning the moment he clocked out.

His superiors he saw as men who had nothing in their lives but the task in hand. Dead men, dead before death itself arrived, dead like his father, clocking in and clocking out like the automatons they were, in love with petty dreams that were commensurate with their own tunnel vision. He tolerated them because, also like his father, they held the reins of power. Their pay cheques were like a stranglehold on him.

If he was away from his desk for even a short time, their alarm bells went off. He became threatening to them if he expressed (whisper it) an Original Thought. Because thinking was dangerous to the mule kingdom. Ours not to wonder why. One should not have the temerity to become human, or treat one's colleagues as human. That was the unpardonable sin. There was a job to be done, that was all that could be said, and you should do it without change, without question. without deviation of purpose. It was like Kafka's Joseph K had come to downtown LA.

He also had physical problems in the post office. He frequently came home feeling dizzy, and with pains in his arms that were so bad he could hardly lift them. The only way he could survive was by turning his mind off, by forgetting he was even there.

Sometimes he went to doctors to have himself checked out but they found nothing. The authorities then concluded that he was malingering. What they didn't realise was that you couldn't see depression on the end of a stethoscope. You couldn't put it on a wall chart. How could one tabulate the residue of a thousand storm-tossed nights?

Another problem with the job was having to mix with people. Ever since grammar school, as noted, he never felt comfortable with 'the crowd'. Such a strain was intensified here. Few could have predicted that he would have stood up in front of hundreds reading his poetry in the years to come. But even here there was a distance. On the podium as on the bar stool or the park bench he was always alone.

His best friend, in a sense, was his typewriter. You could be yourself with that. You didn't have to role-play or perform — or at least you didn't have to if you didn't feel like it. Neither did paper talk back, or accuse you of being unpunctual or absent. Truly, it was a most placid concubine. It didn't even give out to you if you drank too much, or spilled beer on it. And if you bled your emotions onto its surface, it repaid you with its raw beauty — and maybe even some dollars.

He was almost permanently under the gun at the post office. Apart from the flashpoints with the authorities, the silent suffering of his colleagues irritated him — almost as much, in fact, as his mother's silent complicity all those years ago. Her inertia was in the face of a physical cruelty, but this psychological terrorism was no less reprehensible. These people weren't only putting envelopes into boxes but their own souls as well. They came, they saw and they concurred. Others among them lived in denial about their condition, affecting a kind of trite, self-congratulatory air as they traded banter about ball games. These were people who lived in terror of having an original idea, who wouldn't have the imagination to have a nervous breakdown. Each night they went home to lives as toe-curlingly dull as their jobs while he burned his passion onto the pages. Like his father they were only half-alive ... and yet they made *him* feel like the oddball.

He wrote to his poet friend Fred Voss, 'We fight to hold jobs that are killing us physically and spiritually but we are more afraid of no job at all so we swallow the shit and abuse and pretend there's something left of us after we walk out of there. The bottle and the word saved part of me, but there is a part I will never get back: the wasted hours, the wasted years given over to them'.

No matter how bad things became, however, he never stopped writing. If he'd had

a computer in the sixties he could have doubled his output, the 10PM curfew imposed by his landlord cutting a swathe into whatever inspiration hit him as the noise of his clacking kept the other residents awake.

He could do thirty poems a week and think nothing of it, with a few stories thrown in as well. Often quality varied inversely with quantity, and he was never much for editing, but sometimes he hit the nail on the head. It was as if his whole oeuvre was one vast sprawling canvas where he rewrote his history each day, or night, replaying the spools of his life like an old movie with key favourite scenes.

His unfeeling parents. The lawn-mowing incident. The President Hoover story. The boils. The acne. The looking up women's dresses. The occasional kindly teacher. Going mad with drink, or without it. The beatings and the conquest of the beatings. The war and his imprisonment. Meeting Jane and becoming her soul mate. Drinking with her as if there was no tomorrow, until the 1955 experience. The death of his parents, and then her own death. The marriage with Barbara and the child by Frances.

All these became the themes he picked like apples off trees, seeking to make sense of them or not, heaping image upon image in semi-surreal vein as classical music blasted away in the background. And then going into the job the following day to unwind, or rewind.

He abhorred it and everything it represented — or rather failed to — but as he put it 'I have no trade and I like to eat'.

In another sense the job was a necessary evil: the death of the soul that made the life of the page possible. It was the pact he made with the devil to keep going. Also, from a sheer pragmatic point of view, it stopped him drinking during the day.

Hank needed breaks from his writing and he got these when in the post office. After work there was the racetrack to perform the same function. He suffered a lot of physical and mental torture at work, but in a strange sense the job probably prolonged his life. And he didn't *not* write when working there. He was so terrified of selling his soul to the company that he took the necessary precautions to distance himself from its many traps, and practised as much humour as was possible to keep his sanity. His superiors also knew he didn't fear them, which meant he was probably permitted more insolence than his colleagues.

Crucifix in a Deathhand was published in 1965, with the very impressive title poem and a bevy of others written, according to Hank, during a 'hot, lyrical' month in New Orleans. He had become deflated after *It Catches* — a not unfamiliar phenomenon for a first-time author — and this was his recovery collection. It was only possible, he believed, because of the kindness of Jon Webb, who invited him to his house and drank with him every morning at a small table in the kitchen with roaches still running up and down the wall in front of them. There are many beautiful images in these restrained poems, which are characterised by a tenderness we don't usually associate with this man. Two thousand copies were printed, a huge increase from his last effort.

1965 also saw the publication of *Cold Dogs in the Courtyard*, a collection of poems that had Hank gazing into the abyss again. It ran to just twenty-three pages and only 500 copies were printed, but it was at least another title. From a man who once doubted he would even write a single book.

No matter how good the writing was, everybody knew that poets, by and large, starved to death. So why should he be any different? He probably wouldn't have been were it not for a unique train of events.

A furniture store owner called John Martin, who had been watching Hank's career

with some interest, decided to pay him a visit. He had been fascinated by Hank's work for some years, reading every poem he could get his hands on in the underground magazines where Hank was king. He was considering starting his own publishing company and who better to feature than this man, the guru of the 'littles'.

The first thing Martin said to Hank when he called round to see him was 'I worship you'. Hank replied nonchalantly, 'That's all right' and asked him if he would like a beer. Martin refused, being teetotal. He then asked him if he had any writing he could show him, whereupon Hank opened a closet of MSs stacked four feet high. Martin's jaw dropped in shock. A moment later he got down on all fours and started sifting through the material as Hank looked on, bemused. Martin had imagined he might have enough material stockpiled for a collection or two, but there seemed to be enough here to fill the Library of Congress. Martin read as much of it as he could on the spot, agog at the beauty of some of it and the mediocrity of the rest. He felt he'd stumbled on a goldmine.

He was also aware that poetry was difficult to sell. He offered Hank thirty dollars for one of his stories straight off and said he would get back to him on the rest. Hank was quietly optimistic about the encounter but he had been stung so badly by unscrupulous editors in the past he didn't get his hopes up too high. It might come to something or it might not. Martin, meanwhile, went home with enough reading material to last him through many long winters. In time it would become the corpus of over thirty Bukowski books he would publish with Black Sparrow.

As well as Martin, Hank was now communicating with a Chicago-based poet called Douglas Blazek who produced a magazine called *Ole*.

He accepted some of Hank's poems for the inaugural issue and afterwards became his especial penpal through the sixties, the man with whom he shared his dreams and nightmares, hopes and fears. Blazek worked in a factory in a job about as miserable as Hank's so the pair of them compared notes on this theme too. For Hank it was refreshing to at last touch base with a poet who wasn't living off the state. Or the fat of the land. Or some rich relative who bankrolled their verbal masturbation for the delectation of the extended family and a coterie of like-minded solipsists.

Blazek revived Hank's interest in prose, which he'd stopped writing after his 1955 debacle, and published both *All the Assholes in the World and Mine* in 1965 and *Confessions of a Man Insane Enough to Live with Beasts* in 1966 as chapbooks.

In the sixties Hank's correspondence with Blazek, the Webbs and Louisiana poet William Corrington (who had written a flattering introduction to *It Catches*), among others, was prolific. He unleashed his torments in these and subsequent years in letters that are even more explosively frank than his creative work, if that's possible. He literally bled onto the page in these letters, many of which were composed in a drunken state, which often makes them read like the half-mad ramblings of a quasi-impressionistic wordsmith on acid. Isolationist that he was, he used letters to come to terms with the feelings he often couldn't share with people he knew in a more personal capacity. They have his humour, his darkness, his spontaneity, his wit, his terror, his jubilation, and most of all his bewildered attempt to accept his absurd lot in life.

Sadly, the impassioned letters he wrote to these people were often followed up by anti-climactic meetings. 'Don't rub up against your idols,' said Balzac, 'or the gilt will spill onto your fingers'. Hank realised the truth of it when he met Corrington in 1965. Corrington was fine from the safety of the postal system but Hank felt threatened by him in the flesh. He found him too cocky and academic by far.

Neither was he impressed by the younger man's championing of Barry Goldwater, a politician he had little time for, nor by the fact that Corrington told him he had now revised his notions on poetry and put novel writing on a higher plane. This was a reserved sin in Hank's eyes. Corrington turned his back on the form that had kick-started their friendship.

How could he let the novel leapfrog over poetry like that? For Hank there was no contest. W B Yeats once said, 'I'm not feeling well today: I can only write prose', and this too was Hank's view of the creative process.

What was the big deal about novels? Every second fifth-rate writer had one under the mattress, ready to be inflicted on some long-suffering editor. Hank accused Corrington of receiving good money for a bad novel, adding that cash turned a man's head just like a whore could. (Conveniently Bukowski would amend his view of the fictive form when he started writing novels himself!)

The following year he gave Corrington's *Lines to the South* a poor review, after enthusing much about his previous work *The Anatomy of Love and Other Poems*. In subsequent letters to him the tone is decidedly more formal with 'Mr Corrington' (not Willie anymore) being castigated roundly for various misdemeanours.

Corrington had aristocratic blood and right-wing tendencies but such details didn't bother Hank as long as he was writing good poetry and acted decently to him.

Corrington fell far in Hank's estimation when he started to get seduced by campus values, and lost the plot entirely when he went to Hollywood, the last den of iniquity for him. He became the property of the establishment, sucking the lifeblood out of literature by institutionalising it. He became A University Writer — and universities, for Hank, were where good poets (and even good novelists) went to die. So RIP William Corrington — among all the decayed bones of lit crit.

Far from being the soul mate of yore, Corrington was now transmogrified into the enemy, and things got even worse when Hank was offered the proposal of anthologising his letters and asked Corrington to return them to him, which he refused to do, saying by way of excuse that they were too precious to him for that. Hank didn't buy this, and another friendship — or imagined friendship — went down the tubes.

Hank, of course, had no copies of his letters, despising the breed of writer who used carbons when they wrote to people, having one eye on posterity even in these moments of supposed intimacy. What price a shared insight with a loved one? But hey, it's going to be all over the world next year. The even more amazing thing was that a lot of these letter copiers were nobodies. The way he saw it, you should get famous *first* and *then* sell your precious missives.

Sometime before, Corrington had asked Hank to return *his* letters and he had done so without question. He was now asking for the same grace from Corrington, but it wasn't forthcoming.

Hank wrote to Blazek in September 1965 asking him to return his letters, saying that a refusal to do so would be tantamount to a whore taking his wallet while he slept. His tone suggests he expected Blazek to refuse his request, but he didn't, renewing his faith in him in a manner Corrington failed to.

Despite Blazek coming up trumps in this instance, when the pair of them finally met in 1967, the rendezvous was again a fiasco.

Such anticlimaxes, of course, aren't unusual. There are manifold tales of penpals who meet up years after a fruitful correspondence only to find they have nothing to say to one another in the flesh. Maybe the exceptions are the relationships that trans-

late successfully from the page to reality. In his letters to Blazek and Corrington, we could even stretch the point and say Hank was really writing to himself, using these people as catalysts to get his teeming thoughts out. To this extent, the camaraderie they evince is based on fatuous premises. Many of them are like footnotes to the poetry, a means both of winding himself down from the last creative burst and limbering up for the next one.

His correspondence with Jory Sherman was equally dramatic, ending with Hank declaring to his sometime boozing buddy that there had never been anything between them, Sherman having been the one doing all the running in the relationship. This is an allegation Sherman hotly disputed in his memoir, *Friendship, Fame and Bestial Myth*. Once again, he claims, it was simply Hank being Hank, and nervously protecting the second skin he wore around himself.

Sherman relates enough anecdotes in his enigmatic little book to convince us that he was indeed an ally cum confidante of Hank in the pre-fame years. He also praises him highly in the course of it, both as man and writer, but there's an undertow of resentment running through the pages as well, perhaps understandably considering he saw himself as having been disowned by a man he helped build into an icon, both directly and by dint of interventions with publishers like Jon Webb. Hank was obsessed with becoming famous, he tells us, but once he did he spent his time reviling his new status. Despite some cutting asides, however, this is a fond tribute from a man who was there when Hank made the transition from being a big fish in many small ponds to a small but growing one in a big pond. As such, he can't simply be viewed as a hanger-on. In fact he claims he tried to protect Hank from such beings when they were threatening to gobble him up.

Hank also had a mercurial relationship with the poet Al Winans. Winans was editor of the literary magazine *The Second Coming*, one of Hank's favourite outlets in the lean times. Winans went on to write an interesting memoir of him, *The Second Coming Years*, published by the Beat Scene Press. His correspondence with Hank ran intermittently through the seventies and eighties. Hank fell out with him after Winans wrote a poem about him which he deemed pejorative, and also because he felt (wrongly, as it turned out) that Winans was storing up his letters to sell for profit.

Winans, like Hank, was a postal clerk. He was also a big drinker and had been in trouble with the law. (He was arrested one St Patrick's Day for jumping into an empty taxicab that had the keys in the ignition and driving off in it, being heavily under the influence of drugs at the time.) More importantly, they shared a passion for good writing. Their relationship went through peaks and valleys, the best times being when Hank was submitting material to *The Second Coming*. The magazine eventually went belly up after a car accident which virtually emptied Winans' bank account. Hank was miffed when Winans rejected a preface he submitted to him for a poetry collection and subsequently said no to Winans' request to appear in a cameo role in *Barfly*. Winans took Hank's chameleon mood changes on the chin, however, and remained a friend after Hank's career took off while his own remained stagnant. He also kept Hank in touch with literary gossip, which the East Hollywood recluse appreciated.

Hank propped up Winans' spirits anytime he felt dejected about what he was doing, assuring him that *The Second Coming* was one of the best literary magazines around, and always had been. Winans, for his part, remained a cogent critic of Hank's work, publishing as much of it as he could in good times and bad. (Hank appreciated it when he told him it would be wrong to publish a derogatory poem Hank had written about his

sometime friend Steve Richmond, realising it would have jeopardised their friendship, which had grown edgy as time went by.)

Their relationship became strained when Hank refused to do a preface for Winans' poetry collection *North Beach Poems* and also for a Jack Micheline collection. He later offered a blurb puff by way of consolation, but the refusal hurt Winans considering Hank's previous praise both for Winans' own work and Micheline's.

The gay poet Harold Norse was another regular correspondent. Hank didn't generally like gays, but he made an exception for Norse, as he did for Neeli Cherkovski. Norse once suggested Hank might have been a closet gay himself, but the evidence for this is flimsy, based on some chance comments Hank occasionally made when he was drunk. When Hank was intoxicated he was capable of making assertions of necrophilia, never mind homosexuality. (In his book *Memoirs of a Bastard Angel* Norse even suggests Marlon Brando made what could be construed as a gay overture to him in his early years.)

Norse was a globe-trotting poet with a wide orbit. He was close to writers like Gregory Corso, Dylan Thomas, James Baldwin, Allen Ginsberg, W H Auden and Tennessee Williams. He also carried on an extended correspondence with his namesake William Carlos Williams, who was a mentor of sorts. Like Hank, Norse was an underground figure who went on to reach a wider readership with time. Both of them had been published in *Ole* and *The Outsider* before bigger audiences loomed. In the mid sixties a special edition of *Ole* was devoted to Norse himself, with generous tributes from the likes of Baldwin, Anaïs Nin and William Burroughs. (In his novel *Beat Hotel*, Norse used the cut-up technique Burroughs would later fine tune in his own work.)

At one point Hank regarded him as the greatest living poet, and was given to reading his work aloud to friends. If he had a problem with it, it was that it was almost *too* refined, lacking the madness of Hank himself. He told people he could never write as well as Norse, but it's questionable whether he would have *wanted* to. Perhaps it all boiled down to the difference between art and craft. Norse had a holy attitude towards poetry, choosing every word with care, manicuring his nails, as it were, on the edge of the experience. This could never be Hank's way. He preferred to dive in headlong and see what happened. As time went on he began to have mixed feelings about Norse's work, being simultaneously envious of a lot of it and dismissive of the rest.

He also had mixed feelings about Norse himself, with whom he had so much. Both of them came out of the 'underground cobwebs', both wrote for the girlie magazines intermittently, and both spread themselves across the poem/story/novel canvas willy-nilly. More importantly, fame came late to both of them, which in Hank's eye view meant they wouldn't be spoiled by it.

Norse seemed to sneer at Hank on occasions, adopting a superior attitude to him, particularly when Hank had drink taken. If Hank insulted him when he was drunk he took it personally, not realising it was probably the drink talking. (God knows, he should have realised this from the time he spent listening to the drunken rantings of Dylan Thomas and suchlike. As Hank put it to Winans, 'Before a man can meet the gods, he must learn to forgive the drunks.')

As a result of such tensions, their friendship see-sawed with the passage of time. Norse also became irked when Hank used one of his letters as the basis for a piece in *Notes of a Dirty Old Man*, while Hank later accused Norse of bad-mouthing him to John Martin, saying Martin was over-publishing him at the expense of more talented writers... such as himself. Norse denied ever saying this but Hank had his doubts. As if to

get his own back, he reneged on a promise to dedicate *The Days Run Away Like Wild Horses Over the Hills* to Norse, choosing Jane instead for that particular honour.

He also corresponded frequently with another poet, Gerard Locklin, a professor of English at Long Beach State University. Locklin went from a position of being dismissive of Hank's talent to revering it. Locklin knew all the clichés that went round the literary world about Hank but chose to pour cold water on them. He realised Hank's hard-boiled pose was just that, and that his writing was getting better as he grew older. The reason some sentimentalists praised the early lyrical work so effusively was, in his view, as much out of jealousy of his subsequent fame as anything else. Saying Hank sold out was a sly means of assuaging their own frustration at not getting anywhere.

Locklin expressed these views publicly at a time when it wasn't kosher to do so in the set in which he mixed, and he was also generous to Hank's books when he reviewed them periodically in the posh literary journals for which he wrote. He collected such reviews in his book *A Sure Bet*, which gives a very objective appraisal of both Hank's gifts and his shortcomings. Locklin knew Hank had a soft centre but chose not to exhibit it often, adhering to the 'a man's gotta do what a man's gotta do' credo with people until they occupied a place of trust in his heart, which didn't happen often. In *A Sure Bet*, Locklin writes about the conspiracy of silence that surrounded Hank until he became famous, at which point the establishment realised he wasn't going to go away (as they had previously hoped) and decided on a full frontal assault against him. Or, more to the point, against his extra-curricular pursuits. Those who despised him as a drunken bum, Locklin observed, now started to despise him as a drunken *rich* bum.

Locklin stayed friends with Hank the way most people did: by keeping out of his hair. He had his phone number and address but never called unannounced, knowing that Hank came out of his cave only when he wanted to. He found it hard not to be rude to people who inflicted themselves on him when he didn't want to see them, and appreciated friends like Locklin who didn't abuse their privileges. 'I did not,' Locklin once said, 'show up on his doorstep with two six-packs and the conviction that I was doing him a favour'. The result of this was that on the odd occasion that they did meet, at readings and premieres, the atmosphere was always cordial. It also meant that their epistolary relationship (albeit sporadic) lasted the test of time, unlike certain others that wilted from overkill.

Frank Sinatra used to keep a sign on his front gate that said: 'You better have a damn good reason for ringing this bell.' Hank had an invisible one that said the same thing. He knew Santa Claus had the right idea: visit people once a year — even if that.

There seemed to be some fundament of affection missing in him, or maybe his environment made him that way. He'd never been a child you could pick up and cuddle. His grandmother had once bent down to kiss him in the cradle and he punched her on the nose. He seemed to equate tenderness with weakness. In a jungle, maybe you had to.

At this point he saw himself as a kind of insane blitzkrieg of dysfunctionality. Different day, same shit. He felt his life spilling out of him like thread from a spool, unravelling itself every which way as he felt like a distant spectator of its grim coordinates.

Beer. The track. A tryst with a whore. Girlie shows. Write a poem. Listen to Mahler. Throw up. Get a rejection slip. Do a reading. Throw up again. Fall, injure yourself. Write a letter. Grab another can from the freezer. Jack off. Fulminate against the state of the world, the condition of modern man, modern woman, 'the arts'. Everything sucked. Anyone who came through it was lucky, privileged. Into the valley of death

rode the six hundred. Who asked to be born?

He was also tiring of the groupies, telling Douglas Blazek in mid 1966 that he had ignored the overtures of a pretty woman who called to see him because he would no longer 'fuck on demand'. When he turned people away now, however, they didn't call him loopy — they called him a pain in the ass. It was like the old line, 'When crackpots get rich they're not called crackpots anymore: they're called eccentrics'. It was arguably a step up the ladder.

Hank was writing his (in)famous 'Notes of a Dirty Old Man' column for John Bryan's *Open City* newspaper at this time. Once he happened upon the title, he maintained, it wrote itself. It went on for thirteen months in all, and while it didn't net him much cash he loved its instantaneousness.

After years of submitting copy to poetry magazines which was either rejected, ignored or ripped off, it was a buzz for him to write something at a weekend and then see it all over the city a few days later. He also got enormous feedback from his columns from people who were simultaneously shocked and excited by his freewheeling style with no holds barred. A psychiatrist even wrote to him advising him that he needed help.

He was given a wide berth here and he used (some would say *abused*) it to its full effect. But it was the liberal sixties and the term 'open' wasn't accidental. We could say the man had finally met the moment. No longer did he have to solicit editors for column inches. He was given a licence to shock like an open journalistic cheque.

Calling *himself* a dirty old man was a clever ruse to stop others referring to him in this manner. By making a joke of it, he took the wind out of the sails of those who were po-faced about him. It was a protection against any onslaught that might or might not be levelled against him.

Written in a barnstorming, in-your-face style that you either loved or hated but couldn't ignore, most of the columns were self-referential in some sense, which was the way he always liked to write, telling his life story in instalments, as it were, interjecting suitably crass and sardonic asides on politics and literature, sex, work, poverty and health as the occasion demanded. It was an ideal platform for him to sound off on issues that had been burrowing round his subconscious for years, and also to settle some old scores. He let it all hang out, both literally and metaphorically, and Bryan lapped it up.

It was the dawn of a new era in journalism. Hank was a precursor of Tom Wolfe and his ilk, using an open-ended language with no structures or strictures to inhibit his controversial flights of fancy. He could rubbish Shakespeare, cast aspersions on the Beats, demean the work ethic, champion pornography and go into the most explicit detail about topics that were once deemed too intimate to ever see the light of day. He also amplified the angst of embattled working men in a manner that would hitherto have been too outrageous to consider. Many of the columns were written like short stories, the absence of capital letters reminding one of e e cummings and the style a kind of admixture of Henry Miller and Damon Runyon.

Thoughts and images tumble from his pen in vitriolic cascades like a malfunctioning electric current, leaving us in little doubt that for this man, bred as he has been on mendacity and pathetic greed, the American Dream is rotten to the core of its being It's a style of writing that's unprecedented, like a kite let loose in the wind, stinking with disgust at the God-fearing chimeras that have been handed down to him with his mother's milk. This is free-fall parachuting of the mind, undercut with the malevolent

glee of a man who has nothing to lose because he has chosen not to play the game. He bites on negativity like a bone, twisting it this way and that until it emerges into the sick dawn of enlightenment.

Besides black humour, *Open City* also gave Hank the opportunity to indulge his misogynistic feelings. 'Women are basically stupid animals,' he would write, 'but they concentrate so much and entirely upon the male that they often defeat him while he's thinking of other things.' He got away with comments like these because they were delivered in a heartfelt manner rather than a gratuitously offensive one, and sandwiched in between rib-splitting scenarios featuring his 'bad lad' antics.

The columns, outrageous as they were, largely appealed to the hippies, but Hank had spent too many years in a tortuous white-collar post to throw his lot in with the flower children, whom he regarded with as much contempt as he did other effete poets of his ken. When in Rome, his philosophy went, do as the *Greeks*. For Hank these were smoked salmon socialists, the left luggage of a movement that might have originated with legitimate motives, but fast deteriorated into a self-serving attempt to demonstrate that soft drugs led not only to camaraderie but also literary greatness. The reality for Hank was that these twits weren't so much in love with art or solidarity so much as their own solipsism, their adrenalised meanderings disappearing up their own asses in a welter of misplaced enthusiasm. The egos had landed, in other words. But they couldn't realise how much shit they were swimming in until they blew the dope out of their eyes.

He was also turned off by their bumper sticker snippets. 'Make love not war.' 'Buck the system.' 'Don't trust anyone over thirty.' They all sounded neat until you examined them. Maybe war was *necessary* sometimes. And were they really bucking the system by sitting round on beanbags going, 'Groovy, baby'? As regards trusting anyone over thirty, Hank knew that honesty didn't have anything to do with a birth certificate. Neither was a man who worked in a post office necessarily any more traditional than a pot-smoking drop-out. Sometimes you could buck the system better from inside it — at *any* age.

While they dug his style of writing, the hippies found it difficult to reconcile it with his mode of dress or behaviour, or, indeed, the right-wing, redneck quips he dredged up to annoy them. In their eyes he wrote like Lenny Bruce but *looked* like J Edgar Hoover. (Harold Norse described him as dressing in the kind of clothes ex-convicts wore after being released from prison.)

They were as surprised by Hank's strait-laced appearance as were the postal authorities when they called him in to discuss his subversive writings. They expected a hairy bard in scruffy jeans, not this straight-back-and-sides civil servant. But Hank didn't apologise. He knew he was writing authentically, unlike those posey propagandists with their cheesy causes. He also suspected that within a few years many of the marijuana-smoking pretty boys would be pillars of the establishment they now impugned against as though their lives depended on it.

He didn't want to hold hands with anyone like the Beatles, or go to Frisco with flowers in his hair. Still less did the image of a creeping Jesus figure with a florid shirt and jewellery dripping down to his navel appeal to him. He refused to compare mythologies with all those louche hipsters who proliferated at the fashionable coffee houses, or break bread with the tribalistic baby boomers still wet from their mother's milk as they yammered on about the evils of fascism from the bonnet of Dad's E-Type Jag. He would allow such showmen their day in the sun as he plodded homeward in his

distinctly ungroovy mail sorter's shoes to commune with the page. Even James Dean's frenetic 'You don't *understand* me!' from *Rebel Without a Cause* rankled with him. Was this suburban jerk off supposed to typify angst? Try *acne vulgaris* on Longwood Avenue, Jimmy — or a father who incinerated live mice. Dean grew up in an era when the winds of change were blowing, but Hank's formative years were the roaring twenties — with most of the roaring being done by his parents. The 'swinging' sixties had also passed him by. (The only thing that swung for Hank in this hysterically overrated decade was his beer arm.)

Hank's decided lack of cool was a new kind of hip for the self-styled Trotskyites who wrote for the Beat mags. They looked on him with a mixture of awe and incredulity — reactions he took with a grain of something white and crystalline. For this grinder, street cred also meant work cred.

He found it difficult to respect anyone who didn't hold down a day job, feeling such drudgery allowed writers the mandate to whine. He had no time for those poets who were born with silver spoons in their mouths, who courted sponsors to compensate for their lack of ability. That was what he admired about Neal Cassady. Like Blazek he had a 'straight' job.

Cassady was out of his mind with speed when he met Hank. Shortly afterwards he showed his wildness vis-à-vis another kind of speed when he took Hank on a white-knuckle ride in his car. Hank was so drunk he didn't sweat but a few weeks later Cassady was dead — 'deliberately, perhaps' according to Hank. He gave him this dubious tribute: 'he was almost as crazy as I am'. His main problem, he felt, was the fact that he lived in the shadow of Jack Kerouac.

Another writer who died around this time was William Wantling, not long after reading a denunciation of his work by Hank. Wantling's Widow Ruthie remained very bitter with Hank after her husband died, especially when he made a pass at her. When Al Winans asked Hank to do a foreword for a posthumous collection of Wantling's poetry she let it be known this wasn't on and Winans abided by her wishes.

Wantling's personality had always been flaky and even though he was a serious substance abuser, Hank's pejorative comments about him, as far as Ruthie was concerned, could have tipped him over the edge. (Hank also propositioned John Bryan's wife around this time.)

His *Open City* columns eventually came to the light of the post office authorities and they called him in for what was euphemistically called a 'consultation'. They presented him with a drawing of a penis on legs which had been used to illustrate a story he wrote about a man who had anal sex with another man by mistake, being too drunk to realise he wasn't a woman. Hank admitted — or rather boasted — that he had indeed written the story, and not only that but it was true and referred to himself.

He wasn't responsible for the illustration, however. After some aspersions were cast upon the nature of the material, he asked, 'Are we to consider the postal officials as the new critics of literature?' When they replied that certain moral standards were expected of public workers like himself, he retaliated by telling them they were threatening his freedom of expression in a manner that might interest the American Civil Liberties Union. They backed off at this and Hank returned to his desk, the hero of the hour. Once again the Frozen Man had had the last word.

He never saw what he was doing as obscene. The only truly obscene thing for Hank was poor writing. Why didn't people lose their jobs for this? His basic thesis was that there was nothing you *couldn't* write literature about. Nobody had the right to say

what could or couldn't be poetic — least of all the clean fingernail brigade.

He knew a lot of his stuff was 'dirty', but when he wrote for the pornography magazines he gave them more than the usual bump-and-grind gratuitousness, generally trying to graft a storyline, and/or some wry reflections on life onto the boudoir frolics. Even at the basic level, he never tried to sell sex as a fantasy, portraying it more as a natural bodily function: maybe like gorging out on food. He didn't pull the wool over readers' eyes anymore than Hank the loverboy did over his concubines. He never wanted to be erotic like a Lawrence or an Anaïs Nin. He wanted to steer away from the ineffectuality he saw in such writers and towards hard living.

Hard living also meant hard loving. What he spared us was the patina of respectability writers often put over sex. Not for him the shimmering curtains or fiery hearths. He would leave that to the soppy romantics. Which isn't to say he admired Hustler and the rest. Apart from his difficulty in getting money out of them (his pay cheques were often late — or non-existent) he generally reviled sex writing. Much of it, he felt, was imitative of his own work, and when it wasn't that it seemed to spend its time hitting the reader over the head with some message about personal fulfilment. He didn't see it either as taboo or holy grail. It was just there, like the Golden Gate Bridge or the Statue of Liberty. It was tragic because it generally lasted longer than love (or what passed for love) and funny because of the fact that people's needs often got them into ridiculous situations because of it. Hank probably succeeded better in capturing the latter than the former.

The officials were disturbed not only by the Dirty Old Man business, but also the fact that he wasn't married to the mother of his child. That Hank came to the attention of the authorities for his writing meant that they now looked on his absenteeism as fabricated. He hadn't been sick — he had been buying time to write. Also, considering he advertised his drinking habits in much of what he wrote, alcohol poisoning was another possible reason for his absence from the desk, and for his unpunctuality. Whichever way you sliced it, he was now a marked man, his secret finally out in the open.

He knew he'd painted himself into a corner. They couldn't do anything about his drinking or carousing because this wasn't in the public domain, but writing was different. It impinged on his work life by default, as it were. It was like the old definition of writing; a self-invasion of privacy.

It was always going to be a toss-up whether Hank resigned from the post office or was fired, or whether his writing career came to a full stop before he was discovered. If it had, the early work would probably have been seen by posterity as little more than the frantic scribblings of a self-consciously downmarket poser, just one of a legion of bohemians trying to make his mark but lacking an individual voice. It was his stubbornness to keep going that saved him. He continued putting down 'the word' even when it was going nowhere, writing as much to get his feelings out of himself as to have them broadcast to the world.

Writing was his therapy against the fragmented shards of a callous existence rather than a gateway to fame. If that came, it would be an added bonus but until such a time he would continue blackening pages with every idea that flooded through his wired head. His work was more diary than literature, but it was irrevocably himself. It formed part of a jigsaw we're still seeing today: the frayed map of the human heart.

The Most Beautiful Woman in Town was published by City Lights Books in 1967, featuring many stories Hank wrote for various magazines over the years. They have a casual, throwaway style, bringing you into the thick of the action as soon as they begin

in the hard-boiled manner that Hank shared with the likes of Dashiell Hammett, Raymond Chandler, James M Cain and others. The characters are somewhat one-dimensional and the plots wafer-thin, but few writers explored the seedy underbelly of LA and its environs with such fractious outspokenness.

He also evinced the happy knack of making the ridiculous somehow plausible, as in 'Six Inches' where he deals with the male phobia of emasculation in a literal rather than metaphorical manner. Other stories such as 'The Fuck Machine' leave one in little doubt about their contents, whereas '3 Women' is gloriously decadent in its depiction of a menage-à-trois set against the backdrop of boozing, poverty, unemployment suicide and, er, bad clocks. 'The Birth, Life and Death of an Underground Newspaper' concerns Hank's work in Open City and the problems it created with the post office officials, while 'Life and Death in the Charity Ward' deals with his near-death experience in 1955 — leavened, needless to say, with his trademark humour. The most controversial story, however, was 'The Fiend', which to many read like an endorsement of paedophilia. It's undoubtedly Hank's most objectionable printed work and garnered a predictable degree of outrage when published. Neither did he help matters when he admitted he had harboured fantasies of raping young children himself.

Also published that year was Tales of Ordinary Madness, a collection of stories that had originally appeared in magazines like Knight, Pix, Nola Express and Open City. The tone is sassy and succinct, the internal monologues heady and adrenalised and the voice unmistakeably that of Bukowski. Some of the material is autobiographical, some of it delightfully decadent and most of it downright irreverent as he raises the ostensibly banal to the level of hilarity by the sheer force of the writing. Much of it preached to the already converted, being refreshingly free from any convention you cared to mention as Hank cut a swathe through the accepted order of things, again playing the hard-living misanthrope who liked rough-house both in and out of the sack, making one wonder if this was really ordinary madness or rather extraordinary sanity.

An uneasy mix of narrative and manifesto, it has Hank unabashedly embracing all his pet themes: booze, jail, the track, politics, and poets... as well as some slightly more unusual ones like clogged toilets, cliché-ridden pests and surreal blankets. The sex scenes, as one might have expected, make Last Tango in Paris look like Mary Poppins. Other than that, we may either read the pieces as the demented ramblings of an iconoclastic fool or inspirational nuggets from a prophet — depending on where we're coming from. Whatever way we look at it, the feverish intensity of the writing represents an unaccommodated man at the end of his tether but refusing to cave in, kept going both by humour and curiosity as he slouches through his days. More bemused by his lot than tortured by it, he takes some solace from the fact that no matter how badly off he is, he can still detect shit in others — and maybe even pull a chick or two.

There's agony here, but also a what-the-hell attitude that makes it somehow palatable. He filters his suffering into the stuff of high farce, refusing to become solemn about it. It's like Kafka written by Mickey Spillane, a loopy onslaught on inner city slimeballs. Rotgut beer and raw sex keeps the tubes flowing as this latter-day Proust runs the country from the bunker, dredging up sick fantasies as he finds himself confronting a beautifully profane existence.

Notes of a Dirty Old Man, a compilation of all his Open City columns meshed together in a tenuous unity, was also published by City Lights Books, and if it didn't cause quite as much consternation as the columns that was only because Hank, by now, had become something of a mini-legend for the underground.

His comments on sex, as one might have expected, were too hilarious to offend. 'It's interesting but not important,' he speculated. 'I mean, it's not even as important physically as excretion. A man can go seventy years without a piece of ass, but he can die in a week without a bowel movement.' He wrote about sex as a 'stage play laugh,' he said, 'where you have to cry about it a bit between acts'. Boccaccio was his model, but he couldn't do it as well as that author because he didn't have his detachment. The man-woman thing, he conceded, 'even confuses the great Bukowski'.

The collection also contains such contentious aphorisms as: 'there is nothing as boring as the truth', 'the well balanced individual is insane' and 'almost everybody is born a genius and buried an idiot'. Hospitals, he added, were places where they attempted to kill you without explaining why. And before a metropolitan daily exposed an evil, it took its own pulse.

The experience with Barbara Frye was even mentioned. Hank confessed that he proposed marriage to her out of pity one night when he was drunk and then promptly forgot about it, not realising that she would take him seriously. When she did, however, he decided to go through with his promise, even though he had never met the woman. When he did, he found out she was a tiger in bed.

After the relationship faltered he said he had few regrets about kissing goodbye to her millions. All he had to show for his time with her was a 1957 Plymouth convertible which she donated to him. It seemed an apt coda to the whole laughable interlude.

At Terror Street and Agony Way, published in 1968, is a book that very nearly didn't make it, consisting of poems Hank brought round to his friend John Thomas one night. Thomas accidentally put them out with the garbage but luckily for posterity they had also been narrated onto one of his tapes and thus preserved. A mixture of frivolity, rumination and quietly-evoked angst, the book copperfastened Hank's reputation among the growing ranks of those who felt the former renegade deserved a break. It was published by John Martin, which caused Hank to apologise to Jon Webb for not offering it to him, but he couldn't afford to live on Webb's lean rations anymore. Black Sparrow Press was his first taste of 'real' money and he had to go with that. At eighty-nine pages, it was Hank's lengthiest work to date, Martin running off eight-hundred softback copies and seventy-five hardback.

In 1963 he'd promised Webb he would stay with him regardless of whatever other publishers offered him, but he was forced to renege on that promise after Black Sparrow took him on. Hank was always grateful for the fact that Webb published him at a time when things were so bad he could hardly get arrested — if that's not an inappropriate way of putting it for this man.

What he didn't like about Webb was the way he put on the poor mouth even as he was gambling away large sums in Vegas. Hank was also somewhat jealous that Webb had published a book by Henry Miller, *Order and Chaos chez Hans Reichel*. (The relationship reached its nadir when Hank wrote a derogatory piece on him that Webb got wind of.)

Hank also illustrated books for Martin (as did Martin's wife Barbara), having as much a facility for Thurberesque sketches as quirky poems. He looked on this as easy money. They weren't exactly Picasso, but in time they became collector's items. He threw away many he had done before he became famous, just as he had thrown away many poems that came back from the 'littles'. (The mind boggles as to what such material might fetch today).

Towards the end of the book we get another replay of his childhood traumas. Unwanted from the get-go (the term 'love child' was hardly applicable in this context)

he was always going to bear the brunt of his father's anger with himself and the fact that his mother lacked the bottle to stand up to Henry's rough justice only compounded the issue. What was surprising was the fact that Hank carried no resentment about them with him. Put simply, he didn't care enough about either of them to hate them.

Maybe that was why he didn't cry as he was being beaten all those times, making his father believe he had a screw loose somewhere. He could never understand how his father got so worked up about the grass, or about his failure to make it. He could never understand how anyone got worked up about anything, period. As Bob Dylan said, it was life and life only. When he got into brawls with schoolmates or, in later life, barflies, he threw punches not out of anger but because he felt it was expected of him. He would just as soon have let any slights go. Facing down challenges was just another piece of role-playing for him.

The first serious study of his work appeared in 1969. Written by Hugh Fox and published by Abyss, it had a print run of only 300 copies. The style was arresting and Fox obviously knew (and liked) his Bukowski, but there was too much padding and repetition. He also drew overmuch on quotations from Hank's work, making the book look more like a reader's guide to his oeuvre than anything more insightful. He makes his point about Hank being the lonely hobo poet fascinated by death, darkness and decay in the book's first quarter and then insists on making it again and again in a myriad of only slightly varying ways. Hank also comes across as something of a moaner in the book, but it's an interesting read all the same — even if only to remind us how deeply surreal the early poems were. The later work, by contrast, reads almost like so many diaries.

Also in 1969 Hank launched the magazine *Laugh Literary and Man the Humping Guns* with Neeli Cherkovski. His main ambition here was to raise the hackles of the establishment. It was published by the aptly-named Hatchetman Press.

Hank and Cherkovski wrote some of the material under fictitious names, feeling their worst was better than some of the other contributors' best. The magazine ran for only three issues and had just one subscriber... who subsequently withdrew his sub.

Not content merely to return unsuitable MSS to hopeful scribes, he instead poured beer on their submissions, and/or dipped them in eggs. Some he even set alight. Or else he sent rejection slips with four-lettered words plastered all over them. Some submissions he even threw up over — or baked! In previous years he had worked so hard to get accepted he could never countenance sloppy prose from others, which made him almost as harsh an editor as some of those who trashed his own work in the fifties and sixties. Maybe this was his revenge on such a breed. The poacher had become a gamekeeper. It was like a retread of his experience at the helm of *Harlequin* all those years before.

Sometimes he got drawn into correspondence with authors he rejected, but this usually ended in bitterness. He finally learned that you couldn't be a gentleman editor, couldn't let bad writers down gently. The boil had to be lanced coolly and cleanly and without any apologetic overtones. That only brought the crazies round to his door.

The magazine served as a convenient conduit through which he could denounce his pet hates (like Robert Creeley) and publish various authors who meant something to him: Douglas Blazek, Harold Norse and a former Californian law student called Steve Richmond.

Richmond idolised Hank. In 1966 he'd printed a poetry broadsheet featuring some of

his work. The words 'Fuck Hate' were printed on the cover, which led to a police enquiry into the 'obscene' nature of the material inside. Richmond was arrested and imprisoned and litigation concerning the magazine's contents went on for years afterwards.

1969 was also notable for the German translation of *Notes of A Dirty Old Man* engineered by Carl Weissner, who did for Hank's reputation on the continent what John Martin was doing in the States. With Weissner Hank 'crawled back to the Fatherland' in unlikely fashion to begin a much overdue repatriation.

Hank was even featured in a Penguin anthology of poetry that year alongside Norse and Philip Lamantia. Norse had been offered a volume of his own by Penguin editor Nikos Stangos but he nominated Hank and Lamantia as two talents who would provide more resounding back-up. It was a magnanimous gesture and also made sound business sense. As well as clocking up impressive sales, the book gave Hank a good platform to reach a wider readership, even if he didn't have star billing as yet. He was grateful to 'Prince Hal' (as he nicknamed Norse) for the gesture, expecting it to pave the way for bigger opportunities — which, of course, it did. As he approached his fiftieth year, the world was finally sitting up and taking notice of the disaffected scribe.

Martin read all of these outpourings with interest, being amused by Hank's controversiality. Hank rang him occasionally at the dead of night and told him the post office was killing him and Martin sympathised. They became friends from a distance, as it were, neither of them living in each other's pockets but with a mutual respect born of being polar opposites. Hank didn't tell Martin how to publish and Martin didn't tell Hank how to live or write. Having said that, he reserved the right to reject what he didn't like, knowing there was more than enough of what he did like to keep both of them going.

He knew Hank sometimes tried to cure a possible block by overwriting. At such times excision was necessary. Sometimes you had to flush out the detritus to get at the quality material that lay buried underneath it.

Late in the year he cobbled together a plethora of Hank's past work from various sources and called it *The Days Run Away Like Wild Horses Over the Hills*. This book contains some of his purest poetry, even if he hasn't yet found the voice that will be forever associated with him. In a sense it's richer for it because it allows him to exhibit a more eclectic *mélange* of imagery and lyrical richness. There's a plaintiveness always hinted at between the lines but this is largely the rhetoric of suggestibility rather than statement as he piles image upon image in a quirkily fascinating confection. He dedicated it to Jane and it represents the culmination of a body of work stretching over most of his poetic past. Having said that, the versification is often abstruse and there's not a lot of human interest here. If he had continued writing in this vein, one doubts he would have found such a huge following for the anti-literary edge that was to follow. There's no one style or theme and the mood ranges from idyllic to ominous, promising much for the future.

Not long after its publication. Martin decided to approach Hank with a proposal no editor of his past had ever suggested before, nor ever looked likely to suggest.

Martin caught Hank's heart in his hands, making him an offer he couldn't refuse. It was a gamble to end the decade on, and one to finally get him a life.

The Iceman Cometh

> It was good to be old. It
> was reasonable that a
> man had to be at least
> fifty years old before he
> could write with anything
> like clarity.
> *'Women'*

The post office authorities made Hank's life even more miserable than it usually was after the *Open City* column became public knowledge and by the late sixties they were getting ready to suspend him for his repeated absenteeism. He wasn't making enough money from his writing to afford to be able to leave the day job, what with child support and his expensive drinking habits. He was well known for his contributions to prestigious

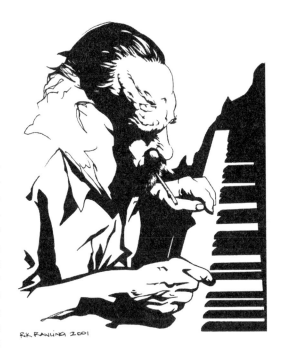

RIK RAWLING 2001

literary magazines; but was not yet a household name. He had attained what Graham Greene once referred to as 'the exclusiveness of unsuccess'. Or as Lydia says to him in *Women*: 'You're the most unknown famous man I ever met'.

In the post office, as in school, he played the role of the noble savage, the quietly simmering idiot in the corner who could be unpredictable if roused.

His co-workers revered him for standing up to the authorities because they themselves didn't have the gumption to do so. Some of them had fallen in love with their chains. But Hank carried an aura of danger about him despite — or maybe because of — his quietness. The unspoken rule seemed to be: don't mess with Bukowski or you'll get your fingers burned. But left to his own devices he was almost docile.

He made no attempt to show interest in the job or to try and get motivated by it. He did it because he had to, pure and simple, using the same rhythm and the same method every day. Varying his routine might have made it more interesting but he wouldn't give it this credit. Communicating with his colleagues might also have helped but he didn't wish to do that either. He didn't even want to realise he was in the building or at his desk. If they were going to treat him as a vegetable he would behave as one. He wasn't resentful about this, or aggressive. Once again he was the Frozen

Man. Hard Hank, the man who wouldn't cross you if you didn't cross him. He did his quota, put envelopes into boxes and then went home. If he didn't drink too much that night he would come back the next day and repeat the performance. But he couldn't go on like this forever. For how much longer could his body take the battering he was giving it?

His ideal would have been a part-time job to keep the wolf from the door, because his needs were never more than subsistence ones, but he gravitated from 'the row' to a job that had a grinding, relentless routine to it. The post office not only played havoc with his health but his head as well. It stole both his writing time and any vestiges of self-respect the white-collar part of him might otherwise have been vouchsafed by giving himself up into the arms of the establishment. He once said to a colleague that he would like to have been able to work just as many hours as would meet his needs. The colleague, who must have known him better than he knew himself, replied, 'It wouldn't work for you. You'd starve to death.'

But one day John Martin, who'd grown even more fascinated with Hank's writing since their first rendezvous in 1965, met him at the house of poet John Thomas to put a proposal to him. 'I might be able to get you out of your job,' he said. Hank asked him what he meant. 'I'm willing to offer you a monthly stipend if you do nothing but write,' Martin told him. Hank's eyes widened. 'How much?' he asked.

'How much can you survive on?' Martin countered. Whereupon Hank hunched his shoulders and put his hands out. Getting paid for writing, he said, was like getting paid for sex. This was as good as it got.

He couldn't do the eight-to-five anymore. Even if he wasn't a writer he couldn't do it. Even if there was nothing else he had to get out.

He knew all too well that nobody ever said on their deathbed, 'I should have spent more time at the office'. If he fell on his face he could well end up back there, but he could live with that too. He'd spent long enough taking orders from men with IQs somewhere below room temperature: it was time to make a break for the border. His decision was also motivated by the fact that he knew the post office officials were circling the wagons. Their patience was at an end and they were getting ready to give him the sack — and not one that contained letters either.

Martin made some space for the two of them at a crowded coffee table and together they did their sums. He would need fifteen dollars a month for child support, thirty for rent and about fifty for food, drink and extras. That worked out at $100 in round figures. It would put Martin to the pin of his collar to pay it, and Hank to live on it, but it sounded like a fair deal.

After all the years of trying, the mountain had come to Muhammad, an angel settling on his shoulder and offering to answer all his dreams, albeit mutedly. So he decided to make a leap of faith. 'I'll do it,' he said, and they shook hands. Which of them could have known that day that they were shaking on an arrangement that would one day run into millions of dollars in almost a dozen countries? They were gambling on literature as Hank and Jane had once gambled on horses or drink.

What Martin offered him wasn't so much a comfort zone as a breathing space, a window of opportunity.

He was about to come out of the hole, to leave the cul-de-sac for the main highway. After all those years in the long grass, recognition suddenly seemed tantalisingly close. The miracle had run up his arm, as he put it in one of his stories, like a crazy mouse. After years of sending messages in bottles to uncertain destinations, one of

them had finally become washed up on the shore. This was the real deal.

No longer would he have to die from doing the other man's thing. The bird had come out of the cage, though for however long was anyone's guess.

He wrote about his feelings in 'the twelve hour night' in *What Matters Most Is How Well You Walk Through The Fire*. It was cowardice, he reveals here, that kept him tied to his routines for so many years, but one day he decided to fight the fear, to snatch at life even as people told him he was insane. It wasn't so much a thirst for adventure that caused him to go as panic.

Which was, indeed, the way it was for him when he first left home. Now history was repeating itself thirty years down the line. Except now he had more to lose. It wasn't like the old days where he could chuck in a labour job on Friday and be in another one the next Monday morning. No matter how terrible those jobs were, at least they were available to him. They wouldn't be now, however. His fifty-year-old bones were creaking. Also, there were all those benefits to be considered. Could he afford to throw them all away in one fell swoop? On the other hand, could anything be worse than where he was?

He had trawled his wares long enough in the B-league. Anyone pushing fifty owed it to himself to grab at a chance for change, however slim it may have looked. 'For an old guy you've got some guts,' a colleague said to him on his last day at the post office. Maybe desperation would have been a more fitting term...

By now he had lost the urge to save his co-workers. Most of them weren't worth it. Maybe they wouldn't recognise liberation even if it jumped up and bit them on the nose.

We can't conceive what Martin's offer must have done to Hank. To realise at the age of forty-nine that he would never have to work again if he wrote well enough was like a miracle to him. But it also filled him with terror. For the first time in his life somebody was putting it up to him. After years of iffy offers, here was one cast in stone. It was the moment of truth for him, the crossing of the Rubicon. Did he have enough self-belief to take it or would he keep his options open?

Martin took him on, he said, because he was read by 'so many whores taxi drivers sex freaks circus barkers and Fuller Brush salesmen.' It was hardly the traditional market for poetry. He also offered him his subvention even in months where he couldn't produce work for one reason or another. The effect this had wasn't to make Hank ease off, but rather push him further now that he had a safety net.

Martin admired Hank's pared-down style. He also liked the way he dealt with the daily frustrations we all have, without any verbal ostentatiousness. His sprawling, bardic tone reminded him of Walt Whitman, who was also regarded as a ne'er-do-well in his day, but came to be seen as a luminary with the passage of time.

Would the same happen with Bukowski? Who knew. But Martin felt it should. He thought Hank was a genius, and made it his business to transmit this view to the world, even shipping his books by hand in the early days to deal with orders. He built up the Bukowski empire by sweat and planning, in time becoming as identified with his prize author as Rogers would be with Hammerstein, or Lerner with Lowe. Sales of the books would outstrip both men's wildest expectations and give Hank the financial security he never thought would come his way.

Martin did unpaid extra work like contacting the libraries, working on archive material and keeping the business ticking over in general. More than anything else, he believed in Hank from the start.

Hank once told Stephen Kessler that he would probably have been 'dead or mad' without Black Sparrow Press. It came along at a time of his life when he was getting ready to give up the ghost. He had struggled against feelings of frustration, but Lady Luck kept dealing him crap cards. This was different, however. Could it be the start of something? He didn't know: he'd been upended too many times before. Hank repaid Martin's faith in him by staying with Black Sparrow even after he became a world figure, when larger publishers tried to poach him with flashing juicy cheques.

Where were they, he wondered, when he was vomiting blood from the gutter? Where were they when the landlord knocked and he had nothing to give? When he was hungry, did they give him to eat? When he was thirsty, did they give him to drink? They hardly wanted him for himself, he knew. They added him to their lists out of a kind of vague tokenism: the down-on-his-luck tramp who made it. But he wouldn't come running when they snapped their fingers.

He was also well pleased at the *timing* of his discovery. Most writers, he felt, made it too early and suffered the consequences, finding themselves unable to last the pace. They were sprinters, but he saw himself as a marathon man: he was in for the long haul. Like a woman who'd always deemed herself a spinster and then got married late in life, he was more determined than ever to make a go of things. If one of his books bombed he took it on the chin because there were so many others bringing up the rear. He was like a writing machine, the total antithesis of Hemingway, who edited almost to the point of contrivance. Hank would have no truck with this form of craftsmanship. He preferred to let the cracks show, to let the reader see it as it happened. If his face was pockmarked, so would his work be. Its beauty, if it had any at all, would be that of an unploughed field, an eroded cliff face.

Financial hardship was the price of freedom but it was a price he was more than willing to pay. He had never been well-off, but now every cent would be even more earmarked than it had been before. He would mildly chide Martin in letters over extra money he felt was due to him but he trusted him implicitly, knowing Martin had gone out on a limb for him, as well as taking abuse from other authors and publishers for allegedly overusing him. The latter emphasis is uppermost in the letters. He tells Martin everything he had for breakfast, as it were, sharing every negligible thought and emotion with him like a blood brother. Other publishers may have given him to pockets of America, but Martin made him mega. It was the classic meeting of the man and the moment. Some men, they say, are born great, some achieve greatness and some have greatness thrust upon them. It was a little of all three with the Bukowski / Martin cartel. From day one, they never really looked back.

Martin didn't become involved with Hank's life any more than, say, Tom Parker did with Elvis Presley's. Each of them had their show to run, and each had obligations. Hank produced the work and Martin packaged it professionally and saw that it reached an audience. What they did apart from that was beside the point. There was a mutual respect but they didn't hang out together. And this was probably why their relationship kept so healthy for so long. Hank tended to turn on people he drank with sooner or later, which could have spelt disaster for their arrangement. If Hank's women left him when they finally realised that the man wasn't as good as the poems — as he often confessed — this could also have been the case with Martin. He preferred Hank from the safe distance of the page. Even at this level, he could almost see the steam rising. Imagine what it would have been like if he had Hank camped at his doorstep, having been thrown out of his apartment by one of his lady friends, or having to face him first

thing in the morning when his mouth felt like the inside of an ash tray?

So who lucked out: Martin or Hank? We might as well ask how long is a piece of string. If John Martin didn't exist, Hank would probably have kept writing and he may have become equally big with another publisher, but it's unlikely. Martin ran a slick operation and was a canny marketer of his merchandise. Hank was a good ball player but he needed somebody to run *with* the ball if he wasn't going to end up being a mute Homer, an icon on the underground circuit but a writer perpetually on the fringes of fame.

He always felt he would do his best writing after the age of fifty, as if there was a genie inside him that was gestating all those years but couldn't quite get out due to the residue of toxic elements in his life. One day he believed it would burst forth like a seasoned wine, in a book the rest of his life had been a preparation for.

Hank allowed Martin a lot of editorial control over his work, making him into something of a Svengali. He was never precious about the deletion of passages or even whole poems, possibly because he wrote so prolifically.

He wasn't the type of writer to crawl round his floor at 3AM looking for a word that rhymed with 'orange'. He didn't believe in revision too much, feeling it detracted from the spontaneity. How it came out was how it was, for better or worse.

He rewarded Martin's enthusiasm by trusting him to the nth degree as regards where his career would go from here. This was understandable considering there hadn't *been* much of a career until now. His writing, like his personality, was all over the place. He knew he needed to be taken under somebody's wing to get his life out of the pit into which it had sunk, and this sparrow would do nicely for the time being.

Hank left the post office for good, literally, on 2 January 1970. It was the second day of a new decade and the first of a new life. He was flying blind in one sense, and it was somewhat late for a job gamble, but he still felt good about his decision. He had escaped what he called 'the yellow men with bad breath and big feet', i.e. those supervisors who had done their best to break his spirit over the years — not with a razor strop but rather the viciousness of their tongues. He had outlasted them and now it was time to look ahead. He said he felt like Jesus coming down off the cross.

The move to Black Sparrow didn't totally result in a rags-to-riches fairytale for him. He was existing on subsistence rations for a long time after leaving the post office, and sometimes even wondered if he'd made the right move. Whatever else about the post office, Hank didn't drink there. Being jobless also meant he would have no respite from his own mind all day. Could Old Stoneface hack this or would he succumb to subterranean homesick blues... again?

The post office robbed him of writing time on the one hand, but on the other it gave him some of the seeds of his inspiration. No matter how talented a writer was, he could do little if he never left his house. (Unless, perhaps, he was a Marcel Proust or a Beckett.) Hank knew this too, which was why he left home in the first instance. He couldn't have written *Factotum* without experiencing all those brutalising jobs, nor *Post Office* without working there. In the same way as going to the track fertilised his mind for the night's work at the typer, the activity of turning up at a preordained venue and participating in the ordinary events of any day — even if one had no respect for those events — was working subconsciously on his mind.

Left to mooch around without any routines, he worried that his source of inspiration might dry up, as it had appeared to do sometimes when he went on unpaid leave. The converse, however, was happily the case, all of his extra time affording him the oppor-

tunity to churn out an inordinate amount of material, which meant Martin was spoiled for choice as he sifted through it looking for the gold dust.

Free time also gave him extra opportunities to indulge in booze, but that wasn't the way it worked. He certainly didn't drink less after he gave up the day job, but he didn't drink more either. And he didn't drink out of desperation any more.

Spirits made him aggressive so he tried to stick to beer. They also blunted his creative drive, making him drunk too fast, which made the writing look for its effects too easily. It was like premature ejaculation. Beer gave him more possibilities of foreplay.

With or without the drink, however, he was aware that he would have to extend his repertoire now that he was, as it were, marketing his wares for a living.

To survive, he knew he would have to go back to writing prose as well as poetry, for the bigger readership. It wasn't a prospect he relished, but he liked the image of himself as somebody who could write in any form. Versatility was the hallmark of the pro and Buk was unlikely to falter on this score.

He had always claimed he preferred writing poetry because he could do it no matter what kind of mood he was in. Prose was different: he had to feel good to write that. (We can probably infer from this that prose took more out of him, which is the converse of the way it is for most poets.) His return path to prose had, of course, been smoothed by the *Open City* columns.

The first week after he left the post office he did nothing but lounge around. This was necessary. When before did he ever have the luxury of goofing off and still knowing he had a cheque coming to him? But if he did it for longer than that it might have been dangerous. There was, after all, a career waiting...

When Martin asked him if he had any novels he told him that he hadn't, but that he could write one. Just like that.

He seated himself at the window facing the street, placed a bottle of whiskey beside him and started typing. Nineteen days later his premature baby was born.

He wrote from 2:30PM until midnight every day, synopsising fifteen years of madness into twenty days. The name he chose for the book was the only thing about it that wasn't original: *Post Office*. It would prove to be a huge seller and put his name on the literary map for keeps. He dedicated it, perhaps fittingly, to 'nobody'. A sort of autobiography from a lovably crazy old coot, it contained in miniature many of the themes he would finesse in later writings. It would also introduce Henry Chinaski to the literary world.

For the diehard Bukowski devotees who had gobbled up everything he wrote from the chapbook days, a novel was something of a compromise. Would he reject poetry like William Corrington had done once the royalties started to pour in? They need hardly have worried.

The novel doesn't so much show contempt for the idea of genre and form as a profound disregard for it, locating itself somewhere between *noir* ruminations and slapstick burlesque. It doesn't fall into any category because it was written by a man who refused to consider what he was doing. A jagged diary of anecdotal mirth interspersed with bouts of agony, you never know what you'll find on a given page. If it's a Marxist document, we would be entitled to enquire if that signifies Karl or Groucho.

Structurally speaking it's everywhere and nowhere. One would feel stupid discussing it in the traditional terms of plot and character because Hank simply never thought in those terms. Thankfully. In this sense it's an *un*-book. (He would have liked Flann O'Brien's *At-Swim Two Birds*, a novel in which the characters rebel against the author).

Post Office is written in the kind of short snappy sentences (and chapters) Hank so admired in John Fante. As well as giving us a gruelling account of his work life, it also has the humour of his hellraising, his love life, his search for a ticket to Easy Street. Betty is based on Jane, Joyce on Barbara, Faye on Frances and Marina is herself. We get anecdotal snippets piled on one another as Hank negotiates his tenuous path through the post office drill and then gets himself in above his head with the ladies before emerging relatively unscathed at the end, taking what life throws at him in as cavalier a fashion as he can muster.

The naturalness that was his signature tune flows from the writing, creating humour from what would have been dark *tableaux* in another writer's hands, which is probably what made the book such a huge success. Few ground down, white-collar men with high sex drives and a healthy sense of the absurd could fail to empathise with it.

From a personal point of view, it was the first time he could write about his daily grind without recrimination, or the threat of a visit from one of his superiors requiring a private consultation. He had broken free from them now, for however long. It wasn't as if he had robbed a bank and skipped over the border to Mexico for there were still hard times ahead, and the perennial spectre of the debtor's prison, but for now he had a living wage and he would sing for his supper any way he knew how. The postal authorities hadn't broken his spirit any more than his father had, and they wouldn't be putting him up on the cross anymore.

Furthermore, in the irony of ironies, he was using their Gestapo tactics as the source material for the work that would put his name on the nation's stage for the first time. The money he received in royalties would be like backpay for the minuscule remuneration they had offered him right through the years of his toil.

Early on in the book Hank rapes a woman after delivering a letter to her, but only after she accuses him of being evil. Such a taunt he takes as a kind of perverse come-on, or maybe he just wants to expose her bullshit. Feminists see this segment as demonstrating the classic male fantasy, i.e. that women who evince prudish sentiments are often just 'asking for it' — the 'it' being sex. For Hank, or Chinaski, something much more perverse was afoot. The woman seems almost deranged, and he seems to rape her more from a power urge than a sexual one.

Feminists often claim that rape is rarely motivated by sex and almost always by a desire to control, so again the incident would fit their thesis. Why, then, do we not scream in horror when it takes place? Probably because it's written not in a tone of rage or vengefulness so much as comic absurdity. For this mailman has no agenda. He just humps his lady because he feels it will do them both good. It purges him of his lust and her of her sniffy attitude. Self-denial was definitely not the order of the day for this scenario.

'It began as a mistake' he writes in the first sentence, but such a mistake would last over a decade and also provide him with the fodder to launch various invectives against any kind of routine. The book captures his humane attitude to those who are even more mistreated than he as they carry out the impossible orders dished out to them. 'I'm not kissing ass; I'll quit or starve' is his own attitude, but it's only towards the end of the book he gets the courage to leave, and then only when his enemies are ganging up against him. In the interim he drinks, has sex, goes to the races and uses every ruse imaginable to spend as much time away from his desk as he can.

He carries his mail in the rain, gets threatened by dogs, observes the vagaries of those awaiting missives and finally becomes a 'regular', which is time for any maverick

to get worried. Afterwards there's the marriage to Joyce — negotiated with the same passion with which he might buy a pack of cigarettes — and a brief sojourn in her Texas home town. It had been picked by experts, he tells us, as 'the last town in the USA any enemy would attack with an atomic bomb — I could see why'.

He attacks it with his own bomb, however: that of his personality. Her father imagines he's after her money, which leads to a discussion of that four-lettered word called work, and suddenly the honeymoon is over, because Charles Bukowski never had the work ethic, and when his wife is a millionairess it makes the prospect even more ludicrous. He goes back to the post office and she becomes a clerk. The marriage rumbles on for a time before she sues for divorce, a decision he accepts with his customary sangfroid. ('All I had lost was three or four million.') Thereafter there's a brief dalliance with Jane but the magic is gone and shortly afterwards she takes her last trip to hospital. When he comes to visit her she utters the classic words, 'I knew it would be you'. She dies soon afterwards and there's a stark and moving funeral scene. Afterwards he picks himself up and it's back to the races, the bars and the women.

Chief among these is Fay, who's trivialised for her philanthropy. He mellows somewhat towards her when she gives birth to his beloved Marina ('Maybe she hadn't saved the world, but she had made a major improvement') but the relationship collapses, as all of his relationships seem destined to do, and she leaves him for her love-ins and her hippie dippy coffee houses, an ageing poster child of the flower power era he so despised. The final two sections of the book deal with his departure from the post office. He feels the lure of suicide but Marina gives him the will to go on. As he wrote in the poem 'the night I was going to die': 'I had a seven-year-old daughter/and I felt sure she didn't want me dead/otherwise it wouldn't have/mattered'.

In real life he also felt the lure of suicide, as already mentioned, but 1970 was a productive year for him all told. As well as finishing the book (it wouldn't be published until the following year) his German agent Carl Weissner — he would become a close friend in time — translated *Notes of a Dirty Old Man* for a whole new readership.

A couple of months later he boarded his first ever plane, travelling to Washington State to do a reading at Bellevue Community College. A jerky video of the event has survived, presenting us with a somewhat raw Bukowski — on his own admission. The atmosphere is muted, with nothing more raucous than giggles being emitted by the very attentive listeners during the feisty bits. Meanwhile Hank reads from a seated position, making little effort to create chemistry with them beyond shy smiles as he mispronounces something by accident or makes an occasional aside about Jane or Marina. Every now and then he sips something from a flask that's not iced tea, assuring one and all that if he's happy, they will be too. They seem to be as well, listening to him as if he's a high priest come to visit.

He has a captive audience here, and it's all eminently civilised, with nary a heckler in sight. The poems do his work for him and he's happy to let this be the case, quietly confident of his ability even though he's only barely setting out on a journey that will be the most sensational one of his life.

Even though he's just cutting his teeth on the 'live' poetry circuit, it's clear he's at home in such an ambience, even if he hasn't learned how to work an audience to its full potential yet. He was so nervous before the reading he threw up but such nerves don't show here. There are hints at his wildness from comments he makes about drink and women but the remark that lingers most in one's mind is when he announces that he could survive without women, but not without a typewriter.

Money was still tight for him, however. John Martin's monthly allowance was welcome, but any other money coming in was harmless. He had to scrimp to meet the money for Marina's upkeep and his own daily living expenses, drinking whatever was left over.

1970 was also the year he met Linda King, the woman with whom he would have the most explosive relationship of his life.

A former actress who now sculpted and wrote poetry, she was just out of a ten year marriage to an old-fashioned Italian and Hank, though two decades her senior, looked to be an antidote to that. The first time they met she did a dance for him and he was impressed. She then offered to sculpt his head. It sounded promising, but would this Salome one day prove too much for LA's sub-angelic John the Baptist?

They fell in love, in any case, over the clay. They also fought over it, it should be added, like cats and dogs. Each abused the other both physically and verbally in what came to seem like a sadomasochistic orgy of negative energy.

No matter how bad things became, however, they still couldn't keep their hands off each other.

The fights between them were almost worth it for the making up afterwards — for *both* of them. The energy each expended on such contretemps seemed to fuel them both with an almost sexual excitement, particularly if drink was involved, which it usually was. (Most of the sex scenes in his books seem to reprise this rough edge.)

She drove him stir-crazy with her unpredictability, as he did her with his. He had too many problems of his own to concern himself with her emotional upheavals so they continued to bounce off one another like electric currents, the arguments ending either in sex or fisticuffs or both. One day in 1971 she riled him so much he actually broke her nose in a tantrum.

Both were riven with contradictions they refused to address, or even acknowledge. Hank felt she set her male admirers off against one another in order to increase her sexual cachet, a form of game playing he reviled because it was so contrary to his own practice of taking what came when it came. Not for him the slick chat-up line or sleek overture.

Linda once accused him of turning her into an alcoholic. Hank said he never pushed a bottle onto her lips, but considering he himself was almost undressed without a drink, she would probably have needed the will-power of a monk to get through some nights with him without imbibing.

Hank was an unlikely lover for Linda, whose father had also been an alcoholic. She was leery of him on this account, and her nascent feminism was irked by his predilection for gratuitously sexist utterances. On the other hand, she was equally likely to have been bored by the politically correct type of man who would furnish her with any women's lib clichés extant at the time. In Hank she saw a challenge, an aura of danger that turned her on. She decided she wanted to tame him, if not quite reform the lovable rogue. For his own part he was attracted to her physically, as well he might have been. She was a beautiful woman, and he had been living a near-monastic life for four years now. She told him once, in fact, that he had missed the sixties altogether. As the old saying went, if you could remember them, you weren't there.

She also told him he was 'a dirty old man with a puritanical streak' The latter part of the barb referred to the fact that he wasn't prone to 'going down' on women, which was de rigueur for this lady if he wanted to keep her sweet. He did, so he learned quickly how best to pleasure her.

Hank called her his black widow spider, his praying mantis. He lived on the edge with her, and maybe part of him enjoyed that. She believed he cut himself off from the possibility of ever loving a woman because of the fear of being psychologically raped. Because his mother let him down, she accused, he felt all women were potential traitors and he tried to inure himself from the fear of being shafted by pretending he didn't care. (Maybe it all went back to that night at the Prom.)

He often said he never left women, even if he carried on in such a way that they were left with no recourse but to leave *him*. Walking out on them wasn't his style any more than walking out of a bar was. The only things he left were bad jobs and a bad home. His nature was to be a stayer — unless pushed to the extreme.

Hank disputed Linda's theories, accusing her of wanting to own not only his heart but his soul as well. And so it went on, she trying to break him down and he wondering what really made her tick. When they went out together she flirted with other men and he was driven crazy with jealousy. Every time they argued, which was a lot, the sculpted head was given back, and this version of artistic table tennis went on interminably. He called her a slut and she called him a pig and they fucked and drank and laughed and partied. In the middle of all this she accused him of using her as raw material for his work. She also criticised his writing as pornographic, which caused him to hit her. If he talked about Jane she said she couldn't exist in a relationship with three people. Then he had affairs with a record company executive called Liza Williams and a cocktail waitress called Pamela Miller and that made it five.

Liza didn't have the 'grand flame' of Linda but neither did she have her penchant for working Hank up. She was a mellow hiatus after the unaffordable luxury that was her predecessor, a safe landing after a period of turbulence.

In July 1972, when Linda was home in Utah, Liza brought Hank to the island of Catalina off the coast of California for what became both his first and last old-fashioned holiday. He studiously avoided doing the touristy things, which frustrated her until she came to terms with it.

He wasn't the type to get high watching ducks on the pond, she realised, or going on moonlit walks on the beach. Nature meant little to this city slicker and package tours even less. So she capitulated. She let him be his own man, do his own thing. She knew that it made no difference if he was on Mars or Mariposa Avenue. He just wanted his beer, his typer and his pussy. She sunned herself while he wrote and drank in the apartment and his spirits lifted. You could take the man out of the study but you couldn't take the study out of the man.

There wasn't as much of an emotional investment in Liza as with Linda so when Hank broke up with her he coped better. He was learning — the hard way — that the deeper you went in, the worse the wrench when it ended.

Miller was a former beauty queen, Miss Pussycat of 1973. She had met Hank when they were both writing for the *Los Angeles Free Press* in the sixties. She was a beautiful, wired lady who drove him nuts with desire. 'She'll be the death of me,' he told Carl Weissner, 'but it's worth it'. He liked her zany attitude to life but wasn't too keen on her hippie friends, nor her drug taking.

She was both pretty and ambitious and had lots of handsome suitors fluttering around her so he was flattered she dated him, but then Linda came back on the scene and told him he couldn't two-time. Their arguments seemed to take up where they had left off months before, with Pam now an added complication.

In the autumn of 1972 he oscillated between Linda and Pam like a shuttlecock,

leaving them when the going got too hot and then being revisited by them as though nothing had happened. He was afraid of getting too intense with either of them because he knew what it did to his insides if or when the curtain fell, but neither could he keep both of them on the go indefinitely. Linda's jealousy of Pam resulted in her stealing the bust of Hank and bringing it back to her own place. At this point it had almost developed the guise of a child in a shared custody situation. Hank responded to the gesture by sending her back one of her paintings to go with it. And so the childishness continued. It was war all the time.

Hank spent sixteen volatile months with Linda before they split. When they got back together again he set up house with her and they had as close to a traditional relationship as was possible. When he stayed off the drink they looked like making a go of things but sobriety was never going to last for very long. When he was drunk his Hyde persona took over and sparks flew. Each accused the other of having affairs — usually with justification.

He had a lot of sex with Linda, but no kids. 'The only thing that saved me,' she told him ruefully, leaving him in little doubt that the lapse bothered her, 'was that your sperm were pickled with alcohol'. She became pregnant by him once but miscarried. The day she gave him the news he was whooping it up with Pamela and she blew a fuse. She came round to his apartment and wrecked it, stealing his radio and drawings and flinging his writings out onto the lawn like his father did all those years ago. Hank ended up calling the police, which must have been a first for him. The man who received the call would have been more surprised at who placed it than the address he was going to. But Hank didn't press charges.

Linda moved to Phoenix after this incident and though he visited her there once, they failed to rekindle the fires of the past. He still carried a torch for Pam, whom he nicknamed Cupcakes, but she was out of his league and baled out when the going got rough. Hank, meanwhile, philosophised about the cruelty of dames who took him to the cleaners. He hated being alone, but the alternative seemed to be giving him brain damage.

He finally split with Linda in August 1973, unable to take her unpredictability anymore — as she was unable to take his. They had broken up so many times before you got the feeling they would somehow patch it up, but this time it was for keeps. As was the case with Jane, the passion somehow fizzled out, leaving an empty hole in its wake.

What was it about these goddam babes? Were they just intent on sampling him as an interesting phase, as in 'My Tryst With The Dirty Old Man'? He needed a squaw to tide him through the rough times, not these hit-and-run merchants who left him with a hollow in his gut the size of the Grand Canyon.

Another part of him enjoyed solitude, and this would become apparent as his iconic status grew. People sought him out from all corners of the globe but he cold-shouldered them more often than not.

He once said that there was no sweeter experience in the world for him than closing the door of his apartment and facing its walls alone. This was infinitely preferable to 'wet-nursing' the masses, but it wasn't always feasible. People now saw him as a kind of Jesus figure. They imagined he could solve their problems by the laying on of hands — or maybe the laying on of sex. He would of course be more amenable to the latter as time went on, but for now these people were trouble.

So obsessive was he about his privacy that he left the phone off the hook sometimes

for weeks at a time. When the phone company informed him this violated one of their codes he took the back off it and put rags round the bell. Overzealous visitors threw rocks at his windows but still he refused to answer. Polite refusals always resulted in anger, he learned. You had to totally ignore people to keep them at bay. Nothing else worked.

One of the main reasons he liked writing, in fact, was because pages couldn't talk back. They didn't insinuate themselves on you when you were feeling poorly, didn't even castigate you for writer's block. They kept their own counsel, being there for you when you were ready for them. Human beings, on the contrary, were selfish and pushy. They presented themselves uninvited at your door, and throttled you with verbal onslaughts. Such prattle bothered Hank no end until he screamed for silence. One of the reasons he liked classical music so much was because it didn't have a human voice. Opera did, so he couldn't listen to it.

He agreed with Walter Pater that all art aspired to the condition of music. That's why he regarded *Finnegans Wake* — a book that has its main appeal in the sound rather than the sense — as James Joyce's finest novel. Most people would regard it as his most inchoate, but that never bothered Hank. He always pardoned glitches in experimental work. Infinitely less bearable was the well-honed non-event.

'When people read me,' he said to his sometime friend Neeli Cherkovski, 'I want to think of them as not reading literature, but actually participating in life'. When he made the statement, ironically, he himself was in the process of *withdrawing* from life.

Not that his desire for seclusion should have surprised anyone. In a way, he was merely reverting back to the way things had been in his childhood — as people always do, sooner or later. Maybe the surprise was that he could entertain the callers at *all*.

He had many problems in his life, but loneliness was never one of them. He informed Sean Penn once that no matter how low he felt, it never seemed to him that the presence of another person could alleviate the situation. You had to change the inside of yourself before looking outside helped.

He once wrote a poem about a man who dug a hole in the ground and lived in it. When people asked the man for his reasons he didn't answer and they became mystified. None of them considered the obvious one: that he was in the hole because he wanted to be in it, that anything was better than being with them.

If he was sitting alone in a restaurant he resented people coming up to him making small talk, the assumption being that anybody unaccompanied would appreciate such a gesture. Hank didn't, and wasn't slow to let his feelings be known. If he was sober he would adopt the path of least resistance, replying in monosyllables to the intruder on his privacy, but if he was in his cups it would be a case of, 'do me a favour, pal, and disappear — now'.

Most people hunted in packs, but not this one. He made Greta Garbo look sociable. 'The more I think of human beings,' he said, 'the less I think of them.' Will Rogers dictum, 'I never met a man I didn't like', made him want to puke.

If people were two feet away, that was good. Two yards away was better. Two miles away was great. The second somebody knocked on his door, he said, his first thought was: how do I get rid of 'em?

It wasn't that he enjoyed being a bad ass, but when you wanted something done, the fist and the bestial wail worked better than a flower. You could be nice to people, but if you were they tended to use you like a doormat.

In an effort to analyse his own character he admitted he was an asshole, but if he

stabbed people it was from the front. His problem was the fact that he played the bad guy so authentically people mistook the act for the reality — and eventually he almost *became* that reality.

He said to Carl Weissner that he was at a loss to know where his tough-guy image came from. He liked to act the innocent about matters like this, conveniently forgetting where or how such an image might have been nurtured, or acting apathetic about the details. Of course a lot of his mad acts would have been perpetrated when he was drunk, so maybe the memory of them was hazy if there at all. And he gave himself a drunk's pardon for these. He didn't really believe in the theory of *in vino veritas*.

He felt the sobriquet 'Hank the Crank' was lazy shorthand for those who didn't take the trouble to get to know him for who he was. The point is that the media needed a hook upon which to hang him, and this was the most interesting and obvious one. Once it went into the machinery it was carved in cement. Ergo, Charles Bukowski, sleazeball, waster, the kind of man who was capable of gouging your eyes out if the drink went down the wrong way. It was as if the poetry, not the violence, was the aberration.

People wanted to be shocked and he decided to oblige them. A gentleman shouldn't let his audience down, as Errol Flynn, a more high-profile hellraiser, once emoted. You had to live down to expectations or you might be seen to be losing your touch.

A man who saw literature as an exemplification of one's feminine side — perhaps rightly — Hank declared war on anything that could be construed as gentle in his own work. On the odd occasion we see this it shouts at us like a grudging admission of the humane. And yet you couldn't call him a cynical writer: it's just that his humanity is hard won. It wrestles with itself like a luxury an existential man can't afford if he's to keep his grip on things. Particularly where women are concerned. To show need for them, he seems to be telling us, is to empower them, and to empower them is to almost invite emasculation.

As for men, particularly those who called to see him unannounced, he didn't have to work hard devising a strategy to deal with them. He just told them to make themselves scarce.

Those who didn't visit him contented themselves with sending him their work for validation. The problem was that most of the material he received sucked. The only value it had for him was the inclusion, sometimes, of a pretty girl's photograph, and/or address, and/or phone number. Would this be abusing a privilege? He drank to help him endure buffoons, but if he took too much it made him even crankier with them than he would have been sober.

And then there were the cynics who sent him their work because they felt they were better than he was, and if *he* could get his work in print, surely he knew some way *they* could. These were the ones who thought it was easy, that Bukowski just woke up one day and found himself famous, like Lord Byron. They didn't know, or want to know, about the down-and-out times, about the clawing at life with his fingernails like a dog-weary climber on a rickety cliff face, about the near-death experiences, about the way he sweated blood to get the words to come out right. Not pretty, not profound, not even intelligible sometimes — but right.

Endurance, he said, was more important than truth. You didn't have to know what life was about: all you had to know was how to live in it, to get through the day. Significance was negotiable. Anything meant what you wanted it to mean. There were no signposts, no diktats. If you were sure of anything you were probably wrong about it.

He had nothing to say, he claimed — but he never stopped saying it. He professed to abhor teachers, but he was one. He said art should never be didactic, and yet he preached every day of his life. It may have been an anarchic *form* of preaching, but it was still preaching. He cast himself in the role of the Antichrist, but he knew he had a message to deliver. And he delivered it with all the self-assurance of any card-carrying Bible-thumper. If you doubt this, read a poem like 'The Genius of the Crowd', one of his most stridently didactic diatribes. It's also one of his most brilliantly written pieces of work.

But fame wasn't tied to talent in his view. It usually meant nothing more than being in a certain spot when somebody was looking for you.

He always said he was no better a writer after he became famous than before. The only difference now was that his books sold better. He hadn't improved his style: he had just kept at it.

Fortune had smiled on him, but it hadn't made him a genius. All it had given him was visibility, options. Lydia says to his alter ego Henry Chinaski in *Women*, 'You like to pretend you're famous,' referring to his gruff manner, and he replies, 'I have always acted the same way, even before I wrote'.

He was like an old racehorse who suddenly started winning for no discernible reason. His byline sold magazines even when he was below par. It had a cachet, and editors knew that so they solicited him for submissions — a veritable inversion of the old order.

It was like changing your trade from the little shop at the corner to the supermarket, but he had a certain amount of nostalgia for the littles. No more than the hockshop and the tavern, they had been there for him when he needed them. They had kept the fire burning inside him when he was, as he put it, 'on the shelf of nowhere'.

He would have continued writing forever even if he was never widely published. No matter how famous he became, he went on sending stuff to the smaller magazines. He got a rush when *anything* he wrote was published. *Anywhere*. To his dying day.

No matter how famous he became, however, he was never as big in America as on foreign shores. He put this down both to jealousy and the fact that he believed (with characteristic humility!) that America trailed behind other countries in culture *anyway*. He might have added that he wrote like a Continental, that his influences were from there (Céline, Dostoevsky) and that as far as European writers were concerned, his outrageous behaviour and attitudes were like a breath of fresh air, whereas in the US he was often seen as a pain in the butt. It all depended on where you were coming from.

So here he was, an old man in a dry month, mixing memory and desire. Famous everywhere but in his own land. Loved by some, lusted after by many, admired by a few. Misunderstood generally, but then that was par for the course for a writer. Condemned for indecency, sacked for sanity, rejected for insight. What else was new? The morons held all the aces. All you could do was ride the storm until your time came. And it mightn't. Ever. So you had to steal a little magic from the horses and the whores. Use them for slack until you walked the sunny side of the street.

Everybody had these dumb phases. It was a question of knowing when to grab the action, knowing you had what it took to crawl over the entrails of the nobodies who asserted themselves above you on zilch talent. Sooner or later the scene would reach a water level. What you needed was patience. Self-belief. Just keep burning the words down hard and straight, as hard and straight as life itself. No decoration, no Fourth of July, no Herbert Hoover promises. Just what you saw and felt when the world was a

strange place and you weren't fully sure if you were going to make it, if it wasn't going to grind you into the dirt like your fellow fuck-ups.

Success brought many changes into his life, most of which bewildered him. How was it that a man who could hardly get arrested a few short years ago was now having beautiful women turning up at his door asking him to do them the honour of making love to them? Men called too, not for this purpose but to tell him they'd been with him in spirit during the lean years. When they said he had saved their asses with his work he replied testily, 'The only ass I really tried to save was my own'.

Lawrence Ferlinghetti of City Lights Books published *Erections, Ejaculations, Exhibitions and General Tales of Ordinary Madness* in 1972, a book that contained many of the stories that had been published in the sex magazines. Some of these were too strong even for Martin, who had ruffled his share of readers' feathers with his star writer.

He did, however, publish a poetry collection of Hank's that year. Called *Mockingbird wish Me Luck*, Hank dedicated it to Linda 'for all the good reasons'. The preface prepares us for the impish tone of what's to follow.

'The rat' gives us another mini-dose of memories, bringing in his father, sex and the war before concluding that nothing has really changed in his life in the past thirty-five years. 'WWII', which is written in such a jerky format it reminds you of everything from Bob Dylan to the Beats, also trades on Hank's old war stories, or rather the much-quoted story about how he *avoided* the war. Nobody could trivialise jingoism like Hank, and here he has a rare old time sending up the draft procedure and how he crawled out from under that particular wire with a mixture of fabricated neurosis and very real apathy. 'A sound in the brush' is a more solemn anti-war statement, a fairly standard polemic about a soldier dying for a 'Cause Unknown'.

A more personal note is struck in 'the dwarf', where Marina asks him what's wrong with a diminutive woman they see. He apologises to the woman for Marina's attitude. The anecdote must have struck a chord with him, having been the butt of so many taunts in his youth about his ungainly appearance.

In 'a man's woman' he gives feminists every opportunity to debunk him as the classic male chauvinist pig. One wonders how much of this is Hank and how much a poet having fun with a persona. Perhaps half and half. The misogynistic streak is continued in 'tight pink dress'. In the penultimate poem he addresses Linda by name for the first time, hinting that she may leave him one day and imploring her to do so with grace rather than ruthlessness.

On the eve of the book's publication he told Martin he thought it represented his best work to date, as excited as a sandboy as he waited for it to hit the shelves. Each title that came out, he said, still felt like the first one, the years of waiting making his recent crop of titles all the sweeter.

South of No North, a collection of his stories, was published the same year, dedicated to Ann Menebroker and containing more tales that would confirm a libidinous Hank as the colossus of rough trade. 'Hospitals and jails and whores: these are the universities of life' he writes, 'I've got several degrees. Call me Mr.'

The beautifully wry 'This Is What Killed Dylan Thomas' (and it probably was) has Hank trawling his way through the world of poetry readings, vomiting before them, going with the hostility, enjoying the girls and thinking back to the years of isolation when his only visitors were money-hungry landladies or the FBI.

'The Way The Dead Love' is another bittersweet exploration of his back pages: the crushing labour, the blinding depression... and Milton Berle saving his bacon. In 'Re-

member Pearl Harbour?' he writes about jail and the draft dodging interrogation in equally risible vein. 'The Killers' borrows Hemingway's famous title but hardly his style, Hank's being more Runyonesque. Hemingway himself appears in 'Class' and also 'No Neck and Bad As Hell' but these are slight and ineffective. He's much better when he's drawing on his own experience, as in 'All the Assholes in the World and Mine' and 'Confessions of a Man Insane Enough to Live With Beasts' where he pulls out all the stops to write about his demonic 1955 hospitalisation. All in all it's a very satisfying collection and an intrinsic ingredient of the Bukowski myth.

Burning in Water, Drowning in Flame was published in 1974 and showcases him developing the voice he would soon make his own. Touching on his wild drinking escapades and his erratic love life, he whets our appetite for future collections.

'Father, who art in heaven' is one of many acerbic poems he would write about his old man, and 'laugh literary' one of many in which he will debunk the writings of others. And, in his capacity as editor, gain sweet revenge for all the years when he himself was the recipient of rejection slips from resentful, narrow-minded editors. The book is divided into four main sections, the last one pleasing him most with the manner in which he dissects the weird times he had with Linda and Liza.

Also that year, Al Winans brought out the aforementioned Bukowski edition of *The Second Coming* which thrilled him beyond description. It retailed at two dollars but copies today — not many were printed — fetch up to a hundred times that figure.

Factotum, his second novel, appeared in 1975, bearing many resemblances to his first in the scatter-gun style he admired so much in John Fante. Short chapters document short jobs on the road as this hard-living, hard-drinking drifter engages in some heartbreaking (and achingly funny) encounters with hobos, employers and (perhaps most importantly) himself. As a record of a life lived on the fringe of society it's indispensable, but Hank never wallows in self-pity no matter how horrible his circumstances become, preferring to milk his absurd scenarios for humour. Each time he gets kicked he dusts himself down, has a beer and runs at life again. It's like Horatio Alger without the breaks.

Written in a style that's both pure and simple as well as curiously restrained, we follow our anti-hero through a barrage of dead end jobs and dead end dreams as he dumbs himself down to drop in and out of society with as much speed as the next beer — or landlord — requires, with women picking up the slack in the background. 'I always started a job,' he writes, 'with the feeling that I'd soon quit or be fired, and this gave me a relaxed manner that was mistaken for intelligence or some secret power.'

He takes over twenty jobs in the book, and also crosses America four times in the course of it. But this isn't Kerouac being adventurous. It's Dickensian toil without any prospect of fulfilment or promotion. He doesn't go hungry, like Hamsun, but the spiritual hunger he feels is almost more traumatic. 'Compared to me,' he would often say in later years, 'that guy didn't even get *scratched.*'

World War Two is conspicuous by its absence throughout. The war ended, he remarks casually at one point, 'during one of our hellish nights'. In the words of the Irish poet Patrick Kavanagh it was 'a bit of Munich bother' that didn't impinge on his life at all, nor deter him from his shenanigans. He wasn't even a conscientious objector to it; it just left him cold. It was too far away from him for his sensibility to be affected by it.

'The idea,' he decides at one point, 'is not to think. But how do you stop thinking? Why was I chosen to polish this rail? Why couldn't I be inside writing editorials about municipal corruption? Well, it could have been worse. I could be in China working a

rice paddy.' The novel continues in this vein as he lines himself up for a succession of jobs at which he's profoundly unsuited, pulling any scam he can think of to preserve his sanity, or fund his penchant for the racetrack. 'I had filled out so many job forms that long ago,' he tells us, 'I had memorised the right answers.' Life isn't a matter of truth or justice: it's a question of doing it to him before he does it to you, of filling in the dead hours of the day before the magic of alcohol, or sex.

All of the jobs do their best to kill his mind. Other things do too, but Chinaski/ Bukowski still hangs in there, as tough as old boots but with a smidgeon of humanity hinting between the near-surreal absurdities of his plight. Thoughts of suicide kick in now and again, but it would be too easy to cave in. He decides to kick against the pricks, to fight fire with fire as he once did with his father (the scene where the old man digs his head into his own vomit is trotted out), but by the end of the book he seems spun out as he sits impotently before one of his beloved strippers.

By now he was fully established with Black Sparrow, and his monthly stipend had increased out of all proportion from the 1969 deal as the royalties continued to flow in and the books to sail off the shelves. There were also back-to-back offers for poetry readings. All of this meant little to him for he had never viewed poetry as a spectator sport. Neither did he need hero-worship to persuade him that what he was doing was worthwhile. It came with the territory: that was all that could be said. It was hucksterism, a performance for mobs of the Great Unwashed. More often than not they laughed and applauded at all the wrong places.

The people attending them weren't the clean-shaven, dickie-bowed, tweed-suited smoothies who usually proliferated at such soirées, but coarse, leather-jacketed 'hards' who believed poetry had to have a connection with their own coarse lives rather than just being a collection of lines put together to sound pretty. This was fine, but such people were often accompanied by a raft of undisguised troublemakers who tried to reduce Hank to their own philistine level. Sometimes, it must be said, he was only too happy to oblige. It was only in later years he became grimly philosophical about the whole charade.

In later years he threw himself into these arenas of hype with aplomb, but at the beginning they fazed him. Unused to being a public figure, he would often throw up before going on. Neither did he enjoy other poets coming to gloat over him. They would look at him as if to say, 'Is that the best you can do?' the implication being that they knew he felt it was a con. He could have been sensitive about this, but deep down he knew these worthies would have given their right arms to be where he was, turning poetry into a pop art and having teenagers drool over his every inane utterance. So what if the poems were sometimes sidelined? He had earned the right to be a card-carrying nutter who charged megabucks to abuse people from a rostrum.

By the mid seventies he was making up to $200 per reading. He hated them but he needed the money, and there was always the hope of getting laid by a co-ed. The downside was that they left him unable to write for weeks afterwards.

Many people left them claiming they'd been sold down the river by a man who seemed to be more interested in guzzling beer than making apocalyptic pronounce-ments about life, but Hank never felt he had anything to apologise for in this regard. He wasn't twisting anybody's arm to attend them: all the twisting came from the promoters' quarters. Besides, he had never set any standards of behaviour for himself so he had none to live up to. And if the moaners were honest with themselves, they should have admitted they would have gone to see Robert Creeley or T S Eliot if they

were looking for a parlour-room experience. What you had to do was forget the poetry and concentrate on the performance.

This was Bukowski Live and Unleashed. And five good minutes of it would last longer in the memory than an hour of a poet who behaved himself and delivered genteel vignettes to the measured applause of the anal-retentive. It all depended on what you were after, but with this man you always had to expect the unexpected. One night at a reading in Michigan he put down his poetry and started to arm-wrestle with one of the students in attendance. Nice work if you could get it. (It was a moment Hemingway would have enjoyed.)

He played the court jester because he knew this was what the people wanted. It was emotional rape, but if the money was right he could tolerate this. He drew the line, though, at going to other poets' readings. These were generally just excuses for ego-maniacs to secrete their narcissism over an auditorium of picked admirers.

The more the audiences poured in, the less he seemed to care. He knew a large segment of them were only interested in being part of the cult, not what the cult was about. They were awed by what Bukowski had become, not what he was. Some of them were the same people who would have passed him by if he were sitting in a trashcan. It was a kind of inverted snobbery, this elevation of him into some kind of dope god. He was, as it were, hiding in plain sight.

The readings usually ended when the wine ran out. 'I'm making these bastards rich,' he would say, 'and killing myself in the process.'

Drunk or sober, though, he had the status of a living legend. He delivered his poems in a susurrant drawl as if he couldn't give a goddam... and maybe he didn't. It was like with the women, where a retro-MCP delivered the most outlandish insults and still they came back for more. He fulminated about broken homes, broken loves, broken lives. Days of nothing, of nowhere. Times when guzzling a beer was the high-light of his day, when not even the gas man called to say he was cutting him off. Again.

He never knew what to expect from the crowds. 'You couldn't underestimate them,' he wrote in Women, 'and you couldn't kiss their ass. There was a certain middle ground to be achieved.' Elsewhere in the book he's more explicit when he says, 'Readings diminished me. They were soul-sucks.' But he knew they were also his meal tickets so he put up with them. And if he was tanked up enough he even entered into the spirit of these zany evenings, giving as good as he got to auditors who might never have been at a poetry reading before, and might never be again. Or, at any rate, never one like his.

He bantered with audiences as if he was going out of his way to make them hate him, but the more he insulted them the more they cheered. And if they abused him back, that was OK too. 'Fuck you!' roared a heckler at one reading. 'At last!' Hank replied, almost relieved. Here was a guy he would enjoy chewing the fat with: a kindred soul.

He admitted he turned on a bit of the madness but added that he was also mad in his private life: it was just a different version of it.

This was Beckett writ small, LA style, the hobo turned millionaire who still acted as if fame hadn't happened, falling down drunk outside the galleries like a transplanted Mailer on helium. He would keep the downbeat pose to the end, beating out a new path for poetry, or non-poetry, suggesting new bottles for old wine. Contaminated, maybe, but his own.

He dealt in the sub-angelic reflections of a man on the precipice, a hollow soul inside a bent frame, bellowing against the horses and the women — and even, occasionally, the gods. People didn't expect anything of him anymore except that he be himself. He had lasted the pace, had outshone the passing flames, and few denied him these moments of bruised grandeur as that slow cowboy drawl lingered in the air, caressing those syllables of want, of disenchantment, of scatology and eschatology, of life on the freeway and the track and in Dead End Gulch, digging up surreal cameos of tawdry lives one last time as a reverential hush descended, only to be replaced by a raucous guffaw the moment afterwards. For this was neither church nor brothel but truly a bit of both. The flesh became word and his disciples knelt at his knee wondering why prophets were never this profane before.

The reason he hiked up his reading fee to $1000 when he became hot wasn't because he suffered from greed but rather to scare promoters off. If they were dumb enough to offer him a grand a go (plus air fare and accommodation) he suffered the pain of performing on tap, but it wasn't worth it to him for anything less. He read poems he no longer cared for, to people he didn't respect, in halls he would hope never to return to. It was blood money, (im)pure and simple.

He was like the character from his story 'There's No Business', a man who didn't want to up the ante for the new crowd. You could only sell your soul so many times before it came back to haunt you. It was time to rethink the plan, to make a dignified exit from arenas where he had reduced himself to the level of the mob too often, heckling back at the hecklers so much it hurt.

Though Walt Whitman was one of his heroes, Hank disagreed with his notion of poetry as an activity that depended on large numbers of people to listen to it for its justification. 'To have great poetry,' Whitman once pronounced, 'we must have great audiences'. For Hank this was putting the cart before the horse. Why should people turn up to hear garbage, as he so often experienced when his mutually backslapping colleagues held forth for picked gatherings of brown-nosing disciples?

After all the readings and the binges, it always came back to a man and a piece of paper, rising at the count of seven to scream against the fates. No matter how many beers were drunk or women made love to, this was always the *terminus a quem*, the final port of call, the one that made the others matter.

Poetry always seemed to be the mistress he loved most at the end of the day. Groupies came and went, but the word went on forever. Such groupies, however, occupied quite a large part of his days.

Were they jerking his chain, these creatures who flirted with a man whose face looked like the craters of the moon, whose stomach spilled over his trousers, who slouched across rooms with the buttons of his shirt undone, dribbling drink?

Did they not notice his boils, his rotten teeth, a beer gut that was going on for a career of its own? After a while he wasn't too concerned whether they did or not, content to take what was offered after years in the sexual wilderness.

They arrived in droves to pleasure him, disappearing before the dreaded 'commitment' word reared its ugly head — which would have caused him to leave skid marks. Some even screwed him as a career move. They slept with him merely to say they'd 'been with Buk', causing him to wonder 'what have I got that Bogie didn't?'

Like many wild people he was shy at base, the residue of his father's beatings making him forever at odds with a life that kicked him in the teeth too many times for its subsequent smiles to act as a tranquillising agent. Just as poor people who become

rich never quite lose the spectre of poverty, so sensitive children with a zest for lust never quite shake off the nervousness of their early years. In some ways his penchant for sensationalism was merely the flipside of his introversion. He had, after all, a lot of years to make up for. Having been a virgin for perhaps a decade longer than the norm, there was some serious loving to be done. (Hank didn't actually lose his virginity until he was in his mid-twenties... and then to a prostitute.)

Many women went to bed with him simply because they were lonely, at least in the pre-fame days. Most of these he would have run into in bars, as he had run into Jane, united with them in little but circumstance. A Hollywood appearance was hardly necessary in such a scenario; it was just one drinker wanting another drinker to go somewhere with. Anything, perhaps, was better than where they had come from.

Part of his attraction was the fact that he was so undemanding. He needed sex but also space. When it was over he liked to go back to his life — for what it was worth. Affairs were a respite from his writing but all too often they cut into the time he would have preferred to devote *to* that writing. In an AIDS-free cosmos, however, what man in his right mind could turn down these kinds of offers?

They came and went as if to a harem and he made up for lost time with them. Peacocks didn't usually sleep with crows, he knew, so these were especially sweeter honours. They were consummations devoutly to be wished. He didn't over-analyse the women's motives. He didn't want to kill the golden goose.

He had heard the word 'no' so often from women in his youth, the affirmation of his desirability was now all the more precious.

Each conquest he racked up was like a slap in the face to his dead father, who had believed he could do no better than a lush like Jane. This wasn't the trendy 'casual sex' of the beachboy set: it was a late blooming adolescence. The boy whose breath had fogged the windowpane at the Prom was now on the inside looking out at all the other poor SOB's. A very unlikely Casanova had pitched his tent in the boudoirs of East Hollywood, giving his women the kind of loving that was light years away from tenderfooted popdreams or marshmallow marriages.

Nothing lifted his spirits like women, but nothing dropped them as fast either. He once described them as 'complaining machines'.

They were like poetry or horses or anything else in his life. He liked to freewheel with them, refusing to make plans until he saw how things were panning out. If the dependence was too big on either side, things usually foundered, but what couple had the ideal balance? He usually found himself locked in impossible binds by the time he (or they) wanted out, which made him doubly leery the next time. They usually expected more from him than he was willing or able to give, or else they reneged on a promise, or a third party entered the fray on either side. When things turned nasty their predatory side emerged, which made him never want to give all the heart, to use W B Yeats' phrase apropos Maud Gonne MacBride, the great unrequited passion of his life. Hank had no Maud Gonne, but many of his concubines approximated to that status.

He always looked for gentle women, he complained, but the whores kept finding him. They knocked on his door and told him they admired him because he was different to all other men, but within a week they usually tried to mould him *into* those other men. You couldn't win.

Women worked you up into a frenzy, he claimed, by making you think you needed them, so that you would go into a decline after they left. But this was another charade. You only *thought* you needed them. What you really missed after they were gone was

the routine of companionship. Once you got over that stumbling-block you were al-most relieved. He had to keep telling himself this every time another one walked or their absence would have destroyed him.

A certain amount of attention was flattering, even pleasurable. but there were times he had to get away from it all, to just go into a room, lock the door and turn the light off in order to get back to the person he had once been, in that place where nobody knew him and he cared less.

It was as if he had a preservation order on his heart, as if there was an invisible wire mesh around it that said 'Beware of Entry: Exclusion Zone Ahead'. The more beautiful they were, he concluded, the more likely they were to be deadlier than the male. They were like Pinochets in panties.

'People in love become edgy,' he wrote in *Women*. 'They lose their sense of perspec-tive. They lose their sense of humour. They become nervous, psychotic bores. They even become killers.' Slightly earlier in the book he asks Dee Dee not to love him, because things go bad for him with love. Love was for 'guitar players, Catholics and chess freaks' — not Henry Chinaski. He wanted slam, bam, thank you ma'am, not bouquets and flowers. He didn't want 'Will You Still Love Me Tomorrow', just 'Help Me Make It Through the Night'.

'I'd love to live in gentle peace with a woman.' he confided to Al Winans, 'but I've never met the one yet. It's getting more now that I just need a housekeeper instead of a soul mate.'

There was little stability in his life at this point, but that was the way he had always played it: like a punch-drunk boxer slugging it out from the ropes. Albeit with a little bit more disposable income than heretofore...

He didn't say no to a bigger house with a swimming pool, and he traded in his old Volkswagen for a BMW. Was this selling his soul to the devil? No, it was his 'golden midnight', whatever the cynics might have said. Most of them, he thought, were Fausts who couldn't even find a Mephistopheles to serve them.

In his poem 'An Old Jockey' from *What Matters Most Is How Well You Walk Through The Fire* he tips his hat to longshots like himself who left the favourites for dead. Such bolts from the blue, he said, beat the Fourth of July hands down. Sometimes, just some-times, the old scouts came through.

Before and after success he was the same person, railing like a latter-day Swift against anything and everything with that fierce indignation. So fierce, in fact, that he couldn't even dilute it into satire like the other man. It was too intense to play around with. It had to come out straight to get the full effect. People said he wasn't a subtle writer but it wasn't really a fair criticism. The point was, he never *tried* to be. He looked on subtlety as a game like any other, as a pose. As he put it in 'consummation': 'I was born to hustle roses down the avenues of the dead'.

When fame came to him he never quite knew how to deal with it. He was like a tired old prospector who suddenly found gold and didn't believe it, imagining he had been too long in the sun. It wasn't that he didn't believe he deserved it, but when life kicks you for long enough you expect that pattern to continue. It's all you know and all you *expect* to know. So he had to adjust his mindset and come out of his cave. No longer would rats leap out of rubbish bins at him. or barmen kick him while he was lying outside their dingy doors. Recognition would bring new responsibilities, but for now he deserved the right to say he had hung in there, had kept the faith.

From the Stygian darkness of an Atlanta cabin to this! Was there any single thing

that had catapulted him into the A-league? Was there a formula for success? No. If there was, somebody would have bottled it. Having his books avariciously sought after as collector's items was a long way from the hand-printed Loujon Press days. After thirty years of being on the pause button, his life had suddenly gone onto fast forward. He had become an overnight success after three decades knocking on the door.

He had spent so long in the underground cobwebs that success couldn't affect him. It had come refreshingly late for him. Too late to enjoy fully, perhaps, but also too late to spoil him. If it had happened in his twenties the bleeding ulcer might have killed him. It wasn't so much that it softened him; more that it educed the softness that was always there but which he never realised, or never allowed to surface.

Fame meant that when the nails came up through his shoes now, he didn't have to beat them out with a hammer. It meant his car started in the mornings. But it also meant people recognised him at the track. And they asked him for his opinions on things — the same people who spent most of their time heretofore telling him to evaporate.

Another reason success didn't spoil him was because he never really had ego. When his breakthrough came he referred to it repeatedly with the phrase 'I got lucky'. Ambition rarely had anything to do with talent, he wrote in the poem 'after the reading'.

Because success came late, each book was sweeter to him, as was each woman he bedded. It was like what Ian Fleming said about making love to an old woman: there was nothing to compare to it because you always felt it could be for the last time. Nothing concentrated the mind like mortality. For Hank it must have seemed like writing his memoirs from death row for thirty years.

If he had been successful early he may not have seen the literary world at its worst, but rejection had brought the long knives out. By the time he became famous he had a pretty good idea of who his real friends were. Early success would also have probably blunted his edge, and/or made him smug. He watched other poets being courted by the press and then demonised by them soon afterwards and hardly envied them their fate. It reminded him of fattening the calf to subsequently kill it off. The bigger you were, the more you had to compromise to society's terms to keep it sweet for you. That was death of a different sort.

Fame also meant everything one wrote was percolated through a sieve based on one's image and praised or damned accordingly. It tamed the beast, and destroyed spontaneity in the process. Hank felt Norman Mailer was a victim of this syndrome to an extent, with his wives' alimony demands and his very public image nailing him to the typer to provide formulaic work on demand. Life with the littles had other pressures, to be sure, but maybe they were less injurious in the long run.

His saving grace was the ability to write as if the outside world didn't exist. He was his own yardstick, as immune to the bouquets as the brickbats. He knew that what the critics said most likely told you more about them than yourself, because people generally saw what they wanted to see on a page rather than what was there. It was like a self-fulfilling prophecy where a given text only made the cut if it lived up to the garbled preconceptions of its reader. The only way you could counteract this was by steamrolling onwards for good or ill until your work got out. Or didn't. If it did it would be both praised and blamed for most of the wrong reasons, but most people wouldn't really give a goddam either way. And maybe these were the lucky ones.

Hank's venom about the writing game reached its nadir anytime he found himself thinking about fellow poets. His feelings towards them almost bordered on the psy-

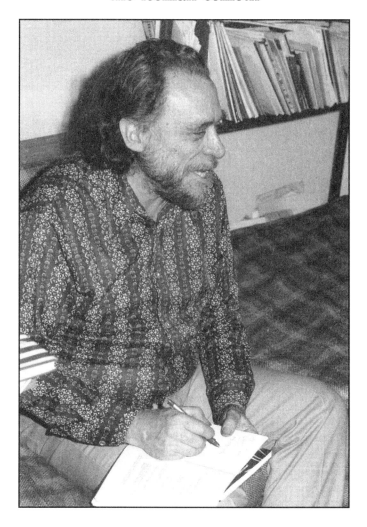

chotic, or paranoid. A lot of his attitudes are easy to understand considering how he suffered at their hands, and how they turned on him when he became famous, but much of his bile was also over the top. (One is reminded of William Wycherley's dictum, 'Poets like whores, are only hated by each other.')

There were basically four kinds of books for him: the good ones that sold, the good ones that didn't sell, the bad ones that sold and the bad ones that didn't sell. No logic governed whichever category his own work would fall into, and little justice seemed to greet a given title's reception, but once he pushed his boat out it couldn't be hauled back into the harbour again, and that was usually enough for him. He would let the wolves howl at his door just as he would let the idolators steal trophies from his apartments, equally immune to both. What was done couldn't be undone, and nobody could gainsay his productivity. At times he seemed to have more of a radar for the horses than his muse, but a body of work was being built up regardless, and sooner or later official America would have to sit up and take notice of him, even as he vomited over their grand tableau.

As an erratic cult figure they could afford to do this, but when his books sold worldwide the goalposts shifted. The old guard still held firm, but the sycophants sucked up to him for favours and approval, some of them secretly hating his guts. He tended to trust people unless he had good reason to think otherwise but his success made monsters of many of his colleagues — and often of himself. The adulation was a novelty for a time and he milked it, but when that wore off he reverted to his old habits, creating a stink in public places even for the sake of it. The difference now was that his commotions sometimes made the papers. He liked it better when they just locked him up for the night, and/or beat him senseless. Now the police were as likely to ask him for his autograph as a statement.

He was flattered that he was read widely in jails and asylums. Hell, some of his best friends were crazies and ex-cons. In fact he wouldn't object to being called either (or even both) himself.

After Martin started to publish him in some numbers there was a groundswell of discontent from his former fellow labourers at the underground vineyard. Martin published him, they said, because he was a 'known' writer. Hank replied that people got known because they were good. That was how the game worked. This, of course, wasn't to intimate that you could draw a line between quality and commercial success, but neither could you equate obscurity with merit, as some of the laggards would have it.

Their own obscurity now began to hurt more and they wanted to take it out on him, to use him as a punchbag. They wanted to tell the world that he was a pretender, a paper man, that this emperor had no clothes. But by now it was too late. The juggernaut had cranked into top gear. There was no going back to cold water rooms now, no reversion to the days of sending messages in bottles to equally forlorn souls on the other side of the globe. With the success of *Post Office* came a demand to see more of his labyrinthine back pages, the material he had flushed out of himself when there was nothing else to do at the end of a day, when he was sick, saddle-sore and waiting for life's switchblade to fall on him. The word 'celebrity' would never fall trippingly from his tongue, but now he had a platform. It was a long way from the days of launching moribund literary magazines with just one subscriber who subsequently asked for his sub back. The world was about to be overwhelmed by Bukowskiana.

One man even wrote offering to leave all his money to him when he died, even though they had never met. There were some strange puppies out there.

Everybody from bums to university professors rang him up and asked him if they could call over. Some of them openly said they idolised him. Others were 'passing through' (or so they said) and were curious. Most of them he ignored. Pretty women, of course, got automatic backstage passes — at least until he felt he had enough notches on his belt to shout 'Stop'.

In 1980 he told Al Winans, 'The day has long past for me when I consider a fuck a very important thing. I still get horny, but when I take in the circumstances, the mind, the strain, the price, I say... let others have it.'

The man who had once splayed himself out on all fours craving recognition continued to turn away door-knockers, groupies, starry-eyed wannabes anxious to touch the hem of his garment. The man who couldn't get a girlfriend for years was now refusing sex free, gratis and without complications. If it was a movie you wouldn't believe it. The no-hoper had climbed a mountain and almost grew bored as he surveyed the surrounding scenery. Maybe a part of him was even sentimental for the stink of the

streets.

In the post office, as in his home, he had been treated like 'a hunk of human shit', so there was no explanation for his sudden emergence into favour. It was as if God had momentarily mislaid the Bukowski script, putting him into the wrong screenplay.

Others — the underground brigade who preferred him down there instead of on ground level — accused him of selling out what he had for money. It was an understandable reaction considering the change in his circumstances, but it wasn't true.

He didn't write for money, but money helped him to write. It was that simple. Like a typewriter ribbon, it was a tool of his trade, of any trade. There was nothing ennobling in poverty at all. It was a curse.

Money wasn't an end in itself. It was what enabled him not to have to think about money. That was the mistake other people made. It was even arguable that the rich worried more about money than the poor from this point of view. 'I always felt better broke than not,' he said once, 'because when you are broke you have nothing to lose and are loose. When you get it you worry about protecting it, and you don't do anything but protect it.'

He always said he couldn't be bought. This was a temptation, because there were times when even a small amount of cash could have eased a given crisis. He knew others who had sold their souls to the survival game but he wouldn't join their ranks even if his day never came. In a previous era he might well have been one of those writers to die for his beliefs, or at least be locked up. Writing as he was in 'liberal' America that wasn't likely to happen, and all he was usually locked up for was disturbing the peace but the point still held. The dirty old man wasn't for turning.

Having said all that, he knew what side his bread was buttered on. He hadn't frittered away all of his father's inheritance and he was a conservative gambler on horses. He also had a habit of putting money away for future use, a fact he didn't generally advertise. So he wasn't totally of the 'eat, drink and be merry for tomorrow we die' school, as his critics perceived him from their parasitical perches.

As far as he was concerned, there were too many hurlers on the literary ditch wasting the energy they should have been expending on their writing into broadsides against himself and others who had broken through the shark-infested waters of small-time publishing.

Al Winans told him to ignore the negative appraisals of his work, but this was never Hank's way. He didn't believe in taking prisoners, preferring to confront challenges head-on. It wasn't that he couldn't take criticism, but as he grew more confident about his ability he started to feel most of the abuse directed against him was argumentum ad hominem, and motivated either by jealousy or simply malicious intent.

Responses to such barbs, of course, inflamed their sources even more, which led to a vicious circle of abuse — and that's vicious in all senses. Not that this bugged him unduly. He liked the cut and thrust of taking people on. Too many poets were thin-skinned pussyfoots, folding their tents at the merest hint of derision. If Hank's life meant anything it was a reversion of that order. He sought a new image of the writer as a ballsy, aggressive animal, and often chose the readings as a conduit for this.

At the City Lights reading in 1972 he lowered beer like it was going out of fashion. A fridge stacked with beer stood beside him on the stage and he helped himself to its contents without any need for encouragement. There were whoops of delight even before he started speaking, and maybe as many for the way he drank his beer as how he spoke his lines — Sean Penn once said he had the classic drinker's way of tilting a

bottle. A lot of such drinking was from need, but a lot also because he felt it was expected of him: it gave him Dutch courage but also embellished his myth. Whatever the motive, it was an almost unprecedented phenomenon for a poet and it became one of his many trademarks. Shakespeare never did this.

After it was over he had a fight with Linda which resulted in him falling down a flight of stairs. For another poet this might have been an event but as far as Hank was concerned it was just another day at the office.

It wasn't like he *wanted* to disgrace himself. It was as if there was an evil twin inside him making him do these things. The following day he would revert back to his taciturn self, possibly not even remembering what he had done. He was like King Kong loping through a forest knocking down trees without even realising it.

A part of him almost enjoyed it, feeling it gave a kick-start to his creative juices. 'If I went to a psychiatrist and found out where all my wires crossed,' he told Fernando Pivano in 1980, 'I think I'd start patting children on the head and smiling at apple trees.' Then he would write crap that nobody would ever read, 'because it would be what everybody else was saying or doing, or pretended to say and do'.

If he found the seed, he feared the plant might not grow. He didn't want to tamper with a winning horse. If it wasn't broken, why fix it? Or rather if it was working better for him in its broken condition, why touch it at all? But of course this increased his unpredictability factor a hundredfold.

Sometimes, as he made clear in the poem 'Captain Goodwine' from *What Matters Most Is How Well You Walk Through The Fire*, he resisted the temptation to be outrageous purely to frustrate the expectations of those who felt they could turn on his shockability factor like a tap. He wouldn't be a performing seal for such individuals. On such occasions he was abnormally normal — for him.

Nobody ever knew what to expect from him. He was like a lion in the circus that allowed its master to put his head in its mouth for twenty years and then one day, for no discernible reason, chomped it off. In this sense he was a ticking bomb. Sartre, he claimed, hit it on the nose when he said hell was other people. This one apothegm alone made Hank sorry he never met him. (He declined such an offer as a young man, which he always regretted afterwards.)

He never understood fan worship of him, or indeed any writer, because he didn't have it himself. He never sought out writers he admired, feeling what they had to offer him was inside the spines of their books. (The Corrington/Blazek experiences, no doubt, strengthened that notion for him.) By the same token, he didn't feel he owed anything to those who admired him except to write well. He never claimed to be Santa Claus or the Statue of Liberty, welcoming all comers.

His home became a shrine for pilgrims anxious to touch base with one who had suffered as they had and was able to get it down. He gave a voice to losers because he had been one himself. Failure was the manner in which he wove his spell. He was a survivor from the trenches, the one who lived to tell the tale. So they came to him and wanted him to act out his designer madness for them. But by then he had evolved into a different person. The very qualities that made him famous were the ones that made him want to turn away from the johnny-come-latelys.

Other people visited him not because they admired his work but merely because he was accessible: the closest to a famous writer they could comfortably come. He didn't always recognise these Cypriots bearing gifts (or six-packs) until it was too late.

At the onset of his career he was even too low on the totem pole for *The National*

Enquirer, but now *Time* magazine was seeking him out.

In the old days people saw him drunk in alleyways and helped themselves to his wallet: now they waited till he went to the can and lifted his signed poetry books. Rich man or poor, he was still the victim — and his belief in the trust of so-called 'friends' was severely dented.

The Germans, he said, thought of him as a cross between Hemingway, Hitler, Bogart and Jack the Ripper: a commingling that must have entranced him. Was there any other writer in creation who could call up such dissonant echoes? They also made it unclear whether his brief was to reform or destroy. And maybe he didn't know himself either. (Those neo-Nazi posturings of his youth would continue to haunt him.)

Recognition also caused problems with the stuffed shirt fraternity. The establishment hated him for two reasons: first because he came from the streets and second because he had escaped them. (Maybe the latter sin was a greater one in their eyes.) League of Decency types saw him as a draft-dodging cheapskate who drank himself stupid and then lay about the place fantasising about raping defenceless little girls.

For many he was the master of the *single* *entendre*, a yellowpack freak whose work more befitted the graffiti-spewed surface of toilet walls than the shelves of libraries or bookshops. Hank wasn't offended by such an attitude. Maybe a part of him was even flattered by it. He liked to enrage, and also to debunk himself. But no matter how much he hooted on about the fact that he wrote like he pissed, and hadn't much truck with editing or agonising over the perfect phrase. he still hungered for something he could call his masterpiece, whatever form that might take. Many authors have a seminal book that seems to define them, as mentioned earlier, like J D Salinger with *The Catcher in the Rye*, but Hank didn't have anything that could be called a classic, and this bugged him.

It was as if his career, in some ways, was like a big blob of circumlocution, as if he kept feeling his way towards the truth of himself but could never quite touch it, like a vanishing point that seemed always in one's eyeline but always stayed the same distance away. And yet in a curious way, this very frustration increased his were so much a part of what he wrote, maybe it would have been inconceivable without them. The junk aspect — for want of a better term — was part of the charm.

In time he grew to laugh about his bad press, about the rumours that he failed to pay child support for his daughter, that he never washed his clothes, that he strangled babies in cribs. Another one claimed that he beat his women, and this had a grain of truth in it, but sometimes he felt driven to this, and other times he was so out of his mind with drink he claimed diminished responsibility. Other times again he argued that it was kill or be killed — for Hank's women were rarely shrinking violets. If they were when he met them, they didn't stay that way long.

The *cognoscenti* felt he did for writing what the Boston Strangler did for door-to-door salesmen. It had bite but no substance, bile but no depth. It was like eating a television dinner: five minutes later you were hungry again. But not for Bukowski. They wanted him to just go away, to drink himself into an early grave. That way there would be one less SOB on the planet. And their mailboxes wouldn't be clogged with the demented expostulations of a horny vulgarian.

Over-attention caused him as much pain as under-attention, but in writing there's rarely a happy medium. No longer was he behind the eight ball, but many of the roses people threw in his path had thorns.

Did they call because they truly revered him or were they simply fascinated by his

notoriety? He feared the latter to be the case. The lion's share of them, he suspected, were nothing but celebrity-fuckers, so many eunuchs in the harem anxious for a bit of the action from one who had been there, done that and got the T-shirt.

He preferred to deal with writers through the mail: it was the personal visits that repelled him. Meeting people like this made him feel he was expected to 'perform'.

That was one of the things he had against The Beats. Neal Cassady, he felt, was working too hard to be the character he was supposed to be. Hank would never fall into the trap of setting up such quasi-bohemian expectations for himself. He would never prettify his streetlife like Cassady and Kerouac did, nor play up the pugilistic angle like Mailer. He never even wanted the image of being a recluse. That only came about when the door-knockers started to arrive, or the fake interviewers who wanted to say they broke bread with him so it would look good on their CV.

He differed from the Beats — who subsequently became the hippies — in that he didn't see literature as something that tried to change people's lifestyles. It was just something you did, preferably well, but it shouldn't occupy hallowed ground. To call attention to it was wrong, especially from the writer himself. That was for others to do — or not do. In a nutshell, the Beats were too bourgeois for this lumpen proletariat. He also impugned against their cheery sense of solidarity. Not for Hank the new man's touchy-feely group hug. And he was a bit fazed by the number of gays among them. Was homosexuality a prerequisite for membership of their self-satisfied clique?

They played the fame game and became corrupted in the process, ending up as part of the very things they originally set out to exorcise. Like so many closet exhibitionists, they'd backed their way into the limelight.

He always felt there was something too trendy about their so-called rebelliousness. It was like the man who said, 'This year I'm going to be a nonconformist, like every-body else'.

Neither did he have much time for their championing of pot. If you took LSD you were automatically deemed an intellectual: thus ran the bullshit-bohemian credo. He had no moral objection to drugs (how could Hank Bukowski have a moral objection to *anything*!) but they didn't give him the same buzz alcohol did, for some reason. Maybe they acted too quickly on the system for him. With booze you knew where you stood, to an extent — or fell. You had at least some control over what it did to you, but drugs snuck up on you. He preferred blackouts to bad trips.

He also preferred drink to pot because it created energy. Pot, on the other hand, just made people bland and mellow. It made them go about the place saying, 'Hey, man, what's happenin'. For Hank this was a deadening of the brain.

Of course his main gripe with the Beats was the fact that they became political animals, something Hank could never do. (This was what also destroyed Hemingway, he felt — and what made *For Whom the Bell Tolls* such a crummy book.)

He felt closer to the punk movement, but this too was posey. Every group was by definition. Once you nailed your colours to any sort of mast you were relinquishing a part of yourself.

All he wanted to be was himself, but that was a tough task for anyone in the public eye. You had only to look around at other writers to see why. All of them, for Hank, had compromised in some way. Ginsberg was a classic example of the syndrome in his view, selling out his gift after he became the property of the establishment and ending up as a solipsistic bore. Cummings also succumbed to this, falling prey to a self-con-scious, self-serving brand of writing that eventually superseded what it was he was

trying to say. Eventually he got to the stage where his work was revered because he wrote it rather than anything it contained. The style polluted the man with its repetitive cutesiness. Even Pound went loopy with all that fascism business. Sooner or later everyone fell victim to the machinery. Which is why Hank tried to concentrate on writing in an unhysterical, unhistorical vacuum. Trust the tale, he would say with Lawrence, not the teller.

In such flip phrases he debunked legends, flushed away a whole body of work with a swipe of his pen, And almost unwittingly you found yourself going along with it, shaking the pillars of the perceived wisdom. Other writers who came in for the mallet were the likes of Tolstoy, Balzac, Marx, Shaw and (his old nemesis) Hemingway.

Hemingway, as we've seen, was always a favourite target for whatever was eating Hank. Papa, he said often, became corrupted by the beast of fame and soon lost his loyalty to art, to the pure hard line that had made him famous. Hank grew up on this but when Hemingway disowned it, Hank disowned Hemingway. He learned a lot from him, of course, and the prose of some of his short stories is almost indistinguishable from the early Hemingway, but it was a debt he was always somewhat shy of acknowledging, perhaps because he knew it was so large. Every time he harped on about Hemingway's shortcomings it looked as if he was protesting too much.

Hank frequently throws authors at us in a haphazard manner without mentioning any of the particular works they had published by name. He doesn't mention highs or lows, or times at which they worked better for him than others. There's usually just a blanket ratification or condemnation. Fante worked for him and Shakespeare didn't. Hamsun did and Shaw didn't. And so on. (He did this with composers too.)

Hemingway went soft, cummings went soft, Ginsberg went soft, even Ezra, God bless his soul, went soft. But Bukowski wouldn't go soft, by Christ no.

He vented most of his spleen on the aforementioned 'lost generation', the much-fêted Paris writers of the twenties who scratched their navels so eloquently, people thought they were actually afflicted with some real primal pain.

For Hank, such pain was little more than a tortuous exercise in solipsism. He couldn't be expected to feel much for all the Scott Fitzgeralds of the world, men who had never known what it was like to wait up in the cold glare of a winter day in a back street, not knowing where your next meal was coming from. Or maybe to bleed from the rectum, or to spend ten years listening to pocketship Hitlers telling you what envelope to put into what box as your head sang with pain and your stomach felt like it was about to explode. If Fitzgerald had passed Hank in the street he would probably have thought: there goes an uncouth malcontent. And Hank would have thought: there goes a choirboy. So let nobody talk to him about angst, or scratching your pimples at a dinner party that went wrong because your southern belle was fractious. That was a slice of tweeness he could do without. In his own world you crawled out of the dungheap to only a muted stab at grandeur. You didn't want the whole enchilada.

He negotiated his own way out of the dungheap, as ever, with beer. Becoming drunk was also a way of getting rid of people because they made themselves scarce when he went into shock mode, thus allowing him to savour glorious isolation once again.

He drank so much his landlord gave him two garbage bags every week, as opposed to the single one offered to the other tenants. The joke was that you could get rich on the empties.

In the same way as his boils were a physical manifestation of inner torment, drink was

like a psychic example of a similar kind of suffering. Adolescence caused him to *look* bad, whereas alcohol made him *behave* badly. Both phenomena were different facets of a poor self-image seeping through. They were like safety valves for his dementia.

Most casual observers of Hank's life imagine alcohol destroyed him, but he never saw it that way. As a child it had come to his rescue anytime he was feeling depressed. When other boys of his age were busy discovering women, or success on the playing field, or maybe an academic career, Hank discovered booze. It became a truly magical moment for him.

He abused drink right the way through his life but never quite saw himself as an alcoholic — probably because it didn't interfere with his work. He hated the description of himself as a drunk as much as he did that of a lowlife, particularly when it was used as a stick with which to beat his work. Even worse were those who tried to intellectualise the topic.

In *Women* he wrote, 'If something bad happens, you drink in an attempt to forget it: if something good happens, you drink in order to celebrate: and if nothing happens you drink to make something happen'. There were no prizes for guessing who he was speaking about. Later on he describes himself as a drinker who writes rather than a writer who drinks.

Henry Miller told him drink was killing his muse and he guffawed. The reality was that it was summoning it. If he stopped drinking he would also have stopped writing — and maybe even living. He had read Tom Dardis' book *The Thirsty Muse* and admired it, but refused to see himself in the same league as the writers Dardis dealt with in this respect, writers who suffered the most horrific hangovers and blackouts, who eventually felt unable to write with drink or without it.

O'Neill was especially pathetic, but Scott Fitzgerald wasn't far behind. The other two Dardis dealt with were Faulkner and Hemingway, both of them raving alcoholics but somehow able to contain themselves for creative splurges. That, in a nutshell, was the dividing line for Hank. It wasn't the damage you did to your body that counted, but whether you could get up the next morning — or evening — and hammer out another novel or poem.

Hemingway could because he was such a giant of a man and Faulkner also seemed lo have miraculous recuperative powers, but Fitzgerald eventually reached a point where drinks were drinking *him* rather than vice versa, and O'Neill also drowned himself and his career in a sea of liquor.

No matter what condition he was in, he put something down on paper, not suffering the DT's like O'Neill and Faulkner, nor writer's block like Hemingway and Fitzgerald. He was a fearsome tippler, but a disciplined one. He didn't seem to drink for bravado as much as the others, and far from inhibiting his muse, it seemed to call it forth. At least for a time. Basically he saw himself as a 'two and a half bottles of wine' kind of writer. The poems written on the third one probably wouldn't be up to scratch. But that still wasn't bad going in comparison to the four writers Dardis treated. (It would be interesting to read a revised edition of the book with Hank as the fifth subject.)

When an acquaintance suggested Dylan Thomas drank himself to death because he felt his talent was waning, Hank's reaction was: Bullshit. Drink for him wasn't so much escapism as a gateway to a higher truth. It was like the philosophy expressed in the film *Fight Club*. Modern man had the life sucked out of him by a grinding consumerism. The only way he could get it back was to revert to a kind of primal behaviour: to become the hunter again, to seek real goals rather than the ones he had been brainwashed into

thinking he wanted by the system.

The destruction of the body was almost worth it for the preservation of one's sanity. Everything had its price. Sobriety, at least for this man, exacted a bigger one. Drink saved him from madness, he said. It allowed him to evolve into another form, another feeling. It was the only friend he had at a certain point of his life.

A side-effect of his imbibing, of course, was the personality change it caused. He was fine until about 11:30 at night, as somebody said about Humphrey Bogart, but after that he thought he was Bogart. After 11:30PM, or whenever he had one too many, Bukowski fell into the trap of thinking he was Bukowski. And performing like-wise.

On the other hand, it's probably safe to say that much of his misbehaviour in this regard was contrived. 'I feel perfectly normal,' he told Fernando Pivano 'in my own mad way.' Like Hamlet he might have said, 'I am mad but north by northwest'. It wasn't that he consciously dumbed himself down; more the fact that the madness was built into his routines rather than something that hit him in spasms and sent him into a tailspin. In a way it was his *life* that was crazy rather than himself — or rather life itself.

Whatever way you looked at it, his quicksilver temperament, whether drunk or sober, carried with it a large degree of aggression. He told Sean Penn he acted tough in order to make people wary of him. Call it misanthropy if you wish, or a revenge on his mercurial past.

The main narrative of life is lived in adolescence, they say, and after that it's just sub-plots. It seemed to be true for Hank, for the cruelty he suffered under his parents and classmates — not to mention the medical establishment — formed the basis for six decades of anger. The critic Philip Young once contended that all of Ernest Hemingway's oeuvre could be accounted for by an analysis of the 1918 war wound that traumatised him.

If we wish to apply such Freudian strictures to Hank's output, we could argue that his vicious attitude towards poets who cried into their mothers' hankies came about as a result of the fact that he himself had no mother's hankie to cry into when he was at his most vulnerable. As was the case with Hemingway, Bukowski cut himself off from a fundament of feeling to survive life's cruelties, the alternative being to go under. But nobody can ever cut off feeling totally: they can only bury it. With Hank it resurfaced in the poetry — in the tenderness he showed towards Marina, Jane and Linda Lee, and in the tranquillity with which he negotiated his final years.

Poetry was the manner in which he threw out the stink bombs. It was his bowel movement, his nosebleed, his period, his giving birth, his excavation of the tensions suppressed all through that horrendous adolescence where he was the misunderstood, acne-riddled liability destined for a deprived or depraved life. Or both.

OK.

Californication

No sexual relationship stands still. No
sexual relationship is bound by com-
mon sense. No sexual relationship is
bound by the will any more than
passion is.
John Braine

Hank met Linda Lee Beighle, the woman who
would become his second wife as well as his men-
tor for the last quarter of his life, in 1976 at a
poetry reading at the Troubadour Club. She told
him she liked his stuff and they exchanged phone
numbers. Shortly afterwards they began dating.
He two-timed her for about six months but she
hung around and it paid off. She had always felt
she would be the one to tame him, having the
patience the other Linda lacked in this department.
At thirty-two she was little more than half his age.

Linda Lee was a flower child who had run away
from home at the age of eleven, going on to be-
come a hippie, an employee at a TV station and,
finally, the owner of a health food restaurant called
the Dew Drop Inn. She swore by the 'If it feels
good, do it' philosophy of the Indian spiritualist
Meher Baba, which of course also appealed to
Hank, though he didn't need any figurehead to
ratify his hedonism. Anybody who preached about
taking care of Number One, though, was infinitely

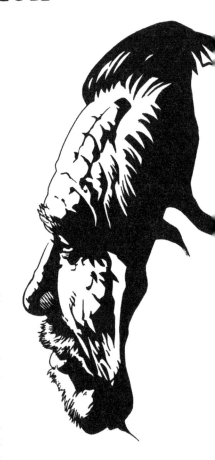

RIK RAWLING

preferable to him than the headier philanthropic visions of such as Frances.

When Hank met her he was looking for an anchor, for somebody to free him from
his penchant for infidelity. Whether he admitted it to himself or not, he knew it was
time to go home. Life owed him a good woman and a stayer and presented him with
one such. She provided what he called 'easy clarity' after a life of chaos and confusion.

He was also having difficulty coping with his hangovers by this time. He had ig-
nored the signals his body gave him for over thirty years, but maybe now it was time to
listen — especially since fate had thrown a kindly woman into his path.

Was the lion finally about to lie down with the lamb? With the first Linda, as with
Jane, it was a roller-coaster of unpredictability, but Linda Lee made him fly low.

She realised his body needed a break from the four-decade mauling he had given it and weaned him off beer and spirits in favour of wine. The upshot of this was that in the morning after the many nights before, he didn't feel as if he'd swallowed 'wet cat turds'. She also got him off red meat, and onto poultry goods.

She even toned down his mood swings: a not-inconsiderable achievement. Her secret was not fighting with him, because she knew he enjoyed that. She allowed him to spin himself out and after that the relationship could be allowed to mature. Too many other women had played his game and burned themselves out.

She ignored his adolescent taunts and in time he grew bored with them himself. 'He could crush you into a tiny piece of dust if he wanted,' she said, 'because he was so good with words. What you had to do to combat that was resist him quietly. Then he ran out of ammunition.'

The Porno King had met the Health Food Queen and the liaison produced sweet music. But also a little cacophony.

An incident where he kicked her off a sofa one day after she denied she was neglecting him was captured on camera by Barbet Schroeder in a documentary. Hank boils over, calling her all the names under the sun, telling her he's going to get an attorney to get her ass away from him. A few years later they were married. This was classic Bukowski — but not too much fun for Linda.

The incongruity of Charles Bukowski dating the owner of a health food restaurant was rich. Few of his detractors gave them a chance, but they barrelled through where he and Linda King had failed to. There was much turbulence in the relationship — no relationship with Hank could ever be without that — but they dealt with it. He moved to a new house with her, bought a computer and started to stock up on his vitamins. She gave him all the free time he needed to work and it looked like the old beast was finally tamed. On the page, however, he continued to forage for mischief.

Love is a Dog from Hell, the aforementioned poetry collection, came out shortly after their relationship took off, but it's much more about the ones he's already gone through. It captures him at a time of his life where he allows his turbo-charged sexuality free rein. This doesn't always make for good poetry, but it's an entertaining book, even if at times the sentiments appear slight and one-dimensional.

Whether he finds himself masturbating (a fairly common activity in the book), being a peeping tom (which sometimes leads to that) or indulging his various fetishes with those only too willing to respond, he adopts a jocose air, metamorphosing a jumble of ostensibly trivial incidents into the tangled skein of his psyche.

There's always one woman to save him from another one, and such serial relationships keep dark thoughts at bay. Women won't ever be as important to him as horses, however, he seems to be saying to us in 'longshot'. The main reason for this is that he can't trust them.

He shows a moving side to his nature in 'an almost made up poem' — which isn't really a poem at all — and he gives a mellow tribute to Frances in 'one for old snaggletooth', telling us she's hurt fewer people than anyone he knows. But generally he's just beating his meat, or fantasising about doing it.

In 'another bed' he outlines his inability to live alone, but the steady stream of

women through his life doesn't seem to be an answer. Maybe the cure is even worse than the disease.

He's able to live with the evanescence, however. For one thing it beats loneliness, so he'll keep with it, keep on falling in love until he gets it right. He knows that somewhere on the planet the right woman exists for him: the problem is trying to track her down. In the meantime, the, whores and groupies will keep calling, and he'll continue to indulge and be indulged by them.

His predicament acquires an added twist in 'the price' where he asks a hooker how much she charges. She tells him $100 but later says she was only joking. When he asks the real price, she replies only with her eyes, presumably suggesting love, or his commitment, and he tells her he can never pay that price again.

'Soul' suggests a change in direction, beginning by telling us Hank gets letters and calls from people worried about the fact that he may be going down the tubes, and thus leading us to believe what they mean is that he may be drinking too much. The opposite is the case, however, as becomes clear in the poem's ironic reversal. What the people are really worried about, according to Hank, is the fact that he's tidied up his act.

Such people are excited by his notoriety, feeling there's a certain ennobling quality in poverty; two shibboleths he gleefully shatters in the latter half of the poem.

Cupcakes appears often, featuring as one of those women with 'cement hearts and beautiful bodies.' He's kinder to Jane in 'some picnic', but there's nothing you could call a love poem here. Quelle surprise!

Many of the poems feature familiar rants against the cosy cartel of writers that always bother him so much: 'the professors', 'an unkind poem' etc. Begrudgery is exposed in 'the 2nd novel', and he's hilarious in the poem entitled 'now, if you were teaching creative writing, he asked, what would you tell them?' as he answers this precise question in typically eccentric fashion. He likens his typewriter to a piano in 'chopin bukowski', and in '462-0614' he documents the phone calls he gets from those who imagine he can solve their problems when he's having far too many of his own. 'How come you're not unlisted' tackles a similar theme.

'Traffic signals' is one of many poems he wrote about his almost pathological fear of old age, while 'the insane always loved me' deals with the manner in which he appealed to lame ducks in his life, like attracting like. 'The crunch' is unusually formal and old-fashioned in tone and 'my old man' gives us an all too rare example of a moment of bonding between himself and his father. The final poem in the collection is the best, ranging over a number of issues and also giving us the phrase 'locked in the arms of a crazy life' which Howard Sounes used as the title for his 1998 biography of Hank. All in all it's an uneven book lit up by occasional nuggets that keep you turning pages more often more out of curiosity than anticipation.

Confusion, of course, is part and parcel of the book's power. Hank never saw himself as having a mission to convert. In fact he usually didn't know what he wanted to say until he said it — and maybe not even then.

One book in which he knew exactly what he wanted to say, however, was Women, which he laboured at intensively in the mid-seventies. He saw it as a tragicomic record of the crazy years of 1970 to 1977, years he would never hope to repeat but which were invaluable for purposes of inspiration.

He wrote Women after his women phase had finished just like he wrote Post Office after his post office one had done so — and Factotum after he stopped being a facto-

tum in the early seventies. Like most writers, he preferred to be out of the forest the better to see the trees.

It's more a series of vignettes than a novel proper, but the scatter-gun style was what he was looking for, having admired it so much in John Fante. It was originally going to be called *Love Tales of the Hyena* but he eventually settled on the simpler title, realising the other one would have befitted a poetry collection better. (The elaborate nature of his poetry book titles is equalled only by the abrupt succinctness of his novelistic ones.)

He envisaged it as a book of 'love, laughter and blood madness', a book that would stop people talking about *The Ginger Man* forever. For Henry Chinaski's bedroom shenanigans make Sebastian Dangerfield look like a choirboy.

Love was ridiculous because it *couldn't* last, and sex because it didn't last long enough. Somewhere between this Scylla and Charbidis, Chinaski negotiates his tenuous trysts.

This was Hank's most ambitious undertaking yet and he awaited its publication with even more excitement than usual. He knew it was a gamble and suspected he would get a lot of heat for it from the thought police. But he also knew that he had put every interesting idea he had ever had about 'the female' into it. To write it, he adopted the guise of the Last He-Man on the Planet: no strings meant no stings.

It finally appeared in 1978, confirming the anti-Bukowski brigade in their suspicion that here indeed was a chauvinist of the utmost proportions. A man who treated women as sex objects and little else, whose idea of foreplay was taking off his shoes first. The fact that the female characters in the book didn't see themselves as sex objects was largely down to the fact that they were portrayed as being as highly-sexed as he was. And about as vulgar as well, which was saying something.

That was the reactionary slant. Pro-Bukowski buffs weighed in by saying that here was a book, perhaps the first, that put down things other writers fantasised about but didn't have the courage to express. It wasn't pornography so much as the demolition of certain myths regarding what Hank termed 'the man–woman thing', and also a rivetting read as his alter ego plays emotional musical chairs with a bevy of women who seem to collect themselves around him like bees round honey, and enjoy him all the more whenever he mistreats them — which is most of the time.

The truth of the matter is probably somewhere in the middle. Hank was coming to the book as a man who'd had a virtual harem in the seventies after thirty years of being a lounge lizard who only occasionally got lucky, and not always with the type of women he would like to look at the next morning, or could even remember bedding. In the book's very impressive first page he tells us that he's fifty, hasn't been to bed with a woman for four years, has no women friends, masturbates regularly, has a six-year-old daughter born out of wedlock, was married to a woman who divorced him, and in love once with a woman who drank herself to death. It's as if he's getting what J D Salinger called the 'David Copperfield stuff' out of the way early so that he can spend the next 290 pages getting up close and personal. He's a man with no history at all, or one he would perhaps prefer to disavow as excess baggage. A CV could be constraining to Existential Man. It was better to forget where you'd been for fear it could cut in on where you were going.

The above circumstances are obviously close to his actual past, but what follows is a mixture of fact, fantasy and some gross misrepresentation of the women in his life. Linda King was unhappy with her depiction as Lydia, and so was Liza Williams, who appears in the book as Dee Dee. Both saw themselves as mere fodder, and also felt

Hank used selective memory in what he wrote about them. Or, more to the point, didn't write.

Voltaire is alleged to have said, after a sexual encounter, 'there goes another novel', but it seemed to work the other way with Hank. Far from suffering post-coital depression, or writer's block, the more women he had on the go the more prolifically he seemed to write. Probably because a lot of his writing was *about* that sex.

With the exception of *Post Office*, the writing of the novel coincides with the events it chronicles more closely than any of his others. This factor is, conversely, both its main strength and its main weakness: the former because of the raw power of the language, the latter because it lacks the kind of panoramic overview that could have given it universality. As it stands, it could be accused of being little more than an amalgam of short (and, it should be said, very brutish) stories loosely cobbled together by the disaffected narrator.

'This novel is a work of fiction,' he writes on the inside cover, 'and no character is intended to portray any person or combination of persons living or dead.' This, of course, was baloney, and few of his conquests had trouble recognising themselves in the book's heady pages. As well as the aforementioned, Linda Lee appears as Sara, Amber O'Neil is Tanya, Joanna Bull is Mercedes, Ruth Wantling is Cecelia and Cupcakes is Tammie. Nor does the list end there. It's as if Hank was busily taking notes all through the years, and, according to some of the women, trying to gain revenge on them for the fact that he spent the first twenty-five years of his life being virtually ignored by the fairer sex. The cynical tone of the book fed into many people's notions that Hank sought out scum, and indeed *was* scum, but if we read between the lines we can see that the sex scenes are counterpointed by a sense of yearning and emptiness within himself that no number of orgasms can assuage. Maybe they only intensify it.

It's too easy to read the book as *The Decameron: Mark Two*. We might be better advised to investigate the man behind the member, a man chasing butterflies, anxious to settle down but unable to tame the beast in himself, at least until the closing pages when he passes up the chance of making it with a groupie after a bad experience with a hooker. As the book ends he's looking towards the kind of stability a Sara can provide. But it's taken him a long time to get there.

Chinaski has all the subtlety of a barracuda in his seduction techniques, if we could even call them that, but somehow he seems to hit it off with women who are only too delighted to perform oral sex on him at every available opportunity, and respond to his caveman antics with yowls of pleasure. We may chaff at the credibility of all this, but the writing is so frank and blunt it seems to usher in a new era of fiction where (literally) no holds are barred. His inset comments on life and love also cause steam to rise off the page, making *Women* into the kind of book that was always guaranteed to be his most memorable, and the one that would perpetuate his iconic status among those who saw him as the super stud of the sewers.

The other way he expresses his macho nature is at the track, where he almost invariably seems to win. Racing driver Stirling Moss once said there are two things a man will never admit to doing badly: making love and driving a car. Here we should add a third: gambling. Because if Hank did this as well as he claimed he could have given up writing and lived off his tote earnings.

One gets the impression from the book that if Chinaski didn't need women sexually, he would just as well do without them. He rarely finds their presence appealing unless sex is hinted at. Because of this need, he busies himself finding out what they want —

even if it means 'eating' them. Their pleasure is important to him only because it increases his own, now or down the road. Turning them on turns *him* on. But we're a long way from love here, or even affection. In fact many of the sex scenes in the book read almost like rape.

If women are indeed predators, maybe sexual violence is the only way to escape being victimised or 'pussywhipped' by them. The fact that they seem to enjoy such violence — the Bukowski female is, more often than not, anxious for some rough-house — only compounds the confusion. Both parties are highly sensuous, but psychologically desensitised. It's like two animals mating, or humans engaged in gymnastic exercises. There's no tenderness, no pillow talk, no sweet nothings. The goal is the maximisation of pleasure, usually by dint of genital stimulation as an appetiser.

'Was she a liberated woman?' he asks of Tanya at one point of the book, to which he answers, 'No, she was simply red hot'.

His characters seem to lack any history. They don't have designs outside the here and now. They speak about vague ambitions between their orgiastic frenzies, but everything seems subservient to these at the end of the day. The zipless fuck (to use Erica Jong's phrase) is the holy grail and everything else leads up to and away from this with varying degrees of jadedness. By the book's end, of course, the sex *itself* has become jaded, as if Chinaski / Bukowski has finally burned all of his testosterone out of himself and is ready to launch himself at life from a slightly different perspective, though what that is remains unclear as he feeds his cat a can of StarKist tuna.

Don't expect any kissing scenes in this book, for Chinaski prefers to cut to the chase, or rather the genitalia, when it comes to close encounters of the female kind.

Debra says to him at one stage, 'I think you fuck women just in order to write about fucking them'. He doesn't flatly deny the accusation either, replying that he doesn't know for sure. The sex scenes certainly read like somebody whose mind is totally disconnected from what his body is doing, or having done to it, so we should take the accusation seriously, particularly in view of what other women featured in the novel (in thinly-disguised form) have said about him in this respect.

There's so much oral sex in the book — hardly a 'love' scene without it — one might imagine his girlfriend was called Linda Lovelace rather than Linda King. The relationship with Lydia is built on friction, a kind of sadomasochistic bantering that reminds one of one of the few films Hank enjoyed: *Who's Afraid of Virginia Woolf*. (He only seems to have been able to admire books and films that in some way related to his own experiences, quite apart from any artistic merit they might otherwise have possessed.)

Chinaski uses his penis more as a battering ram than an instrument of intimacy. Sex becomes little more than a glorified form of masturbation.

So what do women represent to him in the book: beauty or beast, famine or feast? He's hardly quite sure himself. He takes them as he finds them, which is in near-permanent heat, as he is himself, and the closest he comes to being a new man is when he manages to hold his erection for those extra few precious seconds. He's not cruel to them, however, which he sometimes was in real life, so even here he's perfumed the facts somewhat.

A postman once asked him how he 'got' so many women and he replied, 'Getting them isn't the problem, getting *rid* of them is the problem!'

There was some macho posturing here, but the narrator of this book isn't too far removed from such a vantage point. He has moments of need, to be sure, but the fact that he almost expects relationships to fail before they even begin somehow inures him

to the pain of deprivation. He grabs the moment and deals with the inevitable break-down time as he juggles the alternatives. In such an instantaneous universe, two-timing (or even three-timing) acquires something of the status of achievement rather than a moral twilight zone.

'I think it's a damn shame that a man who writes as well as you do,' Lydia says to him at one point, 'doesn't know anything about women'. Maybe this is the failure of the book, but if so it's a magnificent failure, and maybe Hank's ignorance on this score, if indeed Lydia / Linda is right, is more exciting than other writers' profundity about them.

At another point Dee says to him, 'You're good enough with the ladies, and you're a helluva writer', to which he replies, 'I'd rather be good with the ladies'. But a few moments later he says to her, 'Don't love me', as if this will spoil the inconsequentiality of it all. He also tells us that Dee Dee's 'excited and happy reaction to life' irritates him. 'I was glad I wasn't in love,' he confesses, 'that I wasn't happy with the world. I like being at odds with everything. People in love often become edgy, dangerous. They lose their sense of perspective.' So he oscillates between the two women, postponing the kind of commitment that could destroy what they have.

Sex, meanwhile, becomes the sinful joy of expiation:

> The thought of sex as something forbidden excited me beyond all reason. It was like one animal knifing another into submission... When I came I felt it was in the face of everything decent, white sperm dripping down over the heads and souls of my dead parents. If I had been born a woman I would certainly have been a prostitute. Since I had been born a man I craved women constantly, the lower the better. And yet women — good women — frightened me because they eventually wanted your soul. And what was left of mine, I wanted to keep.

He courts prostitutes particularly because they pose no threat to him in this regard: little is lost when they leave. And yet something in him pines for a lasting commitment so he realises he can't win. He's stuck between a rock and a hard place in his zany, self-styled merry-go-round of skewed lechery and riotous post-coital spats.

Love for him is a major encumbrance, a demonic monkey on his back that he must rid himself of as soon as possible. He's happier with evanescence:

> You were with one person awhile, eating and sleeping and living with them, loving them, talking to them, going places together, and then it stopped. Then there was a short period when you weren't with anybody, then another woman arrived, and you ate with her and fucked her, and it all seemed so normal, as if you had been waiting for her and she had been waiting for you.

On the following page he informs us than he would prefer if someone stole his woman than his car, which puts the whole conveyor belt in perspective. The reclusive nihilist needs his space, and tenderness has an unhappy habit of cutting in on that.

In fact it's this sense of alienation that makes the book so impressive. It's easier to recognise Hank in *Post Office*, *Ham on Rye*, *Hollywood* and *Factotum* than here. He's

created a character who lives in a total moral limbo, almost like Camus' Meursault, and takes it from there. There's no other message in the book, in fact no message in it at all. 'People just blindly grabbed at whatever there was,' he tells us, 'communism, health foods, zen, surfing, ballet, hypnotism... and then it all evaporated and fell apart.'

It's only in Chapter 92 that he really comes out of the closet about his true feelings. Here he outlines all the little daily things he enjoys doing with his girlfriends, and how he likes to explore them 'to find the human being inside'... but always with the option of being unfaithful to them, as they will be to him. The understanding seems to be that all relationships are open, and only thus can they succeed, for however brief a time. It's only when he meets Sara and she denies him immediate sex that he's forced to re-evaluate his coordinates, to realise that he might be getting bored with sex. Or is it simply that he craves the challenge of her unavailability in this regard? Whichever, she transforms him into the man he becomes at the end of the novel, and we may take this as pretty close to what happened between Hank and Linda in real life too. He was winding down when he wrote the book, and maybe that was *why* he wrote it. The tired old war-horse needed somewhere to rest his head. After having Everywoman, he wanted his Chosen One to ease him into old age.

Could it be possible that he's even old-fashioned in this sense? Linda, as mentioned, saw him as dirty *and* puritanical, which seems like something of a conundrum. He hints at something like this himself when he attacks the casual sex of the Bel Air set — 'a gymnasium of bodies namelessly masturbating each other'. Such swingers sicken him. He sees them as 'the dead fucking the dead'. There's no gamble or risk in their relationships, they're just cosily liberal: 'It was like a garden filled with poisoned fruit and good fruit. You had to know which to pick and eat, which to leave alone'. OK, so it's not exactly the Book of Genesis, but we know what he means. He needs the passion of desire, the torture of the end if and when it comes. He refuses to be bland — even with hookers. You had to put your heart on the line each time, along with your solar plexus.

Women don't *only* represent sex to him. He writes about the way they walk, the way they dress, the beauty of their faces. But just so as we don't get our hopes up that the petrified Chinaski heart is about to finally melt, he tells us that while men are engaging in typically male pursuits like drinking or watching the ball games, their female counterparts are already planning their demise: coolly, clinically and without mercy. Every woman, put simply, is a praying mantis to Chinaski. One might imagine forewarned would be forearmed, but he doesn't even win out here. Just as he knows booze is bad for him and still drinks it to excess, so also he dives headlong into relationships like a kamikaze pilot, putting all his fears on the back burner.

A later passage takes his feelings into a much wider context, embracing everything from the trivial to the profound as he makes us aware relationships aren't all sex and acrimony for him. They're simply togetherness, being there with your partner, each an extension of the other as ordinary things happen. It's not an idealised scenario but neither is it crude.

In fact it's remarkably balanced for a man so often castigated for beastliness. Hank outlines the things he's sentimental about:

a woman's shoes under the bed; one hairpin left behind on the dresser; the way they said "I'm going to pee..."; hair ribbons, walking down the boulevard with them at 1:30 in the afternoon, the long nights of drinking and smoking; talking, the arguments,

thinking of suicide; eating together and feeling good; the jokes, the laughter out of nowhere; feeling miracles in the air; being in a parked car together; comparing past loves at 3AM, being told you snore, hearing her snore; mothers, daughters, sons, cats... jails, her dull friends, your dull friends, your drinking, her dancing, your flirting, her flirting; her pills, your fucking on the side and her doing the same, sleeping together...

Who else but Charles Bukowski could put miracles, suicide, divorce and urination in the one paragraph and still not appear incongruous?

On the same page he writes — in perhaps the most poignant passage in the book:

I had to taste women in order to really know them, to get inside of them. I could invent men in my mind because I was one, but women, for me, were almost impossible to fictionalise without first knowing them. So I explored them as best I could and found human beings inside. The writing would be forgotten. The writing would become much less than the episode itself until the episode ended. The writing was only the residue. A man didn't have to have a woman in order to feel as real as he could feel, but it was good if he knew a few. Then when the affair went wrong he'd feel what it was like to be truly lonely and crazed, and thus know what he must face, finally, when his own end came.

This is the first (and last?) time Hank will ever make such an analogy.

The passage, in any case, puts the book on another level entirely, and the sexual frolics into a context that involves much larger concerns. They also carry a bigger price tag when (notice he doesn't say 'if') they end. This is Hank pushing himself through the pain barrier of sex as another kind of ballast to shore against the ruins of his emotive meltdown when yet another lowlife maverick calls it quits with him, or when his own ordinary madness makes him long for some breathing space outside the confines of trailer trash high jinks.

The women kill his longing, but they fail to drive out the subliminal beast. They make up for the years of want while he's with them, but nobody, not even Cleopatra, could give him an experience that would last the pace. How could she? He was, after all, the Last Man Standing. The Last Hard Bastard from the bad end of town, sucking up on thrills to kill the enemy inside himself until another binge loomed. Another binge that would intuit a different kind of death. Uh-huh. But in the meantime he would check out every available piece of pussy within spitting distance of Sunset. Maybe the 'perfect moment' lay beyond the next bedpost. Maybe the next piece of ass, the next pair of luscious lips, the next lifting up of a dress would be... therapeutic.

Or, failing that, pass an hour that would have passed anyway as he sat looking into space, dreaming of a lurid and tasty adventure with a woman who would take him up where he belonged; to hog heaven. And so the circle turned. But one of these days he might leave them all, leave them as he once left Jane, or a diseased home, or his own literary dreams.

His attitude to relationships seemed to be that they were going to end anyway so what was the point of investing too much of himself in them. He concentrated instead

on what he could replace them with: another drink or another woman, or both. Such a singular lack of optimism dulls the shock of disappointment when such relationships fail, as fail they must. The question now becomes not 'what have I lost?' but rather 'what's next?'

Women sold 12,000 copies within a year, becoming something of a *succès de scandale* for its controversial author. He was well pleased with the way it turned out, but he wasn't expecting any rave notices from the feminists. Not that he cared. 'I do not,' he proclaimed with wit, 'like arguing with women who wear moustaches'.

Hank's rabid political incorrectness inflamed the critics too. Hans Buch said of him, 'In an age of women's liberation, his poems and stories read like a tragicomic swansong to the last man'.

Hank felt many of those who accused him of sexism hadn't even read Women but were basing their assumptions on the preconceived notions of those who had — readers for whom he was already public enemy number one. And this on the basis of half-baked attitudes to sexuality gleaned from cursory readings of his other books, or potted versions of his life pedalled in shortcut literary profiles.

Maybe we'd be better off to refrain from using terms like 'sexism' or 'chauvinist pig' in this context. At the end of the day, Chinaski feels he's entitled to behave as he does because the women in his life have such amoral agendas. It takes two to tango.

'Sure I make women look bad sometimes,' he once said to Sean Penn, 'but I make men look bad too. Sometimes I make *myself* look bad.' In one sense the book is a blistering attack on women, but it's also a blistering attack on its narrator. We would be better advised to read it as a thesaurus of debauchery rather than any kind of polemic, or manifesto. He had no point to prove when he wrote it. It was never meant to be anything but the story of a man locked between literature, sex, horses and his inability (or unwillingness) to make lasting decisions.

On the surface, Hank's negative depiction of women was indeed sexist, but if we look deeper we should realise that the real sexists are those who give a false view of women in their work. To romanticise is often to patronise. Norman Mailer put it insightfully when he said, 'The main thing feminism taught me about women is that they can be just as shabby and self-centred as us men'. Buk too busted the myth of the female goddess. The pity is that all too often in the course of this he turned her into a she-devil.

He noticed that if he ran *himself* down in books, nobody ever complained, but if he said anything against women or blacks he was automatically deemed sexist or racist. The only safe target for a writer in a corrosively politically correct age, he concluded, was the white heterosexual male.

The reason his women seem to be one-dimensional is because most of them fall into the category of cynical sex maniacs — like Chinaski. Were these the types of women Hank collected around him like magnets and then rejected — or got rejected by — once the allure wore off? He writes of them as if women's lib had never happened, blithely clubbing them over the head like a caveman, but taking the punches too, accepting their rages as if it's the price he has to pay for their liveliness in bed. He often said he lived with voracious women: maybe it's also true he sought such women out, or went places they might be. It's obvious the refined conformist type would have turned him off, but it's a pity he never seemed able to create tempestuous women who weren't cynical and manipulative and prone to throwing tantrums.

For every Jane Cooney Baker there was a Frances, for every Barbara Frye a Linda

Lee, but this isn't the way it comes across here. It's as if he's still writing *Notes of a Dirty Old Man* and needs a supporting cast to match. Some critics have speculated that he knew little about women if *Women* was anything to go by. Or maybe he just dumbed them down so they would slot into his tawdry tapestry more commodiously.

In many ways it's his most assured work, a book with a coarse texture at times indistinguishable from pornography, but perfectly finessed with all those vignettes that approximate to a veritable smorgasbord of the kind of sexism he might have got away with were the book published before the women's movement took root (which was when the actual events in it took place), but certainly not in the late 1970s when the phenomenon of the new man was rearing its head. In another way, of course, its chauvinistic arrogance could be seen as bravely refreshing, flying against the tide of the time as it did. A quarter of a century on, the book serves as Hank's definitive take on 'the man–woman thing.'

Too many feminists mistook the work for the man, mistaking Chinaski for Bukowski. Which isn't to say the latter was an angel, but Chinaski was only one-tenth of his personality, as anyone who's read the rest of his work will instantly realise. He could be an animal when he was drunk, but maybe the reason he drank in the first place was because he was too sensitive to face the world sober. He wouldn't be the first writer to have raised a glass to his lips to try to give himself some iron in the soul.

Such was the power of the writing that not even the feminist broadsides against it carried much weight. Once again the old bastard had gotten away with it.

Any man hooked on pussy, he suggested, was doomed. Whores were fine from a distance but if you got too close you were dead meat. Each one promised to be different but they were all the same at base. Castrators. Feminisers. Hysterical ball-breakers.

Sex, he said in 1969, was a very tragic and a very laughable matter. When he wanted to laugh he thought of his love life, and when he wanted to cry he thought of his love life. Women had first shunned him and then thrown themselves at him. But what were they in love with: him or his fame? Would they have loved him when he was unknown, when the boils were breaking out all over his body and his father lashing him with the leather strop? Would they have loved this ugly, beer-bellied man if he had continued hammering out moribund epigrams from Palookaville? There would always be that niggling doubt with him, and it would be present in all his relationships, particularly the one with Linda King. In general he seemed to look on women as guilty until proven innocent. He seemed to have a permanent fear that they would betray him one way or another — all the sooner the more he cared for them. It had to be in their genes, this need to inflict misery on their victims.

They promised you the earth but gave only slime. But then who had he to blame but himself for trusting them? He was a man insane enough to live with beasts. And, even worse, to love them.

He was the type of man who took love where he found it, in alleyways after midnight or in rooms rented by the hour, neither offering nor demanding longevity. He drop-landed into relationships instead of fabricating them.

Improvisation was the keynote. There were so many types of people in the world, maybe the miracle was that some of them connected rather than the fact that the majority didn't. It was this knowledge that made him try to develop an easygoing personality where women were concerned, but often he felt it backfired on him, that women dumped on him because of it. He thought some of them saw him as the cuddly

dog on the floormat, a victim ripe for the plucking.

Seduction was also a game, which made him forswear it. Why ask a woman up for coffee when you meant sex? Why did every form of activity have to have a lie built into its core? Was there something so reprehensible about the zipless fuck?

Living with a woman was a game run on chess-like machinations. He usually felt like the one that was mated, but he could play his own endgames too.

In his barfly days he didn't get women because he was attractive or stimulating. He got them because he was always around. He was like a piece of the bar furniture that moved, a man women turned to when there was nothing else, using him as a sounding board, perhaps, in the way another hard luck case might use a barman, bending his ear before going out to face the night, or the long walk back to an empty motel.

Because of the way he looked, and acted, he thought women would always flinch from his overtures, but now he had more than he could contend with. And he was also beginning to see the huge price they exacted from him for their concessions. There was nothing more expensive, he realised finally, than free sex.

He had married Barbara for the same reason Hillary gave for climbing Mount Everest: because she was there. He didn't do it from pity or need but simply because she asked him. There's a line in the film *The Magnificent Seven* where Steve McQueen says he knew a man who took off all his clothes one day and jumped into a cactus bush. Asked why he did it he replied, 'It seemed like a good idea at the time.' Hank had the same attitude. He could love and leave equally easily — or *be* left.

Steve Richmond defined him as a radical masculinist, which he would have liked, having had such a beef with what he perceived to be the arrant inequities lodged in the heart of women's liberation.

'The female is skilled at betrayal and torture and damnation,' he subsequently told Richmond, 'Never envy a man his lady.' He followed up these hardly romantic comments by saying that one shouldn't blame women for these qualities because this was simply the way they were made. (By the same logic, one presumes he believed men shouldn't be blamed for satyriasis.)

'Horses, booze and the typer' were his three priorities in the eighties, he told Gerard Locklin — possibly in that order. Women came a poor fourth at that time. He needed them but he didn't want them. And he didn't want them because he didn't trust them.

You knew where you stood with booze, even when it wrecked your head, and with the horses too you played the percentages. They may not have been fair, but at least you went in with your eyes open. Women were different because they made promises they never intended to keep, and then they sucked your soul away. The honeymoon might last a month and then the long knives came out.

He never saw himself as looking for love. If it came at all, he felt, it would do so in its own time 'like a hungry cat at the door.' To that extent he was ruthlessly fatalistic.

Strange as it may seem, he was a one-woman man — and faithful, in his fashion, to whatever relationship he happened to be in at a given time. (Perhaps we should use the term 'in his fashion' advisedly here.) He said he didn't like triangles, but there were times he seemed to be in octagons. And to use women, not only for sex but for literary inspiration.

'I get it off with the word,' he said to Clive Cardiff; no woman could be as glorious to him as the hours he spent at his 'piano'. When he was getting his text down, it was better than good sex. It was like a rush, a mindfuck, a time when all the world's petty excesses and casual cruelties made sense... if only for a moment.

He looked on sex the same way he did eating a meal: you did it, you enjoyed it, and then it was over. But it had about as much relationship to love as a monkeywrench had to a redwood tree.

He seemed to get in deep very early on, but when the relationships ended he also seemed to *recover* quickly. He wasn't a brooder to this extent. He was also able to be as affectionate to total strangers he met in bars as to those he knew all his life. Nobody had a purchase on his heart because he never gave guarantees about how long his feelings would last for somebody. And yet there was an unlikely romanticism at his core.

At the end of the day he seemed happiest with hookers. This isn't schmaltz or a patronisation of street-love: rather his reaction to a raft of humorous, victimised women who were always upfront about what they offered him, and why they did so. There was no hidden curriculum here, no pretentious shot at love. It was like what he had with Jane — a sort of subliminal communion without any baggage or subterfuge. What you saw was what you got so there could be no betrayal, or at least no untelegraphed one.

There was only one thing less predictable in life than a horse, he believed, and that was a woman. But women generally didn't *tell* you they were a gamble; you had to find it out the hard way. He once told John Martin he felt some woman was going to kill him before he reached sixty. (Linda Lee Beighle said she would have done so many times if he wasn't so good in bed.)

Women, he wrote in *Post Office*, denied him the space to breathe. And yet he couldn't breathe without them either. They were as much an addiction to him as alcohol was, and brought just as much agony in their wake.

Both love and sex were ridiculous, he said once, because neither lasted as long as we would wish. You could stretch sex out to a few hours and love, or what passed for it, to a few months or even years, but in the end the woman would turn on you and devour you. Nowhere is the fear of emasculation more evident than in his story 'Six Inches' where the male character is reduced to the size of a puppet — a literal exemplification of a metaphorical reality for him.

That was hardly likely to happen to this man, however, for he continued to play the role of the rake — not only in the States but abroad as well...

In 1978 he made two uncharacteristic trips to Europe. He always said he never wanted to travel, feeling there were too many writers with travelled bodies and untravelled minds. What, in any case, did going to another country mean? Weren't people the same the world over? If his life had taught him anything it was that. It didn't matter what accent you spoke with, or what clothes you wore. We were all treading our own little minefields all the way from Andernach to Andalusia.

Later in the year he went to Paris to appear on a pretentious TV chatshow called 'Apostrophes'. Here he managed to disgrace himself, refusing to allow the cattle call regimentation of television subdue his personality.

He once said that if you ever found him on a talk show, you had his permission to shoot him on sight. It would be like swallowing one's own vomit, he said. How could anything real get said in a sanitised environment presided over by the likes of Johnny Carson or Merv Griffin? It was like a canned culture, the mass hypnosis of mom's apple pie. You dished out sensationalistic scandals or people hit the remote, unhinged by your nerve to be original. That would kill him there and then. 'Conversation destroys talent,' he said. The silence of a graveyard was even more profound.

He was seated between a woman who wrote animal stories and a psychiatrist who had once given electric shock treatment to Antonin Artaud: in itself a formula for something surreal to take place. The latter kept staring at him, he claimed, which unnerved him somewhat. Was he next for the treatment?

Bernard Pivot, who was hosting the show, had got off on the wrong footing with Hank even before it began, Hank refusing a glass of wine Pivot offered him to calm his nerves. After the cameras started to roll, Pivot became increasingly irked by what he saw as Hank's preoccupation with taking over the show. When he finally told him to shut up, that was effectively that. Nobody spoke to Hank Bukowski like that on live TV and got away with it — or anywhere else either. He yanked off the earphone that had been provided to him for translation purposes and stumbled towards the door, putting his hand on the head of one of the other guests to steady himself as he did so; as well as laying some choice expletives on the beleaguered Pivot.

As he staggered towards the door of the studio he pulled a knife on two security guards. Pivot tried to pass it off but it was obvious Hank had stolen the show by taking — no pun intended — French leave. It was all over the papers the next morning and sales of his books went through the roof. Everybody wanted to know who this weirdo was who cut a swathe through all the bullcrap of French protocol — and on an upmarket literary show, no less. Clearly, you couldn't *buy* publicity like this. For Hank it was just another normal night. How many years had he traded *badinage* like this with fellow barflies and nobody wanted to know? That was the thing about celebrity: it made the ordinary extraordinary, the trivial titivating. So he was drunk on television — was this a felony?

Half the population watched Hank insult Pivot, tear off his microphone and stumble towards the exit. It wasn't something the sophisticated French were accustomed to, but they took to it nonetheless, perhaps for that reason.

He remembered nothing of what happened the next morning, and when a critic from *Le Monde* rang him to say, 'You were great, bastard', he hadn't a clue what he was talking about. Linda Lee tried to jog his memory but his alcohol intake, combined with the hot TV studio lights, turned the night into a total blur for him.

He couldn't understand what all the fuss was about. He had drunk too much and got into an altercation: so what else was new? (Apart from the minor consideration that half the population of France had been privy to him doing so. Hardly that many called to De Longpre Avenue of an evening).

Later in the day Hank went to Nice to visit Linda Lee's mother and uncle. Her uncle wouldn't let him into the house as a result of his TV performance so they went to a cafe instead. There the reception they received was somewhat different, with six waiters lining up to bow to him. A French Revolution of a different sort, might say. The whole train of events, in any case, seemed to inspire him for further creative endeavours.

Play the Piano Drunk / Like a Percussion Instrument / Until the Fingers Begin to Bleed a Bit, is probably the weirdest title of any of Hank's books, though it has much competition in this regard. An anthology of a disparate set of poems written at various times of his life, it was published in 1979. It's Hank's smallest collection and betrays its amorphous origins more than once, but there's a clarity and immediacy in the writing and enough hiting imagery to keep you turning the pages.

His mocking tone is evident in poems like 'a little atomic bomb' and 'interviews' (anyone who knows their Bukowski will guess the content of these two simply from the titles), and such jocularity is also evident in many of the other poems, particularly 'an

argument over Marshal Foch'. In 'fire station' he offers Jane to a crew of firemen for money to play cards — an arrangement she seems more than happy to comply with. Sex is also trivialised in the hilarious 'blue moon, oh bleweeww mooooon how i adore you!' where he sends up his stud image. He has a go at D H Lawrence in the ambiguous 'i liked him', a poem with a sting in the tail.

In '12-24-78' he reminds us how much he despises Christmas, with its fake revelry and amateur drunks. The consumption of alcohol was always a very serious occupation for Hank, as we well know, and he had little patience for the 'they tell me I had a great Christmas' brigade who treated it as a kind of cavalier seasonal *divertissement*. Drink is also celebrated in 'some picnic' (a poem that features probably the only pleasant get-together ever experienced between Hank, Jane and his parents) where he raises a toast to Jane's beer belly, which his parents have mistaken for pregnancy. (This poem also appears in *Love Is a Dog From Hell*.)

The most poignant poem in the collection is arguably 'the proud thin dying', which deals with the humiliations of old age, a phobia Hank carried with him throughout his life.

Other poems explore equally familiar themes like horses and literature, the wry 'nothing is as effective as defeat' nicely satirising a creative writing tutor in a manner that puts us in mind of the old definition of a literary critic as a cripple who teaches people how to run. It's a quietly impressive book overall, with many trenchant sentiments, often delivered with crushing insouciance.

Shakespeare Never Did This, also published that year, is a record of two trips he made to Germany and Paris. The ostensible reason for the visit to Germany was to give a poetry reading in Hamburg, but the highlight for him was meeting his ninety-year-old uncle Heinrich Fett, a man who was everything Hank's parents weren't: good-humoured, broad-minded, in love with life and behind him every step of the way. In fact if he had grown up as this man's child his writing career (which was largely born out of pain) might never have happened.

It's a mellow book, the work of a man who has at last found the woman he will spend the rest of his life with and is patently aware of this fact, which gives even the acerbic asides a soft centre. He wrote it without a previously signed contract, which seemed to free his writing hand and give him a wider berth with which to explore his home country through the eyes of a grand old man. Even the poems that he threads through his memories are more restrained than usual, and Michael Montfort's photographs which accompany the text seem to provide proof positive that the beast has finally been tamed. Which isn't to say that he doesn't get up to wild antics, but the anger is gone — even against his father. He's at the point of his life where his reputation is established and he's surrounded by the people he loves most: Linda Lee, Heinrich, Barbet Schroeder, Carl Weissner and Montfort.

He leaves us in little doubt that it's the human parts of the trip that make it memorable for him rather than the architecture, the cathedrals, the castles, the racetrack, the wine or even the poetry. He enjoys himself, but hankers to get back to his own turf: to his writing, his cats, his old routines. In the meantime, he decides to look on the bright side. His expenses have been taken care of and, what's more, 'to get paid for drinking is even more miraculous than to get paid for fucking'.

The Germans also seem to understand his poetry better, he avers, and he makes no secret of his admiration for a nation that had been laid low by two lost wars and still managed to have dignity and fortitude.

He signs his autograph on papier mâché napkins in nightclubs, fends off admirers elsewhere and exists on 'wings of dizzy laughter' with Carl and Barbet. His interviewers he treats with some disdain, either fobbing them off with incoherent rambling or smart-alecky one-liners, which hardly comes as any surprise to us, having already been hip to his aversion towards the Johnny Carson / soundbite culture.

Much of the book deals with the practical details of his travelling arrangements, but it's infinitely more interesting for the capsule ruminations on his life up to this: the madness that has almost suddenly become subdued into what W B Yeats once called 'the smiling public man'. The reading itself attracts 1,200 people into a venue that caters only for 800, and when the chants of 'Bukowski! Bukowski!' start up he replies simply, 'It's good to be back'... after fifty-four years. What would his father have thought?

Neither would his father have known what to make of a reading he gave the following year in Redondo Beach, a suburb of LA. He introduced it by saying he hoped it would be a 'dignified' evening but his tongue was firmly planted in his cheek because most people knew what an audience with Hank Bukowski signified by now. It wasn't long, in any case, before the ambience more resembled a cockfight than an evening of poetry. After a rambling discourse from him, one disgruntled member of the audience groaned. 'Read your poetry!', to which Hank replied, 'I'm running this show, not you,' to wild cheers.

He assured everyone that the beer he had in his hands was a necessity rather than a prop, but they hardly needed to be advised of this. 'I'm Humphrey Bogart!' he roared at one point, 'I'm carrying my steel, man.' And shortly afterwards, 'One more beer and I'll take all of ye — I've been lifting weights!' To those who might have preferred more rarefied behaviour he growled, 'don't ask for your money back cos I already got it'. He then added, 'I got in free... and I'm drinking too'. When a member of the audience screamed, 'You're drunk!', he deadpanned back, 'I wish you were'.

He confessed to the gathering that he had come here 'not to conquer Redondo Beach, but just to get a thousand dollars'. But of course he did conquer it. Turning poetry into a performance art rather than its former status as the Cinderella of literature, his attitude to his listeners was that of a man who knew what they really wanted behind all the subterfuge that generally passed for fastidiousness in this sphere. He may have been standing on a pedestal, but the unspoken understanding was that he was at one with them. That he was coming from the place they were in, that there was a shared experience of life's insanity.

His self-deprecating lyrics, delivered in that deranged oracular tone — at times the voice was so soft it sounded almost effeminate — exposed the sham that so much other poetry was built on. His listeners were coming from the factories and the trailer parks, but that didn't mean they were philistines. What it meant was that they felt they had been sold short by an establishment that predicated quality on the basis of self-satisfied obscurantism. His irreverent antics and his down-and-dirty asides brought the fun back into the literary line.

He sloughed off the Emperor's New Clothes as he chortled both at life and himself, but there was a miasma of darkness shimmering barely beneath the surface. This wasn't always caught, but he was hardly complaining. Everything had a price, and he was willing to play the clown prince for his fee. Ten years ago he was doing this sort of stuff for nothing, or the price of a room for the night. Now he could almost buy another car with what they gave him. It was a form of whoring, to be sure, but a hugely enjoyable

one because he was preaching so much to the converted. Suddenly it seemed a long, long time since Whit Burnett accepted his first work for *Story* magazine in 1944.

He had divested himself of all that adolescent intensity in favour of an assault on anything approaching respectability. 'Don't give me any shit, man,' he droned, taking on all comers, 'or I'll come out into the audience and cut your nodules off your earlobes.' And the place erupted with the whoops of a gathering that seemed to enjoy being insulted. As the real Bogie might have said while slapping his latest moll about the place, 'You'll take it and like it.' And they did.

That year also saw Joyce Fante read him the last chapter of her husband John's latest book *Dreams From Bunker Hill* over the phone. Hank was almost as taken with this as he was with Fante's *Ask the Dust*. By this time Fante's health was in a chronic state. Retinal damage to his eyes had rendered him so myopic he was hardly able to see book contracts, and diabetes, ulcers and running sores made his feet gangrenous. He had toes on both of them amputated, then the left leg below the knee and finally, when this didn't stop the problem, the left leg above the knee. He bore all this manfully, telling his friend Ben Pleasants that bitterness over one's fate was something every writer had to fight against for fear that it would shrivel him up. He got his emotions out by crying but no matter how miserable his plight became he kept his spirits up. Hollywood friends like Francis Ford Coppola, Robert Towne and Martin Sheen buoyed him up, all the more so if they discussed the possibility of future screen work. Like the epitomic Hemingway hero he was destroyed but not defeated.

When Hank met Fante he told him he meant more to him than any writer he had ever read, living or dead, and Fante, despite the horrific state of his health, was touched. By this time he had also opened John Martin up to the rich reservoir of Fante's works after he had brought him to Martin's notice with a passing reference to him in *Women*. Martin took it upon himself to check out *Ask the Dust* upon Hank's recommendation and was as impressed by it as Hank was. He set about republishing it with Black Sparrow, thus opening up Fante to a whole new generation. (The book had been out of print for twenty years by this time.)

Fante asked Hank to write the preface and he duly obliged. He wrote about the first time he had seen the book on a library shelf, in the days when he used to go to libraries to (a) hide from landladies who were looking for the rent, and (b) to avail himself of the toilet facilities. He had been riffling through various tomes, as was his wont, when he suddenly spotted it. He pulled it down, started reading it, and his life changed. He couldn't believe a book could relate to him quite this starkly. The manner in which Fante had chiselled his syllables, his mix of humour and passion, his sense of structure — this was writing at its most captivating, and he resolved to try and replicate it. He read all of Fante's other works afterwards and saw in them the same beautifully textured luxuriance shot through with an aching melancholy, but *Ask the Dust* always held a special place in his heart because it was his first exposure to him. He had read it first in 1940 and now, thirty-nine years later, it still cut it for him.

There was also a spin-off effect on Fante's other books as a result of Martin's action, and in time they too came under the Black Sparrow imprint. Hank even dedicated *Love is a Dog From Hell* to Fante, and Fante in turn helped Hank with the *Barfly* screenplay he was then working on for Barbet Schroeder. What a pity, however, that just as a literary renaissance appeared likely for him after so many years in the doldrums, and so many years working thanklessly on often meretricious scripts for both television and the movies, he wasn't in a fit condition to enjoy it. His right leg had now become diseased, and

the pain was excruciating. And then the nightmare began in earnest, for the same torture he had endured with his left leg assailed the right one as well, with amputations below and then above the knee being necessitated. It was like death by a thousand cuts — literally. Joyce's ever-constant support was invaluable but everybody knew it was the beginning of the end. As if all this wasn't enough, he also had to contend with bouts of paranoia. After being released from hospital on one occasion, he somehow got it into his head that Joyce had kidnapped him. He sat bolt upright in his wheelchair with a loaded gun in his hands, his eyes on fire with the internal demons that plagued him.

Everybody knew it would be a blessed release for him when he finally died, but that didn't make the prospect any easier to bear. When he did eventually die in 1983, Hank truly believed he had lost not only a role model but a friend. Without *Ask the Dust* he might never have been inspired to become a writer; he could think of no greater debt one author could owe to another.

Dangling in the Tournefortia was published the following year. The first poem, 'the stink', reminds us yet again what an incredibly rich memory Hank had as he writes about a childhood experience of a woman who seemed to be permanently drunk. She disgusted him at the time and he couldn't understand her need for whiskey, but forty years later, as he himself has succumbed to its power, his opinion has changed.

The poem that follows this is also set in the past, documenting Hank's first literary efforts at the gentle behest of his English teacher, who gave him the encouragement every fledgling writer desperately needs. He responded in kind, flooding her with compositions which delighted her. All these years later — partly thanks to her — he's still scribbling, and this poem, 'the lisp', so called because she had one, is in her own honour, a panegyric that celebrates her early vote of confidence in an insecure boy.

'Silk' continues the nostalgic strain, but in 'on shooting' we get a more familiar Bukowski, sneaking looks up the legs of a next door neighbour of old. The next two poems feature, respectively, the monotony of work and Hank's manner of dealing with this by going AWOL as often as possible. Thereafter we get much flotsam and jetsam as he picks scenes from his life at will, giving us snapshots of the way he thought and lived before fame arrived.

'I didn't want to' is an interesting exploration of his contradictions. A man who hated classical music in youth and who is now a buff. Who had contempt for money and yet married a millionairess: who hated poetry and then became a poet. In 'taking care of the big whammy' he trivialises jingoism beautifully.

'Ladies' man' has him relating details of the kinds of women he attracted: usually lowlife ones with severe drink problems who called to him in the middle of the night looking for booze. They are, of course, still preferable to the kind of woman he deals with in 'platonic', a pretentious bore he satirises with commendable restraint. When she makes it clear she's uninterested in sex he reflects: 'sex isn't everything. / there was the soul too' — a very un-Bukowskiesque stance. He ends by looking for that soul, but one suspects he really feels it's his anal retentive lady-friend who lacks one.

'Hello, Barbara' is an amusing look back at his marriage to Barbara Frye, the social-climbing heiress who divorced him when she concluded he was an irredeemable bum. He phones her one night years later only to find she's still as cold as ice to him, and as unforgiving. He takes it all on the chin, however, speculating that she may well have been right to throw him out.

'We've got to communicate' has Linda Lee character-assassinating him, which he

also takes on the chin, demonstrating his remarkable ability to see his worst traits and be philosophical about them. She also gives him a going-over in 'dummy', an equally ribtickling résumé of his hardly-hunk status. In fact he appears almost like a fractious child here. He gives a more mellow view of their relationship in 'let it go', which also captures the ordinariness of married life, whereas in 'my big fling' he charts the aftermath of a spat which looks like it's going to end up with him picking up another woman. The refreshing twist is that he doesn't.

His flair for the eclectic manifests itself at full tilt in 'within my own madness' and 'fourteen dollars and thirty-two cents', two examples of his incredibly jumpy mind. In 'on the hustle', meanwhile, he allows us a porthole into the disaster zone that was a post-binge attempt to answer questions about literature to pert college kids. This is very similar in tone to 'a poetry reading' and 'the American writer'. In these three poems he leaves us in little doubt that he likes to be left alone to get on with the business of wordmaking without the intrusions of handshaking brain pickers — but of course we knew that anyway. ('Attack and retreat' also explores this theme).

'Parked' has him looking at a boring young man on the street who's almost physically perfect and imagining that this is how his parents wanted him to turn out: a carbon copy of their own brain-dead conformism. 'Notes upon a hot streak' has him at the races, playing the horses 'like other men play chess', and he's here also in 'do you use a notebook?' and 'suckerfish'. He leaves us in little doubt in these poems that parking attendants rank much higher on his list of desirable people to meet at the track than writers.

'Order' makes the point that creativity can easily be stumped in a room that's too tidy. His parents would never have understood this. The muse flows much better in 'contemporary literature, one' where he starves in a paper shack in Atlanta writing in pencil on the edges of newspapers as his father ignores his requests for money. He has long gone from such penurious circumstances in 'the secret of my endurance' and now other starving scribes are writing to him for advice. He's their working-class hero, they insist, but he wonders if they realise he's now living in a big house with a long driveway behind a six foot hedge. The irony is rife, but his ability to laugh at the sudden reversal of fortune suggests corruption by its blandishments to be unlikely.

Towards the end of the collection we get a 'Prayer for my Daughter' style poem for Marina ('for the little one') and immediately after it a rather desultory set of ruminations on life and death that remind one of Philip Larkin. It's one of Hank's more successful threnodies, but it somehow appears out of sync with the foregoing, probably because of its muted quality.

There don't seem to be as many references to drink here as in his other books. 'night school' casts a jocular look at a drunk driver's class where he shines. In 'produced and bottled by... ' he informs us that you can trust a drink much more than you can a woman, but in 'slow night' he confesses that wine is now destroying him in the way his father once did. On the other hand, his father created Hank's artistry by trying to snuff it out of him so in this way he's inversely grateful to the old son of a bitch.

'You can thank my father for my writing career,' he said once. 'If I hadn't suffered so much at his hands, there would have been no poems, no passion.' 'Fear made me a writer,' he told Neeli Cherkovski 'fear and lack of confidence'. It was all grist to the mill.

It was as if every lash of the razor strop was an extra poem, every temperamental outburst a new short story. Pain was the whetstone from which he sharpened his

sentences. It was the porthole through which he summoned his muse. Without this, he might have remained just another prissy introvert with boils. His father gave him the aggression he needed to make it, to circumvent the host of problems life dealt him. The abuse he got at home even helped him to better deal with what happened in the schoolyard and the classroom. It formed a continuum with later abuse, and stopped him running from it to his mother's apron strings for solace. The point is that there was no hiding-place. The only solution was in himself. No god or family member could protect him from what was coming to him. He had to learn to become immune to it, to assert himself over it.

His father helped him not only with his writing but with all life's other problems as well. Because Henry had given him such inner strength, Hank was able to use this no matter what went wrong for him.

'The father never leaves,' he told an interviewer once. 'Mine was always with me, not in my heart but under my toenails. Sometimes he even took on female form.' Every time Hank found himself with a mad woman he thought of her as his father reincarnated, as if he were the devil in human form.

In fact he once raised a glass to him with this dubious tribute: 'Thank you for my poetry and stories, for my house, for my car, for my bank account. Thank you for those beatings that taught me how to endure.'

Such endurance would have an almost literal manifestation in his next book, which was as close to an autobiography as he would ever come. It was a book he resisted writing for many years for obvious reasons, feeling it was bad enough having to live the pain without dredging it all up again for the purposes of a book, but John Martin eventually prevailed upon him to slay the dragon for once and for all in print. The manner in which he did so raised more than a few eyebrows.

Most childhood memoirs, he felt, were boring and contrived, which was why he agonised for so many years over doing his one — and why he went out of his way to make it different.

Ham on Rye appeared in 1982. If one wishes to divine the essence of Bukowski, this is where to find it. We had read many of the anecdotes featured in miniature in the poems, but here, together, is the long-awaited, long-overdue back catalogue. Containing all of his disgruntlement, all of his alienation and all of his humour, it's as important a part of the literature of adolescence as anything that appeared before it on a similar theme, or has appeared since.

In these turbo-charged pages Hank explodes most of the myths of the all-American childhood, basing us in Nightmareville where his demonic parents make life even more miserable for him than it would have been if he weren't afflicted with walnut-sized boils, a resentful disposition, an unscholarly nature, a diffidence with girls, a nascent hostility and a pronounced discomfiture of temperament.

The early sexual leanings are here, the locker room banter, the derring-do, the peer groups, the irreverence, the generation gap, the fake jingoism, the macho imperatives, the jealousy, the crippling depression that's lifted partly by booze, the long slow slide into post-graduation lassitude.

Hank waited forty years to write this book because the events it chronicles meant so much to him. If he tried to tackle them before he'd honed his craft he mightn't have done them justice and they would have been subsequently lost to the world of literature. He was content to recycle other anecdotes from his life many times with only minor variations, but he didn't want to play around with the childhood years. They

were too painful for that, and you didn't get a second chance at trying to document them faithfully.

His life begins with screaming all round him, his grandmother promising to 'bury' everybody in the kind of tones that make you imagine she means business. Our first reference to Hank himself is that he's unhuggable: when the aforementioned lady attempts such an act, he hits her on the nose. (Even this early, he was a sound judge of character!)

His father, who believes that children should be seen and not heard, barks at him continually, so much so that he feels he must be an adopted child. At school he has few friends but doesn't seem to miss them, content to brood alone about the sad lot life has dealt him. Football provides a temporary respite but at home again there's the roaring, the nagging, his father beating his mother and his mother taking it... and the endless lectures. Lectures about his future, about what he should be doing with his life, about how he should be grateful for being fed and clothed. Would the day come when Henry would actually start charging Hank for the oxygen he breathed on his father's property?

He forms a friendship with a boy missing an arm and they click, one outcast appreciating another. His life has moments of tranquillity, but then the lawn-mowing episode raises its ugly head and his life is hell once again. He's beaten senseless by a man who's either insane or as evil as Hitler, but yet he can't find it in himself to hate him. He takes whatever is dished out to him as if it's his destiny to be a victim.

He also feels it's his destiny to be the school tough guy, as if his sullenness of manner can have no other outcome. Being bad has an allure for him: it gives him the cachet missing from the rest of his life. Being bad makes him a *somebody*.

And then comes the initiation into drink, the most magic thing of all. The potion that took all his pain away, all his feelings of resentment and deprivation, being soothing and uplifting at the same time.

At home his father loses his job but pretends he still has one and goes out each morning. His mother works too so the house is his own. He creeps back in when they're gone and spies on a scantily-clad woman across the street, masturbating as he does so.

Acne is his next crisis, hitting him just as he's beginning to be accepted as a roughneck. So circumstance has played another cruel hoax on him, denting his rebel status by transforming him into a creature people will be disgusted by, and / or jeer at. Now they will avoid him not from fear but revulsion. Especially women. Which woman would date a boy whose face looked like the Grand Canyon?

In senior school he becomes even more conscious of his deglamorised status. He watches the beautiful people take their dates to the beach in convertibles and wonders why he was born poor and ugly. There's no logic in it, no justification. When it comes to gym class he's too embarrassed to take off his clothes so he joins a military squad instead to soak up this time. At home the pus spurts out of him and he bursts his boils in frustration. His parents cover him with ointments that stink and burn and there seems no way out. In the hospital the doctors drill him with needles and the agony continues. His grandmother thinks the devil is inside him and sticks a crucifix into his back to drive him out. Hank screams at her, sending her out of the room, and then curses God.

What little joy there is in his life at this time comes from reading and writing. He begins to write a story about a German aviator called Baron Von Himmlen, an ugly man with scars on his face like Hank, 'but beautiful if you looked long enough'.

Himmlen also drinks heavily, and is a military hero, shooting plane after plane from the sky. It's as close to Superman as the perversely fantasising Hank can come.

Meanwhile, his father finally finds a job at the county museum so Hank's free medical treatment has to stop. He'll miss a kind nurse at the hospital, but little else. He starts reading in the library at this time, filling his mind with the stories of other people as badly off as he is. They become his friends, his soul mates, as close to him as anyone he knows, closer. At school he continues to attract misfits. Girls are still out of reach for him so he pretends they don't exist for fear he'll go out of his mind pining for them. When he goes to the beach he feels doubly uncomfortable, concluding he will never be able to live with people. Maybe he should become a monk, or else he could go to sleep for five years. That would be another attractive escape. A third option, as ever, is the consumption of alcohol.

He's now attending an elite high school because his father hopes that the 'ruler's attitude' will rub off on him. But this is never going to happen. He knows that the poor always stay poor and the rich always stay rich, and all you can do is accept it or escape it, because nobody is going to change it. The ugly will always stay ugly too, as he finds out at the school Prom when he stands outside watching the people who are going somewhere in life dancing together, being happy and pretty with easy manners and fine clothes. The night custodian tells him to go home, which he does. Shortly afterwards, on graduation day, he decides that what the future holds for him is a 'hairy crawling turd'. The land of opportunity will never be that for him. It will only be one dull job after another, with aggressive boneheads making him fulfil functions like a robot until he crumbles. In Mears-Starbuck the tough guy is finally broken.

His father couldn't break him and neither could the teachers, but the world of employment does. He has no future and no past, no anything. And neither does he wish to be anything.

His father twists the dagger in him at home, telling him he's a nothing. He looks for other jobs but they don't materialise. When the Second World War begins he doesn't want to sign up, having a sneaking regard for Hitler, a man who did for Germany what no American politician could do for America. So he becomes a proponent of Nazism, knowing this is making him into public enemy number one with everyone he knows. But why should he care? When you have nothing, you have nothing to lose.

The last straw is when his father finds his writings and throws them out the window, along with his clothes and his typewriter. There can be no going back on this, and no way he can live under the same room as this man again. He's accused of being a dirty writer by a redneck and decides he can do either one of two things: leave or kill his father. So he decides to leave. It's the slightly lesser of two evils.

The place he goes to is no nirvana, no Shangri-La. It's the row, where the other outsiders hang out. He's always known that he's been odd, that he's destined to be a murderer or a bank robber or something like that, anything that might save him from the crippling decay of routine, and the row seems conducive to such an identity.

Nobody preaches to you here, and people allow you to be alone, to sit in your own space and destroy yourself if that's your wish. It's as close to peace as he's been for a long time. The Japanese bomb Pearl Harbour and he's unmoved, as unmoved by patriotic bleating as he has been by anything else up to this. He drinks and plays a boxing game and the book ends, having given American literature a new anti-hero: Henry Chinaski, the misanthrope with a coruscating sense of humour.

The book was a huge undertaking for him and he rose to the occasion with aplomb.

For many it's the great Bukowski novel, the one where he outgrows his bad stylistic habits and gives us solid narrative meat, lyrical interludes, righteous anger and a well-rounded narrator. The poor man's *Catcher in the Rye*, if you like — which may explain why he chose this title, ham on rye being the typical working man's lunch of the time. Eponymous mischief on Hank's part aside, it remains his most ambitious novel, and time has been kind to it. The question he must have been asking himself now was, could he top it? He had spent so many years building himself up for this book in which he was going to reveal so much of what had previously remained private, he was entitled to feel drained, or even written out. For this reason, he was probably relieved that a new dimension was added to his career with a movie from an unlikely source the following year...

1983 saw the release of Marco Ferreri's *Tales of Ordinary Madness*, a film based on some of Hank's stories and featuring a woefully sanitised Ben Gazzara as the thinly disguised boozing/lusty Chinaski. Gazzara and Hank got on well but the project was obviously doomed to disaster by playing it the safe way, i.e. choosing a pretty actor to 'open' the movie. Hank despised it, feeling his voice had been muzzled.

He liked the intensity in Gazzara's eyes, but unfortunately it was the wrong kind of intensity. (In fact Gazzara's expression more than anything else reminded him of a man straining to have a shit.)

Madonna attended the premiere with Sean Penn, but refused a drink from Hank's hip flask when he offered her one. Bad decision! (This was probably the moment Hank decided she was wrong for Penn, whom he had taken to from the outset, enjoying his no-nonsense attitude to celebrity status.)

Hot Water Music, another collection of short stories — this time dedicated to Michael Montfort — appeared the same year. Sassy, sexy, outrageous, spare, they seem to fill the gap between Damon Runyon and Elmore Leonard. Few holds are barred in these smart-alecky pages, and if they all seem like one story told thirty or forty different ways, well then maybe this could apply to all Hank's work — if not every writer's work.

Writers figure strongly in them too, all suspiciously resembling Hank. In fact we even get his familiar diatribe against 'liberated' women (in 'The Great Poet').

The polemical edge is slight, however, and his rogue's gallery of likeable lowlifes throbs with visceral energy.

The autobiographical element is most apparent in the two stories entitled 'The Death of the Father', numbered One and Two respectively. Here he writes about the passing of that man as if he were a far distant relative. Afterwards he has sex with his father's girlfriend, the final ignominious expiation of his hatred for him. In Part Two he writes about the nonchalant manner in which he disposes of all his father's possessions, having something of an auction in the house as it's divested of all his effects, most of them given away for nothing in a kind of expiation. (The whiskey, significantly enough, remains.)

When we get to the vexed question of lawn mower escapades, one expects him to go into a tortured rant about everything that implement conjured up for him, but instead he confounds our expectations and just lets it go. A nullified mood is paramount, but a strange sense of tranquillity also descends as the main threatening influence of his life is removed from it forever.

War All the Time, a collection of his verse from 1981 to 1984, appeared in the latter year. It's impressive in its authority. In 'talking to my mailbox' he berates a young writer for sending him material for vetting instead of submitting it to a publisher. Hank

himself never solicited the aid of middlemen, and he never had much time for those who looked for shortcuts or intermediaries as they burned words onto pages to earn a crust. You've got to do it on your own, he advises finally, the wise words of a man who's clawed his way to the top, who knows all the tripwires.

In 'the last generation', the poem that follows this, he makes a clever contrast between the 1980s and the 1920s where he presumes — rightly or wrongly — that it was much easier to be a genius in the twenties, because there were fewer writers about. 'A Love Poem' sees him reflecting on the women in his life with an uncharacteristically cool and objective voice, but he's back to his irascible old self in 'a beginning' where he suggests that women should only be entitled to talk about liberation when they stop carrying mirrors with them.

'On and off the road' is an interesting insight into his views on poetry readings. He compares peddling his wares in this fashion to being a travelling salesman, with the added bonus of being allowed to insult his clients (his invariable response to hecklers) and, hopefully, getting laid. The same unwriterly stance is in evidence in 'the star' where he writes about being drunk and disorderly after the premiere of a film about his own life. A poetry reading is also the subject of 'the hustle' where Hank reveals that he has no illusions about his talent, but still feels he's better than the opposition.

'Eulogy to a hell of a dame' is a tribute to Jane, a woman he believes was destroyed because she realised everything around her was meaningless, and took that thesis to its inevitable end. She was given little in life and gave little back, but she had style and character and she imprinted herself on Hank so much that since she died he's left with nothing but 'the rotten present'. The other women in his life, the 'girls from nowhere', can't compare to what he had with her. Sitting with her in a cinema with a bag of popcorn in his hand was infinitely preferable to the roller-coaster ride his life has been since. Living in tawdry roominghouses, sex was the poor man's polo for him, but it sufficed. He had, after all, failed at most other things he tried in life.

Nostalgia crops up in 'John dillinger marches on', but in 'on being 20' and 'dear pa and ma' he etches in the dismal tapestry that was his home life. 'How I got started' deals with the miserable jobs he took because he had such a poor self-image, while in 'the walls' he writes about the years of drinking and the toll they exacted on his finances.

In 'oh yes' he tells us there are worse things in life than being alone — as this classic recluse well realised — but seclusion helped him hone his art, even if the pickings from his writings were slim in the early years. After he made the big time he had to contend with begrudgery, he explains in 'an old buddy' and now he's in 'Who's Who in America', as he reveals in 'our curious position'. Begrudgery isn't the only problem he's had to contend with since becoming famous, however. There's also the problem of those he half-knew jumping on the bandwagon as 'old friends' in 'a note to the boys in the back room.' But what a long way he's come since the days when, as a mailman, he delivered a letter to a 'famous writer' and was ignored when he mentioned that he too wrote.

'Practice' is a funny and yet profound rumination on death, a subject that also crops up in 'suggestion for an arrangement', where he says that he wants to die with his boots on rather than with his ass stuck in a bedpan or, like Fante, blind and with amputated limbs. Hank informed Fante once, he reveals, that the gods were punishing the sick man because he wrote so well, an unusual statement from a man who believed in no God at all, reminding us of Beckett's 'The bastard — he doesn't exist!' from

Endgame. Mortality is also the theme of 'eating my senior citizen's dinner at the Sizzler', one of the final poems in the collection.

You Get So Alone at Times That It Just Makes Sense (a typically succinct Bukowski title) appeared in 1986.

Two of the poems deal with his father. In 'retired' he writes about Henry's gluttony, his boring life and shock death, whereas 'my non-ambitious ambition' outlines the manner in which the old man's *Reader's Digest* bromides had the effect of pushing young Hank in another direction entirely.

And of course that's what happened. If we now flash forward to when he's a twenty-one-year-old in New Orleans in the poem 'my buddy' we see him befriending a disabled old man in a seedy apartment. The man tells Hank, 'nothing is worth it', a remark which makes him conclude that he was a sage. One might have imagined a comment like this to depress him, but so huge is his hatred of his father's positive thinking he regards the easy decadence of this affable old man as a pleasing antidote.

Many of the other poems in the collection take up this theme, most prominently 'bumming with Jane' where he writes about the years he spent with that sweet lady — whom his father hated with a vengeance, not surprisingly. His life with her is a smorgasbord of car crashes, hospitals, drunk tanks and fishing newspapers out of trashcans for a free read, but he looks back on these days now as the most wonderful time of his life. He paints a somewhat different picture of their liaison in 'my first affair with that older woman', describing her as somebody who lied to him, stole from him and was both abusive and unfaithful.

Here we have Hank giving two almost contradictory appraisals of the same woman, and yet somehow it all gels. After she dies, he writes, he drank alone for two years, but there's no hint of sentiment or self-pity. Once again he lets the facts speak for themselves, and readers draw their own conclusions. As he puts it in another poem ('well, that's just the way it is…') no matter how grim things get, he'd still prefer to be himself than anybody else.

'Beasts bounding through time -' is a powerful poem dealing with the huge price fame exacts from all artists as Hank trawls through the pages of history with a grocery list of tragic cases. 'The lost generation' is somewhat more specific as he castigates those writers in Paris in the twenties who always irritated him with their 'rich dumb lives'. Scott Fitzgerald comes in for a more detailed hammering in 'their night'. Fitzgerald, of course, is an easy target for Hank with his overtones of prissiness.

In 'final story' we get the Bukowski take on why Ernest Hemingway committed suicide. His contention is that Hemingway was destroyed by the juggernaut of fame rather than anything endemic in himself. This is questionable, but it's not difficult to see why Hank would feel this way seeing as he treated his public life with such ill-disguised contempt. It is, however, a simplistic thesis as Hemingway had a host of problems apart from this. He was an alcoholic depressive with writer's block, as Hank well knew, having read the aforementioned *The Thirsty Muse*, so it's surprising he takes this reductive stance on a man he knew to be so complex.

Another subject close to his heart is the ineffectuality of 'well-worked poesy' which he addresses in the ironically-titled 'for my ivy league friends'. He plays the Hard Man in similar vein in 'termites of the page' where he inveighs against the 'fashionably dull' set who never had to work for a living. This severely dents their ability to craft magic on paper.

He adopts a similar tack later on in the collection when he reveals that it disturbs him

profoundly to be dubbed 'the world's greatest living writer'. Far better, he says, to be known as the world's greatest pool player or the world's greatest fucker. Smoothies are also hammered in 'I meet the famous poet' and 'murder', where he rails against the 'timeclock' compositions of those who 'write for Cadillacs'.

We get an unusually nostalgic Bukowski in 'O tempora! O mores!' One can be excused for blinking twice in this poem which harks back to the days when the glimpse of a stocking was looked on as something shocking. It's hard to believe the man who wrote *Women* would admit a preference for a well-turned ankle to a selection of girlie magazines, particularly after reading 'love poem to a stripper' where he gives a more predictable green light to a red-light district, writing with Runyonesque affection on tarts with hearts. Nostalgia also turns up in 'glenn miller', a poem one finds hard to square with the rest of this man's canon, and in 'magic machine', where he writes about the wonder of listening to a victrola and all those scratchy records of the 1930s. The former ends with a piquant image of the world around him 'opening its mouth / in an attempt to / swallow us all', whereas the latter has a more recognisable sting in the tail, its author emphasising the fact that part of the magic of the machine was the fact that he was listening to it when his parents weren't around and thus making us wonder if the poem is really a tribute to the music or an indictment against them.

The combination of writing and drinking crops up often as well. 'The Master Plan' is a humorous piece featuring Hank deciding to give up poetry when he realises he's getting nowhere fast, content to devote himself instead to the much less arduous practice of drinking for a living. In the latter capacity he doesn't have to worry about bothersome details such as rejection slips, or even paper. All one needs to be a card-carrying drunk is a good elbow and a liver to match. There's no money in it, unfortunately, but neither is there in writing. So what, really, has been lost?

This is a much more preferable scenario than the one he depicts in the harrowing 'death sat on my knee and cracked with laughter'. One night things are so bad he decides to spend the last of his money on a loaf of bread, planning to eat all the slices slowly, and pretend they're pieces of a delicious steak. When he gets home, however, he realises the bread is too mouldy to eat. The mice help themselves to it instead, creeping over his 'immortal' stories as they chew around the mould.

Fame has come his way by the time we get to 'huh?' but more so on the continent than in America, leading him to conclude hilariously that he must have 'some great motherfucking translators'. In the title poem he writes about the hungry years as well, and his ten year lay-off, at the end of which he's ready to give it 'another shot in the dark'. Editors are still as ignorant as they were a decade ago, but he refuses to allow their desultory tones to faze him.

Other topics covered in the collection include religion ('the finest of the breed'), road rage ('drive through hell'), racing ('not listed') and his contempt for authority ('everybody talks too much'). His penchant for reclusiveness crops up in poems such as 'party's over', 'escape' and 'it's ours', the final entry in a very solid piece of work indeed, and one thankfully free of the padding one finds so often when he's struggling with a dearth of inspiration.

By this time, as mentioned, Hank was a supersonic success on the continent but only moderately well known in America for those outside the poetic fraternity. By the late eighties, over two million copies of his books had been sold in Germany alone. A few years earlier, three of his books appeared on the best-seller list in, of all places, Brazil. He was translated into countless languages but was still relatively obscure in America. It

was the old story: the prophet is never recognised in his own land.

That was all set to change, however, with a film about his life which would confer global fame upon him, becoming the text with which he would be forever synonomous.

Moving Towards the Twenty-first Century

> The toughest thing about success
> is that you've got to keep on
> being a success.
> *Irving Berlin*

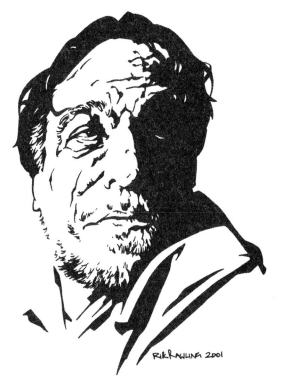

RIKRAWLING 2001

Hank became tamer as he got older but he never lost the fire in his belly. He would have continued to write on park benches with the grimy stubs of pencils even if he was never discovered. Fame was just the way the cards fell and he accepted its comforts accordingly.

He never romanticised obscurity. If somebody didn't make it to the top, he usually felt that was because they weren't good enough. Against that, there were many famous writers he despised, as we've seen. He never really reconciled these two contradictory viewpoints, nor attempted to. He fumed when a colleague suggested he secured major publishing contracts because he was 'known', arguing that one only became known because one had talent. He was citing scripture for his purpose here; you couldn't have it both ways.

He moved with Linda to a posh San Pedro residence, basing himself in an upstairs room with a skylight and immediately writing his first poem, appropriately entitled 'Fear and Madness'. Here he was lord of his demesne. He had finally arrived. No longer would he have to haul a black cardboard box from pillar to post, dodging irate landladies on rent day.

At last it was his turn to laugh at those voted Most Likely to Succeed in the college yearbook, because many of those erstwhile wonder boys were now selling salami to make ends meet while this loser extraordinaire was chewing on expensive cigars and living off the fat of the land. The lowlife, in other words, was now living the high life.

He positioned himself by the window as he had in De Longpre Avenue and anywhere else he had ever read or written, including the libraries of his youth, the sights and sounds of the world outside nudging his muse towards those hard-clipped expos-

tulations. Lugubrious as ever, he started to put the words down on the page, forming tentative visions of society's cast-offs warring with their bitches, their jobs, themselves. The absurdity was peppered with a laconic undertow, as ever, locating his work somewhere between horror and farce.

He had his BMW now as well, relating to it like a child with a new toy. The irony of the situation was choice. Here he was, the oldest swinger in town, getting into his Neal Cassady phase when others of his age were investing in Zimmer frames. The King of Cool was now lord of the freeway as well as the slum pit. The fact that he bought it for tax reasons was beside the point. Instead of Hank the Crank it was now Hank the Swank. Who could deny him his newfound benison after all those years in draughty dumps, after the years having rats crawling across his stomach in back streets?

Years ago he had written in a poem that it was better to be chauffeured round in a car than to own one, but now he was revising that view. Or was he? Just because you were in a stable didn't make you a horse. The trappings of success didn't have to become traps. Maybe he was just having a lark. It was the same Hank who didn't want to go to war or save the whale who needed to be showy about his wealth, but he drew the line at getting a jacuzzi. Jane would surely have turned in her grave at that.

'I'm all straightened out now!' he said, with tongue in cheek, but confessed in a more frank moment, 'I miss the dirty action.' To paraphrase a line from his poem 'metamorphosis', he had been robbed of his filth.

Gone were the clip joints, the mercurial whores, the mad ballet of lives lived on the edge of Hollywood and Sunset, the ghost poets and nowhere men, the goodtime gals and back street spivs, the post-Whitman romantics, the sleazeballs who burned with the fire of subliminal excess. He'd been there, and maybe he'd go there again, but for now he had a good lady busily engaged in keeping him alive for a while more, so it was a case of breaking out another bottle and telling war stories from his latter-day perch. The sheep in wolf's clothing had seen it all and done it all and was now savouring the fruits of success in the San Pedro abode many of his old colleagues begrudged him. But, shit, he could live with that. Maybe their problem was they wanted to be where he was. Not everybody could break through. It was the way the dice flipped. You could be gold or you could be eighty-sixed.

He had emerged into the clearing and he looked back with some nostalgia at the jungle that spawned him, but he was getting to be an old cuss now, and anyway the streets were cleaned up. Even if he wanted to go back, he couldn't: the era of sanitization had set in. He missed prowling 'the ordinary places' but Linda gave him enough solace to dim that desire. Why go out for plonk when your old lady was serving you up fine wines?

As was the way with Humphrey Bogart, to whom he's often compared, his main drinking was done when he was unhappy. Bogart was a veritable alcoholic during his marriage to Mayo Methot, but when he met Lauren Bacall he toned it down. So did Hank with Linda Lee.

He never became a venerable old man, but he developed a kind of craggy grandeur with the passage of the years. He stood in line at supermarkets, cleaned the hair out of his nostrils and paid his parking fines. If only his father could have seen him now.

He had survived. How could this be so when the graveyards were strewn with the corpses of so many others who had taken only small chances, or none at all? Which deity had organised it so? He had spent his days on a 'Live now, pay later' basis since as far back as he could remember, but so far nobody had called for the bill. Maybe he

was being compensated for all the curses that had blighted his childhood with this unlikely reprieve.

Jane hadn't been so lucky. She hadn't met a Linda or found success, or anything else to keep her out of the boudoirs or the drunk tanks. Unlike Hank, she hadn't kicked the booze. So what was his secret? Why hadn't he gone up to that big alehouse in the sky in 1955? But he shouldn't ask such questions. He had never been a questioner. He had always just taken what there was — or wasn't.

All you had was the day. And he was still punching typewriter keys and knocking back beer. To analyse it would be to kill it. Better to just roll along through rough times and smooth. He had served his time with the bitch goddess of life: maybe he deserved something to come back to him. But he would never become a grand old man. He would leave that to the Hemingways and the Robert Frosts. He didn't need to defer to anyone. He would only have quiet heroes, quiet dreams. The crusty shell would remain. And for now there were more words to be got down.

All the same, he couldn't but fail to be amused by his new life. Gone were the days of breaking down doors: now he sat in front of an electric typewriter and listened to classical music. But he also listened to classical music when he was breaking down those selfsame doors and smashing the windows. And even in front of the computer he was given a few years later he drank twenty-nine days a month. The only difference now was that it was slightly better wine. And nobody was losing his poems anymore, or forgetting to acknowledge them.

In 1987 he told journalist Paul Ciotti, 'The wine does most of my writing for me. I just open a bottle and turn on the radio and it comes pouring out. I have no plan. The typewriter gives me things I don't even know I'm working on. It's a free lunch. I don't know how long it's going to continue, but so far there's nothing easier than writing.'

With Linda he fought the 'slow retreat' and tried to mend the wild ways of his past. But was it too late? Was he not just closing the stable door after the horse had bolted? What price a new liver, an unused heart?

He lived apart from her in 1983 and 1984 but then they reconciled and he asked her to marry him, which caused some tongues to wag. They married just two days after his sixty-fifth birthday, thereby putting the final official stamp on a relationship that would last to his death. This time, unlike with Barbara, he wasn't going into unknown terrain. He had married Barbara as a poor man who only had known her a wet day. He was now rich and famous, and was effectively married to his new bride in all but name for many years.

The ceremony was much more civilised than one might have expected, Hank ordering everyone to drink their fill because he was paying the goddam bill. He dispensed mirth and goodwill like one to the manor born, an avuncular old goat at ease finally with himself after six decades battering down the walls of recalcitrance. At the reception he took Steve Richmond and Gerard Locklin aside and proceeded to warn them about the perils of womanhood: a classic gesture only this man could get away with at his own nuptials.

At this time he was also putting the final touches to a semi-biographical script he'd written for Barbet Schroeder, the former jazz impresario turned film director who had worked with the likes of Jean-Luc Godard and Eric Rohmer in the past.

Schroeder simply appeared at Hank's door one day and told him he wanted him to write a screenplay about his life. He gave him an advance to do it, sight unseen, knowing he had enough meat to make a winner. They'd known one another since

1978, becoming friends as well as colleagues. Such a screenplay would become the movie *Barfly*. The original title was *The Rats of Thirst* but, as with *Women*, he finally settled on the more succinct name — largely due to Schroeder's persuasion.

Schroeder had adored it from the beginning, appreciating in Hank's lean style the natural gift of a screenwriter. They also had a lot of fun bringing it to fruition, drinking and jousting together like old comrades. When Schroeder playfully flirted with Linda Lee, Hank said, 'Fuck off, you French frog' (he was Swiss-German actually — how could a fellow kraut miss that?) and Schroeder replied, 'If I bonk Linda you can kill me. You won't be prosecuted because I'll write a suicide note first. How's that?' This was the kind of talk Hank liked. Schroeder's mercurial personality divested him of many of his prejudices about Hollywood. He gave him faith in the film world in the same way as people like John Martin and the Webbs had done for the literary one, ensuring him that there was still room for people who had talent rather than connections.

When Schroeder felt the film wasn't going to get made, he asked Hank if he could shoot some documentary footage of him as a kind of consolation. Hank agreed, and such footage is perhaps superior to the movie itself in its exemplification of this most unique of men. Schroeder shot over four hours of Hank extemporising on all the old faithful topics (women, booze, horses, Hollywood, work, etc.) in a thoroughly engaging fashion, his merry eyes twinkling as the fiery convolutions of his scabrous past are paraded before us.

The documentary focuses almost entirely on Hank, with Schroeder fielding tentative questions at him from the fringes, beyond camera-range. A mixture of street philosophy and racy anecdote, we get the genial essence of him in him in the fifty-two vignettes contained here as he drawls on about everything from bar-room brawls to his rampant reclusiveness, a beer in one hand and a cigar in the other. This is a latter-day prophet of the streets joining the dots on a psychedelic life from his San Pedro eyrie, casting a grim glance at the experiences that have formed him as he re-evaluates their impact. He regales us with stories of the wild women and the wild bars, vaguely searching for dignity from the singularly undignified circumstances that presented themselves to him.

It's a captivating four hours of a man laying his soul bare for us and it's also, one hardly need add, extremely amusing. The old scoundrel has been tamed, but he still shows his teeth occasionally, as in the segment I mentioned where he kicks Linda off a sofa simply because she denies she's been staying out late a lot in recent times. It was a totally unprovoked attack and Schroeder's cameraman felt Hank would prefer it to be excised from the final cut. When Schroeder put this suggestion to him, however, the unflappable Hank replied. 'Hell, no, it's the best part!'

Amazingly, when Hank eventually saw the video, he had no recollection whatsoever of the lion's share of the conversations in it.

Schroeder said his motivation in doing it was to show that 'behind his reputation as a degenerate and old drunkard, which he helped establish, was a poet of exquisite sensitivity who was hard on himself'. It was shot on and off over three years but is delightfully simple in structure. Ninety percent of it consists of Hank's face, but it never becomes monotonous. Schroeder wisely decided to leave himself out of it so as not to disturb the spell of Hank's ruminations. What we get is a man and his thoughts, nothing more and nothing less. Not so much interviews as somebody thinking out loud as a camera is pointed at him.

The questions he's asked hardly even matter: Schroeder is well aware you can turn

him on like a clockwork toy with any half-relevant enquiry. His mind is like a set fire waiting for a match. We enter the furniture of his head like uninvited guests, but intimacy is established almost immediately because of the manner in which he takes us into his confidence. By the end of the fifty-two episodes we feel we know him as well as Schroeder does, his life an open book. (Mae West would have added, 'Open at all the wrong pages!')

The screenplay itself had been in dry dock since 1980, the year Schroeder first showed interest in it. Various studios suggested they might run with it but it always fell through for one reason or another: either the timing was wrong or the money wasn't forthcoming or the suggested actors weren't to Hank's liking. He took particular exception to the idea of Kris Kristofferson playing a guitar-strumming Chinaski!

The producers were sufficiently narrow-minded to find it difficult to accept that a barfly could have the audacity to like classical music. They wanted to portray him as a hipster instead but Hank dug his heels in here, realising such a depiction would totally have guillotined whatever veracity Chinaski possessed. James Woods had also been considered for the part after Hank completed the first draft in 1979. Hank had been understandably impressed with his work in *The Onion Field*, feeling he was the one good thing about it. He liked his edge, his visceral energy, but felt Woods needed to tone his style down a bit to fit the world-weary Chinaski. (Woods' later *Eraserhead* would become one of Hank's all-time favourite movies).

Hank wanted Sean Penn to play the character based on him but such a move entailed Dennis Hopper directing. Neither Hank nor Schroeder were keen on this, having problems with what they saw as Hopper's shallow personality.

Another thing that turned Hank off Hopper was the fact that he was playing the role of the reformed drinker when they met. This was hardly a blueprint for Henry Chinaski by any stretch of the imagination.

Neither did Hank have much respect for Hopper's 1969 cult movie *Easy Rider* which he felt romanticised the flower power set out of all proportion, portraying them once again as the potential saviours of unofficial America. Hank had had a closer experience of the more cynical, spaced-out variety.

Penn offered to do the part for the proverbial dollar considering all the financial problems involved, but because Penn still meant Hopper riding shotgun, this wasn't on.

If *Barfly* became a Hopper/Penn vehicle, Schroeder would have been relegated to the role of producer, which Hank felt would have been scant reward for six years of research on the project.

Hopper felt the reason he was banished from the movie was because he had insulted Schroeder's directorial flair years before, telling him his main talent was for documentaries, not dramas.

Schroeder had a long memory, Hopper felt, and used Hank as an excuse to punish him for the slight.

In the end Mickey Rourke came on board, with Faye Dunaway playing the part of Wanda, the character based on Jane. Hank didn't like Dunaway, but she saw the part as being a door back into the big time for her after some errant celluloid choices in the recent past. 'I haven't felt such passion for a character since *Network*,' she said, seeing the promise of a comeback in the deglamourised face of Wanda, a woman of 'sweet vulnerability.'

She had only made one movie in the past six years, Michael Winner's camp period

farce *The Wicked Lady*. One had to go back to 1981 for her last acclaimed performance: the biopic *Mommie Dearest* where she went totally OTT to play the demented, child-bashing Joan Crawford. Now history could repeat itself.

Before that happened, however, there were some obstacles to be overcome. Executive producers Menaham Golan and Yoram Globus of Cannon Pictures started to go cold on the idea even before filming started. Worse still, they put a prohibitive turnaround figure on the movie which was the amount that would have to be paid to them by another person who would like to buy it from them. Schroeder fumed when he heard this, as did Dunaway. She offered to do the film for no money upfront, to forego her salary in exchange for a deferment or a percentage of the profits. (Dunaway eventually made a lot of money from the movie, investing $90,000 of it in a trust fund for her son's education. 'It will be worth triple by the time he's seventeen,' she said, and she was right.)

Schroeder himself went one better, going into Golan's office with a tiny Black & Decker chainsaw. 'Do you see this finger?' he said, holding up his hand, 'I don't really need it.' With that he turned the saw on and moved it close. 'If you don't reach for your wallets and make this picture,' he said. 'I'm going to come in here and cut off a piece of my finger.' It was, they had to admit, an unusual method of persuasion and they came round.

Their reaction was, 'If Barbet thinks this much of the project, it must have something'. Hank was pleased too. It was so un-Hollywood he liked it. In fact it was like something out of one of his books, like something Henry Chinaski might have done to one of his landlords. Or lady friends.

The film went into production in February 1987, the result of nearly seven years preparation between Schroeder and Hank. It made Hank a recognisable figure to those hordes of people who didn't read poetry, and of course had a spin-off effect on all the titles he already had in print. He was interviewed for all the celebrity magazines as the world suddenly sat up and took note of this hellraising wordsmith who had served such a controversial apprenticeship.

The film takes place over four days but Hank said it represented as many years of his life, compressed into that slim time-frame. He asked Schroeder to get him final approval on every script change and such was arranged — no mean achievement, he realised, in an industry where the lead actor got '750 times' (sic) what the writer did. His contract also stated that he didn't have to be on the set any day he wanted to go racing — a clear case of getting one's priorities right.

At the booze-up after the premiere Hank suffered the phonies who shook his hand and pretended to be familiar with his work, but then the drink took its toll and he reverted to Hank the Crank. When Schroeder informed Hank that he felt 'covered in shit' with all the artifice, Bukowski was delighted to hear somebody else expressing exactly how he felt and took the opportunity to do a runner. (Leaving a reception where there was free beer on offer, he quipped afterwards, gives one some indication of how deeply he was suffering!)

The *Los Angeles Times* magazine ran a major feature of him in March of that year, focusing bemusedly on the sixty-six-year-old man with a 'sandblasted face, warts on his eyelids and a dominating nose that looks as if it was assembled in a junkyard from Studebaker hoods and Buick fenders.' Despite having lived in LA for most of his life, it pointed out, he was still relatively unknown outside literary circles. What made this even more astounding was the fact that he had written over 1,000 poems, three books

of short stories and four novels. Devotees of his work were willing to pay exorbitant prices for rare early editions of his poetry, and he was widely translated. So how come the masses weren't clued in to what he was about? But *Barfly* would surely change all that.

What an irony it was that a film about a down-and-out would suddenly make Hank respectable, even mainstream. The attention it afforded him was a novelty, and to that extent he grabbed it with both hands. He liked the work he did here, even if the finished film had too much designer destruction about it. Dunaway chewed the scenery, and Rourke overplayed the hobo so much Hank couldn't help remarking, 'if I looked that bad in my drinking days I would have been kicked out of even more bars than I already was'. His clothes may have been wrinkled but they weren't dirty, as Rourke's were.

Neither did he ever have his pants hanging down the way Rourke's did — at least not until he got drunk. (At which time they would probably have been down round his *ankles*.)

From a sheer physical point of view, Rourke was direly miscast. Hank was a big man — both upwards and outwards — with rough skin. Rourke, for all his scruffiness, looked like a tenderfoot, and his designer stubble hardly compensated for *acne vulgaris*. You got the impression that if the real Henry Chinaski passed by him, even without touching him, he would have knocked him for six. He could have blown him away — literally.

Rourke made the mistake of overdoing the roughneck bit, just as Ben Gazzara would *under*do it in the earlier *Tales of Ordinary Madness*. The fight scenes were also too brutal, almost to the point of slapstick. Toughness, sometimes, can better be conveyed by a tilt of the head than a pummelling of fists. And Hank was never one to wear his toughness on his sleeve. (Most of the fights he was ever involved in, for that matter, were the other guy's idea.)

As if to compensate for this, Rourke also played up the sensitive poet angle, which led to a character complexity his range couldn't deliver on. He would have been better advised to keep the sensitivity deeply buried, as Hank's was, otherwise you were in danger of making a movie about an angel in the jungle, the last thing *Barfly* should have been. His voice was also too soft: you could hardly hear it behind a matchbox. Maybe the film would have worked better with a noir effect, shot in black and white.

Rourke exaggerated the unkempt appearance in order to highlight Hank's sensitivity by contrast, but this made everything rather too obvious and contrived. He played Chinaski as a pariah carving prophecies from soggy beermats, striking a blow for deadbeats by telling the literary establishment to kiss off. The points were good, of course, but the tone was too strident. Rourke's whisper roared at you much more than Wanda's screams from the balcony.

Hank played a cameo role in the movie, being one of the bar's background characters in the scene where Rourke meets Dunaway. (Such a scene both began and ended his Hollywood 'career'.) Further background cameos were played by other real-life barflies. He knew the world these colourful personalities represented was fast disappearing, the ubiquity of televisions in bars sucking the life out of them. This made them all the more treasurable to him now, even if he himself had, in a sense, departed their world.

The entire movie was shot in thirty-four days, which must be some kind of record. Hank didn't see it as a masterpiece but he felt it had a core of truth about it, unlike

most of the Hollywood wallpaper that passed for art. Watching it also made him thirsty, which seemed to prove some kind of a point.

One of the problems with the film, he felt, was a problem every film faced: there were too many people involved in it, which made its chances of cohesion all the less. He thought Rourke was the best thing about it, even though he came in for the most flak.

Rourke liked Hank, admiring his hard-living lifestyle and his disenchantment with mainstream values. He had just finished making the IRA movie *A Prayer for the Dying*, the final cut of which he felt betrayed him so he virtually disowned it afterwards. The whole episode gave him the kind of cynical and distrustful attitude that was perfect for Henry Chinaski — if not Barbet Schroeder.

Hank had much in common with Rourke, whose father deserted the family home when he was a young boy. He was subsequently beaten by his stepfather, whom he despised. As he grew up he drifted into jobs that almost equalled Hank's in the lowlife stakes: pretzel seller, nightclub bouncer, towel boy in a massage parlour. Hank admired Rourke's iconoclastic attitude to Hollywood. He liked the fact that he didn't run with the 'in' crowd, that he wouldn't walk across cut glass to make a deal like some other Brat Packers. In a way Rourke was the Bukowski of Tinseltown, the man who refused to bend the knee. They were like two mavericks kicking against the pricks, two 'difficult' talents who kept on keeping on — despite being bad box office.

The only problem Hank had with Rourke was his attitude to drink. His father had been an alcoholic, which gave him a prejudice against it. He realised it worked for Hank, but saw him as the exception rather than the rule. Hank would have preferred Rourke if he had realised the liberating properties of booze for large numbers of people — the kind of people, in fact, that Hank fraternised with during the barfly years. In a way, that was one of the things the film was about. Nobody was denying the fact that it was escapism, but the world was such a cruddy place, dreams should be purchasable at any price. Hank didn't let this affect their friendship unduly, however. He appreciated the fact that Rourke had sympathy — if not empathy — for his character.

The first time Rourke read the script he found it irrevocably dark. It was only when the film started shooting that he saw the humour. To play the part he decided he needed to go for it flat out so he mussed his hair, blackened his knuckles, jutted his jaw and dressed like a tramp. He was so impressed by Hank's slow speaking voice that he copied this directly. 'I made the choice to talk like him in about ten minutes,' he said, 'so you can say I'm winging it. I decided that unless I went all the way with this character I'd wind up being mediocre. I decided to make the guy real, not like he was in a Hollywood fucking commercial movie. I took a chance going all the way, not caring if I went too far.'

Unfortunately he *did* go too far. One of the most endearing things about Hank was that he never cast himself as an ersatz hobo, but Rourke's preening pretentiousness runs him the danger of that. If anything, he took the part too seriously, imagining it would give his career the shot in the arm it sorely needed at this point. In Hank he saw his mirror-image, a guy who had taken life's sucker punch once too often and yet come up for more. He tried to play him in the method style, but the essence of the method is that one *becomes* the part, and that never happened for Rourke. You could always see what he was getting at in a given scene: you caught him acting, which is the most heinous sin of all serious performers.

'This character is very close to how I feel about the acting world right now,' he said.

'The film came along at the right time to help me get my shit together and rejuvenate my feeling for the profession.' He had been unhappy not only with *A Prayer for the Dying* but also the quasi-erotic *9½ Weeks* which had been similarly bowdlerised, he felt, by the studios. He had intended to make a film Hank himself might have dug: a subliminal peek into the chasm of sexuality, but the finished cut was more like cotton candy. 'We set out to make a real film about real people,' he complained, 'but the studios reckoned the public would be more interested in seeing me hump Kim Basinger over a coffee table.'

Rourke identified himself wholeheartedly with the manner in which Bukowski / Chinaski had alienated himself from everything that stood for anything, a man at the end of his rope who was still somehow content with his lot because he didn't really wish to be anywhere else, who refused to sell himself out to the literary establishment (represented by publisher Alice Krige). He saw the film as a kind of 'Portrait of the Artist as a Young Drunk'. Chinaski manfully staved off the salon suckerfish with their fat chequebooks in favour of the sewer bums who were his soulmates while Wanda Wilcox was another tortured loser who had managed to preserve her integrity in the mire.

Hank came to the premiere in a white limo, the ultimate irony considering the subject-matter of the movie, but you could bet your bottom dollar he was laughing at it all. Indeed, if there was one thing wrong with Rourke's interpretation of the part, it was his singular lack of humour. Hank always undercut any tendency towards profundity with an expletive or a self-deprecatory gesture, but Rourke played the role like a Bolshie manifesto, which made you feel you were getting a lecture rather than a narrative.

Right from the start the film hits a false note with the fight scene done in a Jimmy Cagney manner. Rourke is left for dead in the alley and then the next night he's bright-eyed and bushy-tailed, hankering for more. Is this man bionic, one wonders?

Neither does Rourke's W C Fields accent help matters. Now and again the sing-song tone might have been amusing, but delivered with this kind of relentlessness it becomes farcical. Farcical also is the way he walks — like somebody who just peed his pants. And when he puts on the classical music you almost want to open a vein — because he looks (and acts) like a man who would think of the Lone Ranger when listening to the William Tell overture. We're expected to believe this guy is a *writer*? He more resembles someone who would move lips as he reads.

Faye Dunaway isn't much better. Looking like somebody who forgot to put her make-up on for the job interview at the William Morris Agency, she was totally miscast, at least if she was meant to be Jane, who had an old-world look like Lillian Gish. Dunaway is too with-it, too together: a wiseacre with a flirty eye rather than a lovable loser. Together this pair is the celluloid mismatch to end all celluloid mismatches. They don't look like they're out of the drunk tank but rather refugees from Bel Air without their respective wardrobes. Rourke also appears too fit. For *Raging Bull* Robert de Niro had put on sixty pounds to play Jake La Motta. Where's Hank's beer belly?

For that matter, where's *Dunaway*'s beer belly? One of the characters calls her fat at one point and she takes umbrage. She's right: she has an hour glass figure.

She talks about the 'penal system'. Jane would probably have preferred talking about the *penis* system. The scene where Wanda searches for the ears of corn is, well, corny, and her vision of angels a hippy-dippy sidebar that just doesn't wash.

Things become even more farcical when Krige pays Rourke a surprise visit and is interrupted by a stabbing incident from the S&M couple next door. Apart from this

ludicrous coincidence, the fact that Rourke shows little or no interest in having a piece of writing accepted flies in the face of his career to date. It may be true that Hank once fobbed off the attentions of a literary agent, but for the purposes of the movie it misrepresents his character, sidelining the huge efforts he made to be recognised in his early years.

Even the tattoo on his arm looks wrong: it's showy in the kind of way Hank hated — an appeal for a very obvious form of macho-jock street cred. Neither is there any scene of him writing anything except epithets, as if it's all this easy, as if the quotable quotes just come willy-nilly.

But most preposterous of all is the romantic triangle. Who could believe that two beautiful women would fall for a man who looks like something the cat dragged in?

The film begins with a ridiculous fight between two men and ends with a ridiculous one between two women. In the interim what happens? Too much — and too little. Why didn't they opt for a 'day in the life of... ' approach rather than all these tacked-on contrivances?

The film marked a kind of watershed for Rourke, whose star failed to shine in subsequent roles. Disenchanted with the glitzy lifestyle, he attempted a career in professional boxing, and followed that up with a stint as a tattoo artist. Neither took off, and his contentious relationship with directors meant that he was low on the totem pole of desirability when, years later, he decided movie-making wasn't so bad after all. (Maybe Hank could have written an even better script than *Hollywood* around this theme.) Rourke also joined a Hell's Angels gang and was arrested for beating up his wife Carrie Otis, as well as her drug dealer.

He subsequently spent time in a psychiatric clinic after suffering a number of panic attacks — all incidents that could have made a great *Barfly Two*. On a more positive note, he won eight of his first ten boxing bouts, and even started writing poetry that carried certain echoes of Hank. ('Most recently I have observed / That movie stars stink / And that nepotism keeps giving birth / To a new generation of scum'.)

Rourke began the 1990s as box office poison. Influential directors gave him a wide berth, describing him as 'an emotional time bomb', which meant he was reduced to fifth-rate movies such as *Another 9½ Weeks* to fund his lavish lifestyle. (There was no Kim Basinger this time, nor any creative ideals either.) It bombed at the box office, and the bank repossessed his mansion and told him to tear up his credit cards. Rourke acted blithely unperturbed about all of this, assuring friends that whatever else may have transpired in his life, he still had his dignity. He also proclaimed his undying passion for Otis, describing her as 'the only woman I ever truly loved', even though they were estranged. He underwent a mini-renaissance as the new millennium began, largely through the ministrations of friends like Sean Penn, Steve Buscemi and Sylvester Stallone, all of whom secured him parts in movies. Hank, no doubt, would have been pleased. Another disaffected slugger who told Tinseltown to stuff itself had come through — albeit with scars. (Dunaway, as might have been expected, pursued a more mainstream path, but her career never again reached the highs of *Bonnie & Clyde* or *Network* and she tended to garner more headlines for her prima donna antics than her performances.)

1987 also saw the release of *Crazy Love*, a Belgian movie also known as *Love is a Dog From Hell* and directed by Dominique Deruddere, who based it on a selection of Hank's stories, all in one way or another dealing with the tarnishing of romantic idealism.

Comprised of three separate segments featuring a character called Harry Voss at various stages of his life, the first sequence has him as a young boy from the country

whose fantasies are nurtured both by his mother, who tells him playfully that her husband loved her so much he kidnapped her, and a film he sees in the local cinema featuring a chivalrous marriage. He's so impressed by the bride in the latter that he steals her photograph from a glass case in the cinema after the film is over. Thereafter he witnesses the vulgar spectacle of his parents having sex, and then an attempt to woo a young beauty at a carnival comes to nothing as a result of his bashfulness. His older friend then tells him he can get relief from his sexual yearnings by masturbation, which he graphically demonstrates. The pair of them then play peeping tom to a sleeping woman, but she wakes up as Harry tries to fondle her breasts and she screams at him, resulting in him running from the house. The segment ends with him masturbating to the photograph he has stolen from the cinema.

In the second sequence Harry is now nineteen and suffering from such an acute case of acne that he draws reactions of mockery and disbelief from those who look at him. In a scene highly reminiscent of the Prom episode from *Ham on Rye*, Harry finds his attempts to ask a girl to dance frustrated by his gross appearance. Things become somewhat farcical (à la Fellini) when he covers his face totally in toilet roll, leaving small gaps for the eyes and mouth. He re-emerges into the dance hall and again asks the lady to dance. Amazingly, she says yes. Afterwards he gets drunk and laughs uproariously as he lies down on the street cradling a bottle of liquor. When two policemen approach him with a poem he's written he tells them to destroy it and asks them to carry him into his house.

The final segment, loosely based on Hank's story 'The Copulating Mermaid of Venice, Calif.', is the most evocative, and probably the reason he admired the film so much. Harry is now thirty-three. After stealing a bottle of whiskey from a bar following a staged fracas, he and his friend see a corpse being put into a hearse.

They steal it, and Harry then has sex with the dead body, an experience he describes as 'the best fuck I ever had'. Overcome by grief afterwards, he refuses to bury the woman, instead taking her to the sea with him where he drowns both her and himself. By now we realise where the title of the film has come from. It's a strange, haunting vignette, and beautifully shot. One can safely say that the subject of necrophilia has never been handled as poignantly as it is here, nor is likely to ever be again — by *any* director. Not many people know about this film but it's a more faithful depiction of Hank's disenchantment with various forms of devotion than higher profile efforts. Hank knew Deruddere hadn't tailored it in any degree whatsoever towards a commercial audience. He sought to capture the raw pining lodged at the heart of desire, and more likely than not doomed to frustration.

The *Barfly* screenplay was published the following year. It's ironic that this is the material which finally made Hank into a household name with the non-poetry-reading public considering it's far from his best work. Too ponderous and self-serving for comfort, it contains a quality one has never noticed in this man's writing before: pretentiousness. All those self-congratulatory one-liners with their inverted snobbery and would-be suggestiveness try to make Henry and Wanda into two ethereal spirits misunderstood by the world, but all it really succeeds in doing is portraying a pair of self-obsessed malcontents.

For much of the time Hank seems to strain at the leash to make a case — or, worse again, a cause — for his protagonists. We see the errant beauty of the sewer in all of his work to some extent, but not because we've been bludgeoned into it, like here. It must emanate from the givens, not be foisted onto them. Two bruised souls bonding in

the sanctuary of the boudoir and the bar makes for a great storyline, but it was handled with much less fuss and fanfare in films like *The Hustler* where you didn't feel like you were being 'got at' to sympathise, or empathise.

The script is best when it carries Hank's truculence rather than his self-righteousness: simple lines which hit it on the nail are what you remember rather than the self-congratulatory knowingness. In the latter mode Henry reminds us of the Beats in his pseudo-intellectual poseyness. Hank's introduction to the screenplay tells us that Henry is 'more sad than bitter' but at times like this he just appears like a self-righteous prat. Which isn't to say it's not a slick piece of screenwriting, but Hank was perhaps too close to the material to do justice to it. A half-century of pain had to have a 'look, no hands' edge. Henry makes so many manifestos for himself it's hard to feel for him.

1988 saw the publication of *The Roominghouse Madrigals*, a collection of Hank's best work (at least in his own view) from 1946 to 1966. There's a lot of rich metaphorical content here, but little of the immediacy we see in the later work. In large part the book has the kind of 'literary' quality we don't usually associate with Hank, and which his whole career, in a sense, sought to extirpate from the written word. In the foreword he tells us he believes it's neither better nor worse than his other work (both opinions were proffered to him by readers) but merely different, and this is the best way to approach it. If he had always written like this it's unlikely he would have achieved iconic status, either in the underground or anywhere else, but there's no gainsaying the book's inspirational content, which testifies to a more sensitive psyche than he usually vouchsafes us.

Elsewhere in the foreword he informs the reader that the reason so much of his early work is unavailable is because many of his books have been stolen from him by visiting 'friends' who waited until he went to the bathroom before taking them from his shelves. Such tomes would have fetched a large price on the black market and increased the rarity of already rare books.

In general he tells us he has a fondness for the material, some of which results from a nostalgic connection with the circumstances of its embryology. It was written, he says, in the dingy rooms he returned to each night after another soul-destroying day in a pathetic job, the typewriter one of the few things that didn't let him down when his luck was bad and the park bench beckoned. The broomsticks of the other tenants downstairs would pound on the floor of his room as they roared at him to call it a day, but Hank would continue to nail those last few precious lines down before closing up shop, propelled into action by the memory of all the losers who had preceded him.

At times the voice is bardic, at times Whitmanesque and at times muted almost to the point of unrecognisability. He writes about everything from death to his father to the thoughts of a man while shaving in an attempt to wrest meaning from absurdity. In later years he would adopt a more commando raid approach to his themes — land on them briefly and then vamoose — but the two decade wingspan of this book bespeaks the teeming head of a colt just about to break out of a tradition of writing on his way towards a fresh way of interpreting ordinary things, which should be the true function of poetry.

The book is figuratively rich as well, even too much so sometimes as the images are clustered in on top of one another relentlessly, but it's the kind of imagery that's more traditional in nature, more 'poetic' in a very un-Bukowskiesque manner, at least in view of the later work.

His honesty emanates from 'whores and hospitals', he writes in 'A Word on the

Quick and Modern Poem-Makers', and such honesty is a feature of the whole collection. He refuses to play the culture vulture game, refuses to join the herd

> huddling in
> one big tent
> clasping assholes

to quote the trenchant phrase that ends 'I Am Visited by an Editor and a Poet'. 'Friendly Advice to a Lot of Young Men' exhorts others to follow this advice too, albeit in somewhat jocose fashion. A similar frivolity is evidenced in 'What to Do with Contributor's Copies', another poem in which Hank sends up the preciousness of the small presses.

A precious *writer*, on the other hand, is sent up in 'About My Very Tortured Friend, Peter', which uses material he also included in a *Post Office* anecdote. A kind of mutedly soulful Philip Larkin tone, meanwhile, is used in 'A Minor Impulse to Complain', a conversational oddity which proves just how protean he can be when he wishes. It's writing like this that makes one regret the 'samey' quality of much of his other work, though of course we must bear in mind these poems were written over a twenty year period so it's not fair to contrast them with any one other collection (as opposed to selection).

Of course the poem that's funniest, and also most savage, about navel-gazing poets is 'O, We Are the Outcasts', where he gets rid of a lot of bile in a most enjoyable manner as he demolishes fat cat dilettantes who write poor work from comfortable studios and fiercely guard their womenfolk from the rapacious Bukowski, who may well corrupt them if he gets his grubby hands on them. There's a lot of righteous anger here, but he's channelled it into a biting satire about the privileged set who believe there's only one way to write: cautiously. Nowhere more than here (at least outside the letters) have we such an articulate exposition of his revulsion for those who've never had to go out on a limb for their art, who've never struggled or who've never had to work shoddy jobs, which means they have all that much more time 'to understand Life'. It's a demolition job on whiners that only just avoids whining itself.

When we come to a poem like 'One Night Stand', which is near-perfect in its evocation of a plaintive emotion, it's hard to resist the thought that Hank could have become swallowed up in a vortex of 'worthy' work had he not had the courage to break away from this kind of conventionality in search of a language less pure but somehow more truthful.

These poems *are* madrigals. They're music; the sad, sad music of human pain. Hank's heart is a lonely hunter here as he sits in his seat by the window and carves sentiments out of the dead wood of his past, the counterpoint of mixed emotion drawing him into webs of language from which he doesn't always succeed in extricating himself. It's like a man silently screaming, soaking up the influences of different times and places in search of the jigsaw that is his life, missing one piece. If he was indeed a 'bastard angel', then this is his angelic self. Even in such an ostensibly simple poem like 'Breakout' we see his desperation, anger mixing with guilt over being unable to come up with the rent for his permanently vigilant landlord or landlady, pushing him towards a premature exit — and the next roominghouse where, hopefully, somebody will treat him better. It's almost like an action replay of his departure from home, where he experienced a different type of let-down, resulting in a slightly different 'breakout'.

Forever on the run to new pastures with his black cardboard case and a smattering of hope, he asks little from life and receives less, but something keeps him going, some spark, some innate belief in himself, smothered between the depression and the beer. He may yet find a Jane Cooney Baker or a kindly editor. He may stave off hunger or thirst or poverty; may yet witness his work being published before a heavy labour job has him back in the hospital or the jail or the madhouse. Or maybe the cemetery. He's always juggling such absolutes, and they give his work that edge of mania offset by the deceptively nonchalant tone.

On a slightly discordant note, the poem 'Practice' has him at his usual habit of viewing the lives of suicide cases backwards, as if this was the only thing of significance that ever happened to them, and to which all foregoing events conspired. Writing of Ernest Hemingway in this fatalistic vein, he says that every time he watched a bull being slaughtered he prepared to die himself.

Hindsight, of course, is always twenty/twenty, but it can be simplistic to imagine that because people's lives ended in a certain manner, this was the *only* way in which they could have ended. Suicide haunted Hemingway for much of his life because his father died that way and he hinted from a young age that he might too, but he never actually attempted it — unlike Hank — until the depression and alcoholism of his final years shoved him into a corner from which he could see no escape. (His powers of creativity had also become blocked by this time.) Before that, it's only fair to assume that sometimes he watched a bull die without thinking of anything *but* the bull.

Hank published *Hollywood*, his fifth novel, in 1989, against the backdrop of the *Barfly* experiences, in the same way as he had always used life to fuel his writings. Transcribed in the clipped, elliptical tones we have now become familiar with, it has Hank being refreshingly sardonic about the skulduggery that surrounds the movie industry. He hated most films he ever saw, so it will come as little surprise to anybody that the *Barfly* trip will be used as a launching pad for airing some of his more treasured bad feelings about the movie cosmos.

Basically he looked on Hollywood as so much candy floss. The reason people praised certain films, he argued, was that since the majority of them were so abysmal, anything even *hinting* at quality became regarded as a minor masterpiece. (In the land of the blind, the one-eyed man was king.) The cult of celebrity attaching itself to film stars also fazed him — so much so that when he met Arnold Schwarzenneger in the early eighties he told him he was a megalomaniac piece of shit.

It's not a corrosively-written book along the lines of, say, Julia Phillips' *You'll Never Eat Lunch in This Town Again*, but rather a more laconic perspective on the deal-making ethos that permeates Tinseltown, and the parasites and hangers-on that buzz round the fringes of the industry. Although the names of the protagonists have been changed — slightly — it's painfully obvious who everybody is, from Barbet Schroeder (to whom he dedicates it all) right down to actors like Mickey Rourke, Sean Penn and Dennis Hopper, and writers like Norman Mailer. It's significant that Hank doesn't even bother finishing the disclaimer at the beginning of the book, writing 'this is a work of fiction and any resemblance between the characters and persons living or dead is purely coincidental, etc.' One imagines him yawning as he wrote that 'etc.' because it's obvious to one and all who he's vilifying.

What made it valuable, he felt, was that he was in the middle of all the hoopla and still got a perspective on it. He was on nodding terms with the sharks but didn't develop their killer instinct. He smelt their blood and they smelt his, and then he went

home. He wouldn't have the Cadillac and the swimming pool just yet.

The anecdotes featuring such sharks are quirkily amusing but the book leaves you with a flat aftertaste. This is no doubt his intention, seeing as he's dealing with a soulless milieu, but you don't have to bore to convey boredom, and he runs the risk of that in these pages.

He had fun making the movie, of that we can be sure, and such fun is clearly visible in his ruminations here, but the book finally expires on its own downbeat tone. One might have expected more sensational insights into the corruption of the movie industry but instead he spills too much ink on the nuts and bolts of contractual stipulations. This is understandable considering how many difficulties Schroeder had bringing *Barfly* to fruition, but it doesn't exactly make for engrossing reading. That said, however, the book keeps you turning pages as Bukowski / Chinaski fights his way past the schmoozers and the cut-throats in search of a script that will pay homage to his years scraping the bottom of the barrel, in the end feeling that while the finished movie isn't a masterpiece, it's still infinitely better than most of the sludge Hollywood turns out in the name of art.

He also casts a bemused eye on the plight of actors, who spend so much of their time adopting poses they eventually forget which life is the real one. The schizophrenia resulting from such manic role-playing is well in evidence in the narcissistic thespians he meets in his guise as screenwriter. But then Hank spent most of his life playing the underdog so it's nothing new to him. He doesn't become aggressive with such beings, content to satirise them from distance as he soaks up the celluloid experience like a sponge.

At the end of the day it's just another job — like working in the biscuit factory or the ladies lingerie department — albeit one that, for a change, actually *pays*.

About two-thirds of the way through the book Hank utters a long overdue paean to the screenwriter, the unsung hero of the movie medium: the person without whom nothing could get off the ground in the first place and yet who's often relegated to the status of fifth wheel once the cameras start rolling.

Hank himself, ironically, broke that tradition, being treated almost like royalty on the set of *Barfly*, but he was the exception to the rule. The world he depicts is one run by dim-witted moguls, more foolish (if that's possible) than the actors they employ in their conveyor belt slipstream.

Barfly, of course, was different, because it's a thinking man's film. And maybe this was its downfall. Hank revisited old haunts to try and jog his memory for how it used to be, but shooting in the same bars where he once drank filled him with a certain emptiness, as if you killed something in the very act of trying to recapture it. Even his relationship with his wife Sarah (from *Hollywood*) suffers as a result of this. They were in a world that wasn't their own, a world of bloodsuckers computing percentages, a world where barflies performed on cue like circus animals, where even the melancholia had to be stylised. And Hank himself was facing them like some kind of fraudster millionaire, an aristocrat of what he called 'trashcan lives'. He knew he hadn't changed deep down, but there was still a sense of contrivance about it all, if not betrayal.

John Fante would have been amused at the idea of Hank seeing in Tinseltown the same type of shoddiness he had already witnessed in the literary world. Would he succumb to it himself?

Hopefully not. All the years dodging landlords and befriending greasers had formed him into the man he would always be. Whether driving a BMW or a fifth-hand Model-T

he would still be Hank the slum survivor and shit detector. Having said that, however, he notes that 'my past life hardly seemed as strange or wild or as mad as what was occurring now'.

Neither does Hank resist the opportunity to write about his philosophy of the race-track, the bittersweet days when he slept on alleyways and park benches, and the short tragic life of Jane.

He also includes his terrifying experience in the charity ward. It's as if the narrating of such stories gives them a significance they didn't have when they were happening. Which is like a metaphor for the whole script / movie / novel in general: he's reinventing his myth to make it almost truer than reality.

Some of the most amusing parts of the book occur when he's meeting reporters, and answering their facile questions with jaded one-liners. He doesn't understand why they seem to be interested in soliciting his views on anything other than literature — which may strike us as surprising considering he spent most of his life sounding off on any subject you care to mention.

The style is assured and authoritative throughout, but in the end his main achievement is to portray Hollywood as a banal rather than a decadent place — which may, of course, be the truth. Whether it is or not, the pages documenting the discussion of percentages are, if anything, more relevant today than when they were written, movies at present apparently being run more by accountants than anyone else.

As a reference book, however, it's too personal to be the definitive guide to the medium and its denizens. For what it's worth, Bukowski Bukowski-ises Hollywood rather than letting Hollywood Hollywoodise him, escaping from it without holes in his soul, unlike the many screenwriters who sold out for the thirty pieces of silver.

Maybe this is why he so enjoys telling us how Schroeder, rather than lose the film deal, was willing to cut off parts of his body bit by bit every day and mail them to the money men in envelopes, like a latter-day Van Gogh.

By the time he wrote this book Hank was already a legend, a man people came from all over the world to meet, interview and/or mate with. Such celebrity status he greeted with a mixture of disdain, bewilderment and grudging satisfaction.

Time was that girls had spat on his shadow: now they were queueing up to genuflect, the better to give him oral sex. Dozens of his books were now in print and each selling profitably as well as being translated into foreign languages. His monthly allowance from Black Sparrow Press had also taken an exponential leap, catapulting him into the A-League. But such details had long ceased to matter to him.

When Madonna came to visit him with Sean Penn the neighbours gawped, but Hank yawned. It was like the inverse of his father's life. When that man lost his job in the depression, as I mentioned, he pretended to drive to work each morning in a pathetic attempt to preserve his image. He had been a nobody trying to be a somebody, but his son was now a somebody acting as a nobody. So Madonna called — so what? She meant nothing to him and neither did any of the Hollywood set. She was just infatuated with the bitch goddess of fame for its own sweet sake. When she asked him if he would be interested in appearing in her would-be erotic tome *Sex* (the title was about as imaginative as the contents) he gave her a flat no. He was bored, he said, with women who talked about sex as if they invented it.

Madonna tried to sanitise sex by making it into a prurient game, an advertisement for herself. Penn, like Hank, abhorred this. Maybe Hank intuited that there would be a problem between the pair even before they did. He saw it as *Who's Afraid of Virginia*

Woolf all over again. Burton and Taylor writ new for the Hollywood babes, the beauty and the beast revisited. But which was which? Not too long afterwards the Poison Penns would spontaneously combust, after a series of flare-ups, arrests (did Penn *really* tie Her Highness to a chair and gag her?) and slanging matches all assiduously reported in the trashy tabloids.

He brought the pair of them out for a meal one night at his own expense, which pissed him off seeing as they were both millionaires. He felt he was being used and wrote a poem about it, but then Penn brought him out a few times and he realised it had been a one-off. He asked Martin to pull the poem in case Penn was offended by it. In time he came to see Penn as he did Schroeder: as somebody who lived in the shit of Hollywood but was still in some way above it. Hank also grew in Penn's estimation — so much so that he dedicated the next film he directed (*The Crossing Guard*) to Hank the year after his death.

The only way Hank could survive, he knew, was by keeping his distance from the glitterati. Hank felt Hollywood destroyed John Fante just as Hemingway felt it destroyed F Scott Fitzgerald. That was why he did his *Barfly* screenplay and cut out, why he took the money and ran. Elsewhere lay insanity.

A different kind of insanity lay in the poetry readings, where people still jerked his chain, goading him on to be offensive just like they did to Brendan Behan a decade before in the pubs of Ireland. Behan allowed such glad-handing opportunists send him to an early grave, but Buk was made of sterner stuff and knew when to shout stop.

Septuagenarian Stew, another poetry collection, came out in 1990, Hank dedicating it to his friend and former co-editor (of *Laugh Literary and Man the Humping Guns*) Neeli Cherkovski.

The book was published to coincide with Hank's seventieth birthday, and combined both prose and poetry, a ploy that would become a feature of future collections.

From the semi-surreal 'Vengeance of the Damned' to a story written as a letter to an editor, 'No Love Songs', or the rather unorthodox literature teacher of 'Camus' — who prefers to pick fights with his students than tutor them — this is vintage Bukowski. There's a hilarious story called 'Bad Night' featuring a man in the throes of a mid-life crisis going from phone sex to the real thing with equally disastrous results: the ultimate sterility trip as Buk paints the sleaze industry with just the right amount of wry lunacy. Elsewhere we get revisions of the Famous Writer Evaluating His New Status. We move from the begrudgery of 'The writers' to the movie premiere horror of 'Mad Enough' to a man in a dentist's office, in 'Blocked', who ranges from paedophiliac fantasies to an old-fashioned grope to kick his brain into action so that he can fill a porn mag writing slot.

Giving a voice to the dreamless underclass once again with his hard-bitten dialogue and his nickel-and-dime thrills and spills, the stories find Hank in inspirational form, whether he's writing about his father (a man who was 'mean without even trying'), Woody Allen, going to the crapper, sending up his own myth or railing against the sacred cow of social change.

In these pages we have a jaded Bukowski. (Or, as he refers to himself in 'The Writers', 'Fucktowski'.) Jaded but still not without joy. He dusts himself down from the flophouses and the crazy women for another hit of booze or horses. Even though he may be 'half-dead' from fame, that still leaves him half to play with before he reaches the drop zone. And for the time being, maybe that's enough.

He doesn't want to go under, like Manny Hyman in *There's No Business*, who's

outstripped by tawdry gimmickry. Better to play the hacks at their own game, to bullshit the bullshitters. Poverty creates neither nobility nor great writers, he assures us, so he'll keep his BMW and his electric typewriter, thank you very much. This isn't compromise, baby, it's *survival*.

The old dog says he's content to smell the roses these days, and such a mellow mood permeates the book, which has the usual ragbag of childhood memories (again casting his parents in a poor light), barfly escapades, literary judgments, sensual frolics and crisp diurnal observations.

In 'the movie critics' he portrays his mother and father retreating to the dream-world of celluloid to blot out depression blues, while 'flying through space' concerns a school incident he defines as the moment he went from nerd to hardchaw.

Immediately after these two poems we have one of his longer, more meditative works, 'the burning of the dream', dealing with the LA Public Library.

It was inside these walls that he spent so many happy years sampling books like food as he escaped from the drudgery of home to immerse himself in the lives of writers for whom he felt an almost instant kinship. The bad ones spurred him on to create his own compositions, but most of these came back to him from editor's slush piles. All the same, the very writing of them saved him from the depression that would otherwise have haunted him. The writers who didn't appeal to him he lists as Shakespeare, Shaw, Tolstoy, Frost and F Scott Fitzgerald.

This is a motley crew, to be sure, but hardly surprising as they all share a penchant for tameness and the well-honed phrase, two qualities that were anathema to Hank. Neither did they live rough, which seems to have been a prerequisite for being appreciated or enjoyed by him. He admits his judgments in this regard have come from his 'forced manner of living' rather than his reason, which makes one imagine that he would prefer to read a bad writer who had been 'on the bum' rather than a good one who hadn't. You always had to win your spurs with this man. He despised smugness.

'The summing up' takes us into the Jane Cooney Baker phase as he remembers those bittersweet years when they lived in hotel rooms and shirked work, the alcoholic over-indulgences of each acting as the balm by which the other sought their alibi, or rationalisation. Paid on Friday and broke on Monday, they rolled out of bed to slake their thirst with the same passion as a starving person coming upon an oasis in the desert.

More practically-minded individuals read the Situations Vacant columns of the newspapers, but this pair of out-of-work hedonists were content to forage and carouse, winging life from day to day, 'almost madder than that which had created us.' It's a sweet paean to a lifestyle that killed one of them and ought to have done the other, delivered in a totally unsentimental manner that's par for the course for Hank. He doesn't put a gloss of nostalgia over the time and neither does he coarsen it. The last phrase says it all: 'we did what we did' — regardless of the consequences.

'My best friend' works a similar beat. One of his many 'life in miniature' poems that stoutly refuses to be specific, it deals with the years when he dragged his (in)famous cardboard suitcase from boarding house to boarding house, taking up jobs when he needed them and dropping them just as suddenly, not having Jane by his side this time but drinking as much as he did with her, 'sucking on gin on the dirty mattresses of nowhere'. He inhales the 'dirty game' of work and then exhales it again, free spirit that he is, drifting on to the next possibility as he leaves behind him all those who aren't even aware of their own stultification.

The following poem, 'if you let them kill you, they will', is a poem that, like 'spark',

is the Bukowski Guide to Positive Thinking — don't quit even when the spoils are negligible — set against the backdrop of his departure from the post office.

The whimsical 'sometimes it's easier to kill somebody else' performs the unique function of actually being funny about a suicide attempt that went wrong — or rather right — as Hank decided that life, miserable and all as it was, was marginally better than gassing himself into oblivion. He's jovially self-critical here, as he is in 'the great slob' where he depicts himself as a rather unsavoury character who still manages to possess an inexplicable fascination for women who seem to like 'rough trade'.

'Cleansing the ranks' adopts a kind of elitist perspective to alcoholism, treating it almost as a badge of honour rather than a disease. There's a lot of macho posturing of the 'You think *you* had a problem?' kind as he targets so-called reformed alcoholics for his invective. 'Nowhere' bemoans the dearth of literary talent in the world in the aftermath of writers like Saroyan, Miller, Céline and Jeffers — who gets a poem to himself later on.

John Martin gets a tribute in 'moving up the ladder' as Hank relates the circumstances of his discovery by that man in 1965. It has taken him twenty-five years to write about the by now legendary rendezvous between himself, Martin and a mannequin named Sadie, who doubled as female company in the days before Hank became a sex symbol. Martin also crops up in 'the good old machine', which sees Hank in contrite form over the gift of a typewriter his editor once presented him with, which he didn't fully appreciate at the time.

These poems are of interest to us because most of them deal with the Bukowski myth in one form or other. He's less gripping with a poem like 'birthday party', which contains a rather trivial Norman Mailer anecdote. 'Always' is hardly much more than an aphorism, and 'just trying to get a little service' is another inconsequential piece that would have been twice as good at half the length.

'A wild, fresh wind blowing' is a poem about anger: the anger of his father, which was inexplicable and abstract, and the anger of the women in his life, equally inexplicable, as they wait for him to solve their problems. His father was best at it, he says, his volatile temper unleashed mainly on Henry Junior.

He grew up to be singularly bereft of the strain himself, he informs us, though some of the aforementioned women would disagree.

He describes himself as 'a dolt of a man, easily made happy or even/stupidly happy almost without cause / and left alone I am mostly content'. It may have taken a lot of abuse to rile him, but when he *was* riled, as I've been at pains to point out in the course of this book, all of the piled-up frustration of his youth came out.

An earlier poem, 'cancer', concerns the death of his mother and her final words to him, 'You were right, your father is a terrible man', the admission that came too late to matter, but a conciliatory gesture nonetheless from a woman who lived a lie for so long, protecting a monster even as he abused her. The day she dies Hank has brought flowers, but he's too late; he sees a wreath on the door, a flower of a different kind, and realises it's over. The poem ends with him driving away like Frederic Henry from *A Farewell to Arms* walking from the hospital in the rain, not seeking the reader's pity at all, just putting it down as it happened.

Another seminal moment in his life occurs in 'poem for lost dogs' when he finally stands up to the Irish barman who's been using him as a punchbag for so long that he expects Hank to roll over. But one day he decides to fight back, to stop being the light relief for the other patrons, just as he decided he wasn't going to take his father's

beatings one day, or when he decided to make the jump in 'flying through space'. He might have said, with the Howard Beale of Network, 'I'm mad as hell and I'm not gonna take it anymore'. (Barfly also draws on the anecdote of facing down the insolent barman.)

'This drunk on the next bar stool' is a poem that illustrates just how uncomfortable he feels in company. He said in an interview with Barbet Schroeder that it disturbed him if a person even brushed against him in a crowd. Here he outlines the discomfort he feels in an elevator: 'I am trapped in an airless cavern of madness — a dull, indecent madness'. To many this may seem a ludicrous overreaction, but only if we don't know our Bukowski. He also exhibits his Garbo-like persona in 'I like your books' where he fobs off an overly-curious fan at the track. He sometimes spoke to strangers here, but only if certain subjects were off-limits. His writing was one of those subjects. The man in this poem crosses that line and gets put in his place as a result. Hank ends by musing resignedly that he's probably lost another one of his fans, adding dryly, 'let 'em go back to Kafka'.

'My father' again brings us back to a theme with which he seems to have had an almost Freudian obsession, but each time he writes about this man he adds in a new spin, as if he's constantly re-evaluating the circumstances of his youth for a new perspective. His father caused him to drop out of society because of his warped attitude to acquisitiveness, he alleges, but when he became a bum he saw greed here as well.

Perhaps as a result of this disappointment, he more or less surrenders himself to the world of BMWs and the American Express Gold Card in the poem 'gold in your eye', set obviously years after his hobo experiences. By now he's a celebrity, having attained the material comfort he never lusted after like his father did but which he likes to wallow in to annoy those people who have romanticised his barfly years out of all proportion and who are now resentful of his new-found prosperity. They claim to be worried about the condition of his soul, in a sudden attack of charismatic zeal. Or are they simply a group of sad fuckers eaten up with jealousy? (Answers on a postcard, please.)

A more meditative note is struck towards the end of the book, but in 'celebrating this' Hank assures us he'll outstay his welcome on the planet as long as he can, and hopefully expire at his typewriter. Three wheels on his wagon, he was still rolling along.

Exactly how long he could continue to cheat death, however, was open to question. Tuberculosis had hit him in the late eighties and now there was the agonising prospect of leukaemia. His trips to hospital for tests reminded him of those he had taken as a child — except now he wasn't just facing embarrassment and / or humiliation anymore, but the prospect of his own extinction.

The first full-scale biography of Hank appeared in 1991. Called simply Hank (a later edition amended that to Bukowski: A Life) and written by Neeli Cherkovski, it was acclaimed critically but actually put the finishing touches to the friendship between the two poets.

The first time Cherkovski met Hank — through his father Sam Cherry — he showed him some poems he had written about him. Hank took one look at them and dispatched them into the fire. A few minutes later he started coming on to Cherkovski's mother. In the following years, however, Hank's poems started appearing opposite Cherkovski's in magazines and he took him under his wing like a kind of Svengali, lecturing him on the best way to write. He told Cherkovski about Céline, Steinbeck, the early Saroyan. He talked to Cherkovski about these writers' gifts and also about the

times they failed to hit the mark. Some writers, Hank said, became famous too early and lost the feeling for why they wanted to become writers in the first place. Others became corrupted by wealth or glory. What you had to do was ignore the paths of others and stamp out your own ground.

Cherkovski saw Hank as a cross between Humphrey Bogart and a character out of a Raymond Chandler book: a dour, but still grittily idealistic pariah creating epiphanies from the raw pain of his experience. He wrote a moving profile of him in his book *Whitman's Wild Children*, which Hank admired so much he felt Cherkovski was the man to write his life story. The resulting book, however, was a disaster in his eyes. He felt Cherkovski betrayed him by the manner in which he used, or rather abused, the material he gave him, cobbling together a hodgepodge of quotes and anecdotes that insulted his hopes. He despised the book and disowned it shortly after reading it. He saw it as a half-baked pot pourri of ham-fisted vignettes which failed to mesh into the depiction of a real person. 'If that's my life,' he said, 'I haven't lived.' He concluded that Cherkovski was a one trick pony who couldn't reprise the talent he evinced in *Whitman's Wild Children*.

What annoyed Hank particularly was the manner in which he had plied him with juicy tidbits about his life. Many of these became mangled between tape and page according to Hank. Cherkovski's book, in his view, didn't capture the mania of his past, skirting round the suicide attempts, the mad women, the jail experiences, the time he spent freezing in that shack in Atlanta. Hank harks back to this very brief spell in his life so resoundingly and so often, one feels Howard Sounes has a point when he says that the 'ten year drunk' phase might have been somewhat exaggerated. Smack in the middle of the would-be debauched decade, Sounes recovered a family photograph showing Hank looking very snazzy indeed in a suit in his back garden. It may well be an 'interview' suit, suggesting the ten years weren't *all* spent falling out of boxcars, or on the bum with Jane. Speaking of boxcars, Sounes also discovered a photograph of him holding on to one of them which was taken by Sam Cherry to illustrate *The Days Run Away Like Wild Horses Over the Hills*. Hank looks much more uncomfortable in this pose than he does in his white suit. Only a fool would deny he roughed it for years, but every writer gooses up his experiences and Hank was no exception. Like other icons of the twentieth century — Bob Dylan, Marlon Brando, Ernest Hemingway, even his beloved Céline — he took great delight in dreaming up apocryphal scenarios about his past.

What also bugged him was the fact that he told Cherkovski that Linda King had hit him one night with a frying pan after one of their kerfuffles. Cherkovski relates the incident having Hank hitting King instead of the other way round. Asked why he did this, he told Hank he thought she'd sue him if he told it as it was! This juggling of events was the last straw for Hank, and seemed to underline its sloppy nature for him. He failed to appreciate any of the valuable aspects of the biography, as when Cherkovski writes thoughtfully (and often movingly) about Hank's attempt to come to terms with the vast complexities of his life and times. The bottom line, he felt, was that Cherkovski failed to put meat on the bones, sanitising his life to such an extent that it approximated to the protected nature of his own one.

There was nothing at all sanitised about *The Last Night of the Earth Poems*, the final Black Sparrow book published while Hank was still alive. Maybe he even intuited this as it has a reflective, valedictory air. It was the first book he wrote on a computer, thus apparently disproving the notion that when one is betting on the muse, technology is

usually better avoided. Here more than anywhere Hank makes a tilt at garnering the tag of elder statesman of letters, though he would probably shoot me for saying that. It has an authoritative edge absent from so much of his previous work, as if he's finally content to wear the mantle of 'writer in residence'. Aged seventy-two, you might say it was about time.

Even in the first poem of the collection, 'jam', he manages to invest a mundane topic (traffic gridlock) with significance, conveying the monotony of his immobility so graphically that the final image of him as a dinosaur crawling home to die doesn't appear in any way incongruous.

In 'the telephone' he reminds us, as if we needed to be reminded, that he's not a great lover of that particular implement as it usually presages an invitation from some undesirable. At one time he would have indulged such a species, suffering the inconvenience out of some misdirected politeness, but now he has no qualms about refusing them.

Besides, such dutiful get-togethers leave lengthy aftertastes. He reassures himself he's not being cruel in rebuffing his callers because this species will simply annoy somebody else instead.

In 'the greatest actor of our day' he writes about a has-been who has a similar attitude to telephone offers. Most likely the (unnamed) actor is Marlon Brando. At times he sounds as if he's trivialising him, but the poem refuses to end on a cliché or a cheap shot. Instead of this easy out, he puts the man into a continuum with the rest of us.

'Days like razors, nights full of rats' is another roller-coaster ride through his back pages, but with the added dimension that he now etches in his schizoid lifestyle of 'library days bar nights'. These two buildings comprised the lion's share of his life, and they could hardly be more opposite. He was quiet in the former, fascinated by the lives of authors, but in the latter his under-self came out. (The Bukowski idea of heaven would be a library that served whiskey!) So which was the stronger influence? Here he seems to suggest it was the library, that 'other temple' where philosophers saved him from 'women bargaining like auctioneers from hell'. It's only when we scour a poem like this that we realise how much of a bookworm this hellraising Antichrist really was.

A 'temple' that *didn't* appeal to him was the cinema, as the poem 'in and out of the dark' exemplifies. This is such a corrosive indictment of the world of movies ('an Academy Award means that you don't stink / quite as much as your cousin') that when he finally escapes from the cinema, even a red traffic light is to be welcomed. (Small wonder then that he so feared Barbet Schroeder when they met.)

'Trollius and trellises' is a tribute to John Martin. He writes frivolously of their 'unholy alliance' and expresses a fear that Martin, being a decade younger than him, will retire from poetry publishing, thus making Hank into somebody who'll have to totally re-invent himself for his successor.

They were both relatively unknown in those uncertain, crazy days, but together they 'laid down the gauntlet' for a whole generation.

He's more frivolous in 'a laugh a minute' where he depicts himself as a kind of circus animal being wheeled out for the delectation of voyeurs: a fifty-year-old, who only goes out for wine or to the races. His love life continues to be an area of high mystery to him. How can an ugly old coot like him get so much pussy? But he still ain't sayin' no to it.

'Death is smoking my cigars' is one of the many poems in the book dealing with intimations of mortality. The Reaper first announced its presence forty-seven years ago when Hank was starving for his art — and bleeding from both ends — and now that

he's a 'minor success' it appears again: more threatening now because he has more to lose. There are shades of Gray's 'Elegy' in the idea of 'storied urn and animated bust' being unable to call the fleeting breath back to the mansion, but he finishes the poem on a positive note, telling death he conned it by getting his Warholesque '5 god-damned minutes' of fame. Is this true, though? Surely it's life he's conned, not death. Rich or poor, he's still waiting for his date with destiny.

Other poems explore similarly familiar areas. In 'hock shops' he reveals that no matter how often pawnbrokers ripped him off in the past, he never grudged them their percentage because their scraps of money kept him alive when nobody else wanted to buy his typewriters or suits or gloves or watches — even for a pittance. No more than the library or the bar, this was another 'marvellous sanctuary' where hard luck cases could keep body and soul together when a salary wasn't coming in.

Such a salary could have been earned from his writing, but in 'hell is a closed door' he tells us that he received enough rejection slips to wallpaper his room. He's not depressed about this, it must be said. A refusal, to his way of thinking, was always better than nothing. (Some editors didn't even grant him the courtesy of a rejection slip.) Further, he would dearly love to see the faces of the faceless people who pen these slips, to see once and for all what makes these 'god-like' arbiters of taste tick.

This is a theme we find quite a lot in Hank's writing: the necessity of something, any kind of a jolt of life, when times were quiet. A fist fight, a rejection letter from an editor, the spit of a whore in his face — all these were better than the silence. It didn't matter if what was happening to him was good or bad; he would accept anything in favour of looking at the wall of a bar as he sought an excuse to go back to the dingy apartments that mocked him with their sparsity.

'Pulled down shade', the poem that follows this, goes on a different tack, being something of an ode to trailer park culture. Here we have one of his girlfriends informing him he exerts a form of perverse fascination for her in his lack of hygiene. The only kind of woman he could appeal to, she argues, is somebody who finds herself vacillating between boyfriends. Hank obviously relished all this, if indeed it was ever said to him, and one presumes it was. Clearly, he had divested himself of the sensitivities he had in youth whenever he was insulted. At this point of his life his decrepitude was almost a badge of honour.

'Dinner, 1933' is an extended résumé of his father's culinary habits — or rather his gluttony. After we read it we realise why hunger, for Hank, must almost have been an antidote.

'Everything you touch', meanwhile, has him coming clean about his overtures to ladies both in LA and New Orleans. And then he gives us that great line: 'maybe that was all you could get and maybe you were all they could get'. Perhaps this phrase more than any other encapsulates the weird happiness he experienced with Jane.

The collection veers off in many directions after this. 'Poetry contest' is a hilarious exposé of the way gullible wordsmiths can become exploited by the system. (Hank was there more than once.) A different take on a similar literary sterility crops up in 'the replacements', where he excavates a hobby-horse theme of universities sucking the lifeblood out of authors. Perhaps he was thinking of his sometime friend William Corrington when he wrote this. And then in 'confession' we have a unique Bukowski poem — an ode to Linda Lee wherein he expresses his love for her.

It's interesting, but not altogether surprising, that he would see such an admission as a 'confession'. Hank could never be accused of being uxorious!

'Mugged' has him feeling spun out. He hasn't been in a fist fight for fifteen years. He drinks alone, listens to classical music and waits for death. His life hasn't been in vain, he says wryly, even though he never met Jack Kerouac. This tasty dig has perhaps a modicum of jealousy in it. Let's not forget that Kerouac, after all, was a legend at a time when Hank, as he puts it in the following poem ('the writer') was sorely dependent upon the kindness of landladies to give him some leeway on the rent as he awaited replies from poetry editors who took a lot of time to say no to him. He was so thin at this point of his life he could 'slice bread with my shoulder blades'.

'They don't eat like us' is reminiscent of 'dinner, 1933' in that it takes another swipe at his father's gluttony. The young Hank watches him stuffing himself and wishes him in hell, feeling more hateful towards him in these excesses than when he endured 'brutal beatings' at his hands. Later in life Hank got some vestige of revenge on the old man, he tells us, but a lot of his resentment has lasted to the present day.

'Spark' takes up the running again from 'the writer', going into more detail about the manner in which he came so close to pushing the self-destruct button in the fifties. The post office crucified him, as did the calcification of his colleagues, who didn't even seem to realise the pit they were in. Seeing them like this drove Hank almost as crazy as the debilitating work he was doing. Drink saved him somewhat but women didn't. He lived with 'the worst kind', and they 'killed what the job failed to kill'. He knew he was dying inside, but he hugged on to the eponymous spark, tiny and all as it was, having some vague intuition that his life could turn on this detail.

The following poems have him philosophising about a world he inhabits but will never fully understand. In 'upon this time' he goes into the subject of writer's block (not a condition one imagines this incredibly prolific man would ever have suffered from). In 'ill' he again addresses the subject of his mortality, writing about a world in which we 'eat, work, fuck, die'. The closer he gets to death, however, the less fearful it becomes. More worrying is the number of visitors who wish to call on him but these he rebuffs, feasting on solitude.

Writer's block is also a concern in 'only one Cervantes', but this time he manages to exorcise it by writing about it. He worries about old people in nursing homes 'grunting over bedpans' (a prospect that terrified him should he ever find himself in this pass) but thanks his lucky stars that thus far the gods have spoiled him — largely through writing.

The next three poems are also concerned with death in various degrees, most-specifically 'D' where his doctor tells him he has cancer, albeit of a non-life-threatening form. 'If I had cancer,' the doctor says, 'I'd rather have your kind'. (The poem doesn't give us Hank's real-life response: 'I'd rather you had it too!')

After these we get perhaps the most beautiful poem in the collection, 'in the bottom'. This is one of his most disciplined and coolest works, written from one of his many dark nights of the soul as he chronicles the 'suicide oceans of night'. Each verse begins with the same line ('in the bottom of the hour') and takes us through a catalogue of tragedies from the back pages of history, rounding itself off with Hank himself, who has become increasingly mystified by life. He reaches no conclusions, but this is far from being a depressing poem. In fact it's curiously uplifting in its lyricism.

Section Three of the book continues the strain of 'Il Penseroso'. Hank strides his *via dolorosa*, bathing himself in the trivia of his days. Life is a movie, he tells us *à la* Shakespeare, in which we're the willing or unwilling cast members. We negotiate the mind-numbing boredom with varying degrees of success, fending off pressmen ('the interviewers', 'between races') smoothies ('the aliens'), nonentities ('splashing') and

insomnia ('darkling'). In the latter poem, again, failure to sleep brings on thoughts of the big sleep.

In 'the lost and the desperate' we find him reminiscing over old movies, and coming out with the surprising revelation that he liked those about the French Foreign Legion the best: an amazingly normal part of an amazingly abnormal childhood. He loses himself in the derring-do escapism, imagining himself as the hero of the hour like any other child his age watching those celluloid images, but of course as soon as the film ends Hank sings an old tune, returning home to the real world and a cruel old man who forces him to mow the lawn and wonder why 'all the brave men with beautiful eyes were so far away'.

The theme is continued in 'the bully' but by now he's no longer terrorised by his father and is starting to analyse rather than fear him. The poem is written from the perspective of a thirteen-year-old Bukowski — three years before he would finally deck his father in retaliation for all the years of abuse — but even now the tables have started to turn, however slightly, as he begins to realise Henry Senior has a serious sociopathic problem. The fact that the guy was an asshole to everyone, not just Hank, somehow makes him not quite as hateful. (After all these decades, he realises it wasn't personal!)

Another interesting poem is 'off and on', in which he writes of his many flirtations with suicide. Again, however, the tone seems more playful than morose. He first thought of ending his life, he reveals, at the tender age of thirteen, and it has been with him 'off and on' since. It waits in 'odd little places' for him but he keeps it in check by carrying out the trivial quotidian acts with which we all crowd our days.

'Luck was a lady' is a confessional poem about the bad days when his vain attempts at chatting up women were summarily rejected. When he watched them being picked up by men better turned-out than himself it was like the Prom experience all over again as he seethes with resentment, imagining he will be 'the idiot in the schoolyard' all his life, like a scar on his soul. 'Crime and punishment' also trades on his childhood, on all those days he was sent to the principal's office for misbehaviour and forced to stand in a glassed-in phone booth for hours as a punishment. The poem ends on an upbeat note with Hank getting some degree of satisfaction from the fact that the aforementioned principal was subsequently imprisoned for embezzlement of school funds. The irony is choice here with this ostensible pillar of the community cooking the books as the supposed ne'er-do-well (who will one day become mega-famous) malingers in a claustrophobic space.

'Inactive volcano' is a fairly typical example of a rather slender narrative that makes an interesting point simply. He goes into a bar he used to frequent when he was a down-and-out, being now famous. The bartender remembers him from the old days and is bewildered to see him with a member of the jet set. Hank gives no explanations and makes no excuses. No, he hasn't gone soft. He's the same man he always has been. Different suit, maybe, but same heart. What's more, he may yet go crazy again, even with his glitterati friend. The poem ends with the playfully ominous: 'wait and see'.

'Creative writing class', the poem that follows this, has him in cocky mood, looking back on the days when he attended these dreaded gatherings of wannabes. The super-confident Hank (who would have guessed?) even then had a hunch that he would be the only one of them who'd make it creatively. This attitude flies in the face of other poems where he seems to tell us he almost topped himself on occasions, feeling the breakthrough would never happen. He even acts surprised that he was fifty before he

hit paydirt.

'Cool black air' is a valentine to his typewriter, which has the self-styled 'old fart' kissing it in gratitude for the happiness it has brought into his life. It may have taken him a half-century to acknowledge the debt but his appreciation is no less authentic for that fact. He disgraced himself often with women but he has always been at his best sitting here at this machine. Neither has it ever given him backchat or been demanding or insulting or selfish. One senses that it's been like another daughter to him, a faithful lieutenant he can always depend on through thick and thin. Providing, that is, his inspiration is 'going hot'.

'The jackals' refers back to the theme he's already covered in 'the interviewers' and 'between races', i.e. those hangers-on at the fringes of literature who continue to hassle him for soundbites to grace their Sunday supplements. He has little mercy for them and seems to take an especial delight in fobbing them off. Following this we get 'warm light', a twenty-line PS to this poem and a pleasant way of ending the section. Having hung up his phone and got rid of the jackals, he's back with his six cats. Without effort and with immense self-composure they tell him everything he needs to know.

Section Four begins with 'dinosauria, we'. It has some interesting vignettes but is really little more than assembly-line apocalyptic fare at best. It's not a weak poem but he's always more engrossing when he's being personal than when he's issuing a polemic, however heartfelt its utterance might be.

'Last seat at the end', an ode to serious drinking, is one such. Providing proof, if proof were needed, that bars provided him with the necessary ballast to fight the world outdoors, it's a kind of pagan celebration of escapism.

So too is 'hangovers', a poem where he outlines some of the more horrendous side-effects of the DTs and the morning after, but then pulls the carpet from under our feet by telling us that his crazy binges were lovely as well as being beastly. He doesn't condemn or condone, merely states that hangovers come with the territory of drinking and are thus a necessary evil. As regards the drinking itself, he seems to be saying, with Edith Piaf, 'je ne regrette rien'.

A more sober side of his character is captured in 'my first computer poem.' Here we have a harbinger of the new Bukowski, who's been dragged kicking and screaming into the modern world by his wife. (Linda Lee bought him a present of the computer for his seventieth birthday.) Among other things he wonders if Whitman would be laughing at him from the grave but decides to press on regardless, viewing his new MO as a beginning rather than an ending. Of course it's both.

Bukowski using a computer was like Bob Dylan going electric at Newport: the ultimate sell-out in some people's eyes. Hank himself was more philosophical about it. He allowed that it was somewhat prissy, but anything that increased his productivity and corrected his spelling in the process couldn't be all bad.

In 'young in New Orleans' he leaves us in no doubt about just how reclusive he is, preferring the rats in his apartment to the humans: the ultimate misanthropic putdown. Even being crazy, he concludes, isn't so bad if you can be that way undisturbed. What he also prefers to people, of course, is symphonies, as he relates in 'classical music and me', where he indulges in a diatribe about how he conquered the myth that such music was sissyish, becoming hooked on it from a young age and thereafter buying out the entire stocks of certain record shops. After he went on the road he had to leave his records behind and then he was dependent on the whims of radio stations for his fixes. Sometimes they turned up trumps, introducing him to composers he wasn't aware of,

but other times the blandness of the well-covered terrain infuriated him. In general, though, it was such music that got him through.

Books also helped in this regard, as he makes plain in 'the word'. This punch-drunk hobo was an unlikely literary scholar but his bibliophilia, he emphasises, possibly kept him from murdering somebody — including himself.

There are many other quality-studded poems in these pages, which seem to usher in a more mature style, even if he's still harping on many of the old obsessions. Sooner or later everything that ever happened to him seems to find its way into one of his books, featuring either as a straight incident or an excuse to make a point about an incident. The former is invariably more effective.

His health was in tatters, however, when this collection hit the shelves. His body was finally putting up the white flag, pleading with him for mercy.

He had contracted leukaemia in the spring of 1993 and the prognosis didn't look good. The doctors were grim but he ploughed on, eternally optimistic as he tried to treat it with alternative medicine when they said the chemotherapy wasn't working.

He had, after all, a right to be dubious about medics: they were wrong to tell him he would die if he took another drink in 1955.

He had negotiated so many crises he could have been forgiven for imagining he was immortal. His ambition had been to celebrate his eightieth birthday in the eighth month of the new millennium. But knowing Hank, of course, if he *had* lasted that long he would have been going, 'I want to live to 2020 — my centenary year'. 'I intended to live to be 80,' he had written in *Women*, 'so that I could then fuck an eighteen-year-old woman.'

He had always believed good writers should be given longer lives than anyone else. In his poem 'the feel of it' from *The Last Night of the Earth Poems* he wrote that sixty-nine was too young for Aldous Huxley to have died. Huxley had helped Buk through some dark nights. Did that not count for something? Did it not count for something that Buk himself had done the like by others — even if his prime motivation had been to save only his own ass?

At seventy, he said, he had drunk more booze than most people had water. But, more importantly, he was still around. And the doctors who had told him he was killing himself for the past two decades were now dead themselves. If it wasn't so funny it might have been tragic. He had supped with the devil using a short spoon and come away smiling. But he couldn't go on forever.

He mentioned almost nonchalantly to William Packard in a letter written in August 1993 that his doctor told him he had about a year to live. He had gone through the agony of chemotherapy for nothing. Another of life's little jokes...

He bore his ill health with fortitude, informing nobody outside his immediate circle, and then only if he had to. The only inkling others had of it was his uncharacteristic failure to reply to their letters. (He was sensationally prompt in this regard, as one may glean from the dates of his missives sent and received in the hundreds of them published by Black Sparrow. The sheer volume of these makes one wonder how he found time for anything else.)

He claimed he had a gigantic yellow streak down his back, but then people who call themselves cowards rarely are, and this man was no exception, as he proved time and again — not least in how he negotiated his final illness. Would he burn out or fade away? His whole life and career had been a crusade against melodrama, so why should he undo that now?

He had always said he feared life more than death — probably because so few people had showed the courage to take it on as he did. He had finally arrived at Terror Street, but he showed no terror.

Another factor which took away potential fear was a touch of the old suicide complex that was still present in him to some extent. And of course his humour. 'Dying might be bad,' he allowed, 'but it can't be worse than hangovers!'

Life was a joke and death a bigger one. The coming in and the going out were equally absurd, equally freaky. All we had to work with was that little dash between the date of birth and the date of death. Everything else was out of our hands. A man could live eighty years and not have lived. A man could fly past your window in a dinner jacket, having jumped to his death for reasons best known to himself. A father in apparent good health could collapse reaching for a glass of water one morning, the tap still running as he fell. A wife could die in India and not have her body reclaimed by her family. A former lover could be given a Christmas gift of one too many bottles of liquor for comfort, bleeding her guts onto the floor. On the other hand an alcoholic, condemned by the experts in 1955, could live four more decades, seeing off TB and leukaemia as he once saw off a bleeding ulcer. Goddam it, he still had some work to do — did this not entitle him to a stay of execution?

Or maybe he had been given this already...

He could hardly complain. He had escaped a tyrannical father, any number of mad women, a death sentence and a life that was going nowhere for so long. His sometime mentor Ernest Hemingway had gone from living an adventurous life to suffering a humiliating death while he, who had lived what many would dub a degenerate one, would end it with dignity and grace.

If he had died in 1955 his life would have been as meaningless as that of his father, a man who did little for half a century but vent his spleen about the necessity of earning a buck. Hank was richer now than that man could ever have dreamed about but he would gladly give back every cent for a little more time.

He had once run errands for sandwiches, had begged for drinks, had even pulled his own teeth out to save money on dentists, and now he was the most translated American author in print.

But all this was now about to end. The man who once described himself as a dog who managed to walk across a busy freeway without looking was about to bow out without even a growl. He had finally met his match. He had more money than he could ever have dreamed possible, but what good was it to him? There were no pockets on a shroud.

He had given death 'many clean shots' at him in years gone by, as he put it in Women, and it hadn't taken advantage of them, but now, when life suddenly meant so much to him, it was about to cast him to the lions.

His circumstances, if nothing else, ratified his long-held belief that life wrecks all of us sooner or later — usually by the dirtiest tricks it knows. It didn't matter if we were opening a can of beans, falling in love or slashing open an envelope. The secret was to know that and expect it. To expect that women would rat on us, that friends would betray us, that our bodies would sputter out finally. What we had to do was make the most of the time we had, even if death held us by the short hairs. Hank knew he was lucky to get this far so there would be no bitterness. It was more a case of 'Ready when you are, motherfucker'. Or, as convicted murderer Gary Gilmore said, 'Let's do it'.

The clock continued to count out his pennies of time but he didn't panic. Que sera

sera. Whether he was cured or not, he would keep nailing the word down. He would die with his boots on, hopefully with a collection in the works.

He didn't jump off a bridge like John Berryman, didn't put a gun in his mouth like Hemingway, didn't drink himself to death like Behan. But he didn't fade away either. He burned until he was burned out and then his body lay down like a tired horse in the sunset after a gruelling seventy-three-year ride.

Bukowski had lived. He had drunk the good wine and the bad, sampled the mad women and the sane ones, communed both with the angels and the devils inside him.

He was the Dylan Thomas who survived, the John Berryman who didn't jump, the Scott Fitzgerald who spat in the face of death, the Hemingway who stared down the barrel of a gun turned in on himself and then guffawed. Because success came late he never grew bored with it. In a way his burn-out was in his pre-fame days. Put another way, he destroyed himself before he was even created. It was like having two lives in one, with the second one lived first.

His whole life had been a revolt against death, but now it was time to fold his tent. He wouldn't have the bedpan or the Zimmer frame; there was at least this consolation.

In a way it was a release from his demons. The boat would finally be stilled as it lay tethered to the harbour. All we owed life was a death, and after that there was no other. Even if you got a lousy hand you had to play it to the last card, preferably with a poker face.

Dying didn't depress him, he said. What depressed him was what he was leaving behind: 'the drunken nights and the days at the track'. It would have been nice if there was more time, but he could hardly complain at seventy-three. He had, after all, been on borrowed time for about two decades now. Death on the instalment plan, as his old friend Louis Ferdinand Céline might have said.

What he resented about death, he said, in Bergmanesque vein, was that it hadn't earned us, hadn't shown any credentials. It arrived unannounced and unasked for, having done nothing to justify its existence. All our lives were death sentences in this sense. We were, as the philosopher Martin Heidegger put it, 'a throwness into being'. We didn't ask to be born nor did we ask to die; it was all arranged before we got here. This was the hand we got, the hand of aces and eights. You couldn't argue with it: all you could do was try to end it early or tough it out on its own terms. Anything else gave it a power it didn't deserve over us.

In a sense he seemed more concerned about posterity's view of him than anything else: he feared the vultures more than the worms. Dying was natural, it was part of life, but the destruction of his reputation would be harder to take. (Though having said that, he hated the fake sentiment that came when people spoke of the dead.)

He had a healthy scepticism up until the day he drew his last breath, going into the Great Perhaps without what he called 'the god-fix'. He would take his chances with whatever apocalypse materialised, or failed to. Death was merely another pit stop for him. He would leave life as he entered it: sullen and without hope, but with the saving grace of his intense belief in himself.

Religious faith was too convenient a way to make sense of the madness of existence. It was a comfort blanket the crippled and tortured pulled around themselves in times of trial, a form of fire insurance that served as a kind of mass hypnosis for those who couldn't face the world naked.

He refused to cave in at the finish, refused to be fucked by the big fear. 'The strongest men are without Gods,' he said, quoting Ibsen. People who believed in God,

as he put it in the poem 'hug the dark', were 'sucking wind through bent straws'. You had to walk naked into the light, to suck on the worm in the apple, not just the apple itself, as in the Garden of Eden story. There would be no crucifix in this deathhand.

If there was a God, it seemed to him, it had to be an evil one to account for the state of the world. Poetry was the closest he ever came to a spiritual experience. Or, dare one say it, love.

He wasn't unduly perturbed about being caught with his spiritual pants down. God, he once said, was marginally less important to him than his local plumber, who kept the shit flowing. What had God done anyway? He gave life only to take it away again, and between cradle and grave there was more malignancy than joy. If this was the work of our benign creator, what hope had we with His nemesis?

Though he didn't believe in God, he felt there was a spirit of goodness running through people, something you saw in little daily things like somebody making room for you on the freeway, which hinted at the possibility of something greater.

The revealed truths of religion were little more than placebos to keep the poor and afflicted content with their lot. It kept them hoping that one day it would all be different, their suffering assuaged as the first became last and the last first. But he couldn't buy into this dream. Like politics it was another big lie, the opium of the people.

The religion he grew up with was that of the Old Testament, the one of a God who represented fire and brimstone rather than kindness and love. Understandably, he jettisoned it along with most of the other socio-cultural baggage Los Angeles tried to lay on him as he struggled through a traumatic youth.

Religion was just another big con for him, like women or the horses. The 'once a Catholic, always a Catholic' credo was still bullshit in his eyes. Man had created God in his image: that was all that needed to be said. Here was where it happened, here in the stinking furnace of life, where flowers occasionally dug their way through the cement, where a hard heart occasionally melted and gave you a blast of hope. But it was never meant to be forever. Only books lasted forever.

He wasn't even quite sure if Jesus Christ was an actual historical person. If he was, maybe he was just a good guy with delusions of grandeur, and, as was the case with most good guys, he was persecuted and died young. Further, according to Hank, he talked too much. Maybe he talked himself into an early grave. Whether he rose out of it was another matter. Personally he didn't think so. (Another man alleged to have risen from the dead as far as the Bible was concerned, was Lazarus. Hank's reaction to this parable was vintage Bukowski. 'How sick', he said, 'to make the poor bastard have to die twice!')

God was never a major character in his work. Maybe we were all God. Who knew? The meaning of life had to be reinvented for each individual. It wasn't there like an oracle before you. There were only road-signs, road signs carved into the convoluted tapestry of your heart. He had always shown more of a romantic attachment to the primitive concept of 'the gods' than the Christian one of 'God'. Such a distinction is crucial in any discussion of his religious yearnings — or lack of them.

If he met God you got the impression he would say to Him: 'Man, why'd you dump on us all down there for so long?' If he ended up downstairs he would probably have shaken the devil's hand and said 'mind if I go see some of my friends?'

He had always thought the devil was a more interesting character than God, and would probably have been on his side in the war that saw the cloven-hoofed one cast into the fires of perdition in Genesis. Lucifer was, after all, the underdog, and who else

could you expect Buk to root for? (If we wish to be Freudian about it we could say that all men see the God-figure as an extension of their fathers, and for Hank that would be an uncompromisingly cruel personage.)

Would God offer redemption to a reprobate like Hank, a man who was more drawn to the Mary Magdalenes of the world than the Blessed Virgins? Maybe He'd evade the issue altogether. What was the old joke... 'God isn't dead, he just doesn't want to get involved'. Maybe there was some truth in it. If He really was up there, He didn't seem to be answering calls a lot of the time. It looked like He'd left the phone off the hook indefinitely.

Maybe, on the other hand, atheists like Buk would go to the top of the line. Why not? At least they were honest. Infinitely worse would be to pretend to yourself that you believed when you didn't. That would be like Pharisaism. Was God so insecure that He needed people to believe in Him so as He could feel good? Hardly. To impute as much would be the ultimate insult.

Hank packed his bags for eternity with what he called 'a deck of unmarked cards' — the final signature tune of the existentialist — expiring in Linda Lee's arms on March 9, 1994. The official cause of death was pneumonia, the chemo having played havoc with his immune system.

So Bukowski was gone. Could this be the end of Rico? Every few years there were rumours that he'd snuffed it, usually put out by his enemies. Now those enemies could dance on his grave if they wished. Would they? Now that they'd got their wish, maybe there was a sense of anticlimax in it. They wouldn't have anyone to kick around anymore.

He died leaving a staggering forty-five books behind him, a tally of near-Dickensian proportions. They would also be translated into countless foreign languages. The demand for them would be constant, as would the demand for knowledge about his life, though if someone had told him this in the sixties he would have referred them to the nearest shrink.

The newspaper obituaries were predictably riddled with the clichés of those who had probably never picked up a book of his in their lives. They referred to the bard of the bar, the laureate of lowlife. The dirty old man who spent his life worshipping at the altar of excess had finally shuffled off the mortal coil. Lazy copytakers spent their time digging up accounts of him that had been on file for up to twenty years now, the people who wrote them arguably dead before such orbits saw the light of day. Once again Hank had had the last laugh.

He was buried in the clothes he wore to the track, a pen in his pocket which he used for filling his racing sheets. In all the years at the track he had probably broken about even, which was a lot better than most. He had beaten the con. The con of death, however, was non-negotiable. This was an odds-on favourite that wouldn't fall. It was a marked dice, a staged finish.

The funeral was a subdued affair presided over by, believe it or not, three Buddhist monks. Hank had embraced Buddhism in his last months, seeking from it the tranquillity that had partly come his way since meeting Linda Lee, the woman largely responsible for him getting this far.

Equally muted and unlikely was the reception afterwards, at which nobody drank alcohol. (How he would have chuckled at that!) He may have died as he lived — with his foot on the pedal — but he was hardly spirited to Valhalla that way. It was like the calm after the storm, the silence of the service in stark contrast to his feisty readings

of yore. What people were doing was giving him the respect he had all too rarely given himself. Those who had cared most about him were present: Linda Lee, Marina, John Martin, Carl Weissner, Sean Penn, Gerry Locklin, but few others, which was the way he would have wanted it. Just as he didn't like gatecrashers at his house, neither would he have liked them at his cemetery. His race was run, his song sung. You didn't need a multitude to seal the lid.

His tombstone carried the inscription 'Don't Try', a phrase that encapsulated his philosophy both of living and writing. Over-elaboration had been the bane of too many, and they fell on their faces as a result of it. You had to live life like the grass grew by the weir, taking it where it called you without asking too many questions. What would happen would happen, and you had to deal with that. Because blessings usually only came when you pretended you stopped wanting them. This was life's sick joke on humanity, and why none of us could ever be truly happy.

Was Bukowski ever happy? Perhaps it would depend on what we mean by the word. Did he deserve to be? As Camus said of Meursault, maybe he was the only Christ we deserved.

He started life with a lousy deal, a deal that promised nothing, but he made something of it. Not wilfully, not, even willingly, but it happened. Unlikely jobs were followed by even unlikelier women, but somehow he hacked it. He never thought it would happen, and when it did he wasn't really ready, but in a way that helped. He expected little, so he wasn't greedy. He set no agendas, laid down no ground rules. To be alive was enough, with or without a woman in tow, or a job or a book contract or a daughter who brought him back to the simple things.

Erica Jong once said that American writers are drunks and melancholics whose main relation to their young aspirants seems to be 'tell me one good reason why I shouldn't commit suicide'. Hank put forward this image, but it was *only* an image — even if he was entitled to make it his reality considering what he'd been through.

He was a cynic only in the sense that cynics are often deflated idealists; they're people who would *like* to be idealists but can find little commensurate with such an ambition in the world they see around them. Rather than turn a blind eye to this, as most of us do, they hit it head on, biting the bullet. But Bukowski the dreamer was always trying to crawl out from under the mire. He was like a diseased romantic who stared into the abyss until the abyss stared back. And when it did, he laughed at it. This was another defence against dreams that could destroy.

Sean Penn put it well. 'He was one of those guys,' he said, 'who was given every opportunity in life to become a jaded, cynical prick, but he was anything but. He was the sweetest, most vulnerable pussycat. He disguised it wonderfully, but he was the real goods in terms of preserving his innocence and optimism and love.' 'I know I'm good,' he told Penn, 'but I prefer people to think I'm bad, because it gives me a dimension.'

'Basically,' he would write to Jim Roman in 1969, 'I am a kind person' and the statement would linger on the page almost like an abomination, because this wasn't the Bukowski we thought we knew. It wasn't the Antichrist of the bar, it wasn't the Rabelaisian iconoclast. Was it possible the old devil had a soft centre after all?

Aftermath

All we gotta do is die.
And after livin', that's
a break.
Charles Bukowski

RIK RAWLING 2001

At the funeral of the film director Ernest Lubitsch, the story goes, film director William Wyler said to his colleague Billy Wilder, 'No more Ernest Lubitsch'. Whereupon Wilder replied, 'Worse — no more Ernest Lubitsch movies'.

The same could hardly be said of Hank's work at *his* funeral, for he left enough unpublished material to last well into the new century.

The posthumous work put out by Black Sparrow Press is as fascinating as anything Hank published while he was alive. At times it appears like a bottomless well. It's been observed that some of his individual poetry collections are larger than the *total* collected works of T S Eliot. When you multiply this by the *number* of collections he published, the overall tally is quite staggering. Some of it is mediocre and some repetitive, but his mind was such a kaleidoscope he never ceases to surprise us with his idiosyncratic take on life.

Four volumes of letters have also been published and these must rank with the most explosively frank letters of any writer in any generation. He tears his heart out and lays it across the page time and again, making us wonder if this could really be the same man who could be so blunt, and indeed cruel, in many of his relationships.

They also read like the total antithesis of the poems, being filled with labyrinthine clutter instead of spare and simple diction, the preferred Bukowski parlance.

They're like the unprocessed expostulations of a subversive genius, but they also have a kind of cerebral synergy. The Ts may not always be crossed or the Is dotted, but this is a man laying the furnace of his heart on the page like verbal napalm. He needed to write letters as much as Hemingway did. They stopped him from being lonely, and also helped keep his literary hand in.

The fetid concatenation of thoughts is semi-hallucinogenic at times, as if he's on one seriously bad trip — and then we get something hilariously banal, like a haemorrhoidal itch, to return us to earth. Images flood from him like lava as he fulminates on every-

thing from percentages due to him for his outpourings to the meaning of life... or the lack of it. He eschews capital letters, eschews paragraphs, eschews any of the niceties of convention as he rants and raves about his predicament at the bottom of the totem pole — and, later, the top. Even though the tone is harsh, it's never gratuitous or self-pitiful. He writes like a Dostoevsky raised in a Los Angeles sewer in the 1920s. If anybody is in any doubt that Hank didn't care passionately about what he did, they should check out these substantial volumes. In them he ranges from tortured and pleading to cackling like a hyena from hell.

His letters are unlike those of any other writer. They're written in blood, sweat and tears, with nothing held back. Sometimes it doesn't even seem to matter who he's writing them to: the emotion just gushes out. They give off the sense of a man living on the edge of his own psyche — bitter, humorous, desperate, rambling, loyal, sensitive, fierce. It's as if they're his private confessional, the manner in which he heals his dementia, or at least keeps it at bay. Whether he's talking about his health, the state of poetry or the dark pit of his life in general, they're suffused with a complex mix of insouciance, and what sometimes seems like incipient neurosis. But if this is so he seems to have a containable level of it. Almost against himself, he manages to keep it under wraps.

They're also awash with ostensibly negligible detail that intrigues. He cashes a cheque in a bank and that gets a mention. In another instance he goes to pee in mid letter. He drops ash on his one good pair of trousers and burns a hole in the leg. He gets hemmed in by his neighbour in the parking spot and blows a fuse. He waves to a child playing basketball, overtakes a motorist on the freeway for a challenge, sings songs from *Oklahoma* with his landlady. In themselves these incidents are hardly worthy of mention, but they bring us so far into every aspect of his life they all form an integral part of the patchwork quilt of his days. At this level, we're not so much reading letters as diary entries.

Sometimes when a poet writes prose he does so in a prosaic manner but these letters could almost be edited down into hundreds of poems themselves, so rich is the language here. No wonder they provided such solace to those who received them when they too were struggling.

'How many poems do you waste by wasting letters on me?' he once asked Douglas Blazek, but it was really the other way round. In fact there's even an argument to be made for the fact that he put his talent into his work but his genius into his letters. Of course they're often formless and inchoate but then so is the poetry. He was one of the few writers who could speak about Camus, classical music and haemorrhoids all within the one paragraph as in his letter to Jon and Louise Webb from February 28, 1966.

It wasn't the large tragedies of life that destroyed us, he knew, because we were generally prepared for these. It was the daily anguishes that finally killed us. A bill. A broken tap. A car that wouldn't start. A bad poem. A bitch with a sore head. Such drip feeds of misery ate away at our souls.

Screams From the Balcony, a selection of his letters written from 1960 to 1970, is easily the best of them, giving us a Bukowski who ranges from excitement over seeing that *It Catches My Heart* has been in fairly continuous demand in a library to one who exhibits the dystopian misery of a man who feels his life is like a used condom.

This is a little big man who gives a voice to the forgotten heroes of the literary pantheon, the ones who didn't make it or who made it too soon and then lost it. The flipside of grandeur. The rats of thirst. Those frozen in time or place, stretching towards fulfilment but finding only the purple entrails of their own insignificance. Dreamers —

like himself — who woke too soon to the morning after optimism. The snail under the stone, the dead spider, the fish that couldn't dance, the woman who fucked him over, the poem that died in his head before he could lay the line down.

He teases out his tensions in the letters, using them almost like a psychiatrist's couch. There's even something medieval about them. He's like a perverse monk seeking nirvana through profanity in the surreal bowels of a Los Angeles that's like Sodom, or maybe even Armageddon. The imagery of hell, apocalypse and crucifixion is never too far away. This is a man who's been burned at the stake, who's still being burned every day. But he doesn't whinge, doesn't sing the blues. The documentation of the pain is never geared towards sympathy. He would spit at sympathy. And often he laughs at his plight. If he didn't have this facility, one doubts he could have come through. He evinces an existential acceptance of the absurd, the kind of blackly comic edge we often see in the likes of Beckett, another author who had a special place in this hobo's heart.

Like most complex men, Hank often changed his mind about things. There are times he writes about his past as a nightmare, and then he might interject out of the blue that his 'ten year drunk' with Jane contained some of his most treasured memories. He writes about women both as sweet liberators and poisonous snakes.

Drink nearly kills him but also saves him. So does literature. Hemingway is both hero and villain, and so is Miller. He also shifts his kaleidoscope to Ezra Pound, Carson McCullers, William Faulkner and Dostoevsky. Very often an author's worth, or lack of it, is a function of how he himself feels at a particular time of his life. In his personal friendships he goes from gushing over people to writing of them as scum.

The same names crop up interminably: Douglas Blazek, Carl Weissner, William Corrington, Jon Webb, and of course John Martin. You can nearly see the high-octane fuel rising from the pages as Hank unleashes his indignation, but there's also a lot of poetry here. In fact if he harnessed the energy from the letters and channelled it into his creative work, one feels he could have made another dozen books out of the insights he throws away so nonchalantly here. Like a deserted victim hacking through the undergrowth in a jungle he fulminates against the posers and the preeners, the tea ladies and the cliché merchants, the easyriders and the bandwagon hoppers. Each day is a struggle but he battles on, his shoulder to the grindstone, waiting for the snow to melt with a new book, a daughter, a woman, a drink, or simply playing the ponies.

In the sixties rejection appears to be the norm for him. The seventies bring a certain upswing in his fortunes but he still can't afford to relax. Black Sparrow Press gets him out of the post office but he still carries out his own garbage from his apartment to save ten bucks on the rent. A more mellow strain is evident in his middle age but he never wimps out, taking an ironic attitude to success. Whether he's struggling to get ten lines accepted by a poetry magazine maybe a dozen people will buy or writing a novel that will be translated into twenty languages he's still the same man laying down the line.

Even when he's afflicted by tuberculosis and leukaemia he still manages a cheery attitude, whistling in the graveyard as death by a thousand blows start to kick in. Chemotherapy is just another trip down the highway. He never caved in before and now wouldn't be a good time to start.

When Douglas Blazek asked for permission to print some of his letters he told him to go ahead as there was nothing he was ashamed of anybody seeing. Frankness, after all, was what his whole life had been about. Occasionally, however, his missives did him no favours, especially if they were written when he was drunk. He cites one example of a letter he wrote to an editor who had accepted some of his poems. After the letter was

received the poems were then rejected. He had, as it were, come out of the closet about his take on life and fell victim to a negative reappraisal of his work as a result. The unethical nature of this procedure is appalling. In fact Hank may have even had the right to take legal action on account of it. Either way it demonstrated to him once again how flaky editors' views were — as if he needed proof of that fact.

His final novel, *Pulp*, was also published posthumously. Dedicating it mischievously to 'bad writing', this was Hank's last two-finger gesture to an establishment that had first pulverised and then championed him. It was his way of saying 'fuck you' to those who claimed he was only a paper god. Poking fun at himself was the best way to inure him to the brickbats of others. The reality was that their jibes hurt him much more than he would admit, so he had to acquire a mechanism to deal with that. The one he usually chose was to cast himself as the fool. This didn't require too much effort because it was a role he had been playing to some extent all his life.

It's an ambitious undertaking from the point of view that Hank, after over five decades of writing almost totally about himself as a menial worker cum poet, has finally stepped out of this groove and into that of the gumshoe. There the ambition ends, however, because he hasn't really carried through on the possibilities the new guise affords, content to stumble back into the predictable Chandleresque wisecracking dialogue, the ultimately pedantic insults and threats, the by-numbers existentialism, the would-be crumpled dignity of the three-times married, three-times divorced private dick who takes cases others won't touch.

Nick Belane is really just Henry Chinaski with a gun. He may talk more eschatologically than scatologically, but little else has changed from the other novels, either in manner or matter.

The character of Lady Death is also contrived, and fails to add depth to the intended autumnal quality of the book. Hank knew it would be his last novel, which is probably why he injected the experimental element into it, but he may have been better off keeping the Chinaski alter ego and writing a more elegiac tome in line with the tone adopted in the *Last Night of the Earth* collection. As it is, the tough guyism and tame stabs at etching in the private thoughts of a loveable loser go for little. We're left with a half-baked slew of subsidiary characters who fail to have a life off the page, who are really nothing more than their elliptical expostulations. The refusal (or inability) to etch in their background is more flat than beguiling; the empty spaces are holes rather than possibilities.

It's a nickel-and-dime kind of book, and intentionally so. In a way, it's so bad it's good.

Maybe it more resembles a comic than a novel proper. All things return to laughter. Such laughter relieves Hank's ordinary madness. It's his valediction not only to the writing game, but also to those who made it possible, so maybe we shouldn't evaluate it from a literary point of view but rather a human one. It would have been best served in a limited deluxe edition presented to friends.

The world-weary tone is familiar to us, but it's hard to care about the plot, which seems to be made up as it goes along. The Red Sparrow/John Barton angle is too obviously *roman à clef* to be interesting and the final demise of our narrator, which ought to have been poignant, fails to involve the reader emotionally.

The discovery of the red sparrow might mean death for Belane, but it also means catharsis and peace: in the same way as John Martin's 'black' sparrow meant catharsis — and literary immortality — for Hank.

This could never have been Hank's first book, distanced as it is from all his favourite themes, and if it was it is unlikely it would have been printed. As his last it has a certain curiosity factor as a coda to his career, but it's hard to see why he cared so much for it when he was writing much superior poetry at the same time. Perhaps it would have worked as a long short story about a fifty-five-year-old misanthrope searching for some grubby significance in a crummy world, but asking the reader to follow him through 200 pages of minimalist intrigue is too much. Having said that, the Bukowski humour is alive and well throughout the book, especially in scenes which have nothing at all to do with the plot, like the one in which a sex-phone lady hangs up on Belane for insulting her. (Surely a precedent in this industry!)

Literary experiments are fine and brave, especially when they mean dispensing with characters, or a character one has lived with all one's working life, but kicking off the traces isn't always in itself a justification for what follows and this is a classic example of such faulty judgement. Maybe it was too late to change the habits of a lifetime. He probably began it with great expectations but didn't have the bottle to disown it when he saw it was going nowhere, settling instead for the jokey disclaimer that only served to highlight its shortcomings. There's no fool like an old fool.

Pulp is the ultimate whodunnit because the 'it' is life and the 'who' is God — or maybe the devil. What Hank has done is to create an absurd cosmos where lost souls beat their brains out in the darkness looking for shards of significance in the muck of their existence. Hank's message is that there *is* no message. But the mere expression of this frustration, by dint of a grim irony, indemnifies it. Language, even scabrous language, is his splash against that darkness — as is humour. When you laugh at the fates you somehow stunt their might. As his world collapses around him it's one of the few weapons Belane has left, but one he's loath to part with. Crying we came hither, but this man at least will shuffle off the mortal coil with a grin on his face.

The most disappointing aspect of the book is the manner in which Hank departs from his lifelong practice of dealing with 'the thing itself' and instead substitutes symbols, allegories and subtextual innuendoes which are too clever by three-quarters. The infrastructural metaphor of the private eye as philosopher is fine if we see his case as the mystery of life itself, which he tries to crack with words and images as much as his gun. The problems arise when the tapestry gets crowded with beautiful space creatures, red sparrows and personifications of death. This is overkill.

Two years later, however, Black Sparrow dug into its archives again and this time they came up with the Bukowski we knew and loved...

Betting on the Muse appeared in 1996, featuring an uneven combination of poems and stories, though the latter represent only a minimal part of the total. It's a large book, like many of Hank's, and features all the familiar themes, all the familiar strengths and all the familiar weaknesses.

Right away we're into battle mode in 'splash' which he informs us isn't a poem (because poems are dull) but rather a 'beggar's knife' — a very apt description of his approach to his art. A selection of narrative poems about his youth follow, his parents driving a nail into his skull as he seeks to beat the Depression blues. His father's unsavoury nature is demonstrated in 'the monkey', 'the snail' and 'me against the world'. The latter ends with Hank reprising his father's cruelty.

In 'to hell and back in a buggy carriage' he chronicles the 'dried, dead, useless' days when his classmates pulled the beautiful women as they drove to the beach on sunny days, leaving him to bemoan his poverty and his miserable lot, being the son of a

jobless father. This was in 1955 and Hank wasn't to know then that his own life would also be 'dried, dead and useless' for many decades before the gods would smile on him in his magic twilight.

In 'stages' he carries on the theme of being a bad ass, a hulking beast who uses insolence to camouflage his insecurities. The principal berates him for his smouldering temperament but Hank refuses to bend the knee. This is hardly surprising as the Frozen Man would have had a much easier time standing in a phone booth (the principal's preferred mode of punishment) than being belted around a bathroom by a bully with a leather strop.

'Escape' is an ode to reclusiveness and 'the secret' a poem wherein he reassures himself that even if others (like the crooked principal) appear to have the answers, most of life is a trick and a con. The secret is not to fall for an image, not to believe one's publicity, not to lust after Andy Warhol's fifteen minutes of fame.

'You don't know' continues the reclusive theme, with Hank portraying himself as a kind of cowboy drifter in love with change, whereas 'let not' reads like a Whitmanesque polemic with a similar message to 'the secret'. Again and again he prevails upon us to be ourselves and not be sucked in by 'the massive zero of life', as he puts it in 'the terror'. In 'the misanthrope', meanwhile, he makes a distinction between disliking people and merely being indifferent to them, his own attitude.

'Met a man on the street' concerns an admirer of Hank's who informs him that his poetry has kept him going. Hank replies, as ever, 'thank you, but who's going to keep me going?' Or, put another way, who does Grimaldi go to when he's down? (Hank often likes to remind us that while his writing is therapeutic in that it assuages his pain, it doesn't altogether exorcise or negate it.)

'The lover' is a rant against the women in his life, the ones who stole from him, who betrayed him, who drove him crazy, so many sharks in dresses. His ability to attract them confuses the mailman, who remarks gingerly that Hank doesn't exactly resemble Adonis. 'Availability' he replies. (How many times on his own rounds must Hank himself have delivered letters to men who had women flocking round them and asked similar questions — out loud or to himself?) The mailman goes away confused, leaving Hank to reflect that the said females were perhaps more trouble than they were worth. At the end of the poem, however, the phone rings and he hopes that it will be a woman. In other words he can't live with them and he can't live without them... like every other male.

'An evaluation' has him speculating on the number of hours of his life he's spent at the racetrack, a place as surreal as the bar or the boudoir but one to which he returns relentlessly, killing time in it until time will one day kill him. The murderous repetition is as bad as any nightmarish job he has ever been in, but he keeps going back for the same reason he kept going back to the bars: because he has nothing better to do. '12 minutes to post' has a more balanced appraisal of the same scenario because here he captures the conflicting emotions of the track: the boredom of waiting which turns to excitement as the names of the horses are read out and 'the lightning flash of hope' descends, promising to make something out of the nothing of the gamblers' lives.

'This dirty, valiant game' continues his fascination with the theme of suicide and psychological malaise among writers — he would always take solace from the (greater?) sufferings of others of his trade — whereas in 'avoiding humanity' he leaves us in little doubt that he's a quintessential isolationist. He defines solitude as both a blessing and a miracle, prompting one to enquire why he spent most of his life living with one

woman or another — or maybe two simultaneously. (His answer would probably be, 'see "the lover"'.)

'Last call' has some beautifully impressionist semi-surreal imagery while 'bad form' and 'the shape of the Star' see him in virulent anti-Hollywood mode. 'The girls we followed home' is interesting in that while the style is lyrical, the sentiments are rather dark. Hank speculates that the female fantasies of his adolescence are now probably drooling on bedpans. (He seems unable to conjure up old age without this notion!) The end of the poem has images of the sun always shining and life being 'new and strange and wonderful', which is certainly not the type of thing one expects from the man who wrote *Ham on Rye*.

'Lousy mail' has him on another favoured tack: the number of wannabes who feel he'll carry them a rung up the literary ladder once they submit their treasured writings to him, which usually turn out to be abysmally bad — at least in his view. Having scraped and struggled himself, Hank was never in the mood to treat such a breed with kid gloves. He never looked for these sort of short cuts himself, nor licked ass to get ahead. 'They don't want to write,' he says, 'they want fame'. So he consigns their work to the nearest waste paper basket. Bad writers are one thing, but *arrogant* bad writers even worse. The people who send him their junk mail never realise their failure is caused by a chronic lack of ability rather than the ignorance of editors. In time he came to share that viewpoint about his own work, but in the early days when something was rejected he tended to throw it away.

He goes into his past career in more detail in 'confessions of a genius', a kind of *apologia pro vita sua* which documents all the years of failure — both as a person and a writer — before success smiled on him. People at readings gobble up his 'crap', he says with typical self-deprecation, but he isn't complaining. He served a long apprenticeship of hocking his typewriters and living on scraps so the gods owed him something. He gets somewhat more defensive when he addresses the subject of women, claiming his perceived misogyny wasn't this at all, but a gross misjudgement by those who never knew the full circumstances of his trysts with frenetic females. Perhaps, but after he wrote *Women*, they themselves came out of the closet and called him a liar and worse for his denunciations of them, claiming he used them both as sex objects and raw material for his work.

In 'my madness', a little memoir that follows shortly after this last poem, he says that while he always desired women feverishly, he wasn't always willing to play the love game by their rules. His writing is replete with this kind of attitude, a depiction of women as a luxury he can't afford because of their whims and coquettishness. 'I simply have problems with human beings' he says earlier, so presumably some of his problems in this regard are his own. He also writes about his pugilistic past, telling us he fought not with anger but more out of self-defence than anything else, and about the poverty that turned to benison after his writing got off the ground. He actually kissed his first book in gratitude, he confesses (books didn't betray like women did!) and now sees writing as 'the best madness going'. He ends the piece on an encouraging note for young writers, despite the sentiments expressed in 'lousy mail', insisting 'There are enough words for all of us'. This is the shortest prose piece in the book but despite this the most moving. Elsewhere he plays the very recognisable beer-swilling malcontent with a dim rasp of hope scudding through the downbeat tapestries of sleaze.

'The gods' is another approach to the same theme, this time harping on about the resentment that greets his work. He has inflamed critics, women and academics but is

now in his seventies so it won't be long before they have their chance to gloat, and condemn him anew from the grave. Meanwhile, however, the gods are still smiling down on him as his fingers bite into the computer keys with his latest *opus*, so for now he will continue to laugh his way to the bank. It's not, after all, the academics who buy his books, but the public, and he sees his main duty as being to them.

In 'it's difficult for them' he expresses his bewilderment at academics who harbour some deep rage at his success while he remains indifferent to theirs, or their lack of it. He doesn't try to put *them* out of business even though their work means nothing to him, so why should they be so obsessed with making the world aware of *his* lack of talent, as they perceive it?

'Slow starter' has Hank getting to places just as others are leaving them, a quintessentially anachronistic individual who now finally feels he's where he wants to be. 'Barstool', the poem that follows this, is like a continuation of the theme, expressing his intuition that even in the days when he seemed to be going nowhere, he had already arrived at a personal watershed, beautiful in its lack of ambition. Years later, as he puts it in 'the luck of the draw', he found a different kind of fulfilment, but in a sense nothing has changed beyond his circumstances. Sitting by his swimming pool or watching a fly beside a pool of beer in a spit-and-sawdust pub he's still the same man, fanning the flame of his vision.

'Let it inflate you' is a beautiful poem on an associated theme, evincing a Bukowski who has the patience to ride out the rawhide years, developing a mellowness that came with an appreciation of the quotidian, making a virtue out of necessity even as life threw him its worst cards. Suicidal thoughts came and went but he stopped fighting them after a time, as he stopped fighting everything that had conspired to lay him low. And then in time he accepted himself, accepted others, and the acceptance grew into a warm glow of peace.

The last dozen or so poems in the book touch on notions of evanescence and eternity, but in a tranquil rather than hysterical manner. He's aware that he's nearing the end of the road, but it's been a good ride. He has his woman, his fame and his cats, so why should he carp? The years since 1955 have been a gift rather than a right, with affluence the icing on the cake. Life may be a 'fixed game', with many of the odds stacked against us, and none of us asked to be born, but we make what we can of it.

A darker note is struck in 'decline' and 'so now?', the last poem in the collection, where he looks forward to the future with some trepidation. He waits for Godot, wishing he could 'ring in some bravery' but knowing he must face whatever is in store for him on his own. Life is a 'lousy fix', but, as he says in an evocative phrase, 'the tree outside doesn't know'. He didn't care if he survived or not in 1955 and *did*. But now he does and possibly *won't*. This is the sense of absurdity he feels as the angel of death alights on him.

The manner in which he personalises Death is reminiscent not only of Hemingway (who also had an obsession with the subject) but the Ingmar Bergman of *The Seventh Seal*, who has one of the characters engage him in a game of chess.

Bone Palace Ballet was published in 1997. Beginning, as is customary, with poems about childhood, *he* gives us cameos of his early feelings about religion ('God's man'), sexuality ('snapshot' and 'burlesque'), literature ('first love') and his own particular initiation rite into manhood ('depression kid'). 'Field exercises' deals with his ROTC experiences against the backdrop of Nazism and World War One whereas 'what will the neighbours think?', in contrast, conjures up a valley of squinting windows where his

parents show more interest in their image than any more substantial concerns. He steamrolls through this whited sepulchre mentality by over-indulging in drink and also beginning his controversial writing career, causing his parents double embarrassment and eventually resulting in him leaving home, which means they didn't have to worry about the neighbours anymore.

Section Two has him on the streets pursuing his own goals, starving for his art as he listens to classical music in a Philadelphia roominghouse and watches mice gnawing at his latest compositions. This poem, 'a place in Philly', is followed by 'the Kenyon Review and other matters', in which he spews bile on the closed shop that is the literary cosmos. He fires manuscripts at a brick wall of cosy incestuousness, perversely amused by the escapist effeminacy of it all. The reading he does in libraries by day is contrasted to his wild nightlife of boozing and fighting in back alleys.

He ends by expressing a preference for the alleys which have blooded him in a way no book ever could. 'Total-madness' is a beautifully measured elegy on a similar theme as we travel with him on his picaresque endeavours through those same roominghouses where he lives with his music, his wine, his mice and his manuscripts, 'a shrunken man on the shelf of nowhere', pretending to the old dears who are his landladies that he's a successful author so that his failure to come up with the rent will be seen as only a temporary problem. 'On the bum' completes this particular trilogy as he enters into a series of hopeless jobs fantasising about becoming rich at the gaming table, in the ring or in the boudoir of a wealthy lady. (Barbara could have been that lady, but her wealth came at too high a price for a man who was always much more idealistic than he let on.)

'Society should realise… ' is a love song to a prostitute, a poem which the prudish may see as the pornographic ramblings of that 'dirty old man' again, but the tone is so gentle and lackadaisical it's better viewed as a humorous little idyll: maybe that's what society should *really* realise about Charles Bukowski.

'Barstool' runs for five pages in those neat little verses he liked so much. This is really prose in poetic form rather than anything else, but it still disarms you with its simplicity. The material will come as no surprise to anyone who knows anything about the years he spent in these bars as part of the furniture. Though the circumstances are dismal, his overall tone is upbeat, so we know he means it when he says that despite the hangovers and the brawls and the evictions, he was where he wanted to be, on that barstool waiting for his next drink, or his luck to break.

He addresses the subject of his father's funeral in 'a $15 boy and a $1,500 casket', a poem full of bitterness about the passing of a man he hated ('I should spit on his phoney face') and the nonchalant manner in which he goes to the races after the funeral and even has sex with the dead man's girlfriend. 'Rosary', which follows it, pokes fun at his father's penchant for aphorisms, those clichés that were trotted out as a substitute for thinking, but 'the smirking dark', a third poem on the same topic, casts more general reflections on death. Here he seems to be more upset about the fact that death killed people like Dostoevsky and Van Gogh than the death of his father — which of course he was.

Section Three has a selection of poems dealing with his much-publicised attitudes to writing, and the practitioners of the craft. In 'the weak' he inveighs against those who mouth up the books they're going to write but rarely do, whereas 'a tough time' has him suffering rejection from a highbrow university magazine specialising in 'boring probes / into the / nonsensical.' 'Some luck, somehow' features another individual who's better with his mouth than his pen, in contrast to Hank himself, who didn't brag about

the work he was doing quietly in the background as he waited for the day he would reach the masses.

'Art class' is an amusing porthole into his relationship with Marina, whom he has put into this class at his mother's behest. He hates the school's twee approach to the subject but suffers it for her sake. When he comes to collect her from the class he wants to be out of there as quickly as possible but as time goes on he finds himself approached by the other doting parents. He does his best to be obnoxious to stave them away, feeling this is really art with a capital F, and is stubborn in his resolve that he won't cave in to the touchy-feely ambience he sees there. He didn't spend his whole life on the edge only to be embraced into this cutesie cocoon.

'Bum on the loose' is another interesting poem. Even though it doesn't contain anything wildly original, it succinctly encapsulates his life up to this, from the days of penury, when he lived with rats, got robbed, made love to volatile women and slept in deserted graveyards as his writing was repeatedly rejected. But then one day he decided to go for broke, realising the so-called giants of literature weren't necessarily better than he was. So he took them on, realising that he could give them a fight of it on his day. (One is reminded of Hemingway claiming he could 'go a few rounds' with Dostoevsky.)

Considering he underwent such agonies, one is somewhat surprised to read at the end of 'coffeeshop', a subsequent poem where he finds it difficult to enjoy his little snack in peace, that he ends up comparing the incident to a descent into hell itself. It may not have exactly been a pleasurable experience for him, being badgered by the staff, but it hardly ranks with leukaemia, tuberculosis, nearly bleeding to death in 1955, being turfed out of apartments for non-payment of rent and/or wandering the streets in leaky shoes searching for crumbs of comfort. The section ends with 'poetry readings', never Hank's favourite way to spend an evening, notwithstanding the fame and fortune they brought him. It was bad enough giving them, but attending readings given by other self-serving nobodies galled him like nothing in creation. He hated the sacred silence accorded to no-talent readers, the fifty minutes of adulation given to pretenders by other pretenders who were either related to them, deluded by them or in the habit of giving or receiving 'favours'.

Section Four is a mixed bag, containing the usual hodgepodge of reflections on women, the races, his past and the changes time has wrought on his life. The latter theme occurs in both 'last call' where he concedes that he doesn't mind ending his life safe, though writers shouldn't start out that way, and 'candy-ass', where has assures us that he enjoys 'attacking the sun with a squirt gun' — presumably his pen — and that when he stops angering people he will probably stop writing. The topic of poetry doesn't matter, in a sense, as he emphasises in 'the word'; all that matters is that a writer can recognise the muse when it arrives, and get it down on paper before that fickle visitor departs.

He's his reclusive old self again in 'please', where he leaves us in little doubt how deeply he suffers when people call to see him. Unnerved by their ineffectual complacency, he's also fazed by their apparent inability (or unwillingness) to recognise the pain they're putting him through by their very existence. He's equally discommoded by the presence of the glitterati, as he explains in 'the powers that be' and 'clever', two back-to-back poems denigrating the smug, and also by those who correspond with him by post, a subject he goes into in some detail about in 'my mail'.

Getting letters from groupies may have been fun once, but in latter times he's been

the recipient of tomes from jails, mental homes and prospective writers, some of whom invite themselves round to see him to chew the fat the next time they're in town. These he dissuades strenuously, letting them know that writing is about writing, not theorising. Birds fly, fish swim and writers write, in other words. They don't shadow-box or procrastinate or over-elaborate; neither should they seek to trade on the tender mercies of one who has been there already. The literary world, like every other, is a minefield where only the fittest survive, but you have to go into that minefield to discover the truth about yourself.

Section Five is also a mixed bag, but the writing is clear, crisp and without padding. 'Finished?' tackles the same theme as 'last call' and 'candy-ass', allaying the fears of Hank's faithful crew of fans from the old days about his perceived sell-out to a champagne-and-caviar lifestyle. This seems unlikely from 'the barometer', where he writes about the kind of people he alienated with his 'ugly' writings. His parents were his first critics, then came the contumely of editors and finally that of his mother-in-law. He says he doesn't worry about the abuse half as much as he would about the prospect of seeing his face on the cover of *Time* magazine.

'The good people' is a broadside against 'cause celebs', i.e. those supposed bleeding hearts whose main cause is actually themselves. It's similar in tone to 'safe', a poem that describes a world like that of his parents, where nobody does anything out of line and yet all seem to live lives of quiet desperation. In a subsequent poem, 'life like a big tender glove', he ponders the issue of what his father would have said had that man divined that his crazy mixed-up son, who could never measure up in school or the world of employment, never mind making a good grass-cutter, would one day be rich and famous. Uh huh. He describes his lifestyle as a 'road to hell' in 'disgusting', though he doesn't argue with some of its perks like the ability to buy a computer, for instance. In 'my computer' and 'thanks to the computer' he describes the radical improvement this piece of technology has made to his life — but he still has a soft spot for his old typewriter, as he says in 'reunion' and 'returning to an old love'.

'Self-invited' traverses the ground already covered in 'please', while 'the young poets' is like a retread of 'my mail', though in more detail. 'Night cap' has him reminiscing on the 'wild and lovely ride' that has been his life up to this, but he discusses the darkness of impending death in a number of other poems like 'welcome darkness', 'old', 'Bach, come back' and 'quiet in a quiet night'. The last of these is the most poignant as Hank writes about 'the last minute arrowing in'. He can't postpone the inevitable ('death has one move left. / I have none') but that still doesn't stop him enjoying the time that remains to him. The wine he sips, on the contrary, gives him near-infinite vibes.

The Captain Is Out To Lunch and the Sailors Have Taken Over the Ship, a typically subdued Bukowski title, came out in 1998, being a diary record he kept (at John Martin's behest) from August 1991 to February 1993. In it he sounds off in genial vein about all the things that have kept him alive over the years — horses, writing, Linda Lee, etc. — and also things that have angered him — like horses, writing, Linda Lee, etc. In tone it resembles the letters, being very frank and intimate, but it gives us a Bukowski growing gracefully old, content to sit at his Macintosh and fulminate about all the familiar obsessions as his cats sit like sentries around him.

His writing has been a celebration rather than a moan, he says, but it's also a fact that he needed the backlog of pain for his inspiration and raw material, even if he didn't wallow in his misery as he wrote. Or, in the words of his hero Robinson Jeffers,

'be angry at the sun'.

He also says that he should have been dead '35 years ago' and that he only writes a little better now than he did when he was poor and starving. This makes him wonder why he had to reach the age of fifty-one before he could pay the rent with what he wrote. (Probably for the same reason that many great writers, even at fifty-one, can't pay the rent with their writings.)

He also rants against bogus interviewers who tricked their way into his house just to meet him. Movies are another target. Even the racetrack comes in for a hammering. It isn't the same as it used to be, he complains. The atmosphere of irresponsibility is gone, as is the sense of adventure. There are no fist fights at the track anymore, no crap games in the parking lots, no chance of meeting a woman sitting at the bar. Now there are just masses of people looking like death warmed up, so many ciphers that seem to typify the brave new world we've given birth to. In such circumstances, maybe dying will be a relief.

Social crusaders also come in for a battering. He writes about those who are in love with causes for their own sweet sake rather than the good that can accrue from them. Perhaps he once felt like that about Frances. He tells us about a group who were apparently disappointed when the Gulf War ended because it meant they had no relevance anymore. They were, in a sense, all dressed up with nowhere to go. He himself, of course, was anti-war before it became fashionable. He was also, he writes, so cool when the FBI arrested him for supposed draft dodging that they were actually impressed by his attitude, which they took to be macho, not realising that it was just plain indifference.

He feels this way *apropos* the track, where he goes every other day — mainly because he has nothing better to do. It's a way of imposing false significance on the meandering mess of his days. Anytime he forces himself to stay away, he knows, he's going to descend into the seventh circle of hell, so it's a question of being damned if you do and damned if you don't. At least during the daytime hours. The nights, on the contrary, have a habit of taking care of themselves for this nocturnal animal, presumably because he spends them writing. So he hies himself thither and works on one of his elaborate mathematical systems to try and come out on top.

From this point of view it's a kind of contrived obsession for him, an almost Beckettian procedure. He's too intelligent to believe it can make him money (which he wouldn't lust after anyway) so the main motive, apart from filling in the day, is to have this challenge. And of course to observe the other gamblers, so many people who are lost like him. He moves with them towards the illusion of bucking the system, concluding that such an illusion is no better or worse than any other one.

Elsewhere in the book he says he goes to the track because he needs routine in his life — the same routine he needed when he drank or bedded all those women. In other words, the imperfect hours he spends there made way for the perfect ones at his computer. They're a necessary nothing, a mechanical device. You have to kill ten hours to make two hours live.

As regards the writing itself, he claims he's never been more productive than in the past two years: he has kept his best wine for last. He's also made his style softer and warmer, and generally more accessible. He was never a believer in editing, as we've seen, so the transformation seems to have come about by itself. After years of burning holes in pages or pouring wine on them to summon his muse, it's suddenly becoming easy for him without him knowing why. Maybe it's simply the wisdom that comes with age.

But he doesn't want to become smug. He has to keep the gamble alive. This he's done by hooking himself up to a new image, a new way of seeing things, a new way of fighting the darkness, of staving off death for just a little while longer. You can singe the page with that desperation if you wish: anything counts as long as you get the word down. Who dares wins.

In order to facilitate this, and to keep his weaponry alive, he must stay away from the lily-livered poets, the comfortable ones who like to be entertained by him, who happen by and exchange pleasantries. Few of them have published much but they seem financially comfortable and they like shooting the breeze with him. They haven't slept on garbage bins or woken up with rats on their stomachs. They haven't had cancer or TB or had to steal food to eat. But they like words and they think that they know about life because they don't have too much apparent difficulty putting these words together.

Hell, for Hank, would be having to listen to such a breed reading their work.

But he knows he's changed since the old days. No longer does he drink incessantly, or indulge in irresponsible violent actions. Instead he sits in front of a computer listening to classical music, or waiting for an alarm system to be installed. Is this selling out? No, it's simply serenity — the serenity he sees in his cats, who sleep twenty hours a day because they realise that the secret of life is not to care. Maybe Linda Lee was right with her ideas about Meher Baba after all.

Classical music, in any case, isn't any less 'establishment' than rock music is, as he emphasises in an amusing anecdote he relates about being at a U2 concert where he's the guest of honour. He meets Bono afterwards but doesn't think enough of him, or his band, to mention them by name. Neither can he remember what they talk about. All he knows is that he's in the VIP lounge ('Wow') and that the concert has been dedicated to him. The music has probably been good and worthy and well-intentioned, he allows, and one imagines Frances would have appreciated the causes the Rock Band espouses, but for Hank these trendified millionaires who protest against establishment values are just as much establishment as the nearest realtor in his BMW. He prefers to chat with the black barman. And then he goes home and has an accident — for old time's sake. Because he's drunk.

In 1989, he tells us, he overcame TB. Later there was an eye operation and 'bits' of skin cancer. The Reaper is gaining on him, but the old coot won't cave in just yet. He tried to drink himself to death once, but failed. Logic would seem to dictate that he hangs on for another while.

The most poignant note the journal strikes is early on when he announces that he's just heard of the death of Barbara Frye in India and that nobody wanted her body flown home. She was right to leave him, he concedes, because he couldn't redeem her from herself. He might have added that she always imagined she'd married a loser, but the loser went on to become the most read author in translation in the world at the time of his death. So it was worthwhile, after all, kissing those millions goodbye.

That year also saw the publication of Howard Sounes' *Locked in the Arms of a Crazy Life*, the best Bukowski biography that's yet been published, even if it gives the poetry pretty short shrift. Drawing on previously unpublished papers and letters to give us an unvarnished portrait of Hank in all his moods and guises, Sounes also conducted innumerable interviews with the likes of Allen Ginsberg, Norman Mailer, Sean Penn and other luminaries to fill in the gaps left by previous books on or by his subject, bringing his skills as an investigative journalist (he's also written a biography of serial killers Fred

and Rosemary West) to bear on an author who had never got his just desserts from the critics. It's a no-holds-barred book, as any work on this man has to be to purport to authenticity, but his affection for Hank is also there too, shining through the denigrations. The reviews were understandably ecstatic, which meant Sounes opened up LA's most vaunted hellraiser to a whole new generation of readers. (More recently, he's written a biography of another iconic figure, Bob Dylan.)

What Matters Most Is How Well You Walk Through The Fire, another large poetry collection, came out in 1999. Reflecting the maturity of recent work as well as a newfound meditative tone, Hank once again revisits old pastures and endeavours to make sense of new ones with a mixture of humour, reverie and rage. The syntax is as simple as ever, many of the poems resembling haikus in the brevity of the lines. There are no startling conclusions, and a lot of them filter out on a dying fall, but they're heartfelt and moving, even if the sense of *déjà vu* rankles at times.

He starts, as he often does, with a poem about his early life. 'My father and the bum' isn't exactly rhapsodic, but it has an easy flow. Hank contrasts the quiet simplicity of his next door neighbour with his father's pretence of having a job, leaving us to wonder who's the real 'bum': the man who sits throwing darts at a wall or one who courts the respect of others on fraudulent premises.

'Legs, hips and behind', another trip down memory lane, is also impressive in its simplicity. He writes about a friend's mother, the lady referred to in the title, with testosterone-charged interest, almost nonchalantly slotting in the fact that her husband committed suicide. (How could that be as important as a pretty pair of legs?) He presents himself as existing in a warm bubble, far from the Depression haunting others around him, which is rather surprising considering his father harped on about it so often to him. 'Madness and sorrow and fear were almost everywhere' he ends by saying — but surely this was nowhere more apparent than in his own house.

'The mice' is a poem which finds his father again in aggressive mood, killing some mice the ten year old Hank was fond of. This is another incident that must have paved the way for the night Hank turned on his old man with drink some years later, having imploded so many times before.

'Legs and white thighs' is another peeping tom poem, leading one to suspect Hank spent half his childhood looking up women's dresses, while 'Mademoiselle from Armantieres' has him filled with excitement over World War One movies. Twenty years later he would be bored by any kind of gung-ho mentality but this was escapist enough to fuel him with boyhood fantasies, being just about far enough away for it to seem dreamlike.

By the time we get to 'Pershing Square, Los Angeles. 1939' he's started to develop his bar-bum persona: indeed to wallow in it, inviting it upon himself as a way of dealing with the fractured coordinates of his existence, much the way he acted the macho man in school as a way of fending off those who hassled him about his boils or his self-perpetuating 'idiot' guise. (Praise, as he says in 'scene-from 1940', was the one thing he found difficult to deal with in those days.)

'The sensitive young poet' gives us the legendary Bukowski of the love/hate, *Who's Afraid of Virginia Woolf* romances, the title being somewhat ironic to say the least. He and his lover give as much as they get to another, thriving on the confrontational adrenalin as they huff and puff. 'I was one bad dude,' he confesses at the end, adding that he 'cured' his partner of living with men by his behaviour.

This frank acknowledgement of his faults counteracts the image of himself he presents

in *Women*, and also the tone of a later poem, 'the first one' which he wrote as a tribute to Jane, the woman he could never quite get out of his system, despite her self-destructive nature. In contrast to this, 'about a trip to Spain' seems to suggest that no woman can ever match a horse in a man's affections, though obviously the tone is on the jocose side.

In 'the 8-count concerto' he presents music to us as the still centre of his chaotic life, and again in 'Christmas poem to a man in jail' he mentions Mahler in such a context, though this is really a polemic about the necessity of poets spurning tradition in search of the free form. 'One more good one' is a livelier way of making this point, depicting the old crow still cracking out those crisp lines against all the odds, cigar in mouth, bottle on floor, and brain on fast forward as the computer keys click into first gear for another full frontal assault on convention.

Section Two of the collection continues in similar vein, 'the last poetry reading' being a satire on the idea of the poet as performer, a role he abhorred unless the bottle galvanised him into action, wherein he could be the barfly again, even if having to substitute a stool for a rostrum. Gin mills were always good preparations for learning how to deal with hecklers and it was here that Hank honed his repartee. He stumbles his way through the reading and as we leave him he's relaxing on the plane home, smoking a cigar and having the complimentary in-flight drink as he thinks, 'so this is what killed Dylan Thomas?... bring on the next reading'. In other words, even a hobo could learn to live with respectability if the price was right. It beat working in slaughterhouses for pin money, in any case.

'The dangerous ladies' is a misogynistic poem in that it both generalises from the particular and also seems to suggest that if men need such ladies there must be something wrong with their heads. Feminists would also be upset by 'butterflies', so as Hank gladly accepts the women who throw themselves at him as a gift of his art. 'Hunchback' adopts a more diffident stance, suggesting that those women who have chosen him as a lover have done so out of 'disorder and confusion' — though the last verse introduces a more ambiguous tone.

In 'me and Capote' he makes it abundantly clear that it's females he wants calling him rather than males, a point he also takes up in 'young men' where he refuses to set himself up as an authority on writing or anything else. (But perhaps if the poem were entitled 'young women' his attitude might be different!) 'Computer class' sees an unlikely Bukowski being a willing pupil for once — because he has something to gain now, unlike in the dog-dull old days at LA High — but in 'image', which follows it, he disabuses us of any notion that he might have gone soft, despite the fact that he 'only'(!) drinks three bottles of wine per night. All the same, 'the crunch (2)' has him being almost schmaltzy ('we just need to care'). Tenderness is easier to take in 'raw with love', one of the most hypnotic poems in the collection, which makes one wonder why Hank didn't delve into this side of himself more often instead of giving us such a barrage of the horse / music / barfly mother-lode.

'Combat primer' contains the ultimate disincentive to prospective scribes, while 'they arrived on time', on the contrary, reminds us how the library saved his bacon even more than the bars when his life was a disaster zone of the emotions. 'Farewell my lovely' again has him in sexist mode, depicting women as so many torturing temptresses who thrive on their power to destroy the men they entrap with their wiles. The verse where he writes of the male victim escaping the female executioner and thus making her life 'hell' is extreme even by his standards.

'Beethoven conducted his last symphony while totally deaf' is an interesting look at the culture of celebrity, or rather notoriety, as Hank wonders if the likes of Lorca or Van Gogh would have been as famous if their lives hadn't ended so dramatically. The identification of creation and creator harks back to the Yeatsian idea of whether we can separate the dancer from the dance, an idea which must have been of particular interest to Hank, whose fame was certainly helped by his own notoriety off the page.

'School days', dealing with the childhood nagging of his parents, should perhaps have been slotted into an earlier page while 'fast track' and 'the gamblers' takes us once again to the horses. In 'the crowd' he demonstrates how purgatorial it is for him to have people over for an evening as he mouths platitudes to dullards to please Linda Lee. He also plays the anti-socialite in 'no guru', a poem that he has written many times before in only slightly different ways, focusing on the fact that he has less answers to life than the readers who expect him to lead them to the Promised Land.

'Carlton Way off Western Ave' gives us a non-personalised treatise on poverty, unique for this man, who generally prefers to take us into his own life rather than the life of a neighbourhood, or at least to use the latter as a gateway into the former. 'Revolt in the ranks' gives us a humorous approach to writer's block, depicting Hank's poems as ungrateful children who wish to punish him. It's not as funny, however, as 'comments upon my last book of poesy' where he gives a grocery list of the perverse, obsequious and wildly varying responses of the public towards his work, ending up with one reader exclaiming, 'you jack-off motherfuck, you're not fooling anybody'. The point is, he never tried to.

A darker element appears in 'ax and blade' where he discusses the 'museum of pain' that life — and writing — brings in its wake. 'Everywhere, everywhere' sees him railing against the anger he experiences all around him, killing people as it must have killed his father. In 'the circus of death' he addresses more primordial concerns, ending with a piquant image. In 'this moment' he utters a reverential hymn to the now, whereas 'on lighting a cigar' has some arresting thoughts expressed by the wise old owl he has become. He also lights a cigarette in 'memory', a poem that reminds us that no matter how many brain cells he destroyed in his life from his enormous intake of booze, he had an almost literal recall of everything that happened to him since he first saw the light of day.

An anti-women slant also appears in 'I hear all the latest hit tunes', but when we reach 'to lean back into it' he's again mellow and objective, conceding that he

didn't know enough
early enough
and knew enough
too late

So maybe he lost good women as well as being brutalised by those one-night stands who stole his money, or the heartbreakers who wanted both his body and his soul.

'Be alone' and 'the crowd' are two more odes to the solitary life, whereas 'a new war', the penultimate poem, is a moving reflection on intimations of mortality.

The biographical sketches once again etch in the variegated coordinates of his past with disarming simplicity. Many of the poems are irreverently funny, as ever. Others are gentle and touching, and some rambling and inconsequential, like 'locks'.

They take him, again, from the 'alleys of starvation' to the comforts of San Pedro,

but he remains profoundly unimpressed by fame, as he makes clear in poems like 'the soulless life' and others. Whether he's a celebrity or not he will continue to walk the lonely road, reclusiveness acting as his key to survival. The world outdoors prevents him from unlocking the key to himself, the world as it is by the groupies, the self-serving females, the dumbed-down public and those chinless wonders, like his father, who believe a steady job is what it's all about. There's a large part of himself, he says in 'dead dog', that has always felt comfortable with 'subnormals', and it's these he has sought out from his childhood, feeling empathy with them since they've been marginalised by society, as he has. His central message that the masses are always wrong is again enunciated.

There are elements of great lyricism in poems like the title one, as well as 'hymn from the hurricane' and many others. Equally there are the inconsequential asides that seem to have been tossed off the morning after the night before. In 'stark dead' we get an oracular tone as the Gospel According to St Charles is unleashed upon us, whereas in 'chinaski' he exhibits a wry third-person appraisal of himself that's both funny and profound. 'Dogfight over LA' is perhaps the most hilarious poem in the book, the anger and sexism bowing to such humour and making his outrageousness so amiable. Elsewhere he's whimsical about doctors, reviewers, his fellow writers, those he meets at the track, outré strippers who appear unannounced in bars, eccentric loners who live near him: the whole cavalcade of characters we've met before in so many other Bukowski books in only slightly different forms.

In 'hymn for the hurricane' he tells us the women in his life impute his tempestuous behaviour to his parents, but he doesn't expand on this other than to say that some-times he feels like a motherless child. He refuses to use his parents as scapegoats for anything he did or didn't do in life. That would have been too much of a psychoana-lytic convenience. He prefers to take responsibility for his actions. Anything else would be too self-serving.

Open All Night, another large collection of poetry published in 2000, features an amalgamation of the same themes that obsessed him since he first put pen to paper. It's an extended ode to individualism, a sometimes hilarious, sometimes piquant series of aperçus concerning strange characters (including himself), thwarted emotions, dismal loves, absurd tragedies. We get the in-your-face women, the lovable oddballs, the risible vitriol, the perception of Chinaski as both champ and chump, the fame, the fans, the hate mail, the celebrity status, the notoriety, the track, the insanity of success and the insanity of failure, the movies, the theatre, the bars, the music, the idiocy of the masses, the tug of the ordinary, the magic of the mad.

Right from the start in '2 buddies' Hank alerts us to the manner in which he has always been attracted to those with disabilities. He continues to inveigh against 'the obvious answers' and to search for meaning in odd places, be it in the eyes of a dog, a woman cutting his toenails or beatnik poets of his ken who have also drifted off the beaten path to commune with their inner demons.

Writing has always meant more to him than anything else, he informs us in 'the best men are strongest alone'. In 'Manx' he rails against the 'sadly sane'. Genius is lonely, he tells us, but the masses have holes in their souls so it's even more imperative to follow your lights into the dirty bars for moments of epiphany. Bars are still sanctuaries to him, the last refuges of the free-minded, at least until television kills conversation and drives him away from them. Afterwards he drinks at home, suffering the leers of delivery boys who unashamedly ogle him, for now he's quote unquote Famous, this

strange unkempt man who keeps harems of ladies, each more demanding than the last.

Some women, however, have a redemptive influence on him. They give him a 'warm grace' and help him lose the fear of loving that has been instilled into him since his profoundly graceless youth.

His average relationship, he tells us, lasts about two and a half years due to his 'degenerate personality' but he doesn't, as is commonly believed, bury the women he dumps, or who dump him, in the Hollywood hills. He doesn't expect virginity, but prefers women who haven't been 'rubbed raw by experience'.

In 'for some friends' he has a foretaste of death, and the delight he fears will attend his passing, but in 'thoughts on being 71' this has largely dissipated. Death is now a 'pet cat', that is neither something to be feared nor sought but an event that's in the nature of things. He's got this far and has no regrets about what happens from here on in. He's young in his mind regardless of the craggy visage that greets him from the other side of a mirror each day.

In 'fame', one of the most interesting poems in the book, he tells us it was never about wealth or celebrity in his eyes. The years of oblivion were the same as the years of plenty for him. If he'd wanted to become famous the words wouldn't have come out as they did. In fact maybe there would have been no words at all. Fame happened and he was grateful for it, but it didn't change him, it merely gave him the latitude to be as outrageous as he had always been. The only difference was that now more people knew about it.

Getting down the right word in the right place gives him a sense of immortality; it oils the machine of his day. There's a beauty in language that's rarely replicated in the world and to that extent it's to be treasured. So are women — at least for two and a half years. And the horses, which give him a 'precise simplicity' the rest of his life somehow lacks. All of these things keep him sane, but not *too* sane. If something goes badly wrong for him he can still be witnessed wandering round the garden naked and spewing expletives — hopefully to annoy the neighbours.

So he plays the horses and the women, and makes poetry out of the little things that happen in his days, even though he finds the performance of daily chores somewhat absurd. But then Hank, like many writers, can find the absurd in most things if he looks for it any way conscientiously.

He also reminisces on the days of stuffing hopeful manuscripts into envelopes and casting them out to whatever editors they would find, only very occasionally getting printed but persevering nonetheless because he was hungry — and not only for food. And if you care that much, then maybe you deserve it to happen for you.

He gives us no answers to the meaning of life — neither his nor ours. All we know is we're here to give things a shot. Some make it and some don't; that's all that can be said. He himself was one of the lucky ones finally.

Of course no collection would be complete without a Jane poem, and this is here too. In 'to Jane Cooney Baker' he tells us she left him many times but always returned, at least until one day in January 1962 when she succumbed to that 'final and terrible and beautiful whore' of death, as he calls it elsewhere. He used to wait for her many times in the past but now, he says, suggesting she has been the one true love of his life, 'you must wait for me.'

A more recent Bukowski book to appear from Black Sparrow is *Beerspit Night and Cursing*, a collection of Hank's letters to artist-cum-author Sheri Martinelli from 1960 to 1967. Martinelli edited *The Anagogic & Paideumic Review*, one of the many literary

magazines Hank submitted his work to at this time, and though she rejected his first effort, her detailed response to it impressed him and the pair of them struck up a correspondence. They were polar opposites in personality, her rarefied twitteriness totally at odds with his blunt laser jabs of bile, but they had a weird kind of respect for one another born of a mutual passion for good writing.

It's a pure Hank we see in these pages, a man who as yet baulks at the idea of doing poetry readings and who, despite the attentions of the likes of Jon Webb and E V Griffith (not to mention certain critics who compare him to Homer!) imagines himself at one point as being so inconsequential in the poetic pantheon that he will be five days dead before his body is discovered. In another man this could be taken as an attention-grabbing, melodramatic aside, but it's vintage Hank. He also informs Martinelli that he fabricated an irascible persona to keep people away from him, and that he stopped writing for ten years to make way for '200, maybe even 2,000' years of experience.

Martinelli seems to have tapped into Hank's feminine side because there's a lot of tenderness in these letters. His tone is also generally upbeat here, which is doubly surprising since his personal life was in tatters during the sixties and his career hadn't really taken off yet. In one letter he tells her he's sent poems to seventeen different literary magazines simultaneously, an uncanny example of his enthusiasm — not to mention a workload that would have killed lesser men, especially when we consider he was holding down the post office job at this point as well. Martinelli, for her part, responds to his diatribes like an Emily Dickinson on acid. Her verbal convolutions, like her thoughts, are quirkily refreshing and Hank responds in kind. It's as if writing is reality to both of them, and the world outside it little more than a minor inconvenience that has to be negotiated.

Martinelli was virtually airbrushed out of Hank's life after he hit the big time, but here she's like his number one touchstone, the woman who seems to understand him like no other, and who knows where his head is about life and love. He confides his most intimate thoughts to her as well as teasing out the obsessions we see in most of his other writings: the need to go for broke in one's art, the necessity of paying homage to Mammon in order to buy time for what's really important, the strengths and weaknesses of fellow scribes, etc. etc. Ezra Pound crops up with enormous frequency, hardly surprising since Martinelli had a deep personal relationship with him, but the pair of them range freely over the gamut of literature as they tease out their own aspirations and disappointments. 'It is best we never see each other,' Hank says to her in one letter, as if a meeting would somehow disrupt the purity of their epistolary communion. Considering what happened with Blazek and Corrington, one can see his point. The statement, however, sits somewhat uneasily with him telling her she's the most beautiful woman he's ever known, 'one woman in ninety million women'.

Curiously enough, in one of his letters to her from 1960 he alludes to the likeliness of such a rift when he tells her he would probably hate her within ten minutes if they ever met. This is an uncanny assertion considering most of his other comments to her verge on the rhapsodic. What he's really saying here is that he doesn't like meeting people, period, that they stand a better chance of seeing the best of him at a safe distance. (Ask John Martin.) From the comfort zone of the page he can flirt with her, casually taunt her, cajole her about her views on 'Ez', and wonder aloud where, if anywhere, his literary career is going. He can send her his poems and sketches and ask her for hers in return. He can speculate on the charlatans who have become mega-famous (like Ginsberg, Kerouac and William Faulkner, to name but three of his pet

hates). He can philosophise on everything from the classics to a slimeball who steals his coat at the track one day. But meeting 'La' Martinelli in the flesh seems somehow a bridge too far. If such an eventuality transpired, Hank seems to fear the hallowed ground between them would somehow become sullied. The mystique would disappear and they would be transmogrified from soul mates into a mere pair of wannabes scratching for a delectable chink in the walls of posey.

Having said that, he asked if he could visit her in October 1961 and she demurred, so the hesitancy cut both ways. Was she also nervous of meeting her visceral penpal in the flesh for fear he wouldn't measure up to his heated ramblings in print? We'll never know now because she died in 1996, having had one of the most chameleonic careers in literary and artistic history.

She became so obsessed with people — Pound, Buk, Ernie Walker, Jory Sherman, etc. — there was all that much more to lose if a rendezvous took place and then backfired, and there's every chance this could have happened with Hank. (Witness what happened between himself and that other literary editor, Barbara Frye.) As things stand, the relationship between himself and Martinelli, even if it fizzled out tamely as the sixties drew to a close, is frozen in time as a beautifully hectic commingling of souls, hermetically sealed from the greater world outdoors as they analyse their preoccupations with untrammelled zeal. Reading their crossflow of letters isn't so much yin and yang as two sides of the same coin, for this is highly combustible fuel flowing in both directions. Indeed, it was Martinelli's looseness of rhythm, combined with an explosive energy rare in women of his ken, that drew him to her in the first place.

They postponed meeting one another so many times it became like a joke between them, one of their many. Hank could express himself to this woman like no other. He could talk books with her in one breath, and the darkness of his soul the next. He shared with her the kaleidoscopic cluster of images that lacerated his head, and she, in response, parleyed with him like a demented school-marm. Or even a sister — or mother. Both of them were wired to the moon but also cerebrally plugged in to their own psyches. Out of such anomalies they created a kind of folksy fodder unparalleled in any collection of letters you're likely to read. From this point of view, *Beerspit Night and Cursing* is a rare treat.

Their relationship, sadly, was abruptly terminated in 1967 when Hank accused her of being economical with the truth after she claimed to be in contact with Pound when he was incarcerated in a psychiatric institution. It was his friend John Thomas who put the suspicion in his mind. The fact that Hank took it on board is surprising considering his relationship with Martinelli went back so far. Also, what point would there be in her telling a lie in the first place? He was aware she knew Pound intimately for years. Was it not more likely Thomas was misinformed?

Martinelli was profoundly distressed by his charge, as she was entitled to be. She didn't attempt to defend herself, her response instead focusing on the discernible shift in Hank's attitude to her. It's difficult to know what caused this. How can a person communicate with a woman on an elemental level for seven years and then suddenly turn against her on such a flimsy pretext? Maybe we'll never fully know what caused this particular seven year itch, but Martinelli is unique in the sense of incurring Hank's wrath without ever having met him. She went from hero to zero almost in an eye blink.

It would be convenient to surmise that Hank lost interest in her after his career took off but it didn't quite happen like that. It's more likely that her repeated criticism of his poetry (well-intentioned and all as it was) began to grate on him more progressively as

the years went on. In the early sixties he was willing to take her barbs on board, almost enjoying her dotty suggestions, but as his work became more widely published he started to develop more confidence in it, and view her eccentric reactions as totally off kilter. If we see things in this context it's not too surprising that he would take John Thomas' word over hers in the Ezra Pound allegation, even simply as an excuse for cutting off communication with her. Whatever his reasons, she immediately recognised the change in his tone and was sufficiently miffed by it to make the wish for a cessation in their communication mutual.

The Night Torn Mad With Footsteps, published in 2001, is another large posthumous poetry collection from Black Sparrow which makes us wonder yet again how Hank found time to live the high life amidst all his scribblings. It's a mixed bag even if, as he admits in 'wine pulse', the last poem, it's awash with familiar preoccupations. It would be churlish of us to deny him, or indeed any poet, the right to sing his joy from the rooftops after so long in the gutter. The difference with this man, of course, is that he sings from the gutter too.

The opening poem, 'one writer's funeral', could equally well have been the closing one as it attests to the end of an era in its account of the burial of John Fante. There's no schmaltz here, no crocodile tears, no easy emotion. After the obsequies are completed, Hank is stuck for anything to say to Fante's widow. A man has died and Hank documents the occasion with surgical precision, not sentiment. Whatever emotion he feels is kept under wraps. An era has ended for him but he doesn't bother us with any verbosities. Is this cold-bloodedness? No, just Bukowski grit. At the end he heads off to the track, giving us a wryly humorous detail to finish: he's wearing a necktie as he goes to place his bet on the first race. The incongruity is choice.

Incongruity is also the keynote of 'a smile to remember', the next-but-one poem, where he tells us his mother expected him to smile when all about him was doom and gloom. Both of them are being beaten by his father and expected to take it all lying down. She does, but Henry only sees the black humour of the situation. His mother will continue to live the lie, pretending there's something worth preserving in the dead crumbs of her existence, smiling even as her spouse feeds the goldfish to the cat.

Elsewhere he looks back on various phases of his life with a mixture of nostalgia and bluntness. 'A drink to that' lays the ghost of his parents again while his reclusiveness is evident in 'never look' and 'not exactly the sun'. 'The closing of the bottomless bar' is a puckish ode to strippers that echoes some of the concerns of Lenny Bruce in its exposé of hypocritical attitudes to pornography, whereas 'the light' is a simple testament to battered dignity, a tribute to an old man who could be Hank himself in his unwillingness to bend to pain. 'Out of the money', meanwhile, creates an interesting dichotomy between Hank's literary and his outdoor life. A jockey friend asks him to recommend a book he should read and Hank, hardly surprisingly, chooses Céline's Journey to the End of the Night. The book leaves the jockey cold, which fazes Hank. There's no accounting for taste, he concludes, and resolves not to talk to him about books anymore, just horses: a salutary lesson.

He's more jocular in 'Room 22', a poem that captures the unique camaraderie of the down-and-out years where fellow vagrants didn't need anything but time (and some plonk) to knock out some fun. A kind of freemasonry of the spirit takes root in the dilapidated US hotel where they trade yarns under the influence, before Hank goes off to check the Sits Vac column in the local newspaper. It may be Desolation Row, but it's not quite Heartbreak Hotel for these mercurial souls who've dropped out of society

without, apparently, suffering any ill effects. Not yet anyway.

Laidback, downbeat *aperçus* punctuate the book. Mad whores and nudie dancers come and go, and he laughs with them and fights with them and loves and hates them and they love and hate him back. Sometimes they leave him and he wonders why — until the next one. In the meantime he goes racing and/or listens to classical music, marking time before the next therapeutic glass of wine or the next reverberative lyric.

At times, as in 'the eternal horseplayers', we get a sense of helplessness, but the mood changes to one of whimsicality in poems like 'A great place, here' and 'Horses don't bet on people and neither do I'. It's hard to know where he's coming from in 'Poem for Brigitte Bardot' because it starts off like yet another diatribe against the ants-in-the-picnic-basket whiners as he compares the suicide attempt of Bardot, a woman who has it all, to that of those who have nothing, but by the end you feel he's expressing genuine concern for her plight.

Some of the bargain basement philosophising he indulges in is solemn ('shack dogs') and some mischievous ('It's just me'). There are cat poems, Jane memories, a would-be Prufrock poem, 'Gamblers all') and any number of ruminations on his misfit status ('They need what they need', 'Hello, how are you?' etc). 'Macho hell' is a moving hosanna to transience, whereas many of the other offerings are laugh-out-loud funny ('No wonder', 'My telephone'). The post office experience is piquantly called up in 'The saddest words I ever heard', while in 'My failure' he draws a stark picture of his inability to let go of his anger. In 'The condition book' he makes the stark revelation that all of the co-ordinates of racing have entered his being by a process of osmosis, while in 'Centuries of lies' he nonchalantly disassembles his own mythology.

Some of the poems might better have been left out. There are few saving graces, for instance, in curiosities like 'His cap', 'You know who's best', 'Divorce', 'The theory of the leisure class' 'My cat, the writer' or 'The hatchet job' — to take but a random sample of negligibility. In fact one seriously wonders if Hank himself would have deemed these worthy of publication. You could say the same about 'Brando', a poem that purports to be about the movie legend but is, in fact, about nothing at all. 'A boor' is equally trivial. These two poems seem to base their relevance on the fact that they pertain to actual incidents, but is this enough? Hardly. Hank was often accused of being too personal in his work, and while this is a silly charge — anything should be permissible in a poem provided it's well written — it acquires a certain relevance in cases like this. This very issue is addressed in 'American Literature 11' where he has a go at academia, acquitting himself admirably in the process, which makes you re-think your reaction.

Maybe the point is that he needed the dross to limber him up for mining the motherlode. When you're insane (see 'Crazy as a fox' and '1810-1856') different laws apply.

As always, it's salt and pepper with this man. No two poems evince the same reaction. We may chortle at 'I cause some remarkable creativity' and 'Casablanca' — his backhanded homage to Humphrey Bogart — shiver at 'Racetrack parking lot at the end of the day', be amused by 'Spelling it out on my computer', and chastened by 'The lucky ones'. Because we've been to all these places with him before, we know the way his mind works. What's new is the little twists he gives to the old anecdotes, and the mellowness he brings to the new ones. His mind seems at once transparent and convoluted; a basic germ underlies each poem, but within that shell he gives himself room to be puckish, irascible, contentious, resigned, warm. Maybe that's why none of his women could live with him for longer than a few years: he was continually re-inventing himself, but in such muted ways you'd hardly notice. Setting himself up as a pariah gave

him enviable opportunities to second-guess the opposition — and sometimes, it appeared, even himself.

He's not shy to tell us how many people think he's a lousy writer chained to the sewer, or about the time with Jane where he had to board up his door with furniture to stop the cops taking him down to the drunk tank. In fact when a woman tries to take him *out* of his slum dwelling in 'Media' — in a scenario reminiscent of *Barfly* — he demurs. Poems like '40 years ago' and 'A time to remember' trawl similar beats, reminding us yet again where the iron in his soul was forged.

A markedly different tone imbues 'It is good to know when you are done', a series of profound ruminations laid out in the stream of consciousness manner of the letters. Contrast that with the slight but amusing 'I demand a little respect', which comes to us with a tone of 'familiarity breeds contempt' as in the case of one of his past flames.

In general, the collection finds our anti-religious, love-bashing Chinaski alive and well, and laughing at life and death to keep both of these beasts at bay.

In such circumstances, maybe it's not altogether unusual that the most moving poem in the book ('Eulogy') is addressed not to a woman but a car! (For his special take on love, sample 'A definition' or 'Girl on the escalator'.)

High school reject, neighbour from hell, gravitating from the casual cruelty of parents to that of employers, editors and demented landladies, at base he just wants time to move the words along, to challenge the likes of Jeffers and Céline with his peculiar catchpenny twist. Felines slump over his typer but he goes on cranking it out with his sweet madness and craggy grace, being angry at the sun sometimes but more often tapping into the tranquillity of San Pedro as a genial old age puts in the first traces. There may not be real beauty in the world, he reasons, but there can be in the *word*, and it's this conceit that sustains him as every passing fancy and minor altercation gets itself trotted out for our edification. Pulverising jobs, critics who know diddly-squat, mendacity in high places, smugness and synthetic emotion, all these can be grappled with if we keep the inner light shining, and an anarchic sense of humour in good working order. This is the best way to beat the devil — and the devil inside.

The resounding question that *The Night Torn Mad With Footsteps* leaves us with is whether this is the real Bukowski or is he just playing a game? In poems like 'Too tough to care', 'Gothic and etc.' and 'Good pay' he takes great delight in sending up his Boozy Scribe image.

He also sends up the whole poetic genre by the inclusion of 'Funny man', a short story written in the form of a poem. But who's complaining? Rule-keeping was always a no-no for him, so why should the life of the page be any different?

In 2002, Sun Dog Press published a book called *Bukowski and the Beats*, written by French novelist Jean-François Duval. The very title will put many off, but Duval makes a persuasive case for his theme, mainly because he resists the temptation to overplay his hand.

Hank couldn't be construed as being a Beat in the strict sense of the term because he didn't intellectualise poverty nor regard bohemianism as anything to be aspired to. For him, as mentioned already, moving from place to place was more escape than adventure, a stratagem of desperation rather than a quest.

He didn't like speed of either kind — on the motorway or the kind that messed with your head. (Yes, he was a drug addict, but his drug of choice was booze.) He couldn't pull the chicks like a Kerouac or a Cassady. That came with fame, or rather notoriety.

Also, unlike Kerouac and Cassady, his life got better as he aged — or should I say

more bearable. If he'd been born with a silver spoon in his mouth, the likelihood is that he would have drunk himself into an early grave. Being indigent meant he had to do 'the forty hour thing' to give him the wherewithal to pay for alcohol and rent... in that order. Such work, ironically, kept him alive, acting as a kind of healthy conduit between binges.

He felt the original Beat dream was hijacked by too many smug would-be adherents living in the comfort zone of economic solvency and ideological laziness. It wasn't so much counter-cultural angst as vapid high jinks from the quasi-left. Hank didn't want any truck with Kerouac's inchoate mysticism, preferring to poeticise the crude and cruddy. Life was about getting through the day, not seeing magic in a flower, or even a commodious fuck.

He liked to hang loose all right, but he never lost himself in Beat-ific funk. And maybe that's why he outlived the Kerouacs and Cassadys. He existed at the dull centre of experience, more comfortable here than on the radiant rim. Kerouac always had his head over the parapet looking for a pot of gold at the end of the rainbow but for Hank a rainbow just meant rain. Significance didn't mean tomorrow for him but today — or tonight. His mission was to get through things rather than to them.

Duval interviewed him at some length in his San Pedro home in 1986 and their conversation, reproduced here in full, contains the nucleus of the Bukowski myth. He retreads the anecdotes and vignettes that have become indissoluble from him with the gentle coaxing of Duval and Linda Lee, a man finally at comfort with himself. And who could deny him this? *Bukowski and the Beats* is a book of two dissonant halves, Duval frequently content to stray from his main business to regale us with material most Buk fans will be well familiar with. This isn't a problem as the book's title is really a mischievous misnomer. Some will accuse it of being a contrived excuse to rope together some hoary old yarns under a self-contradictory umbrella, but this would be to ignore its empathy with a man who went from self-destructive *poet maudit* to venerable wordsmith as he cheated both the Reaper and those naysayers who saw him as little more than the doyen of the dim.

'Trying to be kind to others,' Duval quotes him as saying, 'I often get my soul shredded a kind of spiritual pasta'... but this was before he traded in bad beer for fine wines, and nihilism for a spiritual peace not a million miles away from the Buddhism the aforementioned Kerouac so sweetly espoused.

A lot of ink is spilt on his refusal to meet Jean-Paul Sartre, for reasons best known to the author as it isn't really relevant to the title. Where Duval is best is in his diatribes on Kerouac, or etching in the backdrop to Hank's volcanic energy as he creates a language that isn't so much unliterary as non-literary: language that will appeal to train hoppers, delinquents and ex-cons.

He sees him as a Quasimodo figure, a rough diamond who saw beauty in the rough of others too, probably for that reason. Or a Chaplinesque figure: the hobo clown laughing through his tears at a life too absurd to be taken seriously. And of course Boccaccio. But then we knew that already...

So there we have it, for better and/or worse. Other books, no doubt, will continue to appear from Black Sparrow and elsewhere, all of them adding to his myth, but has anyone fully divined the essence of Charles Henry Bukowski?

He shot from the hip and lip, firing on both barrels to comfort the afflicted and afflict the comfortable. He let his words take him where they would, like his life. Through them he communed with the dark places of soul, the lean grey wolves of the

subconscious. In his brutal/banal depictions of sex he reached a kind of grudging catharsis. In bed nobody could lie, or poeticise. What you were here was what you were period — for better and worse. You were freed from hypocrisy by the body electric.

More than anything else, he taught us a new way to look at life. In his casual denunciations of things like opera, movies, rock concerts and most poetry, we're left at the end with little but Bukowski himself, but he was so persuasive in these tirades you found yourself questioning the validity of the hours you spent indulging in these very activities, and almost feeling guilty about them.

He was intensely involved in his life and yet removed from it — as all writers must be to comment justifiably on it. Sometimes he said he looked on life as a lousy movie we were all trapped in — a revisionist slant on Shakespeare's strutting and fretting one's hour upon the stage, or living a life told by an idiot, full of sound and fury, signifying nothing.

A double-fisted drinker who created literary anarchy until the world sat up and took note, he never made apologies for his recklessness, his cruelties, his inability to feel the tenderness that had been denied him when he most needed it. His parents sent him out into the world with nothing so he felt nothing was what he owed that world back.

He wrote for taxi drivers, for hookers, for slaughterhouse employees and mailmen and racetrack fiends and broken hearts and misfits and malcontents and isolationists and saddle-sore losers — all the people he had been himself.

Bukowski may not always have been the best show in town, but he never hung back, and lived life with all the twisted logic of a wired sage, a bruised romantic, a born-again pussycat.

He was unfashionable for years because he wrote in a language that everyone could understand. The pseudo-intellectuals — who comprised the lion's share of editors and critics — felt that there had to be something wrong with it on that account. They wanted obscurantism for its own sweet sake. They wanted motifs and symbols and paronomasia and classical allusions and ambiguity and multilayered meanings to test their exegetical skills. They wanted haute cuisine but Bukowski only offered them fast food. And they failed, or refused, to digest this. What he did was too easy to be good in their eyes. It didn't pass the litmus test because it didn't have what we might call the Bullshit Factor. He either had to learn that or give up. But he refused to do that. He would die sooner.

Writing had to be an obsession, had to be a pact until death between you and your muse or forget about it. You couldn't do it from nine to five, or when the kids were abed. It had to eat into your sinews until it hurt.

There would be no tiptoeing through the tulips for this man, or rarefied psyches floating on gossamer wings. He made it his mission to take wordmaking out of the chamber-rooms and give it back to the people. All too often poetry had fallen into the hands of those who had never lived, who knew words but not worlds, and he launched a full frontal assault on these. He wanted to get back to the time cavemen had scratched images on walls, to reinvent the Thing Itself. That meant not so much creating a revolution in language, like the neo-modernists, as clearing the decks of excess baggage, excess emotion, excess schmaltz. Hemingway had done it by his iceberg theory, by writing on water. Hank would traverse a different route. He would leave all of the iceberg above the surface, but stain it with his anger, his unequivocal vituperation. There would be no subtlety here, no wrangling between critics about what he meant, no deconstruction of his texts by the revisionists. It would be plain for all to see, the

muck and the savagery, with here and there a tin can glinting in the sun in a vague hint at some redemptive import. But only if he felt like it.

Careful writing was deathly writing, he said. You had to stumble before you flew. As it was with horses, so it would be with the printed word: he would shy away from the favourites.

He didn't go to war, but he knew how to use his pen like a bayonet, and the blood he drew was sometimes his own. A man with a divining rod instinct for the biting phrase, he worked on a narrow canvas, eschewing the larger panorama of life for his own adrenalised niche.

He had a beautiful spirit inside that not-so-beautiful body, but if he had been born prettier he may never have taken that walk on the wild side that gave him so much of his raw material. So maybe he should have been grateful for the boils, and all the physical and emotional pain they engendered.

His idea of a Utopia, he told Steve Richmond, would be to build unpainted wood houses in the desert, put lots of sand between them and sell them to people who would be free to do anything they goddam pleased. There would be no rich people in this never-never-land, and no literary pretenders. Neither would there be a police force. Eligibility would be determined by dint of the residents' paintings.

He told us little stories about his life, about the cameos that fill up all our days. He didn't stylise the mundane like so many others, but merely put it down as it happened.

He had the courage to publicise the crudity others acted out in private, or secretly fantasised about. In this sense he's one of our most authentic talents.

Like the Manny Hyman of There's No Business, he told us the world was shit, and some of us appreciated that and some of us didn't want to be reminded of the fact. But the way he said it made you listen whether you wanted to or not. His words stuck on the page like glue: hard, viscous and unrelenting. You could look the other way but Hank was probably there too, coming at the same theme from a different angle, taunting you from all corners with his phlegmatic malaise.

How will posterity remember him? As a crude drunk who wrote over-long books with funny names or a visionary who pushed out the envelope of poetry by refusing to conform to any of its dictates? Maybe all we can say for sure is that he breathed new life into the form by endowing it with his explosive personality: first in semi-surreal fashion in the early work and then by a dogged (and sometimes pedantic) plainness. Either way, when you finish a Bukowski poem you know you've been somewhere. Exactly where you're not sure, and maybe you don't want to be. You've got a window into a life, that's all. Tortured, abrasive, throwaway... you don't really know how things are going to pan out till you reach the last line, and maybe not even then. It may not be art, but it's cookin'. And you find yourself wanting more of the same. He makes it look so easy you might even want to try something similar yourself, but when you start you realise you can't slam the line down like he does, because a life has gone into its composition. In a word, the style is the man.

So what should be our final evaluation of him? Was he a man who saved literature from the groves of academe and gave it back to the people or — in the words of 'a fan letter' — a 'two-bit burnt-out mental fuck'?

Scorn not his simplicity.